Looking at Italian Renaissance Sculpture

Looking at Italian Renaissance Sculpture offers new and original insights
into the sculpture produced primarily in Florence, but in other
regions as well, during the fifteenth and sixteenth centuries. Focusing
on the achievements of such artists as Donatello and Michelangelo,
this volume demonstrates how the methodologies of cultural anthro-
pology, aesthetics, conservation, political theory, gender studies, and
literary analysis, among others, can be successfully applied to the
study of sculpture. Among the themes explored in this collection of
eleven essays, most written specially for this edition, are the relation-
ship of sculpture to nature, as well as to the cultures of Greece and
Rome; the role of patronage; the development of new forms, such as
statuettes and portraiture; and the creation of public monuments as
vehicles for propaganda. Also emphasized are the techniques of cre-
ating sculpture in a variety of media, including bronze, marble,
wood, stucco, and terracotta.

Looking at Italian
Renaissance Sculpture

Edited by
Sarah Blake McHam

PUBLISHED BY THE PRESS SYNDICATE OF THE UNIVERSITY OF CAMBRIDGE
The Pitt Building, Trumpington Street, Cambridge, United Kingdom

CAMBRIDGE UNIVERSITY PRESS
The Edinburgh Building, Cambridge CB2 2RU, UK http://www.cup.cam.ac.uk
40 West 20th Street, New York, NY 10011-4211, USA http://www.cup.org
10 Stamford Road, Oakleigh, Melbourne 3166, Australia
Ruiz de Alarcón 13, 28014 Madrid, Spain

First published 1998
First paperback edition 2000

Printed in the United States of America

Typeset Bembo 11/14.5

A catalog record for this book is available from the British Library

Library of Congress Cataloging in Publication data
Looking at Italian Renaissance sculpture / edited by Sarah Blacke McHam.
 p. cm.
Includes bibliographical references.
1. Sculpture, Renaissance – Italy. 2. Sculpture, Italian.
I. McHam, Sarah Blake.
 NB615.166 1998
 730'.945'09024 – dc21 97-14906
 CIP

ISBN 0 521 47366 7 hardback
ISBN 0 521 47921 5 paperback

To my husband, Gene, our children, and T

Contents

Illustrations

Figures

Acknowledgments

I am grateful to my collaborators, a very cooperative and stimulating group with whom to work. I especially appreciate Irving Lavin's and Anthony Janson's support of the project. The University of Chicago Press, Cornell University, the University of North Carolina Press, and the Librairie Philosophique J. Vrin graciously allowed the republication here of essays that they had first published. I would also like to thank Christiane Klapisch-Zuber, Claudia Lazzaro, John T. Paoletti, Sheryl Riess, and William E. Wallace for lending me photographs and G. M. Helms for painstakingly creating the drawings that illustrate the processes of sculpture. Donna Serbe Davis, Shari Kenfield, and Stephanie Leone were a great help in tracking down photographs. Phillip Earenfight, Margaret Kuntz, Tod Marder, Deborah Markow, Elizabeth Pilliod, and Betsy Rosasco assisted me by checking bibliographic details. James Holderbaum and Elizabeth Pilliod read my own essay and made a number of helpful suggestions. Emily Wilk provided a great deal of help in the preparation of the manuscript. Most of all, I thank my husband, Gene, who as always provided unflagging support, enthusiasm, and sound critical judgment.

Contributors

Paul Barolsky, professor of art history at the University of Virginia and a leading authority on Vasari's biographies of Renaissance artists, has written a number of books on the subject including *Michelangelo's Nose* (1990), *Why Mona Lisa Smiles* (1992), *Giotto's Father* (1993), and *The Faun in the Garden* (1994).

G. M. Helms, a conservator based in London, was trained as an art historian and a specialist in conservation at the Institute of Fine Arts, New York University. A former member of the editorial board of *Art and Archaeology: Technical Abstracts*, she is currently working on a book for art historians that surveys the materials and technology used in the production of works of art from ancient Egypt to the present day.

H. W. Janson, who died in 1982, was a professor at the Institute of Fine Arts and the College of Arts and Sciences, New York University. He was the author of the universally used survey text *The History of Art*, which has gone through four revised editions since its original publication in 1962. He wrote many specialized studies on Italian Renaissance art, such as *The Sculpture of Donatello* (rev. ed., 1979), and numerous articles, some of which are collected in *16 Studies* (1973). He also pioneered the contemporary study of nineteenth-century academic sculpture with his book *Nineteenth-Century Sculpture* (London, 1985).

Joy Kenseth, who is professor of art history at Dartmouth College and the author of many articles on Italian sixteenth- and seventeenth-century art, organized the exhibition *The Age of the Marvelous* (Hood Museum, Dartmouth) and edited its catalogue (1991). She is currently working on a similar exhibition devoted to magic in the Italian Renaissance.

Christiane Klapisch-Zuber, professor at the Ecole des Hautes Etudes en Sciences Sociales, Paris, is the author of many articles and of books such as *The Tuscans and Their Families: A Study of the Florentine Catasto of 1427* (English trans., 1985), and *Women, Family, and Ritual in Renaissance Italy* (English trans., 1985). She is currently working on family trees in the Renaissance period.

Irving Lavin, professor of art history at the Institute for Advanced Study, Princeton, is the author of numerous articles. His books include *Bernini and the Unity of the Visual Arts* (1980), *Drawings by Gianlorenzo Bernini from the Museum der Bildenden Künste, Leipzig* (1981), and *Past-Present: Essays on Historicism in Art from Donatello to Picasso* (1993).

Claudia Lazzaro, professor of art history and chair of the department at Cornell University, is the author of *The Italian Renaissance Garden: From the Conventions of Planting, Design, and Ornament to the Grand Gardens of Sixteenth-Century Italy* (1990) and many articles on Italian Renaissance landscape architecture.

Sarah Blake McHam, professor of art history and chair of the department at Rutgers University, is the author of many articles on Donatello and on Venetian sculpture. Her books include *The Sculpture of Tullio Lombardo* (1978), *Fifteenth-Century Central Italian Sculpture: An Annotated Bibliography* (1986), and *The Chapel of St. Anthony at the Santo and the Development of Venetian Renaissance Sculpture* (1993).

John T. Paoletti, professor of art history at Wesleyan University and current editor in chief of the *Art Bulletin*, is coauthor (with Gary Radke) of the recently published survey *Art in Renaissance Italy* (1996). He has written many articles dealing with fifteenth-century Tuscan sculpture, particularly on the patronage of the Medici family, as well as the book *The Siena Baptismal Font: A Study of an Early Renaissance Collaborative Program* (1975). He is also an authority on twentieth-century art.

James M. Saslow, professor of art history at Queens College of the City University of New York, is the author of *Ganymede in the Renaissance: Homosexuality in Art and Society* (1986), *The Poetry of Michelangelo: An Annotated Translation* (1991), and *The Medici Wedding of 1589: Florentine Festival as Theatrum Mundi* (1996).

William E. Wallace, professor of art history at Washington University, is an authority on Michelangelo. Among his many publications on this artist, *Michelangelo at San Lorenzo: The Genius as Entrepreneur* (1994) and the five volumes he edited entitled *Michelangelo: Selected Scholarship in English* (1995) are the most significant. He is currently working on a biography of Michelangelo.

Introduction

Sarah Blake McHam

L OOKING AT ITALIAN RENAISSANCE SCULPTURE presents eleven essays by prominent scholars who analyze in depth certain problems and issues regarding Italian sculpture of the fifteenth and sixteenth centuries. As a result, the volume's scope is neither comprehensive nor strictly chronological. Some of the essays have been revised from their earlier publication in scholarly journals or conference proceedings; however, the majority are new and were commissioned for this volume.

Looking at Italian Renaissance sculpture, in the sense of the title, means how to analyze and think about the medium, in the conviction that there are certain characteristic physical properties as well as cultural conventions that influenced the expectations and interaction of artist, patron, and viewers. Enhanced understanding allows a more thoughtful and rewarding appreciation of why sculpture looks the way it does and, once these perceptions are integrated into the larger historical context, why other forms of Italian Renaissance art look the way they do.

Contents

The essays in this volume concern primarily Tuscan and Roman fifteenth- and sixteenth-century sculpture. The decision to limit the geographical range was made for several reasons. The innovations that we associate with the Renaissance began in Florence, and many of the period's greatest sculptors were from that city or its surrounding countryside. As a result of these and other factors, scholarship has focused on the region. Hence Florentine studies have developed beyond the basic historical charting of sculptors and significant monuments still underway in other parts of Italy. In the opinion of the editor, essays chosen to demonstrate a spectrum of different methodological approaches can do so most effectively if the same or related sculptures are a consistent focus of analysis. Insofar as possible, essays that overlap in their discussion were included.

The volume begins with a succinct, well-illustrated account by G. M. Helms of the materials and methods by which all the principal forms of Renaissance

sculpture were produced. No other book on Italian Renaissance sculpture includes a discussion of this crucial area, which Helms, with her unusual double training as a conservator and an art historian specializing in Italian Renaissance sculpture, is ideally suited to provide. She has enhanced her analysis of direct and indirect bronze casting by correlating her drawings of their stages of production with the firsthand accounts by the sculptor Cellini, the most important writer on the subject in the period.

H. W. Janson's essay, originally delivered as a lecture and published in 1971 in the conference proceedings, is a classic in the field.[1] It provides a lucid and pithy outline of some broad aspects of the influence of Greco-Roman art on the Italian Renaissance. The relationship between the cultures of the two periods defines the identity of the Renaissance. Few scholars could have approached this fundamental issue with the authority, wit, and provocative insight of Janson. By adapting a philological approach to the visual arts, Janson attempted to discover the sources of forms and themes characteristic of the Italian Renaissance and to trace their gradual cultural evolution. Like all his contributions to the study of art history, particularly his still unsurpassed *History of Art*[2] and *Sculpture of Donatello*, Janson's intellectual approach and careful scholarship shaped understanding of the discipline for his generation and for posterity. Despite its being conceived almost thirty years ago, the essay is fresh, although there are glimpses of the social attitudes of a different time. More recent publications, many stimulated by Janson's ideas and initiatives, have been added to the notes by the editor.

Irving Lavin's essay reprints his magisterial study of the development of the sculpted portrait bust during the fifteenth century.[3] He pursued in exacting precision and depth the genesis and transformation of the portrait bust, one of the types discussed more generally by Janson. Lavin traced the philology of the format and inscription of the sculptured bust through antiquity and the medieval period by considering relevant examples of widely varying artistic quality. His method of ranging beyond the study of acknowledged artistic "masterpieces" to assess the typological patterns of the actual works produced, no matter how humble, represented a new and extremely important scholarly method in Renaissance art history. Through this double analysis – epigraphical and typological – Lavin suggested as well the outlines of the evolution of attitudes toward death and immortality across this chronological span.

John Paoletti's essay extends his research on the patronage of the Medici family to inside their residence.[4] He depends on inventories of the Medici family's collection and compares the types of art that they displayed in the palace constructed for them by Michelozzo to those owned by other Florentine families. Previous scholars have been stymied by the incomplete information of inventories whose typically broad, imprecise descriptions such as "Madonna and Child" precede monetary evaluations, with the result that commissions for private households have been little studied. It must be admitted that there has also been a residual reluctance to move away from a focus on high-quality works of art by

great artists (the Renaissance is after all the first period in which we can trace such individuals) into the world of inexpensive works of art produced in multiples by often anonymous craftsmen.

Paoletti recognized that the shorthand designations of inventories nevertheless reveal the category to which the sculpture belongs, even if the piece itself cannot be specifically identified. Using these documents in this way he gleaned important new evidence on how the Medici transformed the traditional vocabulary of domestic commissions and introduced a number of wholly new types of decorations and sculptures into their palace to advertise their power and to craft an idealized image of their family.

"Holy Dolls" is one of many influential studies published by Christiane Klapisch-Zuber about the private lives of fifteenth-century Tuscans. The subject – the use of sculptures as dolls to play with and pray to – betrays her long-standing interest in works of art as artifacts of the period. As in all her research, her methodology depends on close analysis of previously unpublished documents.[5] Recently, as "Holy Dolls" and the other essays collected in *Women, Family, and Ritual in Renaissance Italy* reveal,[6] she has combined the evidence of data derived from public tax records and surveys with the personal testimony of fifteenth-century Tuscans in their family memoirs (*ricordanze*).[7] This essay gives compelling evidence of one way in which the tangible physical presence of sculpture worked on the sensory imagination to stimulate religious fervor.

Joy Kenseth's analysis of the period's aesthetic and philosophical fascination with small-scale sculpture (in all sorts of materials, including sausages, which G. M. Helms does not analyze!) derives from her earlier investigations of the concept of the marvelous, which fascinated Europeans from the fifteenth through seventeenth centuries. The culmination of this research was the exhibition entitled *The Age of the Marvelous*, mounted in 1991 at the Hood Museum, Dartmouth College, which then toured the country. The influential exhibition catalogue was written in collaboration with experts in other fields who contributed essays exploring parallel phenomena in literature and science and their origins in theological-philosophical interpretations of the "new worlds" opening to Europeans at the time, whether through the voyages of discovery, the microscope, the telescope, or other means. Her essay here concerns masterpieces of tiny size created by prominent artists usually for the delectation of wealthy private patrons but occasionally for the amusement of artistic colleagues. She explores the relationship between the microcosm and macrocosm implicit in the replication of famous large-scale masterpieces in precious and exotic materials for individual patrons and connects these and other types of small-scale sculptures and artistic objects to contemporary concerns such as nostalgia for the Greco-Roman world and Christian formulations of the role of humanity in God's creation.

My own essay addresses outdoor civic monuments of large scale, elaborating on Janson's discussion of figural sculpture and equestrian monuments. I have extended my earlier research on the political motives underlying the commis-

sions of public sculpture, which I first addressed in an article on Donatello's *Dovizia*.[8] In the interval, I have become interested in cultural anthropology and its implications as a methodology for the study of works of art, specifically its potential for explaining both the symbolic power image intended by the patron and the viewers' responses to that image. I became involved with these issues in a more implicit and very different way in my recent book on the Chapel of St. Anthony in Padua,[9] and in this essay, I turn to an obvious arena of political imagery, the public sculpture of Florence.

Paul Barolsky's contribution depends on a careful literary analysis of the aesthetic and theological premises embedded in Vasari's anthology of biographies of Italian Renaissance artists, the single most important contemporary literary source for Italian Renaissance art. Historians have depended on Vasari's records of individual artists' careers since his anthology was first published, in 1550, and republished in an expanded revision in 1568, shaping their interpretations of the period and its art to Vasari's information, which they took at face value. Barolsky's recent books reveal the surprising degree to which Vasari was a literary craftsman who creatively adapted his "factual" accounts to promote certain ideas of his own.[10] In this essay, Barolsky continues his investigation of how Vasari's underlying attitudes, influenced by the theology of the Counter Reformation, consciously molded his characterization of his fellow artists and the aesthetics of their sculptures.

William E. Wallace's biographical sketch reconstructs a typical week in the life of Michelangelo during the 1520s while he was working on the Medici Chapel in Florence. Wallace's years of study of the notebooks, business ledgers, letters, and drawings left by Michelangelo and of documents and contemporary biographies about the artist culminated in his scholarly text entitled *Michelangelo at San Lorenzo: The Genius as Entrepreneur*. In this essay Wallace conveys his expertise in a different format: he explores the potential of what might be termed fictionalized biography, that is, he uses his detailed knowledge of primary sources on the great sculptor's practices, routines, and habits to recreate an imagined week in Michelangelo's life so that the reader can experience it vividly.

The essays of James M. Saslow and Claudia Lazzaro form an interesting contrast in the application of gender study to Italian Renaissance sculpture. Saslow, an expert on Michelangelo's poetry and on homosexuality in Italian Renaissance culture and art, interprets a number of Michelangelo's most famous sculptures in the light of the great artist's own interior, semiconscious, and largely suppressed homosexual feelings.[11] A few sculptures, like the *Bacchus* (Fig. 91), depict mythological heroes known for their sexual activity, but most represent traditional religious subjects. Lazzaro, the reigning authority on Italian Renaissance gardens, has defined a gendered aesthetic attitude in sixteenth-century treatises anthropomorphizing nature and gardens. In this essay, which is revised from an earlier published version, she explores the male/female duality that sixteenth-century Italians saw in the forms of nature and then embodied in the sculpture of the gardens they created.[12] Her new interpretation corrects the prevailing notion in

modern scholarship that the design of the Italian Renaissance garden reflected man's domination over nature. Instead, as she argues, that notion originated in twentieth-century ideology, whereas in the Renaissance, gardens were considered a domain of complex correspondences among art and nature and male and female.

Rationale

There is no collection of essays about critical approaches and art historical methodology relating to Italian Renaissance sculpture. In fact, there is no such book about Italian Renaissance art in any medium. There are anthologies that assemble scholarly essays exemplifying a particular theoretical approach, for example, feminism. These often deal with a variety of media, perhaps even literature, film, and art, across a broad chronological period. Such collections are valuable for what they indicate about methods of constructing theoretical frameworks and applying them to different contexts. They are usually perused by those interested either in a particular type of literature or form of the visual arts or in a particular chronological period, who typically focus on individual essays relevant to their research and ignore the others. Readership of the entire volume is limited to those involved in its particular theoretical approach and methodology.

This anthology was created for two reasons. First, it seemed time to compile a collection in which the focus would be on the *objects* of analysis, not the *mode* of analysis and its theoretical basis. So this volume assembles essays about Italian fifteenth- and sixteenth-century sculpture with the aim of analyzing how it was created and then suggesting the wide variety of questions and approaches that can be adopted to elucidate what are its multiple, sometimes overlapping, contexts and meanings. The reader will quickly appreciate that many of the theoretical questions and methods of investigation presented here could have been applied just as well to painting of the Italian Renaissance and that others would work equally effectively in the analysis of sculpture from a different chronological period. These essays are not about theory and methodology per se, but instead are about their application. In some, methodological issues are not addressed directly, but their model is implicit in the author's sequence of arguments.

The second reason for assembling this collection is to redress the paucity of literature about Italian Renaissance sculpture. Only a few surveys are devoted to it as the subject,[13] just one of which can claim to be a study in depth, John Pope-Hennessy's three-volume *Introduction to Italian Sculpture*, first published in 1955 and revised in three subsequent editions (1972, 1985, and 1996). Pope-Hennessy's authoritative analysis of sculpture throughout Italy between 1250 and 1600 inaugurated the serious study of the medium in this era and has stimulated many further, more specialized investigations in the decades since its appearance. His text is largely structured on a biographical approach and formal analysis. Its

pithy summaries of artists' careers and relevant bibliography are aimed primarily at a scholarly audience. Its brief, provocative chapters suggest the development of certain categories of sculpture (e.g., the statuette or the tomb) and have been extremely influential on later scholarship, but the text has not been substantially revised in light of that scholarship since the study's original publication.[14]

Most books dealing with Italian Renaissance sculpture have been monographs about individual sculptors.[15] As a rule, books in this format tend to isolate sculptors and their creations from their surrounding artistic and cultural contexts. In addition, because the evolution of an artist's career is the focus, such texts are necessarily concerned with a formal analysis of the stylistic changes in a chronologically arranged sequence of sculptures and do not usually pursue in depth the contextual problems associated with individual sculptures. The lack of monographs on many important fifteenth- and sixteenth-century sculptors indicates the inadequate state of the literature about Italian Renaissance sculpture.

An alternative type of survey, by Charles Seymour, Jr., sought to approach the medium by focusing on the collaborative enterprises more typical of the practice of sculptural workshops in the Renaissance and to analyze comparatively the sculpture produced in various regions of Italy.[16] More recently, scholars have turned to the investigation of particular sculptures or complexes of sculptures in an attempt to ground their evaluation in a more thorough consideration of the historical context.[17]

Reasons for the Historiographical Development

Leon Battista Alberti, the most prominent fifteenth-century theoretician of the arts, articulated in greatest detail the close relationship between what he termed the cognate arts of sculpture and painting. He drew attention to what united them, that is, their common basis in *disegno*, the Italian word for drawing and composition both.[18] Alberti's intellectual position reflected actual practice. Many Italian Renaissance artists, such as Brunelleschi, Verrocchio, and later Leonardo and Michelangelo, worked in more than one medium. On the other hand, Alberti did not address the important interconnected questions, such as why patrons chose sculpture rather than painting for certain types of commissions, how sculpture's physical characteristics differ from those of painting, and what cultural connotations were carried by each medium.

Precisely those issues were seriously explored by intellectuals in the sixteenth century, who used the term *paragone* to characterize what became a sometimes acrimonious debate about whether painting or sculpture was the superior art. This rivalry first emerged in the theoretical writing of Leonardo da Vinci, who championed painting. Nevertheless, with Michelangelo as the hero of sculpture's partisans in central Italy, and Titian the exemplar of Venetian theoreticians, the debate came out about even in the sixteenth century.[19] That assessment is corroborated by the number of sculptors highly regarded in the Renaissance (and still today) or by any itemization of the period's most costly and prestigious

commissions, which were often executed in stone or in bronze at the direction of private, civic, or religious patrons, who decided that sculpture offered the best means for expressing their particular goals.

The sixteenth-century controversy about the *paragone* resulted in a historiographical legacy of separating the two media in most publications other than introductory surveys to the period. Our modern-day perspective on the ranking of painting and sculpture is entirely different from that current in the Renaissance: painting is universally conceded to be the hands-down favorite. Sculpture as the Italian Renaissance knew it, that is, as *the* medium of civic monuments, of tombs, and often of portraiture of private patrons and altar decorations, was moribund by the end of the nineteenth century. Consequently, it is no surprise that now many more books are published about Italian Renaissance painting than about sculpture and that sculpture is often looked at and discussed secondarily to painting and even evaluated unconsciously in terms more appropriate to painting.

During the nineteenth century, for complicated reasons that can only be sketched here, public taste consolidated on painting as the preferred medium. One reason was the development of the camera. Photographic images satisfy the desire for visual likenesses of favorite people and things in a two-dimensional version that captures their colors, contexts, and settings and simulates three-dimensionality. The plethora of images and symbols that surrounds every aspect of our daily lives confirms our disposition to see in these terms and to prefer them.

The challenge of photography's quick, inexpensive capacity to reproduce multiple realistic images encouraged many late nineteenth-century sculptors and painters to move into more subjective interpretations of their subject matter, and, in the twentieth century, many artists in both media to shift to nonfigural abstraction. In seeking these alternatives, artists reacted against the academic traditions that had dominated the arts since the codification of artistic standards and patronage procedures that took place in mid-seventeenth-century France and influenced European, and indirectly, American practice for two centuries.[20] The collapse of the system by which an artist was trained according to academic theories and came to patrons' attention through winning recognition at officially sponsored exhibitions hurt sculptors more than it did painters. The high cost of the medium, in both its expensive materials and its laborious, slow production, meant that sculptors had to depend upon commissions from patrons who signed contracts guaranteeing their fees and the costs of materials.

During the Renaissance all significant examples of sculpture and painting were produced according to this system.[21] From the scant evidence available (inventories and extant sculptures) we can surmise that sculptors rarely created works of art for which they did not already have patrons unless the pieces were of an inexpensive and popular type such as a terracotta mold of a Virgin and Child relief or a doll of the Christ Child.[22] Similarly, painters in the period also had available for purchase in their shops small, inexpensive versions of the best-loved religious subjects or ready-made examples of domestic furnishings.

The demise of the traditional patronage system means that in the twentieth century the situation is radically different. Given the lower costs of their medium, painters can produce most sorts of paintings, with the intent of exhibiting them in commercial or public venues to attract purchasers. Sculptors can afford to operate in this way only by working in inexpensive materials and on a small scale. Art dealers, whose exhibitions have largely supplanted the competitions sponsored by artistic academies, are often reluctant to assume the higher expenses associated with sculpture in the face of uncertain public response.

Another factor in sculpture's decline is the weakened role of the Greco-Roman tradition in defining Western culture and taste, sent packing by the rise of technology and the repertory of modern symbols it stimulated. Patrons and artists alike became less interested in an artistic language valued for its expression of continuity with the past than in one signifying newness. Today's world defines itself in terms very different from the vocabulary of heroic portraiture and idealized personifications and narratives that ancient sculpture inaugurated and that shaped most secular and religious imagery until the end of the nineteenth century. Recently invented materials, including those associated with industrial production; subject matter stimulated by contemporary experience and personal interpretation; or even a negation of representation in favor of abstraction are now favored for their invocation of modernity and the future. The decoration of recent museum buildings in Europe and America is one of the many types of public commissions that could be cited in proof of this point. The National Museum of Modern Art at the Pompidou Center (Beaubourg), the East Wing of the National Gallery of Art, Washington, D.C., and the Pyramid of the Louvre are all characterized by the abstract geometry of their architecture, not by the sculpted personifications of the arts or portraits of great artists that decorated most museum structures before the twentieth century. Even a postmodern structure like the Sainsbury Wing of the National Gallery of Art, London, limits its derivations from the Greco-Roman past to the architectural vocabulary that imitates the older section of the museum and avoids any sculptural ornament.

A visit to a museum such as the Musée d'Orsay in Paris, one of the few collections to give extensive exhibition space to academic sculpture of the nineteenth century, reveals another cause for sculpture's decline. The tradition had become stale: one sees a lineup of figures of superb craftsmanship but of meager inspiration – many figures look alike, and their titles could be interchangeable. Nevertheless, this worn-out coin had a positive side: the sculptures were the products of a universally valued system of imagery, conventions, and representational techniques understood by patrons, artists, and viewers alike.

International culture at the end of the twentieth century has a different kind of universality. Since the end of World War II, it has been driven by America, a country with only a three-hundred-year history, which was founded in a conscious break with the past (despite many continuities). First settled by Protestants, whose aversion to personal commemoration and religious imagery, the

traditional preserves of sculpture, is well known, the country is now self-consciously multicultural and with seemingly few visual symbols meaningful to all its citizens. In the face of these cataclysmic changes, it is no surprise that sculpture as it looked from the fifteenth through nineteenth centuries has largely ceased to exist and that today's audience either anachronistically underestimates the importance of sculpture during the Italian Renaissance or misinterprets sculpture by viewing it in terms of painting.

Cultural Presuppositions

Recognition of its fascination with Greco-Roman civilization is fundamental to understanding Italian Renaissance culture. Certain literary texts by Roman authors like Ovid, Virgil, and Horace had been well known throughout the Middle Ages, but beginning in fourteenth-century Italy, a renewed interest in studying their language and literary qualities and in understanding the authors and the culture in which they had lived led to a zeal for recovering as much as possible about the ancient past. Scholars sought out manuscripts that had lain forgotten for centuries in monastic libraries; the repertory of known literature from the Greek and Roman worlds was greatly expanded, and literary texts, first in Latin, and by the fifteenth century, in Greek and even in Hebrew, were reedited with increasing sophistication and precision. The invention of the printing press in the mid-fifteenth century led to the wide distribution of relatively inexpensive editions of this literature, making it extremely influential. Although the designations of humanism and humanists were coined in the nineteenth century and are not period terms, they are commonly used to describe this cultural phenomenon, the people involved in it, and the educational system they inspired, which capitalized on these discoveries to enhance study of Latin and Greek rhetoric, grammar, history, poetry, and moral philosophy.[23] A parallel fascination with and study of the artifacts of the ancient world meant that inscriptions on extant monuments were examined to improve knowledge of Latin and of Roman history, ancient works of art were eagerly collected, and artists were encouraged to examine ancient art and imitate its model in a wide variety of ways.

Almost all the surviving monuments of the ancient world were architecture and sculpture, and so, as Janson points out in his essay, the first examples of what we term Renaissance art emerged in those media. In fact, the durable properties of their materials of bronze or stone so impressed Renaissance patrons that they in turn chose to commission architecture or sculpture when they wanted a lasting legacy.

The aesthetic system of ancient sculpture, which generally combined study from nature with idealization; ancient sculpture's subject matter, which focused on the human figure; and the types of sculptures popular in the ancient world, such as portrait busts, small-scale bronzes, and public civic monuments, were all revived in the fifteenth century, and the extant examples were copied in whole and in part. The interest in life on earth, especially in humans and their accom-

plishments, found its philosophical justification as well as its physical models in the writings and works of art of ancient Greece and Rome. Even the concept that commissioning splendid buildings and monuments for public benefit has moral value finds a basis in theoretical treatises such as Aristotle's *Nichomachean Ethics*, Vitruvius's books on architecture, and Pliny's accounts of Greek and Roman cities in his *Natural History*.[24]

The revival and study of models from ancient Greece and Rome were not intended to conflict with Christianity, which had been adopted as the official religion of the Roman Empire in the fourth century. The Christian formulation that man was created in God's image and that Christ was both man and God permitted a vocabulary of figural imagery to illustrate the Old and New Testaments and Church dogma. Influential early medieval theologians like Gregory the Great had specifically endorsed the valuable role of art in promulgating the messages of the religion and in inducing devotion, and this viewpoint was reiterated in the decrees of the Council of Trent in 1563.[25] Although there were significant periods of iconoclasm in the medieval history of Christianity in the Byzantine Empire, none had much influence on the West before the Protestant Reformation in the sixteenth century, at which point Protestantism's impact on northern Europe intensified the attachment in Counter Reformation Italy to visual imagery. The corollary endorsement by the Church that the patronage of burial chapels, altarpieces, and tombs demonstrated the commissioner's piety (as well as serving the more worldly goals of prestige and advertisement of power and wealth) encouraged such donations.[26] The durability of bronze and marble, in combination with their allure as status materials in the ancient world, made patrons eager to use them in artistic commissions despite their inherent high cost. In some circles greater expenditure was interpreted as a greater demonstration of piety. Recurrent appeals, especially from the mendicant orders of Franciscans and Dominicans, that artistic commissions should be discouraged in favor of charity to the poor, gained limited sway.

Thus humanism and Christianity together stimulated the development of religious imagery that was increasingly similar in its models and formal language to precedents in Greco-Roman art. Although favorite types of the ancient world such as nude statuary were at first anathema, they gradually became acceptable Christian imagery, as the bronze *David* by Donatello (Fig. 7) indicates. And both systems of belief provided justification, even impetus, to private and corporate patrons to commission works of art.

Nonreligious imagery developed slowly despite the absorption in the literature of the Greco-Roman world. The most obvious category, portraiture, appeared more or less simultaneously in painting and sculpture around the middle of the fifteenth century. The most frequent sculptural type, the portrait bust, which was usually commissioned for display in a family residence, is discussed in this volume by Janson, Paoletti, and especially Lavin. At about the same time the first large-scale public portraits were commissioned in the form of equestrian monuments, of which the earliest preserved example is that honoring the mer-

cenary general Gattamelata (Fig. 15). Although the portraiture of contemporaries was a new phenomenon in the Renaissance, directly revived from precedents in the ancient world, it was justified by its actual or misconstrued early adoption for Christian heroes, notably in reliquaries of saints (Fig. 9) and in the equestrian statue identified throughout most of the period as Constantine (Fig. 16), who was acclaimed as the first Christian emperor. Kenseth and Lavin both discuss how Renaissance philosophers articulated the supreme status of humans in God's creation and validated the commemoration of individuals. The tendency to interpret in Christian terms mythological heroes like Hercules or books about the loves of the pagan gods like Ovid's *Metamorphoses* continued throughout the period.[27] However, the growing numbers of statuettes and functional objects with mythological themes commissioned toward the end of the fifteenth century can usually be connected only to a more diffuse Christian sense of the wonders of God's creation through the macrocosm/microcosm relationship that Kenseth describes in her essay.

In the sixteenth century, statues like Michelangelo's *David* (Fig. 80) or Giambologna's *Appennino* (Fig. 112) were admired as well as proofs of human creative genius.[28] Such an exalted opinion of artistic talents was the culmination of the dramatically changed status of artists as it was redefined during the fifteenth and sixteenth centuries. At the beginning of the period, painters and sculptors alike, most of whom came from modest social backgrounds,[29] were considered artisans and as such belonged to a trade guild that regulated their training and business practices.

The attitude began to change with the renewed interest in ancient authors. Pliny especially demonstrated that the creative talents of artists in the ancient world had made them highly regarded members of society. The most influential factor was the circulation of Alberti's treatises, especially *De Pictura* written in the mid-1430s, which described the cultural education and theoretical training painters and sculptors should possess. *De Pictura*, which was in Latin, was aimed at the educated elite who patronized most commissions. Alberti quickly translated the treatise into Italian, which ensured a wide circulation of his theories among other social groups, including artists. The invention of the printing press in the middle of the fifteenth century allowed their publication and more far-ranging impact.

Alberti's assessment of the intellectual background of artists was confirmed by a series of treatises written by artists themselves. These works included Ghiberti's *I Commentarii*, Piero della Francesca's treatise on perspective and on geometry, and Leonardo's extensive notes about painting, nature, science, and engineering, which although not published in treatise form, were known. By the end of the fifteenth century the degree to which attitudes had evolved is evident in the long-term appointments of Mantegna as artist to the court of Lodovico Gonzaga, marquis of Mantua, and of Leonardo to the court of Ludovico Sforza, duke of Milan, where the artists were paid an annual stipend in accord with their dignified position. During the final years of his life, Leonardo was appointed to the court of

François I, where his duties were primarily to entertain the king of France with his conversation! His younger contemporary Michelangelo had a career of such universally recognized brilliance that he was called "divine." In the sixteenth century dozens of treatises by artists and their partisans dealt with aesthetics, theoretical problems, and the *paragone* and corroborated that the making of art was a creative intellectual process.[30] The single most influential contribution was Vasari's anthology of biographies of artists, published in 1550 (revised edition, 1568), the first such collection. As shown best by Barolsky, Vasari shaped his supposedly factual material to enhance the reader's impression of the contribution of the arts and their creators to Italian culture. The capstone of artists' changed status is the foundation by Vasari and his colleagues in Florence in 1563 of the first real academy, the Accademia del Disegno.

How Is Sculpture Different from Painting?

Sculpture is most obviously unlike painting in its three-dimensionality; the implications of the differences between the two media were defined during the Renaissance. At the beginning of the fifteenth century sculpture's potential for three-dimensionality was not exploited: most statues were made for niches on buildings or were attached to architecture as they had been for centuries. Statues for these settings were not carved fully in the round; instead, their back portions were left in a rough state, although some artists blocked them out sufficiently to make the figure's pose convincing. As a result of this method, forms look as though they were carved in one plane. At midcentury Donatello innovated the first freestanding statues. The uncertainties about the commission of the bronze *David* (Fig. 7) prevent fixing a more precise date than c. 1430–50, although the late 1430s seems most likely. Donatello emphasized the nudity of David's life-size body, which was unprecedented except in representations of Adam and Eve, by the carefully finished definition of David's boots and hat and the high polish of his softly modeled prepubescent forms.[31] These sensuous features draw the viewer's attention to every aspect of the figure and underscore its three-dimensionality. Donatello's much more complex two-figure group *Judith and Holofernes* (Fig. 65) dates from the 1450s and further develops the possibilities of three-dimensional sculpture. The drama of Judith's murder of Holofernes and the intimate physical proximity of the seductress and her victim are carefully calculated by Donatello to make the spectator move around the sculpture to see every fascinating detail.

 Whereas Donatello positioned the figures so that the juxtaposition of their bodies created different viewing points for the spectator, Michelangelo explored how to carve the body so that it seems to turn or move organically and actually exist in three-dimensional space. His early sculpture *Bacchus* (Fig. 91) shows the beginnings of this technique especially in the small satyr who twists toward Bacchus to nibble on a bunch of grapes. In later sculptures, such as *Victory* (Fig. 96), Michelangelo concentrated on creating a tight group of two figures whose posi-

tions and limbs are gracefully, if unrealistically, turning and intertwined. The composition epitomizes the inevitable triumph of youth over old age and, ironically, the equally ineluctable transition from one to the other. Michelangelo also meant the virtuosity of his sculpture's impossibly complex three-dimensionality to refute Leonardo's claims that painting, which could create an illusion of three-dimensionality, was superior to sculpture. The controversy of the *paragone* between the two arts lay at the heart of theoretical discussions about aesthetics and inspired many sixteenth-century sculptors to carve technically astonishing versions of choreographed figure groups that exploited sculpture's unique capacity to be viewed from all sides. Giambologna's *Rape of the Sabine* (Fig. 71), in which the violence of an abduction is denatured into a fluid spiral of male and female bodies, is the most famous of these demonstrations by sculptors of the greater artistic and intellectual skills demanded by their medium and its more effective creation of verisimilitude.

Sculpture's three-dimensionality gives it a palpable physical presence that can have a profound emotional impact on its audience. It already exists in the viewer's world and does not require the degree of sensory imagination to invoke its reality that painting does. This means that sculpture can affect a wider audience than painting can and that sometimes it moves individuals in ways that painting cannot. The private patrons who commissioned refined small bronzes such as Giambologna's *Venus Urania* (Fig. 55) kept them on their desks to hold and to stroke in tactile pleasure. Select groups of aristocratic guests marveled at the artistry and delighted in the tiny details of maritime mythology on Cellini's Saltcellar (Figs. 59 and 60), while they seasoned their meals with its salt. Women from every background played with inexpensive dolls of the Christ Child (Fig. 49) to relive what he had experienced by playacting the role of his mother.

Even when sculpture cannot be used in these ways, its physical actuality can manipulate the imagination. Worshippers praying before Donatello's *Annunciation* (Fig. 73) can be induced by its lifelike figures in arrested movement to believe that they are watching the incarnation of Christ as man. A portrait bust in the family home evokes powerful memories of a relative by actually recreating his features and the shape of his head (Fig. 35). A public monument in the civic square consolidates its patrons' notions of their identity in the minds of citizens and inspires allegiance because it creates an impressive constant presence in their lives (Fig. 69).

Renaissance patrons knew from the survival pattern of ancient art that only materials like stone and bronze provided the chance of a lasting legacy. Although authors like Pliny had extolled the merits of ancient painting and sculpture equally, hardly any Roman wall or easel painting had survived. Patrons necessarily selected stone or bronze as the materials for exterior architecture or in public monuments, unless these were intended to be ephemeral decorations for processions. But, despite their great expense, these materials were the choice of patrons for whom cost was no object, especially for erecting monuments they hoped would provide an eternal setting for the prayers to be said in perpetuity

for their souls and for the souls of family members, such as funerary chapels, tombs, and altar decorations. Those in political power preferred durable materials for governmental or personal memorials in public settings, whereas wealthy families often chose to commemorate their relatives through sculpted likenesses.

The use of color is a major difference between Renaissance sculpture and painting, but not because painting depended on color and sculpture did not. The monochromatic impression that determines our notion of Renaissance sculpture today is another accident of survival. Much architectural sculpture and many large-scale monuments in stone were originally gilded and painted. Often the materials of the sculpture were contrasted against the color patterns of their architectural settings, as in the case of the niche sculptures at Orsanmichele (Fig. 77; P/R, illus. 4.41).[32] Wood and terracotta sculptures were generally painted, as the details of gilding that remain in the ragged locks of Donatello's *Mary Magdalen* reveal (Fig. 2). Bronze sculpture depended for its aesthetic impression on the sheen and color of its patina and often on gilding or silvering of its details. Some small-scale bronzes used metal of a contrasting color, usually silver, for decorative accents (Fig. 52). The recent conservation of Ghiberti's *St. John the Baptist* for Orsanmichele revealed that the irises of the eyes were in silver, as was often the case on Greek bronzes, suggesting that even large-scale bronze sculpture may have used more of this technique than we now appreciate.

It is even more of a surprise to realize that many marble sculptures had accessories in contrastingly colored materials, such as Donatello's *St. George*, which once held a bronze sword or lance, or Michelangelo's *David*, which originally carried a gilded slingshot and wore a brass victor's wreath embellished by copper and silver leaves.[33] Frequently, little is left of the actual paint or the accessories have been lost over time, and one must turn to documents or contemporary descriptions to reconstruct the original colorism of Renaissance sculpture. Fortunately, many Renaissance relief sculptures of the Virgin and Child from all areas of Italy survive that retain their color and gilding. Some life-size polychromed statuary in wood survives in Tuscany (see Donatello's *Crucifix* in Santa Croce, Florence; P/R illus. I. 23), but wood and terracotta statuary were more popular in other areas of Italy, such as Emilia and Naples. We must turn to the sculpture of those regions to gauge the powerful impact that three-dimensional, life-size, realistically colored groups of figures can make. In addition, we must keep in mind the distorting impression that black-and-white photography, which is usually used for sculpture, makes of its appearance.[34]

What sixteenth-century advocates of the superiority of painting stressed was that color, even through the actual fabric of its application, allowed an illusion of reality not possible in sculpture. They noted that different colored oil glazes can be seen translucently through each other and create a wide range of subtle hues, nuances of light-and-shade, modeling, and textures. They also argued that painting could create a convincing semblance of the atmosphere and environment surrounding forms in the natural world and that its techniques of atmospheric and linear perspective permitted the suggestion of a more complex setting and narrative.

It seems that Renaissance patrons appreciated those advantages and commissioned paintings when these effects were best suited to their goals. They turned to sculpture, however, when they wanted that medium's compelling physical effect, either to induce reverence or to give pleasure, and they bought ready-made Madonna and Child reliefs in terracotta or stucco or commissioned statuettes in bronze, according to their budgets and needs. Moreover, the richest patrons selected sculpture in bronze or stone to make a particularly impressive display of their wealth, status, and generosity, whether to the Church, or, for the ruling elites, to their fellow citizens who might appreciate their monument's contribution to the urban setting and be influenced by it. The references to ancient Greece and Rome inherent in bronze and stone sculpture signaled to the knowledgeable the patrons' taste and erudition. And these lasting and magnificent materials offered the best prospect of creating an enduring marker of religious devotion in the eyes of God and of prominence and power in the regard of contemporaries and of posterity.

Practical Points about the Book

The selected bibliography at the end of this volume includes more generally useful references; other specifically relevant books and articles are included in the endnotes of each essay. Unavoidably, there is a range in the types of material in the endnotes. Some of the essays already published in scholarly journals retain the exacting, complete citations expected in that context. The authors who wrote essays specifically for this volume tried to limit their citations to primary sources and references necessary to document new interpretations. Otherwise these authors used their notes to provide broader information to a more general audience not necessarily versed in the subject.

Additional illustrations relevant to these essays are cited from John T. Paoletti and Gary M. Radke, *Art in Renaissance Italy* (New York, 1996), using the abbreviation "P/R illus."

Notes

1. See *Medieval and Renaissance Studies: Proceedings of the South-eastern Institute of Medieval and Renaissance Studies,* ed. O. B. Hardison, Jr., V, Summer, 1969, 80–102.

2. H. W. Janson's *History of Art* revolutionized the study of art history when it was first published in 1962. The volume has been revised and updated four times since then, the recent editions by his son Anthony F. Janson. It is still the favorite choice of text for the introductory survey course.

3. It was first published in the *Art Quarterly, XXXIII,* 1970, 207–26, and followed by a sequel on the sixteenth-century portrait bust, "On Illusion and Allusion in Italian Six-teenth-Century Portrait Busts," *Proceedings of the American Philosophical Society,* CXIX, no. 5, October 1975, 353–62. For the long list of related publications by Lavin, consult the first note following his essay.

4. His earlier articles are referred to in the notes to his essay. He is coauthor (with Gary Radke) of the recently published survey *Art in the Italian Renaissance* (New York, 1996).

5. Her earliest research, statistical analysis of the records of marble quarries at Carrara (*Les Maîtres du marbre: Carrare, 1300–1600*), concerned another topic important to Florentine art production in the Renaissance. She next applied statistical analysis to Tuscan tax records and surveys in order to study the family. That research, in which she col-

laborated with the American historian David Herlihy of Harvard University, culminated in the publication of *Les Toscans et leurs familles* in 1978 (published in English in 1985 as *The Tuscans and Their Families: A Study of the Florentine Catasto of 1427*).

6. Translated by Lydia Cochrane (Chicago: University of Chicago Press, 1985), 310–29.

7. Klapisch-Zuber's interest in this sort of social history and anthropology was spurred by her association with a group of ethnologists and historians in seminars at the Ecole des Hautes Etudes en Sciences Sociales, Paris. Many in this group were trained by Claude Lévi-Strauss. They frequently published essays in the influential journal *Annales: Economies, Sociétés, Civilisations*. The wide chronological and geographical range in which they comparatively studied the family and its institutions is revealed in the articles from *Annales* selected for inclusion in *Family and Society: Selections from the Annales*, ed. R. Forster and O. Ranum, trans. E. Forster and P. M. Ranum (Baltimore and London, 1976), where the focus ranged from France to Mongolia, from the twelfth to the eighteenth centuries. Klapisch-Zuber contributed as well to another compilation of essays translated as *A History of the Family*, ed. A. Burguière et al. (Cambridge, 1996).

8. S. Blake Wilk, "Donatello's *Dovizia* as an Image of Florentine Political Propaganda," *Artibus et Historiae* XIV (1986): 9–28.

9. S. Blake McHam, *The Chapel of St. Anthony at the Santo and the Development of Venetian Renaissance Sculpture* (Cambridge, 1994).

10. The volumes in the "trilogy," *Giotto's Father, Michelangelo's Nose*, and *Why Mona Lisa Smiles*, were followed in 1994 by *The Faun in the Garden*.

11. His books include *The Poetry of Michelangelo* and *Ganymede in the Renaissance; Homosexuality in Art and Society* (New Haven, 1986).

12. Some of these ideas were first explored in her major book, *The Italian Renaissance Garden: From the Conventions of Planting, Design, and Ornament to the Grand Gardens of Sixteenth-Century Italy*. She developed them specifically in the essay "The Visual Language of Gender in Garden Sculpture," published in *Refiguring Woman: Perspectives on Gender and the Italian Renaissance*, ed. M. Migiel and J. Schiesari (Ithaca, N.Y., 1991).

13. Short, well-illustrated surveys include Charles Avery, *Florentine Renaissance Sculpture*, for which a new edition was just published (London, 1996), and Roberta J. M. Olson, *Italian Renaissance Sculpture* (London, 1992).

14. The most recent edition, published in three volumes by Phaidon (London and New York, 1996), is the most attractive visually and easiest to use because the photographs, which are larger and in duotone, are integrated into the text.

15. A. Venturi, *Storia dell'Arte italiana . . .* (Milan, 1911–40), 11 vols. in 25 pts. is unique. It covers all Italian art from the early Christian period through the sixteenth century. Volume 10, while out of date, provides an unmatched photographic corpus of sixteenth-century sculpture.

16. See his *Sculpture in Italy, 1400–1500* (Harmondsworth and Baltimore, 1966).

17. Seymour's own *David: A Search for Identity* (Pittsburgh, 1967), on Michelangelo's *David* is an influential example. The contributions of his colleagues and students, such as A. Coffin Hanson's *Jacopo della Quercia's Fonte Gaia* (Oxford, 1965) and J. T. Paoletti's *The Siena Baptismal Font: A Study of an Early Renaissance Collaborative Program* (New York, 1975) (derived from a 1967 dissertation), are early examples of this methodology, which has become increasingly popular in recent historiography.

18. The most important among his treatises for these issues are *On Painting and On Sculpture: The Latin Texts of De Pictura and De Statua*, ed. C. Grayson (London and New York, 1972), the most authoritative edition. The treatise on painting pertains to relief sculpture as well, whereas that on sculpture is explicitly about statuary. Another of his treatises, the *De re aedificatoria*, translated as *On the Art of Building in Ten Books*, by J. Rykwert, N. Leach, and R. Tavernor (Cambridge, Mass, 1988), is also important for its comments about sculpture in an urban setting. The major modern analysis of the relationship between painting and sculpture in the fifteenth century remains J. Pope-Hennessy, "The Interaction of Painting and Sculpture in Florence in the Fifteenth Century," *Journal of the Royal Society for the Encouragement of the Arts, Manufacturers and Commerce* CXVII (May 1969): 406–24.

19. On Leonardo's theories, see the most recent translation of his *Treatise on Painting* by C. J. Farago, *Leonardo da Vinci's Paragone: A Critical Interpretation with a New Edition of the Text in the Codex Urbinas* (Leiden, 1992). L. Mendelsohn, *Paragoni: Benedetto Varchi's Due Lezzioni and Cinquecento Art Theory* (Ann Arbor, Mich., 1982), traces the theoretical development of the controversy in the sixteenth century.

20. Artistic academies were first founded in late sixteenth-century Florence and Rome, but the French version was very different. Overseen by a government official, it established a hierarchy that rated subject matter and artistic models and provided a set training. For an artist to flourish, he had to be accepted as an academy member and well ranked in the competitions or salons. See N. Pevsner, *Academies of Art Past and Present*, 2d ed. (New York, 1973). For the gradual demise of these traditions in nineteenth-century France, see P. Mainardi, *The End of the Salon: Art and the State in the Early Third Republic*, 2d ed. (Cambridge and New York, 1994).

21. The best general survey remains M. Wackernagel, *The World of the Florentine Renaissance Artist: Projects and Patrons,*

Workshop and Art Market, trans. A. Luchs (Princeton, 1983). William E. Wallace's essay provides fascinating specifics about the practical problems Michelangelo confronted creating the Medici Chapel.

22. See John T. Paoletti's essay for examples of religious sculptures and types of architectural reliefs created for private dwellings in inexpensive materials like terracotta and stucco and produced from molds. G. M. Helms discusses how these molds were made. Christiane Klapisch-Zuber traces replicas of Desiderio da Settignano's marble *Christ Child* that were used as dolls.

23. J. Hale, *The Civilization of Europe in the Renaissance* (London, 1994), provides an excellent discussion of cultural issues important in Europe in the fifteenth and sixteenth centuries. In many ways, J. Burckhardt's *The Civilization of the Renaissance in Italy* (Oxford, 1965), first published almost 150 years ago, is still unsurpassed. Judicious recent accounts that focus on Italy include D. Hay and J. Law, *Italy in the Age of the Renaissance, 1380–1530* (London and New York, 1989), and its prequel, E. Cochrane, *Italy, 1530–1630*, ed. J. Kirshner (London and New York, 1988), in the series on Italian history and culture published by Longmans.

24. See most recently, L. Green, "Galvano Fiamma, Azzone Visconti and the Revival of the Classical Theory of Magnificence," *Journal of the Warburg and Courtauld Institutes* LIII (1990):98–113.

25. For devotional practices in the Renaissance, see *Christian Spirituality: High Middle Ages and Reformation*, ed. J. Rait (New York, 1988), particularly the essay by Richard Kieckhefer, "Major Currents in Late Medieval Devotion," 75–108. Recent significant contributions to the study of the role of images in devotion include D. Freedberg, *The Power of Images: Studies in the History and Theory of Response* (Chicago and London, 1989); J. Hamburger, "The Visual and the Visionary: The Image in Late Medieval Devotion," *Viator* XX (1989): 161–8; and J. T. Paoletti, "Wooden Sculpture in Italy as Sacral Presence," *Artibus et Historiae* XXVI (1992): 85–100.

26. J. Le Goff, *The Birth of Purgatory*, trans. A. Goldhammer, 3d ed. (Chicago, 1986), described the codification of the doctrine of Purgatory by the Church in the late Middle Ages. It led Christians to try to expiate their sins through paying to have prayers said for their souls and for the souls of family members to reduce the time that their souls would suffer in Purgatory. This spurred the endowment of funerary chapels, tombs, and church decorations like altarpieces to create a distinct, identifiable setting for those prayers. R. Goldthwaite, *Wealth and the Demand for Art in Italy, 1300–1600* (Baltimore and London, 1993), and Lisa Jardine, *Worldly Goods: A New History of the Renaissance* (New York, 1996), trace how the development of the economy in Italy during the Renaissance fueled these donations.

27. See J. Seznec, *The Survival of the Pagan Gods: The Mythological Tradition and Its Place in Renaissance Humanism and Art*, 3d ed. (Princeton, 1995).

28. Claudia Lazzaro's essay traces the theoretical basis by which Giambologna's sculpture was related to contemporary interpretations of nature.

29. See P. Burke, *Culture and Society in Renaissance Italy, 1420–1540* (London, 1972), and R. and M. Wittkower, *Born under Saturn* (London and New York, 1963).

30. A. Blunt, *Artistic Theory in Italy, 1450–1600*, first published in 1940 and now available in a new paperback edition, is the best introduction to this material.

31. Nudity is necessary to indicate Adam and Eve's shame after their loss of innocence and so is traditionally allowed. Nude depictions of anyone else are rare throughout the fifteenth century, and nude male figures remain unusual in the sixteenth century because of lingering Christian ambivalence about the body. On this issue see Saslow's essay.

32. See John T. Paoletti and Gary M. Radke, *Art in Renaissance Italy* (New York, 1996), abbreviated to "P/R illustration".

33. See K. Weil-Garris, "On Pedestals: Michelangelo's *David*, Bandinelli's *Hercules and Cacus*, and the Sculpture of the Piazza della Signoria," *Römisches Jahrbuch für Kunstgeschichte* XX (1983): 385, where the gilding of the tree stump is also described.

34. The other distortions that the camera can inflict on sculpture are less well-known to nonspecialists. The appearance of a sculpture can be totally transformed by the camera angle and the position and intensity of lighting. The fact of sculpture's three-dimensionality is what creates the difficulties. The photographer has to be sensitive to the viewpoints from which the sculptor intended the object to be seen. Most authorities agree that the best photographs are taken in natural light using a very slow exposure.

 The best photographers of sculpture are knowledgeable about the history of the medium and its aesthetics, such as Clarence Kennedy, whose photographs of Desiderio da Settignano's sculptures are works of art themselves. Ralph Lieberman, an art historian specializing in the careful photography of sculpture and architecture for art-historical purposes (Figs. 82, 99, 101–13), has thoughtfully addressed its technical problems in lectures. He is currently preparing for publication a study of the relationship between photography and art history that includes a discussion of the rhetorical nature of photographs in the service of scholarship.

The Materials and Techniques of Italian Renaissance Sculpture

G. M. Helms

I N THE ITALIAN RENAISSANCE by the time a contract for a sculptural commission had been drawn up, the parties involved had agreed to the type of materials to be used in the project and to who was to supply the materials, how the materials were to be finished, and the time frame for the project. Implicit in the choice of materials was an acknowledgment not only of the artistic effect of different materials but also of the effort and expense of working them.

Fifteenth- and sixteenth-century treatises on sculpture and architecture provide the fundamental information on contemporary techniques and attitudes toward different materials.[1] When studied in conjunction with technical examinations and analyses of sculptures, extant documents, and archaeological evidence, they clarify the issues and consequences involved in the selection of materials.

Alberti, in *On Sculpture*, differentiated between three types of sculptors:[2] first, those who sculpt by adding and taking away, such as sculptors who work in wax or clay; second, those who sculpt by taking away, like marble sculptors; and third, those who work by addition, such as silversmiths who do repoussé work.[3] He distinguished these types solely on process. Process is the natural way to consider sculpture; however, because many Renaissance sculptures were designed to be polychromed, sculpture should also be thought of in relation to the desired final result. Alberti also did not discriminate between materials that were used in their natural state and those that were manipulated and transformed.

Stone, the only important sculptural material in which the natural raw material was unaltered and the finished surface not obscured by polychromy,[4] was also the most heterogeneous of sculptural materials.[5] In choosing the stone or stones for a project, the sculptor and the commissioner would have to consider a variety of factors including workability, color, durability, block-size availability, ease and cost of transport, and local traditions. The stone carver used his empirical knowledge built up from practice and experience to select the most acceptable stone for a project.[6] For many projects, the sculptor or his assistant went to the quarry to pick out stone instead of buying it from the local stone importers.[7]

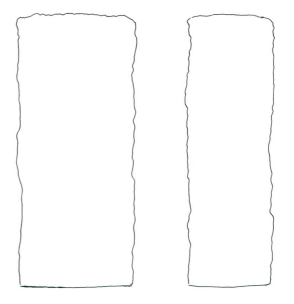

Stones used for sculpture can be divided roughly according to their working properties.[8] Soft stones are easy to carve but unpolishable. Some stones are so soft that they can be worked with woodworking tools and techniques. Their even grain means that they can take fine detailing. The most important soft stone was Istrian stone, a fine-grained limestone used extensively in the Veneto. Although these stones were usually finished to an even matte surface, sometimes they were worked with a variety of chisels that gave them a vivacity of surface through texture rather than polish.

Stones of medium hardness that can be polished were called marbles, even though not all of them are geologically marbles. The greater difficulty in carving them is offset by their ability to take both fine detail and polish. Because of marble's crystalline structure, sculptors have to be very careful to carve the final layers at a sloping angle so that the marble is not bruised.

Hard stones, such as porphyry and granite, have consistent coloring and great durability and can be polished to high gloss, but they are extremely difficult to work and do not take fine detail. They are often worked by holding tools vertical to the surface so that the surface is smashed rather than chipped away.[9] Hard stone can also be shaped with abrasives.

The sequence of steps used to sculpt stone is essentially the same for most types of stone.[10] The design and size of the tools used and the manner in which they are held and struck are the most important variables in the process. The first step in working the stone was usually rough dressing at the quarry using axes and hammers (Drawings 1 and 2).[11] Back in the workshop, the most important tool became the point chisel. Held at a variety of angles and usually hit with a metal hammer, depending on the type of stone and the texture to be created, the point chisel was used to remove almost all of the stone that had to be removed in the carving process (Drawings 3 and 4). With the point chisel the forms were roughed out to within one to three centimeters of the final surface or, as Cellini said, within a half finger of the *penultima pelle* (next-to-last skin) (Drawings 5 and 6). Drills were also used to carve in depth or to create decorative effects.

In the next step, a tooth or claw chisel was used to clean away the furrowed or pitted surface left by the point chisel. The claw chisel was held at an oblique angle, and each strike carried it along the surface of the stone, leaving a characteristic surface of broken parallel lines. Tooth or claw chisels were used to round forms (Fig. 1). The disturbed surfaces left by claw chisels were in turn removed by flat chisels, the most common finishing tool (Drawings 7 and 8). The flat, sharpened surfaces of flat

Drawing 1. Conjectural representation of some of the steps involved in marble carving: front view of dressed quarry block (author)

Drawing 2. Side view of dressed quarry block (author)

Drawing 3. Conjectural representation of a front view of the roughed-out figure of Donatello's *St. George* (author)

Drawing 4. Side view of the roughed-out figure of Donatello's *St. George* (author)

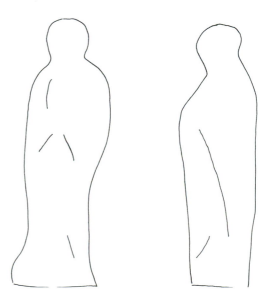

Drawing 5. Conjectural front view of the "within the next-to-last skin" of Donatello's *St. George* (author)

Drawing 6. Side view of the "within the next-to-last skin" of Donatello's *St. George* (author)

Drawing 7. Front view of finished *St. George* (author)

Drawing 8. Side view of finished *St. George* (author)

chisels leave fine lines on the surface of the stone with each strike. Rasps and scrapers were also used for finishing. Unlike chisels, which work by chipping or cutting away the surface, these tools actually rub the stone away. They were used for smoothing and fine shaping. Rasps were often used in a back-and-forth motion so that they leave fine crisscross lines. Scrapers produce fine, long, shallow scratches. The surface could be left matte or polished by rubbing with abrasives and water.

Vasari and Cellini, respecting the finality of stone carving, both suggested that full-size models, based on small sketch models, be made before any carving was begun (Drawing 9), although Cellini acknowledged that Donatello used small models and that Michelangelo worked directly from both small and full-size models.[12] Vasari recommended modeling a full-size nude figure with clay mixed with baked flour to retain moisture and cloth clippings or horsehair so that it would not crack, over a wooden armature wrapped with tow or hay.[13] Cloth dipped in clay was then used to clothe the figure.[14]

Cellini believed that Michelangelo's method of approaching the block, once satisfactory models had been made, was the best he had seen. After drawing the principal views of the sculpture on the stone block, Michelangelo then began to round the block as if he were chiseling a half-relief.[15] According to Vasari, Michelangelo, in order not to spoil the block, made models of wax or other similar material that he then laid horizontally in a vessel of water. As the figure was raised little by little above the water more of it was revealed. In the same way figures were carved out of marble, with the highest parts revealed first.[16]

This famous description of Michelangelo's working method must be read in conjunction with Vasari's technical description of how to enlarge proportionately or transfer measurements from models to the block.[17]

Let the artist proceed to carve out the figure from these measurements, transferring them to the marble from the model, so that measuring the marble and the model in proportion he gradually chisels away the stone till the figure thus measured time after time, issues forth from the marble, in the same manner that one would lift a wax figure out of a pail of water, evenly and in a horizontal position. First would appear the body, the head, and the knees, the figure gradually revealing itself as it is raised upwards, till there would come to view the relief more than half completed and finally the roundness of the whole.[18]

Vasari and Cellini, with their emphasis on the use of models as a sign of good practice and craftsmanship, did not even allude to the use of drawings by sculptors, although it seems likely that they were used.[19]

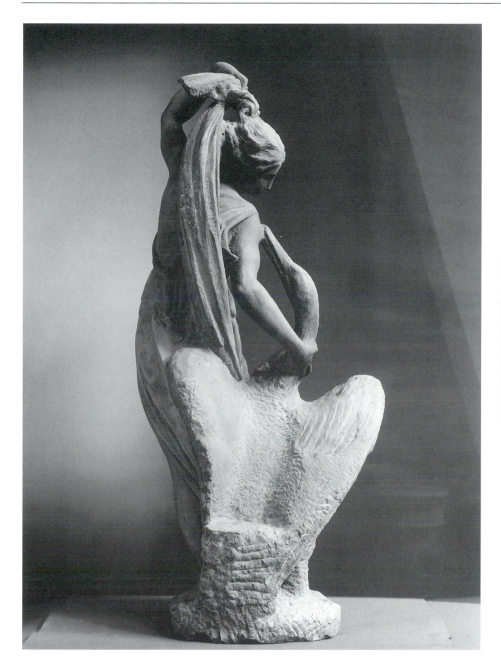

Figure 1. Ammanati, *Leda and the Swan*, Victoria & Albert Museum, London, c. 1560. This oblique view of the marble sculpture shows how the sculptor first blocked out and then articulated the forms down to the next-to-last skin with point chisels and then used claw chisels to refine the contours further. (photo: Courtesy of the Board of Trustees of the Victoria & Albert Museum)

Wood is also carved by a subtractive method; however the action of sculpting wood is only part of the process of making a life-size wood sculpture. Gauricus considered wood carving and ivory carving the simplest genres, consisting only of cutting, gluing, and painting.[20] Vasari, in his section on wood carving, stated that wood was used primarily for Christian sculptures, such as crucifixes, but that the material did not have the softness or fleshlike appearance of marble, metal, stucco, wax, or clay. He advised using lime wood because "it is equally porous on every side, and it more readily obeys the rasp and chisel"[21] and limited his technical information to the best methods of adding pieces of wood if the original piece was not large enough for the figure.[22] After a sufficiently large, or complex, block was assembled, the sculptor could carve it according to the model.[23]

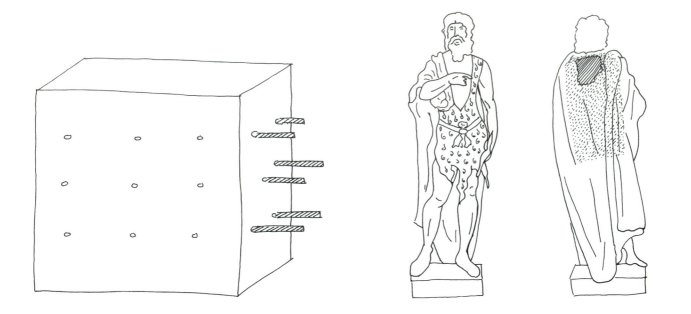

Drawing 9. Leonardo's mechanical method of transfer: a box with holes was placed over a clay model for a sculpture. Rods were inserted until they abutted the model. The length of rod extending from the box was blackened and tagged with its hole designation. When a marble being carved was put in the box, the blackened rods, reinserted in their appropriate holes, would be completely black only when the marble was sculpted to the same depth as the clay model. (author)

Drawing 10 (middle). Wood figure of *St. John the Baptist* by Francesco di Giorgio, 1464, carved from a single lime tree trunk, hollowed out on the interior (author)

Drawing 11. Back of wood figure of *St. John the Baptist* by Francesco di Giorgio showing the large, thick, broken plank that extended from the shoulders to the base, closing the sculpture's back and interior cavity. The plank, carved into the Baptist's mantle, has suffered a loss at the upper edge exposing the interior cavity. (author)

Curiously, Vasari did not even allude to the most common reason for piecing and gluing wood. If the outer layer of a trunk of wood, the sapwood, dries out while the interior, the heartwood, is still saturated, stresses are set up in the outer layer. Eventually the outer layers rupture, and the trunk develops longitudinal splits or checks. By eliminating the heartwood, the sculptor could reduce the effects of the differential stresses.[24] Therefore, most wood sculptures were carved out of tree trunks that had been hollowed out in the body of the figure to stabilize the wood structure (Drawing 10).[25]

Depending on whether the sculpture was to be essentially a high relief or finished in the round, the sculptor would either leave the back open or close it up. Different sculptors appear to have had different methods of closing figures, the usual method being the addition of planks of wood to complete the block before carving (Drawing 11).[26] One sculptor split the tree trunk, hollowed out the interior, and reassembled it before finishing.[27]

Gauricus's third element of wood carving, the painting, unmentioned by Vasari, is the most salient aspect of Italian wood sculpture. Technical examinations suggest that the painting techniques and pigments were similar to those used for contemporary panel paintings. Unlike panels where the illusion of three-dimensionality was achieved through a careful build-up of light, medium, and dark tones, wood sculpture was painted with relatively large, flat areas of color. Faces were the only areas that were "modeled" with paint.[28] Many wood sculptures were, in fact, painted by panel painters.[29] Like panel paintings, wood sculptures were prepared for painting with one or more coats of gesso (powdered, treated gypsum) mixed with animal glue. In some cases, however, this gesso layer functioned both as the final sculptural step as well as the preparation for painting. The finest details of Donatello's *Mary Magdalen* were carved in the thick gesso layer (Fig. 2).[30]

Many wood sculptures are notable for their extensive gilding. Vasari describes two methods of gilding on wood.[31] In the first, several layers of Armenian bole (a soft orange or red-brown clay) mixed with egg white are

painted over the areas to be gilded, the bole is then lightly wet with water, and the gold leaf is applied. When partially dry the gold was burnished with a dog's or wolf's tooth.[32] The second method, mordant gilding, could also be used on stone, canvas, and metals of all kind, as well as on leather. The mordant was made of oil burned with some varnish and drying oil pigments. This oil was brushed on wood that had already had two coats of size. When the oil was half-dry, gold was applied. Mordant gilding was not burnished, so it had a rougher surface than water gilding.[33]

Unlike stone and wood, the other important sculptural materials were processed before being used, and at some point in the sculptural process, the primary or secondary material was modeled or molded. Clay, although used extensively for sculpture in the Quattrocento, was discussed in most of the treatises as a secondary material reserved for models or for molds.[34] Fortunately, Gauricus wrote a short description of clay sculpture as an example of modeling: clay sculptures were dried, baked in a potter's oven, put together with a glue made of chalk and egg whites, and painted with colors in linseed or nut oil.[35] Once fired, a clay sculpture is called a "terracotta," literally, a baked earth.

Figure 2. Donatello, *Mary Magdalen* (detail), Museo dell'Opera del Duomo, Florence, c. 1455 (photo: author)

Clays vary widely in their chemical compositions and characteristics; however, as natural materials clays are unique in their degree of plasticity, which means that when wet with the proper amount of water they will tend to hold any shape given to them. Because clays contain so much water, they shrink up to 5 to 8 percent as they dry. The amount and type of shrinkage depends on the clay's plasticity, the way in which the clay is formed, and the drying process. To avoid warping, cracking, or deformation, clay must be dried slowly and evenly. If the firing is to be successful, it must be carefully controlled because as the temperature rises, clays undergo chemical and physical transformations that make them extremely vulnerable until they have been fired and cooled down. During firing, clay shrinks about

Drawing 12. Some terracotta reliefs were made using the following steps (through *Drawing 17):* clumps of clay were put down over sheets of paper used as release agents on a wooden easel (author)

Drawing 13 (above right). The major forms of the terracotta relief were modeled (author)

Figure 3. Verrocchio (attr.), *St. Jerome,* Victoria & Albert Museum, London, c. 1470. The back view of this terracotta statuette, which was not intended to be seen, shows how the chunks of clay used to build the forms were left essentially unamalgamated and the base was hollowed out to facilitate drying and hardening. (photo: Courtesy of the Board of Trustees of the Victoria & Albert Museum)

as much as it did during the drying stage. The chemical and physical changes during firing create a new fused ceramic fabric that gives fired clay its strength.[36]

By the fifteenth century, the well-developed brick and pottery industries assessed clays by color and texture and knew from experience which clays were suitable for particular products.[37] Local clays might need to be refined or mixed with different clays or with other ingredients, such as sand, before they had a suitable workability.[38]

Clay reliefs were built up on temporary wooden supports like easels or boxes that were first covered with paper for ease of removal and to isolate the support.[39] The sculptor would use large handfuls of clay to begin building up a relief or a figure (Drawing 12). It must not have been considered important to amalgamate them completely, as discrete clumps of clay are visible on the backs of reliefs and on the bases of sculptures (Fig. 3). Forms are built up by adding clay

Drawing 14 (above, left). Areas to be in high relief, in this case Christ's head, were hollowed out before the walls were built back up (author)

Drawing 15. Additional elements such as drapery were added (author)

Drawing 16 (below left). The modeling is finished (author)

Drawing 17. The relief is removed from its support (author)

Drawing 18. Schematic representation, not to scale, of some of the steps Cellini recounted in his autobiography about the creation of the *Perseus and Medusa* by the technique of direct casting (through *Drawing 20; 22-25)*: "So then I . . . constructed the skeleton in iron." (author)

Drawing 19. Clay figure of Perseus built over the iron skeleton: "Afterward I put on the clay . . . " (author)

and are refined by taking clay away with wood and iron tools, just as Alberti described the process (Drawing 13). For some sculptures parts of figures were modeled separately and then added to the wet clay.[40] Keeping the sculptures draped in wet cloths retarded drying and made it possible to retain the plasticity of the clay so that changes could be made. Reliefs were removed from their supports when they were sufficiently dry to handle.

To allow for the even drying and firing of terracotta as dictated by the nature of clay, sculptors tried to make sure that the sculptures had as uniform a thickness as possible. For large figures, this meant that, after they had dried to what is called the leather-hard state, they were hollowed out, except for internal struts or buttresses of clay. Internal voids were built into high reliefs as they were modeled (Drawing 14). The exact methods by which the hollowing and buttressing were done probably varied from workshop to workshop. Cracks that developed from differential drying during modeling could be repaired by keying in the sections of clay.

When the modeling was finished the sculptures were allowed to dry out slowly (Drawings 15, 16, and 17). Depending on the clays used, the sculptures were fired at temperatures varying from 500 to 950 degrees centigrade in traditional up-draft kilns[41] of vertical format;[42] particularly large or tall figures were fired in sections.[43] Because of the importance of the firing, the figures were arranged very carefully in the kiln according to the best place to fire them, and the heat was built up as slowly and as evenly as possible. The kiln operator controlled the process by observing through the spy holes the variations in color temperature within the kiln. He could regulate the fire by adjusting the opening and closing of the flues and by varying the amount and type of wood for the fire.

According to Gauricus, terracottas were painted with linseed and nut oils. Technical studies of the polychromy on monumental terracottas[44] has revealed that while some terracottas were indeed prepared with an oil-based layer often containing lead white and painted using an oil medium, other sculptures had gesso preparatory layers and were painted with egg tempera.[45] Gauricus may have been aware only of a particular local practice as many of the techniques used to polychrome terracotta seem to reflect contemporary local painting practice. The pigments used were of the same type and quality as the pigments in paintings, but the structure was simpler. Except for the faces, which were painted with a modeling technique, the other areas of color on terracottas were relatively unmodulated. The gilding was a variant of mordant gilding with pigments mixed into oil.

As Gauricus noted, Tuscans glazed their terracottas. Vasari said that Luca della Robbia, after much experimentation, invented the process so that he could preserve and protect his clay sculptures.[46] Whether Luca invented the process or not, he developed a variant on glaze technology that was particularly well suited to sculpture. Instead of using either the traditional system for maiolica of white undercoat and applied pigments or the new three-layer structure of a white

undercoat, pigment layer, and transparent cover layer,[47] Luca laid in each color separately directly on the terracotta. He used overpainting for details. His white glazes had three times as much tin in them as normal potter's glazes, which made them much whiter and more opaque. Even his blue glazes had almost double the tin content of the traditional white glazes (see Luca's *Resurrection* relief in the Duomo, Florence; P/R illus. I. 25).[48]

The technical proficiency needed to prepare the clay, design a model that could be successfully fired, and fire a terracotta sculpture is quite impressive. This expertise has been overshadowed, however, by the more glamorous and more complex technique of bronze casting. Even more than for terracotta, a successful casting of bronze was the culmination of a sequence of steps, and even a slight misjudgment or miscalculation in almost any step could jeopardize the cast.[49] Because of this complexity, various treatise writers wrote detailed descriptions of the processes involved in bronze casting, emphasizing slightly different aspects of the techniques. A conflation of their accounts provides a useful framework for the interpretation both of existing documents about bronze sculptures and of recent technical examinations.

A bronze sculpture was the result of a protracted process whose physical realities dictated the pace of the work. Contracts reflected the inherent timing needed to coordinate the specialists involved, to assemble the materials, and to use best practice for every step in the sequence. Therefore, payment records can provide strong (albeit sometimes circumstantial) evidence about the process a sculptor may have used to make a particular sculpture.

The most straightforward method of casting is the so-called direct lost wax method in which the original wax model is destroyed during the casting.[50] Cellini used this method to make his famous *Perseus* in Florence (Fig. 69).[51] For a large figure, the sculptor would make or have made for him an iron armature over which he would build up the clay core of the figure (Drawings 18 and 19). The lean clay, neither too rich and soft nor too sandy, was mixed with between a third or fourth part of cloth clippings and, according to some recipes, mule or horse dung.[52] Cellini's secret was to allow this well-mixed and beaten clay mixture to decompose for at least four months first.[53] Cores were built up in successive layers, the classic method for making cores for casting bells.[54] Each layer was dried and baked before another was added. Finally, the entire core was baked to make sure that all the moisture in the core had been removed. Then wax was applied and the model finished. As Cellini had modeled his core to within a finger's width of the desired size, his wax layer would have been about a centimeter thick (Drawing 20).

The other major procedure in casting is the indirect lost wax process. Cellini had originally planned to use this method for the *Perseus*; however, he decided it would take too long (Drawing 21).[55] As described by Biringuccio, Vasari, and Cellini, the indirect method of piece molding is time consuming and difficult.[56] Nevertheless, it has several distinct advantages over the direct method. Because the original model would not be destroyed, a workshop member could use it as

Drawing 20. Clay figure of Perseus modeled in detail with wax layer added over it: " . . . and when that was modelled baked it . . . Having succeeded so well with the cast of Medusa I had great hope of bringing my Perseus through; for I had laid the wax on, and felt confident that it would come out in bronze as perfectly as the Medusa." (author)

Drawing 21. Dovetailed piece molds around the leg of a figure of Perseus modeled in plaster on the exact scale of the intended bronze statue. Cellini's first solution, which he abandoned, had been to cast the bronze indirectly by using a plaster model and piece molds: " . . . I prepared a great number of molds in separate pieces to compose the figure, intending to dovetail them together in accordance with the rules of art, and this task involved no difficulty." (author)

Figure 4. Plaster cast (made by piece molds taken from Mino da Fiesole, Marble *Portrait Bust of Piero de' Medici*), Victoria & Albert Museum, London, c. 1900. The mold lines still visible on the plaster surface reveal the organization and scale of the separate pieces needed to make this piece mold. (photo: Courtesy of the Board of Trustees of the Victoria & Albert Museum)

a guide for the chasing and finishing of the bronze. Furthermore, because a mold existed, if there were any problems during casting, a new wax could be made quickly. The piece-mold process was also adaptable to the use as a model of a preexisting sculpture in a hard material such as bronze, marble, or terracotta (Fig. 4; *cf.* Fig. 19).

The first step in making a piece mold was the preparation of the original to be molded. Whatever the material of the original, a release agent, usually oil or oil and tallow, would be brushed over it. For a clay model, which would have been susceptible to the moisture in the gesso molds, Cellini suggested applying before it was oiled an isolating coat of tinfoil laid over a brush coat of boiled turpentine.

Piece molds, as the name suggests, are cast in plaster as discrete negative pieces. In Cellini's method, a figure was divided into sections, such as the front top half of a figure, so that there were no undercuts that would make it impossible to remove the molds. Each piece mold was cast in moist plaster and allowed to dry before the piece mold next to it was cast. The complexity of the area to be molded was the determining factor in the size of the individual molds. A complex area might have several molds, whereas a large, relatively flat surface could be molded in one piece. To make sure the pieces could be reassembled

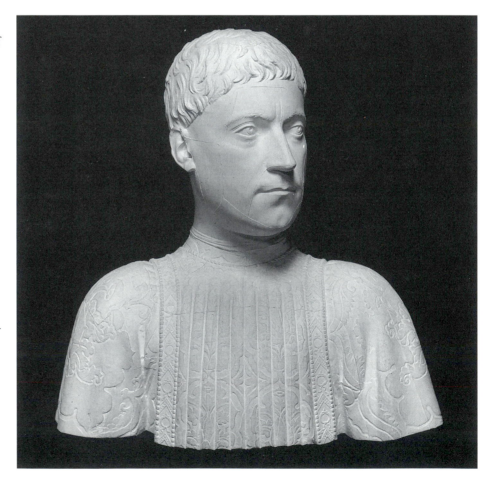

properly after removal, the pieces were either threaded together, marked with some type of identification, or made with mortise and tenons. Once a section was prepared, the smaller piece molds were given a thick coat of gesso as an outer shell that would later be used to hold them in place when wax was applied to them.

Once all the sections were made, the sculptor made an iron armature and began making the core for the figure in the same materials and way in which a direct model core was made. However, as the core was being made for an existing mold the sculptor, for example, Cellini, had to constantly measure and adjust it. By using a temporary spacer layer in the piece mold, Cellini was able to build up his core until it fit properly. He then removed the spacer, assembled the piece mold around the core, and poured in the wax. After the wax cooled, the piece mold was removed, the mold lines were cleaned off the wax, and any changes deemed aesthetically necessary were made to the wax surface.

After the mold lines were cleaned off, the indirect and direct wax models would have been virtually indistinguishable, and the remaining steps in the process would have been the same. At this stage either bronze or iron rods, a finger in width and several fingers long, were driven through the wax and into the core. These were to prevent the shifting of the core during firing and casting, which could damage or even destroy the casting.

With the wax model complete, the sculptor would assess the form of the figure in order to design the system of channels and vents necessary for the introduction of the molten bronze and the escape of air from the mold, making sure that they were placed to do the least damage to the model. The number and design of the channels and vents depended on the complexity of the figure and workshop practice (Drawing 22). From one or two funnels, or gates, on the top, a number of channels, sometimes with added runners, ran down the figure, arranged so that the mold was filled from the top down or from the bottom up. Vents were put mainly in the upper areas of the molds. Obviously, for figures in the round, there would be channels on all sides, whereas for reliefs channels and vents were attached to the back. A poor design would mean incomplete filling, areas of excessive porosity, or other damage. The channels and vents were made out of rods of wax or, in some cases, may have been carved in the clay mold.

After the model was channeled and vented, the wax was brushed with several thin coats of a very fine-grained preparation, based on either gesso or clay, which would become the negative surface of the mold.[57] The exterior mold was built up of as many layers of the clay mixed with cloth clippings as necessary to support the weight and resist the pressures of the bronze. Each layer was allowed to dry thoroughly before another was applied. Most molds were wrapped with iron wires, and large castings with iron hoops or bands (Drawing 23).[58] Vasari suggested tying these into the iron or bronze core supports.

Because wax was so expensive, the sculptor tried to recover as much of the wax as possible, and there were several different ways in which the wax was liquified and drained from the mold. The mold had to be baked thoroughly

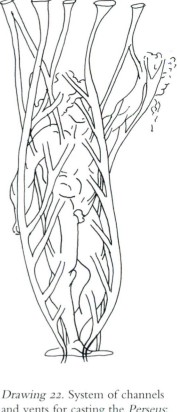

Drawing 22. System of channels and vents for casting the *Perseus*: "I supplied it with two issues for metal, because this twisted figure could not otherwise have come out perfect. Now my pipe, which runs six cubits to the statue's foot, as I have said is not thicker than two fingers. However it was not worth the trouble and expense to make it larger, for I shall easily be able to mend what is lacking." (author)

Drawing 23. Mold wrapped with iron hoops: "I clothed my *Perseus* with clay which I had prepared many months beforehand . . . After making its clay tunic . . . and properly arming and fencing it with iron girders." (author)

before casting; otherwise, it could blow up or cause severe defects in the cast. For a large mold, the sculptor would construct a temporary furnace around the mold (Drawing 24).[59] This furnace, loosely constructed of bricks placed a few inches away from the mold, was fired with wood or charcoal placed between the bricks and clay.[60]

After the mold was baked, all of the vents and channels were sealed so that no moisture could get back into the mold. The mold was then placed in a pit dug in front of the metal founding furnace (Drawing 25). This pit needed to be deeper than the mold; all of the vents and inlet channels were extended above the top of the pit. Earth was rammed in around the mold. Channels leading from the furnace to the mold were constructed, and once the metal was ready, the mold and furnace were opened and the casting begun. The mold was not removed from the pit until the mold was cold.

While the model and mold were being prepared, the metal for casting was bought or assembled.[61] From documents, it is clear that the stock of adequate metal was never completely assured and that the metal often had to be assembled from many sources.[62] In choosing the bronze alloy, the sculptor would have had to consider not only the materials' cost and availability but their color, ease of fabrication, suitability for the casting, and other characteristics.[63] Donatello's *Lamentation* relief was cast in such a thin layer of bronze that there are gaps between the figures (Fig. 5).

According to Biringuccio, bronze for sculpture should be made from between eight and twelve pounds of tin for every hundred pounds of copper, whereas bells might need from twenty-three to twenty-six pounds of tin. Bronze alloys could also contain brass (an alloy of copper and zinc)[64] or lead. Vasari said that statuary bronze was two-thirds copper and one-third brass.[65] In recent analyses of some Florentine monumental bronzes, the alloys were found to be approximately 90 percent copper, with lead ranging from 0.25 percent to a little over 2 percent, and the rest tin.[66] Analyses of over two hundred portrait medals have shown a wider range of alloys used, which may have been due to differences in casting large- and small-scale works.[67]

Alloying and preparing metal for casting required skill and years of experience.[68] The process was wholly empirical; the caster had no temperature gauges or other instruments and so to achieve the alloy needed had to rely on the color of flames, the look of a sample of metal, and the feel of metals as they were being stirred during melting. Metal could be alloyed and melted in a variety of furnaces ranging from medieval hearth or basket types to brick-built reverberatory furnaces well known in the sixteenth century. Usually the caster began by melting the copper and then adding tin. If scrap metals were being used, the caster might make the alloy first and then remelt it for the casting.[69] When the metal was ready, the furnace was opened and the molten metal was allowed to run down a channel and into the funnel or gate of the mold. If the mold had not been properly prepared, the casting could fail at this point, with the mold breaking or the metal splashing out.[70]

Once the bronze was cast, the tedious procedure of finishing could begin. After the outer mold was removed, the channels and vents now cast in bronze needed to be chiseled off and the cast cleaned. Depending on the success of the cast, damage caused by shifting of the core or porosity would have to be repaired with cast-in sections or bronze plugs. Finally, the chasing could start. Using burins, burnishers, chasing tools, punches, chisels, and files, the workmen would remove any excess bronze, push down the uneven surface to smooth it out, and shape, shave, and clean the piece (Fig. 6).[71] It could take months to clean and chase a bronze, and most sculptors had assistants, often goldsmiths, to help them.

Unfortunately, only a few fifteenth- and sixteenth-century large bronzes have undergone complete technical examinations; therefore it is impossible to tell whether certain techniques identified by technical examination but not mentioned in the treatises were common or not. For example, Ghiberti used a cast-on technique for the reliefs of the *Gates of Paradise* (P/R illus. 5.2). Figures in the round, such as the merchants at the Temple in the *Joseph* relief, were cast from a different pour of metal, one that had a higher fluidity, directly onto the bronze relief.[72] The *St. Louis of Toulouse* (P/R illus. 4.41) and *Judith and Holofernes* (Fig. 65) by Donatello were also made using variations in technique not mentioned in the treatises. The *St. Louis* is a high relief assemblage of cast-bronze sections. Presumably, this method was used so that the sections could be mercury gilded.[73] The *Judith*, instead of being cast whole, like Verrocchio's *Christ and Doubting Thomas* (Fig. 78) or Cellini's *Perseus* (Fig. 69), was cast in three principal, and several minor, sections that were then joined by internal recasting. This was probably done to facilitate casting such a large and complex ensemble.[74] These techniques may not have been mentioned by the treatise writers because they were developed to solve specific problems or were considered primitive or old-fashioned by the time the treatises were written.

Drawing 24 (above, left). Mold baking in furnace: " . . . I began to draw the wax out by means of a slow fire. This melted and issued through numerous air vents I had made . . When I finished drawing off the wax, I constructed a funnel-shaped furnace all around the model of my *Perseus*. It was built of bricks, so interlaced the one above the other, that numerous apertures were left for the fire to exhale at . . ." (author)

Drawing 25. Mold in pit with vents and channels extended above pit: "At length when all the wax was gone and the mold well baked, I set to work at digging the pit in which to sink it . . . As ever the earth grew higher, I introduced proper air vents, which were little tubes of earthenware . . . After I had let my statue cool for two whole days, I began to uncover it by slow degrees." (author)

Figure 5. Donatello, *Lamentation* (view of back), Victoria & Albert Museum, London, 1458–59. The view of the back of this small bronze relief reveals the importance of achieving an overall even thickness of bronze as the hollows on the back of the relief conform to the projections on the front of the relief. (photo: Courtesy of the Board of Trustees of the Victoria & Albert Museum)

The treatises did include other methods and variations that have not received as much attention as the accounts of direct casting and of the piece-molding techniques. Recently, the sophisticated replica system of slush casting, mentioned by Biringuccio and Vasari, has been identified through technical examinations.[75] Documents for bronze sculptures may also be analyzed to identify the actual employment of other methods that have been described.[76]

Casting is not the only way to make metal sculptures. In Alberti's third type of sculpture, repoussé, sheet metal is modeled by hammering and punching. Generally associated with gold and silver, this method can also be used to model pure copper.[77] Repoussé metalwork, because of the tools used and the properties of the material, lacks the sharpness and definition that can be achieved with a cast sculpture. However, it does have several advantages over cast work. Because no metal is lost in the process and the hammered work is often put over a support, repoussé needs less metal and the metal that is used can be manipulated in different ways.[78]

Many of the other molding techniques that were part of a bronze caster's repertory, as described by Gauricus, Biringuccio, and Vasari, could have been used to make molds for sculptures in other materials.[79] The techniques, which were specifically adapted to the material of the original model, were designed to produce refractory molds capable of withstanding the high temperatures needed for bronze casting, so they would have had to have been slightly adapted for casting other materials. The survival of multiple versions of many reliefs in stucco, terracotta, and *cartapesta* (papier-mâché) signify just how important molding was as a sculptural technique. Some designs have over twenty extant variations in different materials, attesting to both the popularity of the image and the ease and flexibility of molding as a technique.[80]

If the original model could be sacrificed, the direct lost wax method could be used for a wax model and the potter's clay method for a freshly modeled clay relief. In this technique, the model was greased, possibly overlaid with tinfoil, and then covered with liquid clay mixed with cloth clippings. Once bound with iron wire, the mold was heated gently to separate the clays and then the clay original was scraped out of the mold. If the sculptor wanted to save the wax or clay model of a low relief, he could take a plaster mold of it. However, if the original model was a high relief, the sculptor might have made a flexible glue mold. Essentially, a strong glue made of hide or parchment was cast on the

Figure 6. Donatello, Bronze Doors, Old Sacristy (detail), S. Lorenzo, Florence, 1437–43. Detail of the pattern of markings characteristic of different chasing tools chosen to create various textural illusions. (photo: author)

greased surface of the relief, which might also have been isolated with tinfoil, silver, or base gold.

For models in bronze, marble, or wood, clay molds were made by filling the undercuts with clay, allowing them to dry, then greasing the surface and applying clay. When the clay was taken off, the infills were attached with nails or clay. For complex reliefs, plaster piece molds were useful.[81] Another method mentioned by Gauricus and Biringuccio was to dip the model in molten wax several times until a thick enough coat of wax to make a mold was built up. This coating was then cut off with threads or wires and reassembled.[82]

For Gauricus, plaster, one of his five genres of statuary, was associated with molding.[83] In his description of molding, plaster is poured into an image imprinted in clay or liquified wax.[84] Plaster was also the material used by

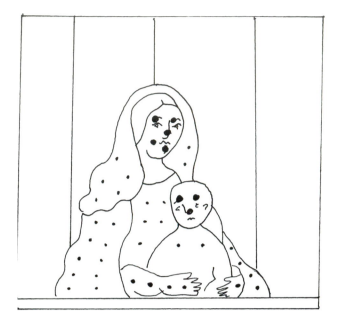

Drawing 26. For stucco reliefs, sculptors drew the design directly on the wooden panel and then hammered nails into the panel to be the armature of the relief (author; not drawn to scale)

Cennini in making casts from life molds.[85] The relationship between the available molding techniques, the use of plaster, and the making of multiples is far from clear. It is made even more confused because many of the multiples were cast in stucco, yet Vasari considered stucco an original modeling material for creating architectural decoration.[86] Vasari's recipe for stucco, two-thirds lime mortar and one-third ground marble, either was stamped with a wooden mold or was hand modeled over a framework of bricks for high reliefs or nails for low reliefs (Drawing 26).[87] Terracotta, also thought of as a modeling material, was used for multiples as well. Because both the originals and the multiples were intended to be polychromed, the distinctions between modeling and molding may not have been as important as they seem.

From the treatises, documents, and sculptures, it is clear that Renaissance sculptors respected the intrinsic properties of the materials they used. With the knowledge acquired over generations, they knew the advantages and disadvantages of each material and developed techniques to minimize the inherent problems of materials while maximizing their aesthetic value.

Notes

1. C. Cennini, *The Craftsman's Handbook "Il Libro dell'Arte,"* trans. D. Thompson (New Haven, 1933; reprint, New York, 1960) and *Il Libro Dell'Arte,* ed. F. Brunello (Vicenza, 1982) (end of the fourteenth century); L. B. Alberti, *On Painting and On Sculpture,* ed. and trans. C. Grayson (London, 1972) (*On Sculpture* c. 1443–52) and *On the Art of Building in Ten Books,* trans. J. Rykwert, N. Leach, and R. Tavernor (Cambridge, Mass., 1988) (c. 1450); P. Gauricus, *De sculptura,* ed. and trans. A. Chastel and R. Klein (Geneva and Paris, 1969) (1504); V. Biringuccio, *The Pirotechnia of Vannoccio Biringuccio,* trans. C. S. Smith and M. T. Gnudi (New York, 1959; reprint, New York, 1990) (1540); G. Vasari, *Vasari on Technique,* trans. L. Maclehose and ed. G. Baldwin Brown (1907; reprint, New York, 1960) and *La Tecnica dell'arte negli scritti di Giorgio Vasari,* ed. R. Panichi (Florence, 1991) (Introduction to *Lives of the Artists,* 2d ed. 1568); B. Cellini, *The Treatises of Benvenuto Cellini on Goldsmithing and Sculpture,* trans. C. R. Ashbee (London, 1888; reprint, New York, 1967) and *I Trattati dell'Oreficeria e della Scultura,* ed. C. Milanesi (Florence, 1857; reprint, Florence, 1994) (1568). The Italian editions cited all have useful glossaries.

 An earlier treatise invaluable for comparative studies is Theophilus, *On Divers Arts,* trans. and intro. J. G. Hawthorne and C. S. Smith (Chicago, 1963; reprint, New York, 1979) (c. 1100).

 Additional technical information can be found in Leonardo da Vinci, *The Notebooks of Leonardo da Vinci,* trans. and ed. E. MacCurdy (2 vols. London, 1938; reprint, London, 1954) B. Cellini, *The Autobiography of Benvenuto Cellini,* trans. J. A. Symonds and ed. J. C. Nelson (New York, 1963) (1556–62), and G. Vasari, *Lives of the Most Eminent Painters Sculptors and Architects,* trans. G. de Vere, 10 vols. (London, 1912–15). J. Mills, *The Encyclopedia of Sculpture Techniques* (London, 1990), is a useful introduction to modern sculptural practice.

2. Alberti, *Sculpture,* 121.

3. Gauricus, *De sculptura,* 70–1, distinguished five genres in the art of statuary: 1. wood and ivory: cutting; 2. clay: modeling; 3. plaster: molding; 4. stone: striking; and 5. metal: a double process, on the one side, the making of a direct model in wax and on the other side, the running of molten metal into molds.

4. According to R. Rossi-Manaresi, "On the Treatment of Stone Sculptures in the Past," in *The Treatment of Stone,* eds. R. Rossi-Manaresi and G. Torraca (Bologna, 1972), 81–93, polychromy on fifteenth-century sculptures was used primarily for decorative accents. For example, there

is a payment for some painting on the *Siena Baptistry Font*, see J. Paoletti, *The Siena Baptistry Font: A Study of an Early Renaissance Collaborative Program, 1416–1434* (New York, 1979), 91 and Doc. 273.

5. The literature on all aspects of the sculptural and building stones in Italy is vast. The easiest way to approach the literature is through publications about the conservation of individual monuments; these usually summarize the current literature about the stones used.

6. For example, G. Alessandrini, R. Bugini, and U. Zezza, "The Pavia Certosa: Materials and Decay of the Church Facade," in *Scientific Methodologies Applied to Works of Art*, ed. P. Parrini (Milan, 1986), 61–4, believe there was a strict correlation between the quality of stones and the style of work on the facade, with particular care taken in choosing the blocks for sculpture. All stones were chosen and worked as a function of their intrinsic structural characteristics.

7. For information on the procurement of stone, see W. E. Wallace, *Michelangelo at San Lorenzo: The Genius as Entrepreneur* (New York and Cambridge, 1994); S. Connell, *The Employment of Sculptors and Stonemasons in Venice in the Fifteenth Century* (New York, 1988); R. Goldthwaite, *The Building of Renaissance Florence* (Baltimore, 1980), 212–37; and C. Klapisch-Zuber, *Les Maîtres du marbre: Carrare, 1300–1600* (Paris, 1969).

8. I am indebted to the knowledgeable lectures by Peter Rockwell and to his excellent book *The Art of Stoneworking: A Reference Guide* (Cambridge, 1993), for information on stone carving.

 For contemporary descriptions of stones, see Alberti, *Building*, 47–50; Vasari, *Technique*, 25–62; and Cellini, *Treatises*, 134–8.

9. See S. Butters, *The Triumph of Vulcan: Sculptor's Tools, Porphyry and the Prince in Ducal Florence*, 2 vols. (Florence, 1996) for an exhaustive discussion of hard stone carving in the sixteenth century.

10. Vasari, *Technique*, 148–53, and Cellini, *Treatises*, 135–7, describe marble carving.

11. See Rockwell, *Stoneworking*, 31–68, for descriptions and drawings of tools, and J.-C. Bessac, "Problems of Identification and Interpretation of Tool Marks on Ancient Marbles and Decorative Stones," in *Classical Marble: Geochemistry, Technology, Trade*, ed. N. Herz and M. Waelkens (Dordrecht, 1988), 41–53, for excellent photographs of tool marks.

12. Vasari, *Technique*, 150; Cellini, *Treatises*, 136. For the use of models by sculptors, see G. Radke, "Benedetto da Maiano and the Use of Full Scale Preparatory Models in the Quattrocento," in *Verrocchio and Late Quattrocento Italian Sculpture*, ed. S. Bule *et al.*, (Florence, 1992), 217–24; A. Radcliffe, "The Model and the Marble in the Renaissance," in *The Thyssen-Bornemisza Collection: Renaissance and Later Sculpture*,

ed. A. Radcliffe, M. Baker, and M. Maek-Gérard (London, 1992), 10–15; and C. Avery, *Giambologna: The Complete Sculpture* (Oxford, 1987), 63–70.

Painters also used models. For example, according to Vasari, *Technique*, 214, many painters used models to study the effect of light and shadow on compositions. Sculptors also made models for painters, Vasari, *Lives*, IX, 188. See also L. Fusco, "The Use of Sculptural Models by Painters in Fifteenth-Century Italy," *Art Bulletin* LXIV, no. 2 (1982): 175–94.

13. There is a full-size nude model of a river god for the New Sacristy in the Casa Buonarotti, Florence. According to the label, it was made of crude clay, river sand, animal skins, vegetable fiber, wood, and iron and metal net. The wire net, which must have been a type of key for the clay mixture, is visible in the break at the back of the left shoulder. From other breaks one can see that it was roughly built up in layers.

14. Vasari, *Technique*, 150–1.

15. Cellini, *Treatises*, 136.

16. Vasari, *Lives*, IX, 106–7.

17. Vasari, *Technique*, 151, suggested using a method based on carpenter's squares and rulers. This is a simpler method than that proposed by Alberti, *Sculpture*, 125. Alberti's proportional method, developed as an aid to help sculptors make a figure "artistically and methodically," was based on rulers, a type of caliper and an instrument that measured the projection of a figure in space. Both of these methods would be more efficient than the box-and-rod method discussed by Leonardo, *Notebooks*, II, 368. Gauricus, *De sculptura*, 240–3, instead of describing a transfer method, gave directions for how to find the axes within a block of stone and suggested using a compass to fix the position of the mouth and eyes of a figure.

18. Vasari, *Technique*, 151. Rockwell, *Stoneworking*, 70–2, suggested that this passage referred to Michelangelo's *St. Matthew*, in the Gallerie dell'Accademia, Florence, which he views as uncharacteristic of Michelangelo's technique. R. Wittkower, *Sculpture Processes and Principles* (New York, 1977), 116–18, also connected the water bath analogy and the *St. Matthew*; however, he used it as an example of Michelangelo's working method. Neither of the authors discussed Vasari's use of the water bath analogy in the two different contexts.

19. See F. Ames-Lewis, *Drawing in Early Renaissance Italy* (New Haven, 1981), 104–10 and 128–31. Rockwell, *Stoneworking*, 70, believes that Michelangelo's unfinished tondos may have been based on drawings.

20 Gauricus, *De sculptura*, 240–1.

21. Vasari, *Technique*, 173–6. Lime grows up to 30 m in height and 1.2 m in diameter and poplar rarely exceeds 18 m in height and 0.6 m in diameter; the most popular woods used for sculpture are soft, fine-textured woods with a

uniform texture that makes them easy to carve in any direction without chipping. Walnut (up to 25 m in height and 1 m in diameter) and pear (up to 12 m in height and 0.4 m in diameter) were also often used for sculpture.

22. Although Vasari advocated the use of wooden pegs rather than iron nails to join the necessary blocks of wood, apparently many sculptors used iron nails. See the x-radiograph of Desiderio da Settignano's *Mary Magdalen* in A. V. Coonin, "New Documents concerning Desiderio da Settignano and Annalena Malatesta," *Burlington Magazine* CXXXVII, no. 1113 (December, 1995), 792–9.

23. Vasari's chapter on wood carving reads like a description of how to make a crucifix. U. Procacci and U. Baldini, "Il Restauro del crocifisso di Santo Spirito," *Münchner Jahrbuch der bildenden Kunst* XV (1964): 32–6, describe how the sculptor (Michelangelo?) made additions to the trunk of a poplar tree so that he could obtain a wooden unitary envelope, not unlike a block of marble, that he could then carve. Unlike most wooden sculptures where the joints are hidden, the Santo Spirito sculptor seemed not to have thought about or cared where the joints went through the figure. Contrary to Vasari's description and the technique of the *Santo Spirito Crucifix*, most additions to wood sculptures, such as arms, were carved separately and then attached. See also L. V. Pesciolini, "L'intervento di restauro," *OPD Restauro VII* (1995): 26–32, on a wooden crucifix attributed to Andrea del Verrocchio.

24. For an introduction to the structure and identification of wood, see F. W. Jane, *The Structure of Wood* (London, 1970); H. E. Desch, *Timber: Its Structure and Properties*, 5th ed. (London, 1973), and *The Concise Encyclopedia of Wood and Wood-based Materials*, ed. A. Schniewind (Oxford, 1989).

25. See M. Baxandall, *The Limewood Sculptors of Renaissance Germany* (New Haven, 1980), for a stimulating treatment of lime wood carving in Germany.

26. For a variety of methods see the catalogue entries in *Scultura dipinta: Maestri di legname e pittori a Siena, 1250–1450* (Florence, 1987).

27. This method is considered typical of the Sienese sculptor Francesco di Valdambrino. See the *Annunciation*, 1398–1403, in *Nel secolo di Lorenzo: Restauri di opere d'arte del Quattrocento*, ed. M. Burresi (Pisa, 1993), 16–21.

28. A. Gallone Galassi, P. Fumagalli, and E. Gritti, "Conservation and Scientific Examination of Three Northern Italian Gilded and Painted Altarpieces of the Sixteenth Century," in *Gilded Wood Conservation and History*, eds. D. Bigelow *et al.* (Madison, Conn., 1991), 192–203.

For early Quattrocento painting techniques and materials see Cennini, *Craftsman's Handbook*, and D. Bomford, J. Dunkerton, D. Gordon, and A. Roy, *Art in the Making: Italian Painting before 1400* (London, 1989). Information on later techniques can be found in various National Gallery (London) Technical Bulletins.

29. The most famous of these is the documented Annunciation group for the Collegiata of San Gimignano, which was sculpted by Jacopo della Quercia and painted by Martino di Bartolomeo, illustrated in *Scultura dipinta*, 156–7.

30. See J. Plesters, "A Note on the Examination of Surface Coatings on Polychrome Sculpture," *The Conservation of Stone and Wooden Objects, New York Conference* (New York, 1970), 137–40. See also the *Madonna and Child* attributed to Domenico di Niccolò dei Cori in *Scultura dipinta*, 111.

31. Vasari, *Technique*, 248–50.

32. This was the method identified by Gallone Galassi *et al.*, "Gilded and Painted Altarpieces," 193–203.

33. The gilding on Donatello's *Mary Magdalen* was applied with a mordant. The gilding was applied over several layers of brown ochre painted in tempera; see Plesters, "A Note," 139.

34. Recently, there has been a revival of interest in terracotta sculpture. See G. Gentilini, "Nella Rinascita della Antichità," in *La Civiltà del Cotto*, eds. A. Paolucci and G. Conti (Florence, 1980), 67–99; A. Lugli, *Guido Mazzoni e la rinascita della terracotta nel Quattrocento* (Turin, 1990), and *Presepi e terrecotte nei musei civici di Bologna*, eds. R. Grandi, M. Medica, S. Tumidei, A. Mampieri, and C. Lorenzetti (Bologna, 1991); and *La scultura in terracotta: techniche e conservazione*, ed. M. G. Vaccari (Florence, 1996).

35. Gauricus, *De sculptura*, 240–1.

36. For an introduction to ceramics see W. D. Kingery and P. B. Vandiver, *Ceramic Masterpieces: Art, Structure, and Technology* (New York, 1986). For more information see R. W. Grimshaw, *The Chemistry and Physics of Clays and Allied Ceramic Materials*, 4th ed. (New York, 1971).

37. See Alberti, *Building*, 50–2, for a discussion of bricks, and Biringuccio, *Pirotechnia*, 392–401, for pottery and brick manufacture. The only treatise on ceramics from this period is C. Piccolpasso, *The Three Books of the Potter's Art*, trans. and ed. R. Lightbown and A. Caiger-Smith, 2 vols. (London, 1980). Vol. I is a facsimile edition (1557). Piccolpasso wrote about all aspects of making pottery, including the locating and refining of clays.

38. Biringuccio, *Pirotechnia*, 218–20, suggested test firing the clay for bronze casting before use. Recent studies have confirmed that it is possible to distinguish clays from particular regions and provide information on production methods. For example, see M. Hughes, "Provenance Studies on Italian Maiolica by Neutron Activation Analysis," 293–7, and M. S. Tite, "Technological Investigations of Italian Renaissance Ceramics," 280–5, in *Italian Renaissance Pottery*, ed. T. Wilson (London, 1991). Typical mid-fifteenth-century maiolica bodies were calcareous clays with 15–25% lime and abundant quartz and feldspar. See also the articles in *La scultura in terracotta* for analyses of the clay bodies of several sculptures.

39. For the technique of modeling terracotta reliefs see S. Rees-Jones, "A Fifteenth-Century Florentine Terracotta Relief: Technology-Conservation-Interpretation," *Studies in Conservation* XXIII (1978): 95–113; for monumental sculptures see A. Andreoni, F. Kumar, and E. Tucciarelli, "Note sulla tecnica di esecuzione del *Compianto*," *Restauro di una terracotta del Quattrocento; il "Compianto" di Giacomo Cozzarelli* (Florence, 1984), 23–30. For a Florentine perspective see G. Gentilini, "La scultura fiorentina in terracotta del rinascimento: tecniche e tipologie," in *La scultura in terracotta*, 64–103.

40. For example, the *Virgin and Child* by Riccio, c. 1520–25, in *Thyssen-Bornemisza . . . Renaissance and Later Sculpture*, 74–9.

41. Biringuccio, *Pirotechnia*, 393; illustrated and discussed in great detail in Piccolpasso, *Potter's Art*, II, 64–71 and 109–10. The basic up-draft kiln consists of a fire box below a chamber that has a vent in the top. The pottery in the chamber is baked by the draft of hot air through the chamber. According to A. Kosinova, "The Conservation of the Portrait Bust of Giovanni de' Medici (later Pope Leo X)," *V&A Conservation Journal XVII* (1995): 14–15, the bust was fired at between 500° and 800°C.

42. Andreoni *et al.*, "Compianto," 25.

43. The 186 cm tall sculpture of *Santa Lucia* by a Sienese sculptor close to Francesco di Giorgio, 1480–85, was fired in three pieces; see *Francesco di Giorgio e il Rinascimento a Siena, 1450–1500*, ed. L. Bellosi (Milan, 1993), 396–9.

44. See: M. Matteini and A. Moles, "Analisi chimiche e stratigrafiche per lo studio della tecnica pittorica," *Restauro di una terracotta*, 31–6, A. Tucci, "Indagini tecniche sulla policromia del *Compianto* e del *San Domenico* di Niccolò dell'Arca," in *Tre artisti nella Bologna dei Bentivoglio* (Padua, 1985), 345–8, and P. Bensi, " 'Alla vita della terracotta era necessario il colore: Appunti sulla policromia della statuaria fittile," in *La scultura in terracotta*, 34–46; for technical analyses of polychromy on monumental terracottas.

45. Donatello's terracotta statue, now destroyed, made in 1410 for one of the buttresses of the cathedral in Florence, was gessoed and painted with white lead in linseed oil; see G. Poggi, *Il Duomo di Firenze* (Berlin, 1909), docs. 417, 418, 421. This statue is generally thought to be the sculpture described by Vasari, *Lives*, II, 249, as being made of bricks and stucco. If it was indeed made of brick and stucco rather than terracotta, then Giambologna's *Appennino*, second half of the sixteenth century, constructed of brick and finished with a mortar-type stucco, may be an interesting survivor of the technique. See F. Fratini, C. Manganelli Del Fà, M. Matteini, A. Moles, E. Pecchioni, and M. Rizzi, " 'Il Colosso dell'Appennino' del Giambologna: Studio delle malte e dei laterizi pertinenti della struttura e del rivestimento," in *Le pitture murali*, ed. C. Danti, M. Matteini, and A. Moles (Florence, 1990), 59–72.

46. Gauricus, *De Sculptura*, 240–1; Vasari, *Lives*, II, 122.

47. W. D. Kingery and M. Aronson, "On the Technology of Renaissance Maiolica Glazes," *Faenza* V (1990): 226–34, and W. D. Kingery, "Painterly Maiolica of the Italian Renaissance," *Technology and Culture* XXXIV (1993): 28–47.

48. W. D. Kingery and M. Aronson, "The Glazes of Luca della Robbia," *Faenza* V (1990): 221–24. According to Vasari, *Lives*, II, 122, Luca fused tin, litharge (a lead compound), antimony, and other minerals and mixtures in a special furnace.

49. In Biringuccio's preface to his 6th book of the *Pirotechnia*, 213–17, he underscored the need for a methodical and knowledgeable approach. He stressed that "The outcome of this art is dependent upon and subject to many operations which, if they are not all carried out with great care and diligence and well observed throughout, convert the whole into nothing, and the result becomes like its name [cast away]."

50. For more information on casting see P. K. Cavanagh, "Practical Considerations and Problems of Bronze Casting," in *Small Bronze Sculpture from the Ancient World*, eds. M. True and J. Podany (Malibu, 1990), 145–60.

51. Cellini's account in his *Autobiography*, 335–95, of making and casting the *Perseus* provides a vivid corollary to the description in his treatise.

52. Biringuccio's requirements for clay were that it be worked easily, dry without fractures, hold its own shape well, and be resistant to fire (*Pirotechnia*, 218–20). The organic fiber was probably added to reinforce the tensile strength of the clay, which would increase its strength and resistance to cracking. According to C. L. Reedy, "Petrographic Analysis of Casting Core Materials for Provenance Studies of Copper Alloy Sculptures," *Archaeomaterials* V, no. 2 (1991): 121–63, the primary core material for Renaissance bronzes was a sandy clay, often with added organic matter.

 See also A. E. Werner and P. T. Craddock, "Appendix – Scientific Examination of the Samples of Bell-Metal and Moulds Submitted to the British Museum Research Laboratory," in "An Umbrian Abbey: San Paolo di Valdiponte," *Papers British School at Rome* XLII (1974), 145–8, for the analysis of the core and mold clay of a late fifteenth-century bell mold.

53. This may indeed have been a secret because the payments for cloth clippings for most projects come at the same time as for other materials. For example, Maso di Bartolomeo listed cloth clippings on the same day as wood to dry the forms for the two eagles he made for S. Miniato al Monte, Florence, 1448–49. See C. Yriarte, *Livre de Souvenirs de Maso di Bartolommeo dit Masaccio* (Paris, 1894), 52–3.

54. Theophilus, *Divers Arts*, 168. M. Vidale, A. Melucco Vaccaro, M. R. Salvatore, M. Michli, and C. Balista, "From Theophilus to C. S. Smith: Discovery of an Eleventh-Century AD Bell-Casting Mold from Venosa (Southern Italy)," *Materials Research Society Symposium Proceedings* CCLXVII (1992): 757–79, describe just such a layered

structure in the excavated core of a bell. The core material was very rich in organic fibers, including perhaps animal fur.

55. Cellini, *Autobiography*, 341: "Here I modeled the statue [*Perseus*] in plaster, giving it the same dimensions as the bronze was meant to have, and intending to cast it from this mold. But finding that it would take rather long to carry it out in this way, I resolved upon another expedient. . . . So then I began the figure of Medusa, and constructed the skeleton in iron. Afterward I put on the clay, and when that was modeled, baked it."

56. Biringuccio, *Pirotechnia*, 230; Vasari, *Technique*, 158–60; and Cellini, *Treatises*, 114–18. By the time these authors were writing, the technology of indirect casting had been fully developed. R. Stone, "Antico and the Development of Bronze Casting in Italy at the End of the Quattrocento," *Metropolitan Museum Journal* XVI (1981): 87–116, believes that Florentines continued to use a primitive direct-cast technique even into the sixteenth century. However, according to M. Leoni, "Casting Techniques in Verrocchio's Workshop When the *Christ and St. Thomas* Was Made," in *Verrocchio's Christ and St. Thomas*, ed. L. Dolcini (New York, 1992), 83–99, archival documents indicate that Verrocchio made models for the *Christ and Doubting Thomas* (1467–83) and then had castings done so that the models could be reused. From the technical examination of Donatello's *Judith*, M. Leoni, "Considerazioni sulla fonderia d'arte ai tempi di Donatello: Aspetti tecnici del gruppo della Giuditta," in *Donatello e il restauro della Giuditta*, ed. L. Dolcini (Florence, 1988), 54–7, concluded that the *Judith and Holofernes* was indirectly cast (*cera persa a modello salvo*).

57. T. F. C. Blagg, "The Bell-Casting," in "An Umbrian Abbey: San Paolo di Valdiponte," *Papers British School at Rome XLII* (1974): 133–48. There was a 2 mm thick layer of fine clay with no inclusions on the inner surface of the outer mold.

58. Vidale *et al.*, "Venosa," 768, identified traces of the iron reinforcement bands in the outer mold at Venosa.

59. This furnace should not be confused with that used for melting metal. When interpreting documents, if a furnace is discussed in conjunction with a mold it is probably one for baking the mold rather than for melting metal. For example, C. Zarrilli, "Francesco di Giorgio pittore e scultore nelle fonti archivistiche senesi," *Francesco di Giorgio*, 530–8. Among the payments for the bronze *Angels* for Siena Cathedral are those: "Per mattoni comuni per fare fornelgli da rrichuociare ed da ffondare."

60. The bell molds at San Paolo di Valdiponte were fired to at least 400–500 degrees centigrade for some time to a red heat (see Werner, "Appendix," 147).

61. For a useful introduction to copper alloys see P. T. Craddock, "Three Thousand Years of Copper Alloys: From the Bronze Age to the Industrial Revolution," in *Application of Science in the Examination of Works of Art*, ed. P. A. England and L. van Zelst (Boston, 1983), 59–67. For a review of smelting, refining, and alloying processes during the medieval and postmedieval periods, see R. F. Tylecote, *A History of Metallurgy* (London, 1976).

62. According to Zarrilli, "Fonti archivistiche," 532, the metal assembled for Francesco di Giorgio's *Angels* in Siena included bronze, old brass, old copper, brass of old candlesticks, copper, and tin.

63. Centro Ricerche Europa Metalli, L.M.I., "Ricerche su leghe e indagini metallografiche," in *Donatello e il restauro*, 63, suggested that the different alloys used for the *Judith and Holofernes* were specially chosen for their different properties.

64. Biringuccio, *Pirotechnia*, 210 and 299–300. Brass can contain up to 25% zinc. See *2000 Years of Zinc and Brass*, ed. P. Craddock (London, 1990).

65. Vasari, *Technique*, 163.

66. See, for example, the analyses published in Leoni, "Casting Techniques in Verrochio's Workshop," 90. It should be noted that the composition of monumental bronzes is difficult to analyze and that varying compositions have been published for Donatello's *Judith and Holofernes*. Only one of the monumental works tested had an appreciable amount of zinc.

67. L. A. Glinsman and L. C. Hayek, "A Multivariate Analysis of Renaissance Portrait Medals: An Expanded Nomenclature for Defining Alloy Composition," *Archaeometry* XXXV (1993): 49–67, concluded that artists had an extensive knowledge of practical metallurgy and could produce a desired alloy without the use of modern technology.

68. Not every bronze sculptor knew how to alloy metal. In his discussion of alloy technology, Gauricus, *De sculptura*, 218–9, noted that Donatello did not know the science of making alloys, so he hired bell casters. Unfortunately, this sentence, when taken out of the context of the specialized knowledge needed for alloying metal, has been interpreted to mean that Donatello was not a skilled bronze worker. For example, recently, Leoni, "Giuditta," 54–7, suggested that Donatello was responsible only for making the model and finishing the casting of his *Judith and Holofernes*.

69. Biringuccio, *Pirotechnia*, 297–300.

70. This happened to Michelozzo when he was casting a bell; see G. Poggi, "Michelozzo fonditore di campane," *Miscellanea d'Arte* I (1903): 16.

71. See J. R. Spencer, "Filarete's Bronze Doors at St. Peter's," in *Collaboration in Italian Renaissance Art*, ed. W. S. Sheard and J. T. Paoletti (New Haven, 1978), 33–45, for the importance of chasing, and J. Draper, *Bertoldo di Giovanni: Sculptor of the Medici Household* (Columbia, Mo., 1992), 167–76, for a discussion of the unfinished, partly chased *Apollo* in the Museo Nazionale del Bargello, Florence. For

excellent photographs of the chased and unchased surfaces of a monumental bronze, Donatello's *St. John the Baptist* in the cathedral of Siena, see E. Carli, *Donatello a Siena* (Rome, 1967), plates XXXI–XLIII.

For examples of surface finishing see S. Boucher, "Surface Working, Chiseling, Inlays, Plating, Silvering, and Gilding," in *Small Bronze Sculpture from the Ancient World* (Malibu, 1990), 161–78, and R. Stone, R. White, and N. Indictor, "Surface Composition of Some Italian Renaissance Bronzes," *Ninth Triennial Meeting ICOM* (Dresden, 1990), II, 568–71.

72. P. Parrini, "Sulla tecnica di esecuzione," in *Metodo e Scienza Operatività e ricerca nel restauro*, ed. U. Baldini (Florence, 1982), 199–206. Theophilus, *Divers Arts*, 137–8, describes the use of a cast-on technique to repair missing or damaged sections of a cast. See also the other articles on Ghiberti's reliefs in *Metodo e Scienza*, in particular, M. Fondinelli, L. Ippolito, A. Gregori, and W. Ferri, "Il rilevamento fotogrammetrico," 184–85, for the surprisingly even profile of bronze thickness of the reliefs.

73. B. Bearzi, "Considerazioni di tecnica sul S. Ludovico e la Giuditta di Donatello," *Bollettino d'arte*, 4th ser., XXXVI (1951): 119–23.

74. P. Parrini, "Donatello: Giuditta e Oloferne," in *Metodo e Scienza*, 158–63, and Leoni, "Giuditta," 54–7. Fusion welding was used to assemble Greek and Roman bronzes and by bell founders to repair cracked bells.

75. For an exemplary analysis of the casting techniques of small bronzes, see Stone, "Antico." His work is especially valuable in his innovative use of technical examinations, especially x-radiographs, to evaluate casting methods described in the treatises.

76. For example, Zarrilli, "Fonti archivistiche," indicates that in 1489, Francesco di Giorgio ordered for his *Angels* in Siena, a *chassa* of iron (18 February), linen cloth to make the shifts (11 March), and flour and tow for the cores (25 June). This sounds quite like Biringuccio's description, "make their statues of tow and paste, on an iron, and if the statue if to be clothed, they dress it with thick or thin canvas covered with glue," in *Pirotechnia*, 231.

77. See Cellini, *Treatises*, 83–95; H. Maryon, *Metalwork and Enameling*, 4th ed. (New York, 1959), and 5th ed. (New York, 1971); M. Bernabò with M. Scalini, "Le tecniche e gli strumenti," in *L'Oreficeria nella Firenze del Quattrocento* (Florence, 1977), 203–32; and D. L. Carroll, "Tools of the Renaissance Jeweler: A Goldsmith's Workshop in 1576," *Archaeomaterials* I (1987): 153–72, for hammered work.

78. See D. Covi, "Verrocchio and the *Palla* of the Duomo,"

in *Art, the Ape of Nature: Studies in Honor of H. W. Janson*, ed. M. Barasch *et al.* (New York, 1981), 151–69, for the cast and hammered balls for the Duomo in Florence.

79. Gauricus, *De sculptura*, 224–31, 240–1; Biringuccio, *Pirotechnia*, 232–4, 324–32; and Vasari, *Technique*, 165.

80. A. Radcliffe, "Multiple Production in the Fifteenth Century: Florentine Stucco Madonnas and the Della Robbia Workshop," in *Thyssen-Bornemisza . . . Renaissance and Later Sculpture*, 16–23, for a brief review of some of the most famous multiple images in the Quattrocento.

81. See, for example, the *Virgin and Child with Four Angels*, workshop of Agostino di Duccio (c. 1465–70), in which the sectional molds used to cast the stucco are slightly out of register in places, *Thyssen-Bornemisza . . . Renaissance and Later Sculpture*, 54–7. Excellent illustrations of the procedure are provided by R. Cassano, "Tecniche esecutive, indagini di laboratorio e operazioni di restauro," in *Jacopo Sansovino a Vittorio Veneto: Il rilievo in cartapesta della Madonna col Bambino*, ed. M. Elisa Avagnina and V. Pianca (Treviso, 1989), 50–62.

82. Gauricus, *De sculptura*, 226–9, and Biringuccio, *Pirotechnia*, 331–2.

83. Gauricus, *De sculptura*, 70–1. On plaster see L. D'Alessandro and F. Persegati, *Scultura e calchi in gesso* (Rome, 1987).

84. Gauricus, *De sculptura*, 240–1.

85. Cennini, *Craftsman's Handbook*, 123–9. Life molds seem to have been used for molding terracotta busts, see A. Andreoni, "Scheda di Restauro," in *Omaggio a Donatello, 1386–1986*, ed. P. Barocchi *et al.* (Florence, 1985), 258 (on the *Niccolò da Uzzano* bust), and A. Kosinova, "Portrait Bust of Giovanni de' Medici" (1995): 14–5.

86. Vasari, *Technique*, 170–2.

87. This was exactly the technique used by Donatello for the stucco reliefs in the Old Sacristy, San Lorenzo, Florence (P/R illus. 5.8). He worked freely in situ, hand modeling the stucco over an armature of nails that had been driven into the wall to support the areas of highest relief. C. Danti, "Donatello's Stuccoes Restored: Scientific Examination and Art-Historical Hypotheses," in *Donatello at Close Range*, 23–37 (the English translation of *Donatello e la Sagrestia Vecchia di San Lorenzo. Temi, Studi, proposte di un cantiere di restauro* appended to the *Burlington Magazine* CXXIX, no. 1008 (March 1987). See also F. Kumar, "Intervento," *Metodo e Scienza*, 155–7 (on the *Madonna dei Cordai* in the Bardini Museum, Florence).

The Revival of Antiquity in Early Renaissance Sculpture

H. W. Janson

IN HIS TREATISE ON PAINTING, Leonardo da Vinci at one point advises the painter to look at stained walls, varicolored stones, clouds, or the ashes of a fire, as an aid to invention.[1] "You can see there," he says, "resemblances to . . . landscapes . . . battles . . . strange expressions on faces," which can become the starting point of pictorial designs. "This happens . . . as in the sound of bells, in whose pealing you can find every name and word you can imagine." Surely Leonardo was not the first to observe that (as the nursery rhyme has it) "Oranges and lemons / Say the bells of St. Clement's," although he may well have been the first to refer to the phenomenon in writing. Be that as it may, I often think that classical antiquity has the quality of Leonardo's bells, inviting later ages to find in it whatever they want to find. I sometimes wonder whether it might not be worthwhile to establish an anti-Warburg Institute, devoted to the cataloguing of ideas and traditions that can be shown to be definitely *not* of classical origin. If we were to do that, we should of course have to start by defining what we mean by classical antiquity. We could not, I believe, afford to tackle the impossible job of singling out what we might choose to call the "classical aspects" of Greco-Roman civilization; we should have to concern ourselves with all of that civilization, from the time of the Doric migrations to the final collapse of the Roman Empire in the West – a span of nearly fifteen hundred years in the course of which the Greeks and Romans absorbed not only the territories but also the cultural traditions of most of the ancient Near East. This adds up to a vast and varied "sound of bells" (if I may revert once more to Leonardo's simile). To be sure, not all the bells were audible at all times, but in the aggregate they have never stopped pealing, and people have never ceased to listen for the "names and words" they wanted to hear.

It is, needless to say, necessary and instructive to locate the bells that were going at a given time and in a given place. Was this or that classical text available then, and if so, in what form? Was this or that ancient work of art visible as a potential model? Such is the purpose of the Census of Antique Works of Art Known to the Renaissance, which has been growing ever since 1949 under the joint sponsorship of the Institute of Fine Arts at New York University and

the Warburg Institute.[2] But this "locating of the bells" more often than not is a frustrating and uncertain procedure. Until we get to comparatively recent times, that is, the seventeenth century, the instances when we can say with assurance that a specific text or work of art was rediscovered in such-and-such a year after having been lost since late antiquity are few and far between. How can we be certain that another example, perhaps one that failed to survive until the present day, was not known before the supposed rediscovery? The chances of this having happened vary greatly and must be carefully appraised in every single case. There are, of course, some bells – a small fraction of the total but nevertheless a sizable number – of which we know that they sounded throughout the Middle Ages and the Renaissance, such as Pliny's *Natural History* or the equestrian statue of Marcus Aurelius in Rome (Fig. 16). These in particular, it seems to me, bear out the analogy I used in my opening remarks; for they spoke differently to every age. Pliny's chapters on the visual arts and the architectural treatise of Vitruvius are a good case in point. Certain passages in them have been cited in order to account for such novel Renaissance phenomena as the notion of "artistic progress," the rise of landscape painting as a genre in its own right, and the appreciation of unfinished works such as drawings and sketches.[3] All this is certainly illuminating; but why did these same passages fall on deaf ears in the Middle Ages? Once people were ready to appreciate drawings and sketches they were surely pleased to find that according to Pliny certain painters in antiquity were more highly esteemed for their sketches than for their finished works, because the sketches showed the workings of the artist's mind. Yet this hardly justifies the claim that the Pliny passage kindled the Renaissance collector's enthusiasm for unfinished works. On the other hand, is it not true that the Renaissance read Pliny with more attention and respect than did the Middle Ages? Otherwise we should find it hard to differentiate the Renaissance from the various classical revivals of medieval times. Perhaps, then, the Pliny passage did play a significant role in stimulating the Renaissance collector's interest in drawings and sketches.

Such may indeed be the case in our particular instance, but the Renaissance way of listening to the sound of the classical bells was by no means invariably superior to the medieval way. The classical attitude toward the visual arts may serve as a test case. To the ancients, painting and sculpture were crafts, mechanical arts rather than liberal arts, and the notion of a painter or sculptor of genius would have struck most of them as absurd; genius – or inspiration, to use an alternative term – was reserved for the poet. Strange as this low ranking of the fine arts may seem in view of the towering achievements of ancient artists, it is attested by the overwhelming majority of classical thinkers, from Plato to Seneca and Plotinus. And the Middle Ages faithfully accepted their verdict. It was the Renaissance, beginning in Florence around 1400, that sought to promote painting and sculpture to liberal arts status.[4] Needless to say, the claim had to be buttressed with evidence drawn from classical sources, but such evidence was hard to come by. It is astounding to observe the intellectual acrobatics by which this

feat was accomplished, disregarding all arguments to the contrary. Thus we read that painting must be a liberal art because Alexander the Great rewarded Apelles with his favorite mistress and because Nero is said to have been a painter. The humanists might of course have argued that if painting and sculpture had been mechanical arts in antiquity they were liberal arts *now*; but that would have demolished the authority of ancient art as a guide for modern artists, hence the argument would be self-defeating.

Leon Battista Alberti faced a similar conflict when, in his treatise on architecture, he claimed that the ideal plan of a temple (by which he meant any house of God, pagan or Christian) was round, polygonal, or square, rather than rectangular.[5] The Christian basilica, he argued, had originally served a secular purpose and thus could not be expected to conform to the ideal, unlike the Pantheon in Rome. Yet it could hardly have escaped Alberti that the vast majority of ancient temples were rectangular in plan and that the Pantheon and the handful of smaller round temples in or near Rome were the exception rather than the rule. In these cases, then, and in many similar ones, the Renaissance heard "liberal arts" and "round" when the bells were actually saying "mechanical arts" and "rectangular." To differentiate the revival of antiquity in the Renaissance from the various medieval revivals can thus be a rather delicate matter at times. Yet I have not the least desire to abolish the Renaissance as a historic period, or even to defend my not wanting to abolish it. My cautionary remarks are intended merely to suggest that my subject is a difficult one, perhaps even more so in the visual arts than in literature or philosophy. For that reason, I propose to limit my remarks to Florentine sculpture, and to the first half of the Quattrocento, so as to permit a reasonably full discussion of the instances I want to examine.

Panofsky has defined the difference between the Renaissance and the medieval renascences of ancient art as the reintegration of classical form and content.[6] In the Middle Ages, the two were oddly dissociated: a medieval artist might copy, let us say, a statue of Venus, but in doing so he would give it a new identity such as one of the cardinal virtues, whereas if he wanted to represent the goddess Venus he would visualize her as a courtly lady in modern dress. Not until the Quattrocento in Italy – as we all know from the famous picture by Botticelli of the *Birth of Venus* – did the goddess regain her classical appearance. This process of reintegration, however, took place mainly during the second half of the century. If we were to seek a similar formula for the first half, we might say that it is characterized by the imposition of classical form on nonclassical subjects that had escaped this process during the Middle Ages. We shall see several instances of this. Once we have settled on the first half of the Quattrocento, the further limitation to Florence is almost implicit; although Florence was not the only home of early Renaissance art during those decades, it was its original home, and its position of leadership was undisputed.

But why concentrate on sculpture only? There are several good reasons. First of all, early Renaissance art began with sculpture. If we imagine ourselves visiting Florence in 1420, we could have seen the new style embodied in a number

of statues and reliefs, but not yet in any buildings or pictures. This is, needless to say, mainly the achievement of Donatello, the founding father of Renaissance sculpture. Still, it was not his individual genius alone that accounts for the priority of sculpture. Here we may recall the title of the earliest Renaissance treatise on art, Alberti's *De Statua* of about 1430, probably written in Rome while the author was in contact with Donatello.[7] Why did Alberti write on sculpture before he wrote on painting or architecture? And why did he call his treatise "On the Statue"? He did so, I suspect, because statues — that is, freestanding images in the round — are as characteristic of ancient sculpture as they are alien to the Middle Ages.

It was on freestanding statues that the early Church had centered its wrath as pagan idols par excellence and the dwelling places of demons. Countless numbers of them were destroyed as Christianization spread through the Roman Empire. And the conviction that statues are the seats of demons — which is simply the negative counterpart of the worship formerly accorded to them as the seats of the gods — persisted throughout the Middle Ages. In order to serve a Christian purpose, sculpture in the round had to be "deactivated" by becoming attached (and thus subordinate) to the architectural framework of the house of God or its furnishings, such as pulpits and choir screens. Hence Alberti must have felt, and quite rightly, that there could be no rebirth of antiquity in art without the revival of the freestanding statue.

The stages by which Donatello and others accomplished this between 1410 and 1430 need not detain us here. Let us turn, rather, to Donatello's bronze *David* of about 1430 (Fig. 7), the earliest surviving life-size example and very probably the first freestanding statue made since the end of antiquity. It would retain this claim even if it were not nude, but its nudity lends special emphasis to its classical qualities, because it brings to mind all the nude statues of youths in Greek and Roman art (Fig. 8). There is the same balanced and self-sufficient stance, the same sensuous beauty of form. However, as soon as we compare the *David* with specific examples of ancient nude youths, we begin to realize how different Donatello's figure is. His forms are leaner, more angular. Nor has he taken over the classical formulas for subdividing the torso but has, to all appearances, worked from the living model. (It may not be irrelevant here to recall that he had the reputation of always chasing after beautiful apprentices.)[8] There is indeed no reason to believe that any statues of nude youths were accessible to him; all those we have today were discovered later, with the single exception of the *Thorn-Puller* (Capitoline Museum, Rome), which was visible in Rome throughout the Middle Ages but could at best have furnished the idea, not the concrete model, for Donatello's statue.

Small bronzes, on the other hand, were easily available, especially those of Etruscan manufacture such as could often be found in Etruscan tombs. We know that these tombs were opened and their contents appreciated in Donatello's day.[9] The link can be proved, I think, if we turn to the three nude *Putti* Donatello did in the late 1420s for the baptismal font in Siena (P/R illus.

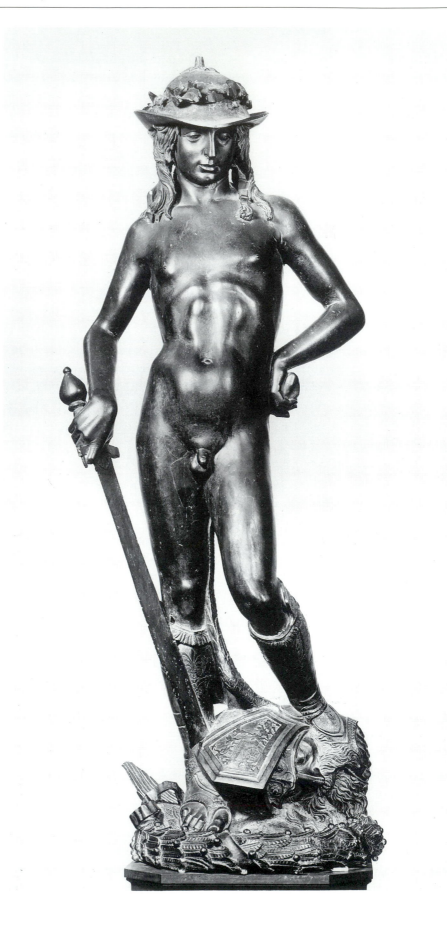

Figure 7. Donatello, *David*, Museo Nazionale del Bargello, Florence, 1430s–1450s (photo: Alinari/Art Resource, N.Y.)

4.69). They are the immediate predecessors of the *David*, with whom they share the circular base (a wreath in both cases) and the fact that they stand on an uneven surface (a scallop shell in Siena, Goliath's head in the *David*).

Why should an artist have complicated his task in this fashion when experimenting with freestanding figures for the first time, instead of adopting the straight horizontal plinth of classical statues? I suggest that the idea came to Donatello from looking at Etruscan bronze statuettes attached to vases and cysts, unique in ancient art for their precarious perch on sloping surfaces. These bronze vessels ornamented with statuettes were produced in large numbers; many hundreds of them still exist today. Donatello may very well, therefore, have known figures similar to our example. The lively movement of the Siena *Putto* also seems to have been suggested by the same source.[10] In the *David* the movement has disappeared, but another Etruscan feature persists: both figures, though nude, are wearing boots. To a Greek, or to a Roman, this would have appeared incongruous, whereas in Etruscan art the "booted nude" is far from rare. If we are right in assuming that no large-scale standing nude statue was available to Donatello as a model for his *David* — and so far no evidence has come to light to gainsay us — we begin to understand why the artist arrived at so original a solution. Had a large-scale model been at his disposal, he might well have produced something more conventionally "correct" by ancient standards but far less striking as a work of art.

Another species of ancient sculpture that had lapsed during the Middle Ages was revived in the early Renaissance — the portrait bust. This, too, was long thought to have been an achievement of Donatello, but it turns out not to be.[11] The earliest specimens we know were made by younger sculptors in Florence in the 1450s. Apparently the revival of the portrait bust occurred during the decade 1443–53, which Donatello spent in Padua. In the art historical literature, it has always been treated as a simple case of picking up where the Romans left off. Yet when we compare any Roman bust (Fig. 18) with a fifteenth-century example such as the *Piero de' Medici* of 1453 by Mino da Fiesole (Fig. 19) it becomes apparent that the process could not have been as straightforward as that. Mino undoubtedly knew Roman busts — we know they were collected as early as the mid-fifteenth century — but the differences are as striking as the similarities.[12]

Mino's bust looks like a statue cut off at a point midway between the shoulder and the elbow, whereas in the Roman specimen the chest is treated as a sort of bib

Figure 8. Roman Sculpture, *Idolino*, Museo Archeologico, Florence, copy of Greek 5th century B.C. original (photo: Alinari/Art Resource, N.Y.)

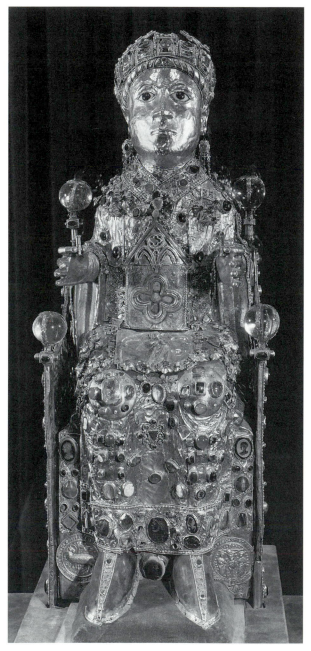

Figure 9. Reliquary of Ste-Foy, Ste-Foy, Conques, 9th–10th century (with later additions) (photo: Giraudon/Art Resource, N.Y.)

attached to the neck. This somewhat irreverent description must be allowed to stand for the moment, because it takes in all the essentials of the Roman solution: the chest is a hollow, sloping shield, which demands that the bust be placed on a special stand or foot, whereas the early Renaissance bust can be set directly on any horizontal surface. The "bib" can be seen more clearly in the front and side views of a Roman bust. That of Marcus Aurelius (Archaeological Museum, Lausanne) has lost its stand, but the piece obviously required one. This bust is of special interest to us. It was found in Avenches, a large Roman military camp in Switzerland, and the precious material – beaten gold – suggests that it was a cult image for the emperor worship of the Roman legions. There must have been many such gold busts, although for obvious reasons few have come down to us.[13]

Oddly, however, it was these, rather than the far more common marble busts, that survived after a fashion in medieval art. They are the ancestors of a widespread class of medieval sculpture: the head reliquary, that is, a head made of beaten gold or silver (or gilt or silvered copper) as a container for the skull of a saint, such as that of *Pope Alexander* in the Royal Museum, Brussels. Despite its early twelfth-century date, this head retains some distinctly Roman features.[14] In another instance, the link with the gold busts of Roman emperors is clearer still; the gold statue of *Ste-Foy* in Conques, the most elaborate of all reliquaries, has a head that turns out to be that of a late Roman emperor, cut off at the neck and reused for the head of a female saint (Fig. 9)[15] Apparently *Ste-Foy* started out as a head reliquary, with the rest of the body added somewhat later. Returning for a moment to *Pope Alexander*, we note that the head rests on a jeweled box. In Gothic head reliquaries such as that of *St. Ursula* in Cologne (Fig. 32) the box and head merge, and we now have a bust of the early Renaissance type, rather than of the "bib" type.

The final link between these reliquary busts and *Piero de' Medici* is Donatello's *St. Rossore* of about 1424 (Fig. 33), in which the shoulders and chest have been given their proper size in relation to the head and the features are so individual that it might almost pass for a portrait. The early Renaissance bust might thus be termed a secularized reliquary; its revival-of-antiquity aspects consist of the use of marble in place of precious metal, the realistic facial geography, and the fact that it represents a living individual. This type proved extraordinarily persistent; not until the sixteenth century do we find a resumption of the "bib" type in Renaissance portrait busts. Why it proved so per-

sistent is a difficult question that I cannot attempt to answer here.[16] To human-istically schooled patrons, who had read in classical sources about Roman ances-tor worship and the *imagines maiorum* kept in a special shrine in Roman houses and displayed in funerary processions, these portraits may well have had an odor of "pagan sanctity," so that their shape, recalling reliquary busts, had exactly the right connotations.[17]

The evolutionary sequence just outlined also throws an interesting light on the medieval attitude toward sculpture in the round; the imperial gold busts were, after all, not only sculpture in the round but "idols," yet they were absorbed into the medieval tradition. What saved them were three factors, I sur-mise: they were not complete bodies; they were of precious material (which had important, and positive, symbolic connotations in the Middle Ages); and they were hollow. They thus lent themselves to "conversion" by becoming contain-ers of holy relics. I imagine the Middle Ages discarded the "bib" of the Roman busts to emphasize the character of the head as a fragment.[18] It was Gothic nat-uralism that reconstituted the shoulders and chest, thereby giving birth to a new form of bust that survived throughout the early Renaissance and far into the six-teenth century.[19]

The merging of medieval head reliquaries and Roman busts in the Quattro-cento could not have occurred if early Renaissance artists had not sensed an affinity between the two. Another such affinity links the medieval prophet and the Roman orator. It becomes evident from a comparison of two prophet stat-ues by Donatello, made about a decade apart. The earlier one, the so-called *Beardless Prophet* (Museo dell'Opera del Duomo, Florence), dating from about 1417, still conforms to the medieval tradition – an old man swathed in ample garments and displaying a long scroll to which he points with his right hand (Evangelists, in contrast, usually hold books). Only the head departs from the established type; instead of showing the long beard of an Eastern sage, it is clean-shaven, and obviously modeled after a Roman portrait. In the later statue (Fig. 10), the entire type has been transformed. The prophet now wears a toga that leaves one shoulder bare; his glance is directed at the beholder; and the scroll has been reduced to the size of "lecture notes" which he holds in his left hand even though he does not really need them. Apparently in the interval Donatello had come to think of Old Testament prophets as the counterpart of Roman Repub-lican orators, those champions of moral rectitude and political freedom about whom he must have heard a great deal from his humanist friends in that age of revived classical eloquence. Did he perhaps also see images of Roman orators? What he is likely to have known are modest and small-scale figures, such as that from the tomb of Quintus Sulpicius Maximus (Fig. 11), in no way comparable to his own overpoweringly expressive statue. The proof, it seems to me, is the shape of the scroll and the way it is held.[20]

To modern eyes, the Roman orator's tombstone holds little aesthetic appeal. Donatello obviously found it of greater interest, for reasons I have tried to sug-gest. This is one reason why the "visual philology" with which we are here con-

cerned often resembles the hunting of the snark – our own taste, our sense of quality in the field of ancient art, is very different from that of the early Quattrocento. Nor is it only a matter of paucity of large-scale classical sculpture in those days. A great many antique works that were widely known and admired in the fifteenth century can no longer be traced today; they were lost track of during the interval, after the taste in ancient art had begun to change. A striking instance is the so-called *Bed of Policlitus*, a relief described and highly praised in Ghiberti's *Commentaries*. We know it only from Renaissance copies, none of which make it easy for us to grasp what the early Renaissance saw in this piece.[21] The subject remains uncertain, perhaps because the copyists omitted some tell-

Figure 10. Donatello, *Jeremiah*, Museo dell'Opera del Duomo, Florence, 1427–35 (photo: Charles Seymour, Jr. Archive)

tale attribute; all we know is what we see: a nude young woman uncovering a sleeping nude man as she sits on the edge of his bed. We may be able to share the fifteenth-century's point of view a bit better once we see how Donatello has utilized the figure of the woman. She reappears in the foreground of his marble relief the *Feast of Herod* (Musée Wicar, Lille), recognizable though completely transformed.[22] The severed head of St. John has just been brought in by a servant, and our figure shrinks away from it in horror. Her only function is to exemplify the emotional impact of the event, for she is not one of the dramatis personae. What must have struck Donatello in the *Bed of Policlitus* was the extraordinary twisted pose of the woman – exactly the sort of thing he had not been taught as an apprentice growing up in the Gothic workshop tradition. He wanted to use this pose, to learn from it, but he could do so only by reinterpreting it to fit the context of his own work (there was as yet no demand for amorous scenes like the *Bed of Policlitus*). That he converted a gesture of seduction into one of horror demonstrates the sovereign freedom with which he handled his classical models. If I were a psychoanalyst, I might also link this particular transformation to the artist's homosexuality. But I firmly resist this temptation.

The desire to give new dramatic impetus to traditional narrative schemes must have been one of the chief reasons for Donatello's borrowings from ancient art. Let us compare his stucco roundel showing the *Apotheosis of St. John the Evangelist* (P/R illus. 5.8) and the same scene depicted by Giotto more than a century earlier (P/R illus. 2.7). Giotto's modest stage architecture leaves us in doubt whether the scene is placed indoors or out; Donatello has developed it into a city square framed by tall buildings and

seen from below, so that the upward flight of St. John achieves a wholly new, visionary quality. The city square is like an elevated stage, with a sudden drop on the side facing the beholder, and on this lower level we see a number of bystanders some of whom look up at the miraculous event. One even tries to raise himself by clinging to the edge of the stage for a better view. It is this figure that provides the clue for Donatello's source of inspiration: a Roman relief from the Arch of Constantine showing Marcus Aurelius distributing largesse. The emperor does so on a tall podium, with beholders at the lower level, and here again we find the figure, seen from the back, who pulls himself up for a better view. Once again we witness Donatello's power of synthesis – only a genius could have combined this scene with a composition by Giotto and achieved so astonishing a result.[23]

And now an instance of the hunting of the snark. Donatello's *Assumption of the Virgin* (Fig. 12) shows the aged Mother of God being carried heavenward within an oval frame of clouds that is supported by angels.[24] In Orcagna's relief of the same subject on the Tabernacle at Orsanmichele, made three-quarters of a century earlier and a

Figure 11. Roman, Tombstone of Quintus Sulpicius Maximus, Museo Capitolino, Rome, 2d century (photo: Museo Capitolino)

work Donatello surely knew well, we find much the same arrangement except that the oval frame is a solid molding and that there is no angel supporting it from below (P/R illus. 3.35).

It is this "bottom angel" that concerns us, for it is a new element in Donatello's composition, unknown in medieval examples. In its earliest form, our type of the Assumption shows the Virgin as a half-length figure in a small oval supported by only two flying angels,[25] as the size of the oval grew, the number of angels increased to six. This formula, in turn, derives from a well-known classical model, the wreath or medallion held by flying putti, which we find on numerous Roman sarcophagi and, in Christianized form, in early medieval art.

Figure 12. Donatello, *Assumption of the Virgin*, S. Angelo a Nilo, Naples, 1427–28 (photo: Charles Seymour, Jr. Archive)

Our type of the Assumption, then, developed from a composition designed for a horizontal format; hence no "bottom angel."[26] I also rather doubt that medieval art could have invented a flying angel that supports an overhead load.

Well, Donatello did, and the question is, what was his source, if any? The first proposal came from an archaeologist, who pointed to a Roman sarcophagus in the Villa Medici, Rome, that has been known at least since the early sixteenth century. It shows, among many other things, a group of Olympic gods seated above a bearded nude figure who emerges from behind some rocks and holds a curving veil extended over his head. He represents Coelus, the personification of the sky, and the veil is the curving firmament. Could this have been Donatello's source? Maybe so, but the similarity is not really striking. The same figure, still in the role of Coelus, also appears below the enthroned Christ on early Christian sarcophagi (Fig. 13), so that Donatello might just as well have taken it from one of these.[27] For him, this too would have been a classical source, because the early Renaissance did not differentiate between ancient and early Christian art. But we note that there is no oval frame in these alleged prototypes and that Coelus does not support anything – he merely holds a veil. These surely are significant differences.

There is, however, at least one ancient work of art, a Roman silver box lid (Brera, Milan), where Coelus actually supports an oval frame.[28] The frame is inscribed with the twelve signs of the zodiac, for the months, and the figure

within it personifies either the year or eternity. This seemed a rather better source for our angel. But then it struck me that in all these examples Coelus is visible only from the chest up (he is meant to emerge from behind the horizon) and that even in the last instance he does not support the oval with any show of effort, whereas Donatello's angel is a complete figure and labors with a considerable sense of strain. Thus a nagging doubt persisted in my mind. Donatello's angel, I felt, really looked like an Atlas supporting the world. Could Donatello possibly have seen ancient representations of Atlas in that role?

Then, some months ago, I stumbled upon the solution to my problem – in the Florentine Baptistry. Among its splendid thirteenth-century mosaics, there is one showing the dome of heaven supported by four crouching Atlas figures who are young and beardless and evince very much the same sense of physical strain as Donatello's angel (Fig. 14). So his source in this case was not classical at all but medieval! Or at least his immediate source (needless to say, he knew the Baptistry and its mosaics like the back of his hand); for these medieval Atlantes are thoroughly classical in form. How did they get into the Baptistry mosaic? The artists who designed these mosaics were strongly influenced by Byzantine art, which was capable of preserving classical figure types like flies in amber, and we must assume that they imported our Atlantes along with a lot of other Byzantine artistic baggage. Yet, as supporters of the dome of heaven the Baptistry Atlantes are unique;[29] everywhere else, the dome is supported by angels, who of course show no physical effort at all but merely stand with upraised arms. Our Atlantes, then, are surrogate angels, and that must have made them particularly suitable as models for Donatello's "bottom angel."[30]

At this point we face an even more intriguing problem – what did Donatello think of the Baptistry mosaics? Did he recognize them as medieval, or did he by any chance regard them as antique? The question is less foolish than it may sound, for the early Renaissance was firmly convinced that the Baptistry (built between 1060 and 1150) was an ancient temple of Mars converted to Christian use. Thus Donatello might well have thought of the mosaics, too, as ancient; that is, he might have regarded them as dating from the time of the supposed Christianization of the Mars temple in the days of Constantine the Great. We could hardly hope for a better illustration of the circuitous ways in which the classical tradition sometimes managed to enter the early Renaissance.

I should like to conclude with a consideration of the equestrian monument *Gattamelata* in Padua, Donatello's largest bronze work and his boldest achievement (Fig. 15). Its fame spread so rapidly that as early as 1452, a year before it was put on public view, the king of Naples wanted to engage Donatello in order to have him make a similar equestrian statue.[31] And the Venetian Republic was repeatedly twitted about permitting their general to be immortalized as if he were a conquering Caesar.[32] The fame of the monument is usually explained with the claim that it is the first bronze equestrian statue since antiquity, inspired by the *Marcus Aurelius* in Rome (Fig. 16). Actually, however, the situation is a good deal more complicated than that.

Figure 13. Early Christian Sarcophagus of Junius Bassus (detail), Vatican Museums, Rome, c. 359 (photo: Alinari/Art Resource, N.Y.)

First of all, the *Gattamelata* was not the first bronze equestrian statue since antiquity. The earliest recorded statues of this kind date from the late fourteenth century, some seventy-five years before the *Gattamelata*; they represented the sainted kings of Hungary and stood in front of the cathedral in Budapest until their destruction by the Turks.[33] Unfortunately, we have no adequate pictorial record of them, although they are visible, on a tiny scale, in a late sixteenth-century view of the city. Then there was the bronze equestrian statue of Niccolò d'Este in Ferrara, commissioned of two Florentine sculptors soon after 1441, three years before Donatello received the commission for the *Gattamelata*, and unveiled in 1451, two years earlier than Donatello's statue. It was destroyed in 1796 by a revolutionary mob, and again we lack an adequate pictorial record of it.[34] Only its base, a peculiar combination of column and arch attached to the Ducal Palace in Ferrara, has survived.[35]

Thus, when the king of Naples needed someone to make him a bronze equestrian statue in 1452, he might have opted for the two masters of the d'Este monument in Ferrara, which after all represented a sovereign like himself and would seem a more suitable precedent than Donatello's statue of a mere general. That the king nevertheless preferred Donatello (even though he surely had seen neither monument) tells us a good deal about the importance of artistic fame in the early Renaissance as the two monuments will make it obvious that they have little indeed in common. The *Marcus Aurelius* need not even have provided the idea of a bronze equestrian statue, for another Roman example was available in Italy, and in a place much nearer Padua than Rome: the so-called *Regisole* at Pavia, destroyed in the 1790s and now known to us only from some less-than-adequate illustrations.[36] In some ways, it was closer to the *Gattamelata* than the *Marcus Aurelius*, because it had a real saddle and stirrups whereas the *Marcus Aurelius* had neither. The stirrups must have been added in the Middle Ages, because they were unknown in the West before the eighth century, but Donatello and his contemporaries surely accepted them as part of the original monument.[37] The "visual philology" of the *Gattamelata* is thus a rather complicated affair. As I hope to demonstrate, the statue is a synthesis of medieval and antique traditions, and I think we need to understand this in order to account for its artistic greatness and instant fame.

As we have seen, the *Gattamelata* was not the first bronze equestrian statue since antiquity. Nor, as we shall see, was it the first equestrian monument to a general. But it was the first *bronze* equestrian monument to a general. This fact needs explaining, for freestanding equestrian monuments, especially bronze ones, had ever since Imperial Roman times been regarded as the prerogative of the head of state and a symbol of sovereignty. The *Regisole* was not made in or

for Pavia; it was the statue of a late
Roman emperor that the Lombards
imported from Ravenna to the new
capital of their kingdom to assert its
claim as the "new Rome." Similarly,
Charlemagne imported another
bronze equestrian statue of a Roman
emperor from Ravenna to Aachen, to
show that Aachen was the "new
Rome," but it caused such a scandal
that it disappeared in short order. We
do know of two equestrian statues of
sovereigns made in the thirteenth cen-
tury, but these were of stone and
attached to architecture rather than
freestanding.[38] The earliest freestand-

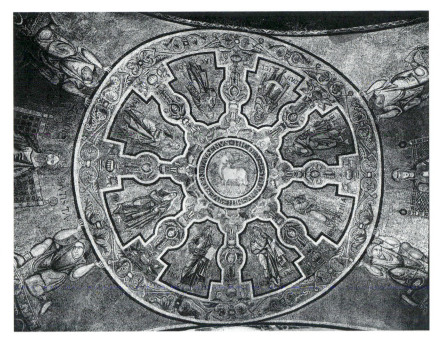

Figure 14. Mosaic of the *Sacrificial
Lamb and Prophets and Atlantes*,
Scarsella, Baptistry, Florence, 13th
century (photo: Alinari/Art
Resource, N.Y.)

ing equestrian statue I know of since antiquity was, until 1792, in the Cathedral
of Notre Dame in Paris (the French Revolution took a heavy toll of equestrian
monuments, old and new). It represented Philip the Fair, who had had it erected
as a thanks offering to the Virgin for his victory over the Flemish at Mons-en-
Puelle in 1304. We know its appearance from several pictures and descriptions.[39]

How was such a statue possible, we may ask. Does it not disprove my claim
that there were no freestanding statues in the Middle Ages? The head reliquar-
ies, we recall, were a partial exception to this rule. Here, apparently, is another.
What saved the equestrian statue of Philip the Fair from the odor of idolatry was
that it served as a "stand-in" for the king himself offering thanks to the
Madonna. Very probably it was of wood, rather than of stone or bronze, and
horse and rider wore actual armor and real cloth. In other words, it was the
medieval counterpart of a store dummy, a lay figure. Medieval and Renaissance
churches were full of such ex-votos, until the clutter became so great that they
were all taken out and destroyed.[40] It must have been northern Gothic statues
like that of Philip the Fair that inspired Can Grande, the lord of Verona, some
twenty-five years later to put a stone equestrian figure of himself on top of his
monumental tomb.[41] Here the Gothic equestrian statue has moved out-of-doors
and is certainly freestanding in the technical sense. Yet it is also the crowning
ornament of a piece of architecture, like an overgrown Gothic finial; and I think
it must have been this that saved it from the accusation of being an idol. Still,
the statue was obviously a very presumptuous idea, designed to proclaim the sit-
ter's megalomaniacal claims as a sovereign. (He had taken the title Can Grande
so as to liken himself to the Great Khan of Cathay, the "Emperor of the East,"
about whose realm the most fanciful stories circulated in the West; when his
tomb was opened some decades ago, the body was found wrapped in a piece of
Chinese silk.)

The tomb of the Can Grande set a pattern that was followed until the end of

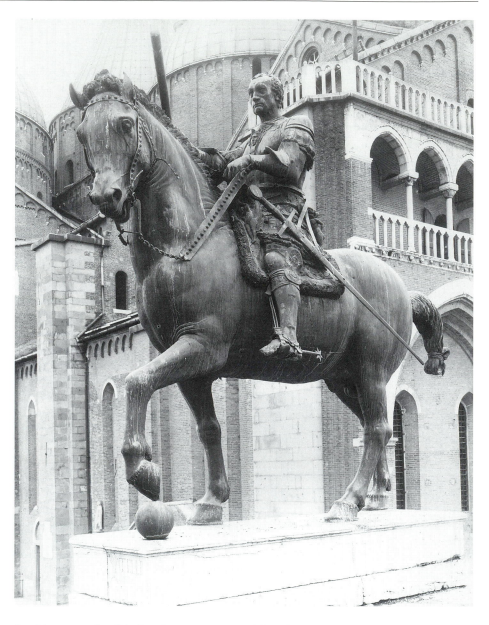

Figure 15. Donatello, Equestrian Statue of Gattamelata, Piazza del Santo, Padua, 1447–53 (photo: Alinari/Art Resource, N.Y.)

the Trecento by his local successors and by the Visconti in Milan. Only the equestrian statues of the royal saints of Hungary belong to a class we have not met otherwise in the Middle Ages, being of bronze and clearly neither tomb statues nor ex-votos. If we only knew what they looked like! I suspect, however, that they were a good deal less than life-size, like a bronze equestrian *St. George* in Prague that came from the same workshop. Thus the monument to Niccolo d'Este in Ferrara, which was at least life-size to judge from its base, was very probably the first real attempt to resume the tradition represented by the *Marcus Aurelius* and the *Regisole*.

How could a mere general such as Gattamelata, and the general of a republic at that, claim a monument of this kind? Let us now take a quick glance at equestrian monuments to generals. They were, until the sixteenth century, an exclusively Italian tradition, as we might well expect, Italy being the land of mercenary armies and condottieri. Until Donatello's *Gattamelata*, however, the

Figure 16. Roman, Equestrian Statue of Marcus Aurelius, Campidoglio, Rome, 176 (photo: Alinari/Art Resource, N.Y.)

tradition is restricted to tombs. It begins very modestly with that of Guglielmo Berardi, who died in the battle of Campaldino in 1289. He is shown in relief on his sarcophagus, charging into battle. The style is purely Gothic – it derives, in fact, from charging knights on French and English seals – but the idea may have been suggested by the tombstones of Roman mounted soldiers.[42] These Gothic equestrian tomb figures soon grew to life-size statues, but they always remained part of a wall tomb. Many were of wood or other cheap materials and have disappeared. The earliest preserved example, made soon after 1405, is a wooden statue of very modest ambition (Fig. 17).[43] Originally, it was probably framed by a canopy, like the slightly later tomb of Cortesia Sarego in Verona, which has an equestrian statue of stone.[44]

I suspect the heirs of Gattamelata had this kind of tomb and statue in mind when they called Donatello to Padua. The idea of a bronze statue to be placed outdoors and not to be part of a tomb may well have been conceived by the

Figure 17. Equestrian Monument of Paolo Savelli, S. Maria Gloriosa dei Frari, Venice, 1405 (photo: Alinari/Art Resource, N.Y.)

artist, who "sold" it to his patrons. In fact, Gattamelata's tomb was not begun until several years after the equestrian monument had been installed; it is inside the church of St. Anthony, quite modest in scale and design, and by a minor local carver. Yet although Donatello's statue is not part of a tomb, it is not entirely free from a funerary context. Not only does it stand in front of the church where the general is actually buried, but it stands on hallowed ground that was once the cemetery attached to that church. Moreover, the pedestal has doors in it, suggesting a burial chamber (they are, of course, not real doors, and there is no chamber behind them). We may thus term it a cenotaph, a memorial monument that is not the actual tomb. But the extraordinary fact is that such funerary symbolism as the monument has (e.g., the doors on the pedestal) is purely classical and taken from Roman sarcophagi rather than from Christian art.

There is indeed no trace of Christian symbolism anywhere on the pedestal or on the statue itself. The pedestal, oval in cross section, is termed a "columna," a column, in the documents; it is surely meant to evoke the tall columns on which ancient equestrian monuments were displayed. The *Regisole* stood on top of a column, and so did the equestrian bronze statue of Justinian in Constantinople, which was later destroyed by the Turks but which Donatello may have known about through his friend Ciriaco d'Ancona. The suggestion of a burial chamber in the base thus seems to have the purpose of keeping the monument from being too obviously "imperial." The main purpose of the statue is to serve as a monument to the general's fame, and this was clearly understood by all those who described it in the fifteenth century or composed inscriptions for it. (The monument never did receive an inscription, apparently because the Venetian government and the general's heirs could not agree on a wording.)

How did Donatello go about this novel task of creating a monument to an individual's fame? We have seen that the choice of the material, the placement outdoors, and the tall oval base evoke the memory of ancient imperial statues. But obviously Donatello could not represent the general in the guise of a Roman emperor. He had to show him as a general and yet in such a way as to suggest more than just his individual appearance. Gattamelata had died, in advanced age and after a long illness, a year before Donatello came to Padua. Even if there was a death mask or other portraits of the general, the artist could hardly make his statue a mere realistic portrait and at the same time project the aura of a hero. Needless to say, Donatello had to show Gattamelata in military costume. The kind he chose is not contemporary but armor *all'antica*, a cross

between ancient and modern armor, richly embossed with figural designs that include a modified Gorgon's head on the chest. The right hand holds the baton of command, the visible sign of the general's authority.[45] None of these Roman features can be found in any ancient equestrian figures. The *Regisole* and the *Marcus Aurelius* do not wear armor, nor do they hold a baton; and the mounted officers on Roman sarcophagi or tombstones wear rather simple armor and again do not carry batons. What Donatello must have seen was a statue of a standing Roman commander such as that of Marcus Holconius Rufus (National Museum, Naples), which does have all the features we are looking for. Apparently he just picked it up and put it on a horse. But the resemblance of *Gattamelata* to a Roman commander does not stop here. We can see it even in the face, which despite its high degree of individuality is not a portrait in the documentary sense at all. It, too, has a distinctly Roman air, derived from ancient portrait heads, a quality suggesting both intellect and *virtù*, that untranslatable word that sums up all the highest praise the Renaissance could bestow upon an individual.[46]

Notes

This essay has been updated and revised by the editor from the article published in *Medieval and Renaissance Studies: Proceedings of the Southeastern Institute of Medieval and Renaissance Studies*, ed. O. B. Hardison, Jr., V (Summer 1969), 80–102, copyright © 1971 by the University of North Carolina Press, by the gracious permission of the publisher and the author's estate, represented by his son, Anthony F. Janson. Some of the photographs have been omitted; books in which they are illustrated are indicated in the notes. ED.

1. Leonardo da Vinci, *Treatise on Painting,* translation A. P. McMahon (Princeton, 1956), I, 50–1. See also *Leonardo On Painting: An Anthology of Writings by Leonardo da Vinci with a Selection of Documents Relating to His Career as an Artist* (New Haven and London, 1989), 222. Janson explored these ideas further in "The 'Image Made by Chance' in Renaissance Thought," *De Artibus Opuscula XV: Essays in Honor of Erwin Panofsky*, ed. Millard Meiss (New York, 1961), 254–66 (reprinted in H. W. Janson, *16 Studies* [New York, 1973], 53–74).

2. The census has been published by P. P. Bober and R. O. Rubinstein, *Renaissance Artists and Antique Sculpture: A Handbook of Sources* (New York, London, and Oxford, 1986).

3. On "artistic progress" and landscape painting as Renaissance phenomena, see E. Gombrich, "The Renaissance Conception of Artistic Progress and Its Consequences," in *Norm and Form* (London and New York, 1966), 1–10, and *idem*, "The Renaissance Theory of Art and the Rise of Landscape," *ibid.*, 107–21. Pliny's discussion of the appeal of unfinished works of art is to be found in his *Natural History, XXXV, xl*, 145, 155; Pliny's descriptions of Greek and Roman art are collected in *The Elder Pliny's Chapters on the History of Art*, trans. K. Jex-Blake and ed. E. Sellers (London and New York, 1896; reprint, Chicago, 1968). On the unfinished, see also P. Barolsky, *The Faun in the Garden* (University Park, Pa., 1994), 63–76. Vitruvius's treatise *The Ten Books on Architecture*, trans. M. H. Morgan, is available in a convenient paperback edition published in New York in 1960.

4. The earliest explicit claim of this sort occurs, so far as I know, in the chronicle of Filippo Villani, *cf.* J. V. Schlosser, *Quellenbuch zur Kunstgeschichte des abendländischen Mittelalters* (*Quellenschriften*, n. s., VII) (Vienna, 1896), 371. For the evolution of the artist's liberal arts status, see R. and M. Wittkower, *Born under Saturn* (London and New York, 1963), 1–16.

5. See R. Wittkower, *Architectural Principles in the Age of Humanism* (London, 1949) (republished New York, 1965), 3–13. Alberti's treatise on architecture is available in a recent translation, *On the Art of Building in Ten Books*, trans. J. Rykwert, N. Leach, and R. Tavernor (Cambridge, Mass., 1988).

6. E. Panofsky, *Renaissance and Renascences in Western Art* (Uppsala, 1960), 162–82.

7. See Leon Battista Alberti, *On Painting and On Sculpture: The Latin Texts of* De Pictura *and* De Statua, ed. C. Grayson (London and New York, 1972), 18–19, where Grayson argues that c. 1443–52 is now more generally accepted as the date of Alberti's treatise on sculpture.

8. See H. W. Janson, *The Sculpture of Donatello* (Princeton, 1963), 77–86.

9. *Cf.* J. R. Spencer, "Volterra, 1466," *Art Bulletin* XLVIII (1966): 95–6. For an illustration of the *Thorn-Puller*, see Bober and Rubinstein, *Renaissance Artists*, pl. 203.

10. For an illustration of a figure wearing boots on the handle of an Etruscan bronze vessel (Museo Civico, Bologna), see M. Moretti and G. Maetzke, *The Art of the Etruscans*, trans. P. Martin (London, 1985), pl. 85 top. Donatello's *Dancing Angel* from the Baptismal Font in the Baptistry of Siena is illustrated in Janson, *The Sculpture of Donatello*, pl. 31d. For a fuller discussion of Donatello's borrowings from ancient art, see H. W. Janson, "Donatello and the Antique," in *Donatello e il suo tempo, Atti dell'VIII Convegno Internazionale di Studi sul Rinascimento* (Florence, 1968), 77–96 (reprinted in Janson, *16 Studies*, 249–88, where the *Dancing Angel* is fig. 51).

11. Janson, *The Sculpture of Donatello*, 237–40, rejected the traditional attribution to Donatello of a polychromed terracotta bust identified as Niccolò da Uzzano (Museo Nazionale del Bargello, Florence) and dated between the late 1420s and 1440s. However, recently, the attribution to Donatello was revived by J. Pope-Hennessy, *Donatello* (New York, 1993), 141–3, who argued that it was made before Uzzano's death in 1432. If accurate, then this would be the first extant portrait bust produced in the Renaissance and the inventor of the portrait bust would be Donatello. The issue is much contested.

12. Janson here illustrated the closely related bust by Antonio Rossellino of Donatello's personal physician, Giovanni Chellini (Victoria & Albert Museum, London); see J. Pope-Hennessy, *An Introduction to Italian Sculpture*, II, *Italian Renaissance Sculpture*, 3d ed. (New York, 1985), pl. 59. That Roman portrait busts were known in the fifteenth century is proven by the document discovered by F. Hartt and G. Corti; see Hartt and Corti, "New Documents Concerning Donatello, Luca and Andrea della Robbia, Desiderio, Mino, Uccello, Pollaiuolo, Filippo Lippi, Baldovinetti, and Others," *Art Bulletin* XLIV (1962): 157, n. 12.

13. For the Avenches bust and related material, see P. Schazmann, "Buste en or représentant l'empéreur Marc-Aurèle trouvé à Avenches en 1939," *Zeitschrift für Schweizerische Archäologie und Kunstgeschichte* II (1940): 69–93. A recent addition to this small group, a gold bust of Antoninus Pius found at Didymoteichon, is described by A. Vavritsas, "Gold Bust from Didymoteichon," *Athens Annals of Archaeology* I (1968), pp. 77–96.

14. For an illustration and commentary, see Suzanne Gevaert, *L'Orfévrerie Mosane au Moyen Age* (Brussels, 1943), no. 6.

15. See the technical analysis and illustrations in the exhibition catalogue, *Les Trésors des Eglises de France* (Paris, 1965), 289–94 (with bibliography), and J. Taralon, "La Majesté d'or de Sainte-Foy du trésor de Conques," *Revue de l'Art* XL–XLI (1978): 9–22.

16. See I. Lavin, "On the Sources and Meaning of the Renaissance Portrait Bust," *Art Quarterly*, XXXIII (1970): 207–26, republished in this volume. On Donatello's *St. Rossore*, see *ibid.*, and Janson, *The Sculpture of Donatello*, 56–9.

17. *Cf.* Pliny's account of ancestor portraits, *Natural History, XXXV*, ii. He reports that Messala was outraged when he discovered an "alien" portrait among those of his family. Yet Pliny, to whom a portrait represents a species of immortality, suggests that false ancestry is better than no ancestry, because it betokens admiration of the virtues of the "adopted" ancestors. His remarks may help us to understand the raison d'être of the bust of Giovanni Chellini: in 1456, the year inscribed on the bust, Chellini established his funerary chapel and made his nephew his universal heir, all of his own children having died. Because he did not order the bust himself (had he done so, the fact would appear in his account book, which is preserved), it seems probable that the portrait was commissioned by his nephew, who through Chellini's last will had acquired considerable wealth as well as a new ancestor. If this hypothesis is correct, the nephew ordered the bust not in 1456, but after Chellini's death several years later, and the date on the bust refers not to the making of the bust but to Chellini's "adoption" of his nephew as universal heir. On Chellini's account book see H. W. Janson, "Giovanni Chellini's Libro and Donatello," *Studien zur toscanischen Kunst: Festschrift für Ludwig Heinrich Heydenreich* (Munich, 1964), 131–8 (reprinted in Janson, *16 Studies*, 107–16).

18. *Ste-Foy* is, to my knowledge, the only medieval reliquary representing a complete figure. The body, which is out of scale with the head, may have been kept as small as it is to minimize the danger of "idolatry." Two hundred years later, in the twelfth century, this fear would seem to have lessened to some degree, as evidenced by the seated funerary statues of two Carolingian kings, Louis IV and Lothaire, posthumously erected in St.-Remi, Reims, and destroyed in the French Revolution. Their appearance is known from eighteenth-century engravings. The surviving fragments show that they, too, were significantly less than life-size. See A. Prache, "Les Monuments funéraires des Carolingiens élevés à Saint-Remi de Rheims au xii siècle," *Revue de l'Art* VI (1969): 68–76.

19. There exists in central France a group of reliquaries in the form of half-length figures (see the catalogue, *Les Trésors*, cited in n. 15 above, pp. 229, 236, 246) including both arms. It seems unlikely that this local type accounts for the origin of the Gothic bust reliquary. A more plausible source may be the Mosan aquamaniles in the shape of late classical busts such as the specimen in Aachen; see K. Hoffmann, *The Year 1200* (New York, 1970), 118, and H. Grundmann, "Der Cappenberger Barbarossakopf und die Anfänge des Stiftes Cappenberg," *Münstersche Forschungen* XII (1959): 35. So far as I know, these aquamaniles are the only medieval copies after classical busts. Significantly, however, they are very much smaller than

life-size (the Aachen example is 7¼ in. high), and they are containers.

20. On the two prophets, see Janson, "Donatello and the Antique," 263–5, and *idem, The Sculpture of Donatello*, 33–41.

21. See Gombrich, *Norm and Form*, 126, 154.

22. For photographs and commentary on the *Feast of Herod*, see Janson, *The Sculpture of Donatello*, 129–31.

23. See Janson, "Donatello and the Antique," 260–1, for illustrations and a fuller discussion. See also *idem, The Sculpture of Donatello*, 132–40, for analysis and a series of photographs of the Old Sacristy roundels.

24. Janson, *The Sculpture of Donatello*, 88–92.

25. See, for example, the thirteenth-century manuscript illustration of the *Assumption of the Virgin* (Museo Diocesano, Pistoia, MS No. 40, f. 225r; illustrated in M. Chiarini, *Museo Diocesano di Pistoia, Catalogo* [Florence, 1968], 21). The sculpted version of the theme on the Tabernacle in Orsanmichele is discussed and illustrated in J. Pope-Hennessy, *An Introduction to Italian Sculpture*, I, *Italian Gothic Sculpture*, 3d ed. (New York, 1985), 196.

26. There is, however, a bottom angel of sorts in another type of Assumption that shows the Virgin surrounded by cherubs' heads; see E. Carli, *Lippo Vanni a San Leonardo al Lago* (Florence, n.d. [1969]), pl. 33.

27. See the expanded discussion of these points in Janson, "Donatello and the Antique," 253–4, where a detail of the sarcophagus in the Villa Medici is illustrated as fig. 2.

28. See M. J. Vermaseren, *The Legend of Attis in Greek and Roman Art* (Leiden, 1966), 27–30, pl. xvii.

29. K. Lehmann, "The Dome of Heaven," *Art Bulletin* XXVII (1945): 16, was able to cite only one precedent, a Roman mosaic floor in Ostia showing four standing Atlantes that support a turreted city wall. The Baptistry figures must, I believe, be regarded as reflecting the general trend toward upgrading the status of Atlantes in the thirteenth century, *cf.* H. W. Janson, "The Meaning of the Giganti,"*Il Duomo di Milano, Atti del Congresso Internazionale, I* (Monografie di Arte Lombarda), ed. M. L. Gatti (Milan, 1969), 61–76 (reprinted in Janson, *16 Studies*, 303–28). For Atlas and his transformations in early medieval manuscript illumination, see E. Panofsky, *Studies in Iconology* (New York, 1939), 20–1, figs. 7–10.

30. Mr. Jerry Draper was kind enough to draw my attention to a late-Gothic "bottom angel" in a Dutch woodcut of c. 1465 showing the Virgin and Child in Glory (A. M. Hind, *An Introduction to a History of Woodcut with a Detailed Survey of Work Done in the Fifteenth Century* [London, 1935], 111–12; the lower half of this angel, who supports the crescent moon on which the Madonna is standing, has been lost, so that we cannot determine whether he is of the crouching, Atlas-like type.

31. See G. L. Hersey, "The Arch of Alfonso in Naples and Its Pisanellesque Design," *Master Drawings* VII (1969), 21 (two letters of Alfonso dated 26 May 1452).

32. On the *Gattamelata*, see Janson, *The Sculpture of Donatello*, 151–61; for the reaction to it, p. 160.

33. See M. G. Agghàzy, "Lasse d'Ungheria e i rapporti tra Milano e Buda nel 1391," *Il Duomo di Milano*, 89–94.

34. See Janson, *The Sculpture of Donatello*, 158.

35. The statue it supports today is modern. For an illustration, see H. W. Janson, "The Equestrian Monument from Cangrande della Scala to Peter the Great," in *Aspects of the Renaissance: A Symposium*, ed. A. Lewis (Austin, 1967), 73–85 (reprinted in Janson, *16 Studies*, 157–88, where it is fig. 7).

36. L. H. Heydenreich, "Marc Aurel und Regisole," *Festschrift für Erich Meyer zum sechzigsten Geburtstag*, ed. W. Gramberg (Hamburg, 1959), 146–59.

37. On the origin of the stirrup and its diffusion, see L. White, Jr., *Medieval Technology and Social Change* (New York, 1962), I, ii.

38. They are the famous "Rider" in Bamberg Cathedral and Otto I in Magdeburg. See H. Steuerwald, *Der Reitermeister von Bamberg und Magdeburg: Wer war der Schöpfer des Reiterstandbilder von Bamberg und Magdeburg?* (Berlin, 1967).

39. See *Art de France* III (1963): 127, 132.

40. *Cf.* A. Warburg, *Gesammelte Schriften*, I (Gluckstadt, 1933; reprint, Nendeln, 1969), 116–19, 349–50.

41. On the equestrian of Can Grande, its ancient sources, and later equestrian monuments, see Janson, "The Equestrian Monument." On the Can Grande monument itself, see Pope-Hennessy, *Italian Gothic Sculpture*, 200–1 (with illustrations); and E. Panofsky, *Tomb Sculpture* (New York, 1964), figs. 385–7.

42. For an illustration of the Tomb of Guglielmo Berardi in SS. Annunziata, Florence, see Panofsky, *Tomb Sculpture*, fig. 382. For a tombstone of a Roman mounted soldier, see Heydenreich, "Marc Aurel und Regisole," 156, fig. 11.

43. This is the tomb of Paolo Savelli, who died in 1405, in the Church of S. Maria Gloriosa dei Frari, Venice, for which see Panofsky, *Tomb Sculpture*, fig. 388, and Janson, "The Equestrian Monument," fig. 14.

44. The Sarego monument is illustrated in Janson, "The Equestrian Monument," fig. 20.

45. See the illustrations in Janson, *The Sculpture of Donatello*, 70a–73d.

46. For illustrations and further discussion, see Janson, "Donatello and the Antique," 264–5. For equestrian figures on medieval and Renaissance tombs, *cf.* Panofsky, *Tomb Sculpture*, 83–7. More recent bibliography on equestrian monuments includes L. Camins, *Glorious Horsemen: Equestrian Art in Europe, 1500–1800* (Springfield, Mass., 1981); W. A. Liedtke, *The Royal Horse and Rider: Painting, Sculpture, and Horsemanship, 1500–1800* (New York, 1989); and *Leonardo da Vinci's Sforza Monument Horse: The Art and the Engineering*, ed. D. C. Ahl (Bethlehem, Pa., and London, 1995).

On the Sources and Meaning of
the Renaissance Portrait Bust

Irving Lavin

INDEPENDENT PORTRAIT SCULPTURE was revived around the middle of the fifteenth century in three main forms – the equestrian monument, the bust, and the medal. Equestrian monuments are over life-size, they were made by public decree, and were displayed in public places. Sculptured busts are life-size, were privately commissioned, and were displayed on private property. Medals are small in scale, they might be commissioned officially or privately, and they were intended for a selected audience that did not include the public at large but extended beyond the sitter's personal domain.[1]

None of these classes of portraiture had actually disappeared during the Middle Ages, but when they occurred they were included within some physical and conceptual context, such as church and tomb decoration, or ordinary coinage.[2] The Renaissance portrait categories cannot be regarded only as revivals, however, for, not to mention questions of style and form, their meaning was profoundly different from what it had been in classical times. With equestrian monuments and medals, the difference is illustrated readily. In antiquity the former were the exclusive prerogative first of the nobility, then of the emperor himself;[3] medallions were restricted to the imperial family.[4] In the Renaissance anyone might be honored by an equestrian monument if he deserved it, and anyone might commission a medal if he could afford it. The change in both cases can be explained partly, but only partly, by what became of equestrian and numismatic portraiture in the Middle Ages.

This essay is concerned with the characteristic Renaissance bust type.[5] The purpose is to analyze its relation to its predecessors, ancient as well as medieval, and to define the significance of its particular form and content. It will appear that the early Renaissance type was more or less equally indebted to classical and medieval traditions and that in certain fundamental respects it was a new creation.

We begin by comparing as to form and function two representative busts from antiquity and the Renaissance. The classical bust (Fig. 18) is rounded at the bottom, hollowed out at the back, and set up on a base. It has an inscription on the front saying it was dedicated to the deified spirits of the dead by the parents of the girl named Aurelia Monnina, who died at age eighteen.[6] It probably

formed part of her tomb or stood in a niche in her family's house along with other portraits of her ancestors. The Renaissance bust (Fig. 19) is cut straight through just above the elbow, it is carved fully in the round, and it has no base. It has an inscription on the underside saying that it represents Piero de' Medici at the age of thirty-seven and was made by the sculptor Mino da Fiesole; thus it was carved in 1453, sixteen years before the sitter died, and is, incidentally, the first dated portrait bust of the Renaissance. This bust and others of Piero's wife and brother, also by Mino, stood in semicircular pediments above doorways in the Palazzo Medici in Florence.[7]

Before exploring the comparison it must be emphasized that the difference in the treatment of the backs is related to the special and perhaps unexpected way in which the Renaissance bust manifested its independence. Neither of these sculptures was meant to be seen from all sides. In antiquity and in the early Renaissance, busts (as distinguished from herms) were normally set in recesses or on consoles projecting from an architectural member. The idea of the bust as a "freestanding" monument with a columnar pedestal reaching to the ground was a late development in both periods, Early Christian in the former, sixteenth century in the latter.[8] The Renaissance bust, however, as is indicated by two companion paintings attributed to Jacopo del Sellaio (Figs. 20 and 21, above the doorways), might be displayed in profile as well as head-on,[9] and this equivalence of front and side views made the Quattrocento bust independent in effect, although it was not so in fact.

Visually the classical work is a self-contained, abstract form, conceived only from the front and set apart by a base from its support. The Renaissance work is an arbitrarily cut-off, incomplete form, conceived in three dimensions and not isolated from the support. It could be deduced from their forms alone that both objects were created by rational beings, but whereas it might be concluded that the classical work is purely an artifact, it would be evident that the Renaissance work represents part of a whole. The classical bust is an ideal form; the Renaissance bust is a deliberate fragment. The locations of the inscriptions are also significant: the dedicatory formula on the classical portrait, D(iis) M(anibus), is in this case cut into the torso itself, emphasizing that the bust is an object; the inscription on the bottom of the Renaissance portrait serves purely as documentation, since it is ordinarily invisible, and it does not interfere with the suggestion that the bust is part of a human being.[10] From each artist's point of view the other's creation is grotesque, in the one case because the bust appears like an amputated body, in the other because a human being is made into an inanimate thing.

The visual contrast is paralleled on the functional level. Classical sculptured portraits may be grouped into two broad categories. One group consists of official, honorific portraits displayed publicly. They depict persons, living or dead, who by virtue of rank or achievement merited recognition. They were set up in open fora, in temples, libraries, and baths. The second group consists of private ancestral portraits. They represented deceased persons of no special distinction, and were displayed on the tomb or within the home as part of the family

cult.[11] There is no literary or epigraphical evidence that portraits of living friends or members of the family were displayed privately.[12] The classical bust, therefore, was never just a record of an individual. In all its uses it was basically an idol, a cult image – for ruler or hero worship in the case of public portraits, for ancestor worship in the case of private portraits.[13]

Most Renaissance busts, by contrast, are neither honorific nor are they family ghosts.[14] Moreover, they were not only displayed on tombs or inside the house, but on the facade of the dwelling as well; they were private, but might be seen by one and all.[15] And they had no role in religious cults, whether of the hero, though the sitters might be alive, or of ancestors, though they might represent members of the family.

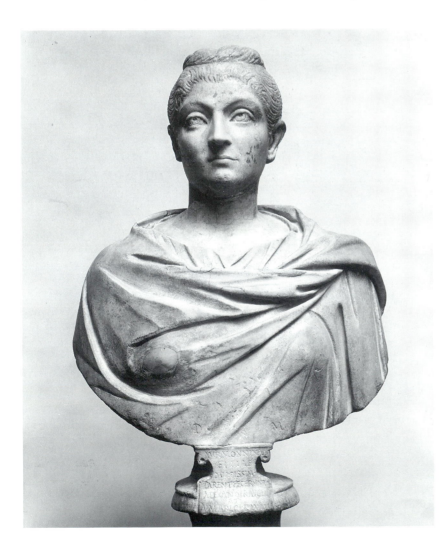

Figure 18. Roman, *Portrait Bust of Aurelia Monnina,* Antikensammlung, Staatliche Museen, Berlin, 3d century (photo: Antikensammlung, Staatliche Museen zu Berlin-Preussischer Kulturbesitz)

The Sources of the Renaissance Bust

Antiquity

The classical portrait bust, in all its forms, transforms the body into an abstract, ideal shape. The development of the "canonical" type of Roman bust may be defined as follows: starting from the head, the torso increased in width and length to include the shoulders and arms, while the back was hollowed out, the bottom rounded off, and the base introduced (Fig. 22).[16]

The horizontally cut bust, with or without base, does occur throughout the Roman period, in two contexts.[17] It occurs when the body is fully articulated but the whole bust is not included. This is the case with the herm, where the shoulders and arms are sliced off vertically, and with certain votive terracottas, where the shoulders are included but the trunk is severed at the breast line or above (Fig. 23).[18] The horizontal cut also occurs in portraits where more of the bust is included but the body is not fully articulated. Such is the case with portraits in relief (Fig. 24),[19] or with freestanding busts that are flat or merely roughed out at the back (Figs. 25 and 26);[20] busts of this kind were regularly framed by an aedicule or set in a base, so that the lower part of the

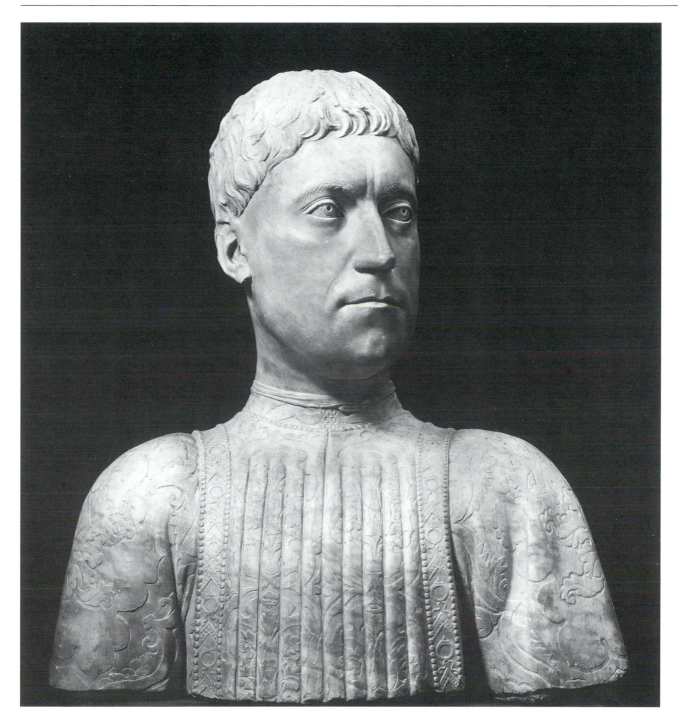

figure did not appear to have been cut off but hidden.[21] Such is the case also with various types of funerary terracottas and cinerary urns that have no frames or bases (Figs. 27–29); here the arms are not articulated (that is, the bust is a simple rectangle, circle or oval in plan), the back is flat or unworked, openings are left in the sides or back.[22]

Thus, if the Renaissance bust was inspired by classical models, they were transformed both physically and conceptually: Physically, by lengthening the abbreviated type, or by executing the partially articulated type fully in the round. Conceptually, the portrait was transformed from an idol or cult image into the

Figure 19. Mino da Fiesole, *Portrait Bust of Piero de' Medici*, Museo Nazionale del Bargello, Florence, 1453 (photo: Alinari/Art Resource, N.Y.)

Figure 20. Jacopo del Sellaio (attr.), Scene from the *Story of Esther* (detail), Uffizi, Florence, mid-15th century (photo: Alinari/Art Resource, N.Y.)

Figure 21. Jacopo del Sellaio (attr.), Scene from the *Story of Esther* (detail), Uffizi, Florence, mid-15th century (photo: Alinari/Art Resource, N.Y.)

representation of a private living person. Antiquity did not create portraits of individuals, pure and simple, and it did not create a complete bust form for the portrait, that is, a human protome, including head, trunk of the body, shoulders and upper arms, and worked fully in the round.

These formulations have linguistic counterparts. There is no equivalent in classical Latin for the word "individual" used as a substantive noun in reference to a human being. The parent word *individuus* occurs only as an adjective, or as a neuter noun referring to inhuman entities (atoms).[23] Other terms, such as *persona* or *homo* or *privatus*, were applied to human beings, but these did not focus, as does "individual," on the quality of uniqueness.[24] Similarly, antiquity had no name for the bust in the sense of a complete human protome. *Truncus* meant as do our words "trunk" and "torso" (from *thyrsus*, stalk), the main stem of the body, excluding head and arms. *Herma* or *imago clipeata* (that is, the shield portrait) might be used for abbreviated likenesses, but these terms do not refer to the protome as such.[25] *Bustum* (from *urere*, to burn) was used in the context of funeral rites to mean the place of incineration, the ashes or bones left from the pyre, the tumulus of earth on the tomb, but it was never used for the human protome.[26] It has been suggested, on the basis of the anthropomorphic funerary urns just mentioned, that the later use of *bustum* was a linguistic extension from the place where the body was burned to the urn in which the ashes were kept.[27] This hypothesis finds support in the fact that in late classical Latin *bustum* was used to mean brazier.[28] *Bustum* was first used with the connotation of human protome by medieval writers, who also applied it to containers for holy relics.[29] The ancient cinerary urn was, after all, a sort of reliquary.

The Middle Ages

In the Middle Ages the horizontal cut was the canonical form for the portrait bust.[30] It occurs both in relief and in the round. An example of the former is the portrait of Wenceslaus I (Fig. 30) that forms part of a series of busts by Peter Parler and his workshop set in niches in the triforium of Prague Cathedral (around 1375);[31] an example of the latter is a thirteenth-century bust in the classicistic style of the period of Frederick II (Fig. 31) that crowned the tympanum of the cathedral of Acerenza, which is left unfinished at the back.[32] Such busts are generally seen without separate frames or bases, so there is no suggestion that the lower body is hidden, as was the case with their classical antecedents; rather there is implied an inner continuity between the torso and its architectural matrix.

The horizontal cut occurs in the late Middle Ages in one class of independent monuments, namely, bust reliquaries (Fig. 32).[33] These often include the whole bust, and they are worked fully in the round. This is a form we could not find in antiquity. The bust reliquaries differ from the Renaissance portrait in three respects: they are normally isolated from the support, either by a base or necking or a lip around the lower edge; being portable, they are completely free of their environment; and they represent distinguished dead people.

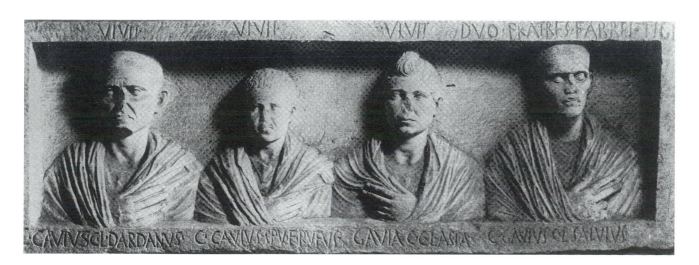

Figure 22 (above left).
Development of Roman Portrait
Bust Forms (after Bienkowski)

Figure 23. Etruscan Votive
Terracotta of a Man, Temple of
Vignale, Falerii Veteres, Museo
Nazionale di Villa Giulia, Rome,
2d century B.C. (photo:
Alinari/Art Resource, N.Y.)

Figure 24. Roman Tomb
Monument with Four Figures,
Cloister, S. Giovanni in Laterano,
Rome, 1st century B.C. (photo:
Fototeca Unione, Rome)

The medieval reliquary was functionally related to the ancient cinerary urn, and this relationship seems to have become explicit in the genealogy of the term *bustum*. Both were cult images and served as containers for the remains of a venerated person. The difference is that in antiquity this honor might be accorded to any man: it was, so to speak, a "death right"; in the Middle Ages the honor was accorded only to a sanctified few. In this respect the reliquary is comparable to the pagan idol. The difference here is that, as with the Byzantine icon, the worship was not accorded to the object itself, but to what it represented.[34] The image was not the deity, it merely represented the deity. The icon and the reliquary allude, in a way the pagan idol does not, to a reality beyond that which is actually represented.

If the Renaissance bust was inspired by the medieval reliquary, the model was

Figure 25 (above). Portrait Bust of a Woman from a Tomb at Palestrina (front view), Museo Etrusco Gregoriano, Vatican Museums, Rome, 2d century B.C. (photo: Fototeca Unione, Rome)

Figure 26. Portrait Bust of a Woman from a Tomb at Palestrina (side view), Museo Etrusco Gregoriano, Vatican Museums, Rome, 2d century B.C. (photo: Fototeca Unione, Rome)

again transformed physically and conceptually; physically, by taking the bust off its base and connecting it to a setting; conceptually, by making it into a representation of a living, private individual.

The Transition to the Renaissance Bust

Two works seem consciously to mediate between the independent, bust-length portrait of antiquity and the medieval bust reliquary on the one hand, and the Renaissance portrait bust on the other. One of these is Donatello's reliquary of *St. Rossore*, of around 1424 (Fig. 33). Here the realistic treatment is obviously intended to suggest an individual likeness, there is no horizontal band or lip, and there was evidently no base.[35] By a striking illusionistic device, however, Donatello made it clear that the *St. Rossore* is not really half a human being. The bottom edge of the drapery spills out onto the underlying surface, so that while the figure appears amputated, the bust appears as an object resting on its support.

An analogous device is seen in the much-discussed *Bust of a Youth* in the Bargello, often attributed to Donatello, in which case it must date from around 1440 (Fig. 34).[36] In that it is worked in the round and is not a reliquary, it anticipates the portrait busts that appear a decade later. But in that it has a rim at the base, on which the drapery rests, it is again an object, not half a man. There is a specific reference to the reliquary tradition in the oval relief at the front: it has been observed by Wittkower that this recalls the jewels which often decorate the

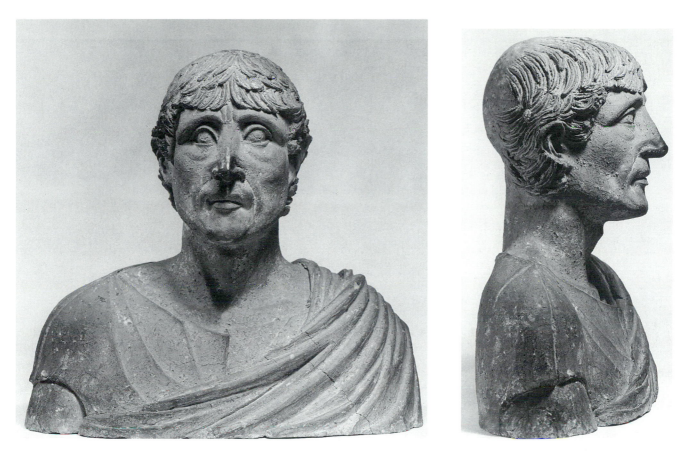

breasts of bust reliquaries, but it also recalls the openings in the breast that often provided a glimpse of the relic inside. The relief depicts Plato's image, described in the *Phaedrus*, of the human soul as a two-horsed chariot and driver – which appears here as if it were the relic. The interplay between medallion and view of the soul is a perfect visual counterpart to the Platonic relationship between visible form and the idea behind it. The bust thus represents Man, whether it portrays a particular man or not.

Both the *St. Rossore* and the *Bust of a Youth* break radically with tradition: in the former a reliquary appears as if it were a portrait; in the latter what appears to be a portrait is given the character of a reliquary. Both involve an existential pun in which generic notions – Saint/Man – and concrete things – reliquary/portrait – are fused.

Figure 27 (above, left). Terracotta Bust of a Man (front view), Antikensammlung, Staatliche Museen, Berlin, 2d century B.C. (photo: Antikensammlung, Staatliche Museen zu Berlin-Preussischer Kulturbesitz)

Figure 28. Terracotta Bust of a Man (side view), Antikensammlung, Staatliche Museen, Berlin, 2d century B.C. (photo: Antikensammlung, Staatliche Museen zu Berlin-Preussischer Kulturbesitz)

Conclusion

The ingredients from which the Renaissance bust was created had all existed in the classical and medieval past. The Renaissance bust itself, however, is something that had never existed before, conceptually and visually: an independent portrait of a living, private individual, and a full human protome, horizontally cut, without a base. This unprecedented portrait form creates a three-dimensional illusion which the full-length figure, by its very nature, cannot achieve and which the shaped, hollowed bust inevitably contradicts. The arbitrary amputation specifically suggests that

Figure 29. Terracotta Bust of a Man, Museo Nazionale delle Terme, Rome, 1st century B.C. (photo: Fototeca Unione, Rome)

Figure 30 (middle). Workshop of Peter Parler, *Portrait Bust of Wenceslaus I*, Cathedral, Prague, c. 1375 (photo: Fototeca Unione, Rome)

Figure 31. Bust of a Man, Cathedral, Acerenza, mid-13th century (photo: Fototeca Unione, Rome)

what is visible is part of a larger whole, that there is more than meets the eye. By focusing on the upper part of the body but deliberately emphasizing that it is only a fragment, the Renaissance bust evokes the complete individual – that sum total of physical and psychological characteristics which make up the "whole man."[37]

"Totus homo," the whole man, was in fact a Renaissance expression. Though used in various contexts, and never precisely defined, the concept of the *totus homo* occurs widely in the writings of Renaissance thinkers. It has been studied only in the case of Luther, but it first appears, so far as I can discover, in the famous treatise *On the Dignity and Excellence of Man* written in 1451–52 by Giannozzo Manetti, the Florentine statesman and historian.[38] Having considered the body and soul separately, Manetti devotes the third book to the whole man. His main theme here is the uniqueness of man's nature, the qualities of which are shared, he says, by no other of God's creatures, not even the angels.

From Manetti it was but a short step to the view of man as a free and independent being midway between heaven and hell, a concept which is one of the principal glories of Florentine humanist thought in the second half of the fifteenth century. This forms the basis of the long poem on the significance of human life, the *Città di Vita*, written in the 1450s and 1460s by the lifelong friend of Cosimo and Piero de' Medici, Matteo Palmieri, whose bust dated 1468 by Antonio Rossellino, now in the Bargello, stood above the entrance to Palmieri's house in the Via de' Pianellai (Fig. 35).[39] Palmieri formulated the heretical theory that man was the descendant of those archangels who remained neutral at the time of the rebellion, when Michael sided with God and Lucifer fell; in man, according to Palmieri, the neutral archangels are given a second opportunity to choose their destiny. I will only mention the passionate hymn to the uniquely indeterminate nature of humanness in Pico della Mirandola's *Oration on the Dignity of Man* of 1486.[40] Neither Palmieri nor Pico use the term, but thereafter *totus homo* became intimately linked to the problem of the freedom of the will, and entered into the dispute on this subject

between Erasmus and Luther; its connotation here has been defined as that of a "neutral" concept of human personality, a sheer self-awareness which participates in but is essentially independent of body and soul, good and evil, salvation and damnation.[41]

I do not pretend that the Renaissance idea of the whole man and the peculiar form of the Renaissance portrait bust were specifically related. But they were specifically correlated, historically in the sense that both emerged at the same time in the same close-knit ambience of Florentine humanism, and ideologically in the sense that both embody a notion of man's nature as a totality which can be reached only by implication and allusion.[42]

They are also analogous in that they belong to the unarticulated premises

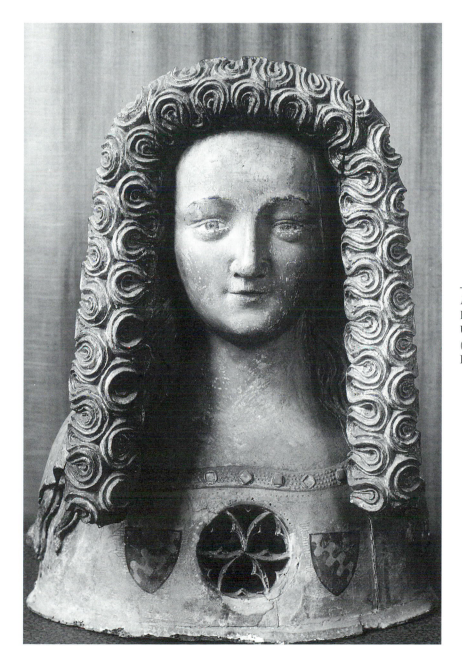

Figure 32. Reliquary Bust of a Female Saint, Church of St. Ursula, Cologne, 14th century (photo: Foto Marburg/Art Resource, N.Y.)

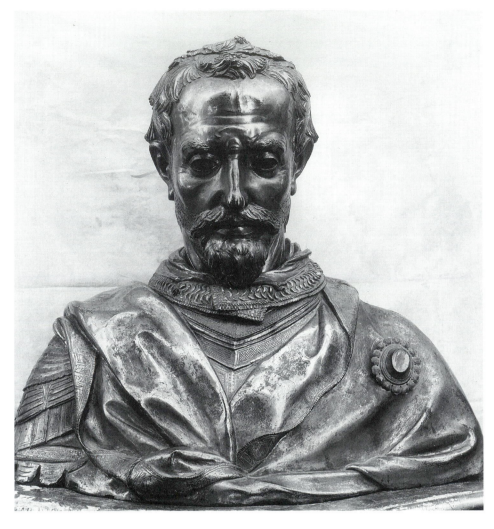

Figure 33. Donatello, Reliquary *Bust of St. Rossore*, Museo di San Matteo, Pisa, c. 1424 (photo: Charles Seymour, Jr. Archive)

rather than the explicit deductions of Renaissance culture. For just as none of the writers ever says what he means by *totus homo*, so one cannot cite external evidence for the significance of the bust form as such. Fifteenth-century references to portrait busts are, in fact, exceedingly rare, and, except for a number of poems, limited to bare notations of their existence.[43] The poetical evocations are deeply revealing, however, because they create in words the same effect as do the portraits in marble. This is true of the earliest poem on a portrait bust I have found so far,[44] which contains, incidentally, the word "bust" for the first time to my knowledge with its modern meaning.[45] It is one of a series of Latin epigrams by Alessandro Bracci, a member of Ficino's Platonic academy and friend of Poliziano and Lorenzo de' Medici, eulogizing Albiera degli Albizzi, who died betrothed in 1472, at the age of fifteen.[46] The epigram, which is on a lost or as yet unidentified portrait of Albiera,[47] reads in translation as follows:

TO THE MARBLE BUST
Albiera, whose noble form is to be admired, asks, O passerby,
That you stop a little and consider
Whether Polykleitos' or Praxiteles' deft hand
Ever made such visages from Parian marble.

But lest there be on earth any lovelier than the goddesses,
Death, at the command of the deities, carried me off.

Works of art that speak are, of course, commonplace in the classical literary tradition of *ekphrasis* and in medieval accounts of miraculous holy images; inscriptions on tombs and commemorative statues are often couched in the first person. But Bracci's epigram is remarkable in two respects. It is the earliest case of such elocution I know that involves a portrait bust. The second point concerns the structure of the poem. The title tells us that we are confronted by a portrait. In the first four lines Albiera is represented as asking us to compare her noble form with faces by famous sculptors. Were it not for the title we would assume the living woman was asking to be compared to a work of art. In the last two lines there is a crucial grammatical shift from indirect to direct discourse, and Albiera says she is dead. The difference between life and death is therefore deliberately conjured up, and dismissed, for it is impossible to know in either case which is speaking, Albiera or her counterfeit. The verbal equiv-

Figure 34. Donatello (attr.), *Bust of a Youth*, Museo Nazionale del Bargello, Florence, c. 1440 (photo: Alinari/Art Resource, N.Y.)

Figure 35. Antonio Rossellino, *Portrait Bust of Matteo Palmieri,* Museo Nazionale del Bargello, Florence, 1468 (photo: Alinari/Art Resource, N.Y.)

alent of the horizontal cut-off is the title: in an arbitrary way, because it is not part of the poem, it calls attention to the material and the incompleteness of the object. In the text, however, the words "form" and "visage" are used, and these refer not to an object but to an image and a person. Thus, because the title addresses a marble bust and the text alludes to a human being, on reading the epigram we inevitably think of what can only be described as the whole individual.

Notes

The substance of this paper was originally presented as a talk at the American Academy in Rome in February 1969 and published in revised form in the *Art Quarterly* XXXIII (1970): 207–26. It is one of a series of essays that deal in a similar way with the Italian portrait bust in the sixteenth and seventeenth centuries, including "Five Youthful Sculptures by Gianlorenzo Bernini and a Revised Chronology of his Early Works," *Art Bulletin* L (1968): 223–48; [with the collaboration of M. Aronberg Lavin], "Duquesnoy's Nano di Créqui and Two Busts by Francesco Mochi," *Art Bulletin* LII (1970): 132–49; "Bernini's Death," *Art Bulletin* LIV (1972): 158–86; "Afterthoughts on Bernini's Death," *Art Bulletin* LV (1973): 429–36; "On Illusion and Allusion in Italian Sixteenth-Cen-

tury Portrait Busts," *Proceedings of the American Philosophical Society* CXIX, no. 5 (October 1975): 353–62; "On the Pedestal of Bernini's Bust of the Savior," *Art Bulletin* LX (1978): 547; "Bernini's Bust of Cardinal Montalto," *Burlington Magazine* CXXVII (1985): 32–8; "Pisanello and the Invention of the Renaissance Medal," *Italienische Frührenaissance und nordeuropäisches Mittelalter: Kunst der frühen Neuzeit im europäischen Zusammenhang* (Munich, 1993), 67–84; "Bernini's Portraits of No-Body," and "Bernini's Image of the Sun King," in my *Past-Present: Essays on Historicism in Art from Donatello to Picasso,* (Berkeley, 1993), 101–37, 139–200; "Bernini's Bust of the Medusa: An Awful Pun," forthcoming in the Acts of a Symposium entitled *Docere, Delectare, Movere,* Istituto Olandese,

Rome, 1996; and "Bernini's Image of the Ideal Christian Monarch," forthcoming in the Acts of a Symposium entitled *The Jesuits: Cultures, the Sciences, and the Arts, 1540–1773,* Boston College, Boston, 1997 (Toronto, 1998).

Since this essay was written, a good deal of literature on the subject of the Renaissance bust has appeared, references to which will be found in the latest work on the Venetian contribution: A. Luchs, *Tullio Lombardo and Ideal Portrait Sculpture in Venice, 1490–1530* (Cambridge, 1995).

1. The most useful survey of the kinds of Renaissance portrait sculpture remains that of J. Burckhardt, "Skulptur der Renaissance," in *Jacob Burckhardt-Gesamtausgabe* (Stuttgart, 1934), XIII, 302–17. See further the articles "Bildnis" (P. O. Rave), "Büste" (H. Keller), and "Denkmal" (H. Keller), in *Reallexikon zur deutschen Kunstgeschichte* (Stuttgart, 1937–73), II, cols. 639–79; III, cols. 255–74, 1257–98; and H. Keutner, *Sculpture Renaissance to Rococo* (London, 1969), 27–9. On the medal, G. F. Hill, *Medals of the Renaissance,* (Oxford, 1920).

 The isolated standing portrait monument did not appear until the sixteenth century (see H. Keutner, "Über die Entstehung und die Formen des Standbildes in Cinquecento," *Münchner Jahrbuch der bildenden Kunst* VII [1956]: 138–68), although a columnar monument with a seated figure of Borso d'Este was erected at Ferrara in the mid-fifteenth century (W. Haftmann, *Das italienische Säulenmonument* [Leipzig-Berlin, 1939], 146–7). The honorific papal portrait statue, which emerged in the late Middle Ages, forms a category apart (W. Hager, *Die Ehrenstatuen der Päpste* [Leipzig, 1929]).

2. On the medieval portrait, see H. Keller, "Die Entstehung des Bildnisses am Ende des Hochmittelalters," *Römisches Jahrbuch für Kunstgeschichte* III [1939]: 227–356.

3. See H. W. Janson, "The Equestrian Monument from Cangrande della Scala to Peter the Great," in *Aspects of the Renaissance: A Symposium,* ed. A. Lewis (Austin, Texas and London, 1967), 75, 77.

4. See Hill, *Medals of the Renaissance,* 15.

5. For a survey of Renaissance bust types and bases, see W. von Bode, "Die Ausbildung des Sockels bei den Büsten der italienischen Renaissance," *Amtliche Berichte aus den preuszischen Kunstsammlungen* XL (1918–19): 100–20.

6. C. Blümel, *Staatliche Museen zu Berlin: Römische Bildnisse* (Berlin, 1933), no. R118.

7. The busts of Piero and Lucrezia are mentioned by Vasari: "fece (Mino) il ritratto di Piero di Lorenzo de' Medici e quello della moglie, naturali e simili affatto. Queste due teste stettono molti anni sopra due porte in camera di Piero, in casa Medici, sotto un mezzo tondo" (G. Vasari, *Le vite de' più eccellenti pittori scultori ed architettori,* ed. G. Milanesi, 8 vols. [Florence, 1878–1906], III, 123). The busts of Piero and Giovanni are listed in the inventory of the Medici Palace made in 1492: "Nella Camera della scala grande detta di Lorenzo – Una testa di marmo sopra l'uscio dell'antichamera della (i)mpronta di Piero di Cosimo. Nella chamera che risponde sulla via chiamata di Monsignore dove sta Giuliano – Una testa di marmo sopra l'uscio dell'antichamera di tutto rilievo ritratto al naturale di Giovanni di Cosimo de' Medici" (E. Müntz, *Les collections des Médicis au XVe siècle* [Paris and London, 1888], 62, 84–5).

 In general, on the placement of family portraits, Vasari's phraseology is significant: "onde si vede in ogni casa di Firenze, sopra i cammini, usci, finestre e cornicioni, infiniti di detti ritratti . . ." (Vasari, *Le Vite,* ed. Milanesi, III, 373).

8. On the modes of displaying classical busts, see M. Wegner, *Die Herrscherbildnisse in antoninischer Zeit* (Berlin, 1939), 289–91. Both in antiquity and in the Renaissance the freestanding bust monument seems to have been related to the conception of the bust form itself as a sign of veneration. The custom may be traceable to the imperial cult. Portrait busts are shown on altars, which may take cylindrical shape, from the later Republican period: *cf.* a gem attributed to Sulla, in M.-L. Vollenweider, "Der Traum des Sulla Felix," *Schweizerische numismatische Rundschau,* XXXIX, 1958–59, pl. VII, no. 6, p. 24, n. 8, a reference for which I am indebted to Mr. Dawson Kiang. Related material was kindly brought to my attention by Professor Henri Seyrig: H. von Fritze, *Die Münzen von Pergamon* (Berlin, 1910), 90; F. Imhoof-Blumer and P. Gardner, *A Numismatic Commentary on Pausanius* (reprinted from the *Journal of Hellenic Studies,* 1885, 1886, 1887), 94, pl. S, fig. XVIII. See also a coin of Caracalla, C. Vermeule, *Roman Imperial Art in Greece and Asia Minor* (Cambridge, Mass., 1968), frontispiece; *cf. The Museum Year: 1968. The Ninety-Third Annual Report of the Museum of Fine Arts, Boston* (Boston, 1969), 33. Subsequently, busts are shown placed on columns in scenes of Nebuchadnezzar ordering the three youths to worship his image and on an ivory representing a poet and his model (Wegner, *Herrscherbildnisse,* 290; H. Kruse, *Studien zur offiziellen Geltung des Kaiserbildes im römischen Reiche* [Paderborn, 1934], 84–9). Related phenomena are imperial portrait busts set on movable stands and surmounting scepters (*ibid.,* 101–2, 106–9; A. Alföldi, "Insignien und Tracht der römischen Kaiser," *Mitteilungen des deutschen archäologischen Instituts, Römische Abteilung* L [1935]: 116–17). In the Renaissance, busts were not put on separate supports until the sixteenth century (A. Sciaparelli, *La casa fiorentina e i suoi arredi nei secoli XIV e XV* [Florence, 1908], 194), along with the revival of the "canonical" form of the classical bust.

9. Alinari photos 30716–7. I am indebted to Professor Ulrich Middeldorf for referring me to these paintings. *Cf.* P. Schubring, *Cassoni* (Leipzig, 1923), 307.

10. I know of no Renaissance bust inscribed on the body of the sitter, and in most early examples the inscription appears on the underside. I include here, with no claim to completeness, a chronological checklist of inscribed Florentine portrait busts of the Quattrocento (where no reference is given I have copied the inscription myself).

1. Mino da Fiesole, *Piero de' Medici*, Museo Nazionale, Florence
 Inside hollow at front:
 PETRVS. COS. F
 Inside hollow at back:
 AETATIS. ANNO. XXXVII (*i.e.*, 1453)
 Under right arm:
 SCVLTORIS
 Under left arm:
 OPVS. MINI

2. Mino da Fiesole, *Niccolò Strozzi*, Staatliche Museen, Berlin
 Inside hollow at back:
 "NICOLAVS. DESTROZIS
 INVRBE. A. MCCCCLIIII."
 On underside of rim at front:
 "OPVS. NINI"
 (F. Schottmüller, *Die italienischen und spanischen Bildwerke der Renaissance und der Barock. Erster Band. Die Bildwerke in Stein, Holz, Ton und Wachs*, 2d ed. [Berlin and Leipzig, 1933], 55, no. 96.)

3. Mino da Fiesole, *Astorgio Manfredi*, National Gallery, Washington, D.C.
 Inside hollow at back:
 ASTORGIVS. MANFREDVS.
 SECVNDVS.FAVENTIE. DOMINVS
 On underside of rim at right side:
 ANNO. XLII. ETATIS. SVE
 Under right arm:
 1455
 Under left arm:
 OPVS.NINI

4. Antonio Rossellino, *Giovanni da San Miniato*, Victoria and Albert Museum, London
 Inside hollow:
 "Inscribed within the slightly hollowed base: MAGisteR IOHANES MAGistRI. ANTONII DE SancTO MINIATE DOCTOR ARTIVM ET MEDICINE. M.CCCCLVI, and in the center: OPVS ANTONII."
 (J. Pope-Hennessy, assisted by R. Lightbown, *Catalogue of Italian Sculpture in the Victoria and Albert Museum*, 3 vols. [London, 1964], I, 124.)

5. Mino da Fiesole, *Alessandro Mini di Luca*, Staatliche Museen, Berlin

On the plinth at the front:
 "ALEXO DI LVCA MINI 1456"
 Inside hollow at back:
 "MCCCCLXV"
 (F. Schottmüller, *Die italienischen und spanischen Bildwerke*, 56, no. 2186.)

6. Mino da Fiesole, *Rinaldo della Luna*, Museo Nazionale, Florence
 Around front lower edge beginning behind right shoulder:
 RINALDO. DELLA. LVNA. SVE.
 ETATIS. ANNO. XXVII.
 Around back lower edge beginning behind left shoulder:
 OPVS. MINI. NE M̊CCCCLXI.

7. Antonio Rossellino, *Francesco Sassetti*, Museo Nazionale, Florence
 Inside hollow at back:
 FRAN. SAXETTVS
 FLORENT. CIVIS
 AETATIS. ANN. XLIIII (*i.e.*, 1464)

8. Mino da Fiesole, *Dietisalvi Neroni*, Louvre, Paris
 On base:
 "+AETATIS. SVE. A̅N̅ A̅G̅E̅S̅ . LX
 TYRC . . . FACI̅V̅. DVM.ͥͥ. CVRAVIT.
 DIETISALVIVS. OPVS. MINI
 MCCCCLXIIII."
 (A. Venturi, *Storia dell'arte italiana*, 11 vols. [Milan, 1901–39], VI, 640, n. 1.)

9. Antonio Rossellino, *Matteo Palmieri*, Museo Nazionale, Florence
 Inside hollow at back:
 MATTHEO PALMERIO
 SAL. AN. MCCCCLXVIII
 Inside hollow at front:
 OPVS ANTONII
 GHAMBERELLI

10. Benedetto da Maiano, *Pietro Mellini*, Museo Nazionale, Florence
 Inside hollow above a banderole at back:
 A̅N̅ 1474
 Inside hollow on a banderole at the back:
 PETRI. MELLINI. FRANCISCI.
 FILII. IMAGO. HEC
 On underside of rim at front:
 BENEDITVS. MAIANVS. FECI

11. Benedetto da Maiano, *Filippo Strozzi* (died 1491), Louvre, Paris
 On interior of base:
 "PHILIPPVS. STROZA. MATHEI.
 FILIVS. BENEDICTVS. DE. MAIANO.
 FECIT"
 (J. Babelon, "Un médaillon de cire du Cabinet des

Médailles. Filippo Strozzi et Benedetto da Majano," *Gazette des Beaux-arts*, 5th ser. [1921]: no. 4, 204, n. 2.)

12. Antonio Pollaiuolo (?), *Portrait of a Man*, Museo Nazionale, Florence
 Inside hollow on tabula ansata at back: MCCCCLXXXXV.

11. For a survey of the Roman uses of portrait statuary, see L. Friedlaender, *Darstellungen aus der Sittengeschichte Roms in der Zeit von Augustus bis zum Ausgang der Antonine*, 4 vols. (Leipzig, 1919–21), III, 57–78.

 For the types and placement of ruler portraits, *cf.* Wegner, *Herrscherbildnisse*, 100–22. For portraits of philosophers and poets, *cf.* T. Lorenz, *Galerien von griechischen Philosophen- und Dichterbildnissen bei den Römern* (Mainz, 1965), 35–44. For ancestral portraiture, see A. N. Zadoks and J. Jitta, *Ancestral Portraiture in Rome and the Art of the Last Century of the Republic* (Amsterdam, 1932). An intermediate group might include votive portraits displayed in a sanctuary to invoke the deity's beneficence, as in case of illness; for example, our Fig. 23, a terracotta portrait in the Villa Giulia, from the Tempio Maggiore at Vignale, Falerii Veteres (see below, n. 18).

 A passage in Pliny is often cited as evidence that ancestral portraits were displayed publicly on the outside of houses; more likely, it refers to the placement of such images around the door leading to the family record room: "Tabulina codicibus implebantur et monumentis rerum in magistratu gestarum. Aliae foris et circa limina animorum ingentium imagines erant . . . " (*Historiae Naturalis*, 35, 7). This passage may, nevertheless, have had considerable influence in the Renaissance; see below, n. 15.

12. H. Jucker, *Das Bildnis im Blätterkelch* (Olten, 1961), 136: "Devon aber, dass sich der Hausherr Porträts seiner noch lebenden Familienangehörigen oder Freunde machen liess, um sie bei sich aufzustellen, ist, so viel ich sehe, weder in der Literatur noch in Inschriften je die Rede."

13. "Das Bildnis zeigt überall eine noch viel stärkere Kraft zur Vergegenwärtigung, es ist in intensiverem Masse stellvertretend für den Dargestellten, als wir im allgemeinen empfinden können" (Jucker, *Bildnis im Blätterkelch*, 135).

14. All the busts listed in n. 10 above with the name of the sitter and his age or the date inscribed were made while the sitter was alive.

15. The bust of Matteo Palmieri (Fig. 35) stood until 1832 over the entrance to the Casa Palmieri in the Via de' Pianellai in Florence (see below). For a later Quattrocento example in Naples, see G. L. Hersey, *Alfonso II and the Artistic Renewal of Naples, 1485–1495* (New Haven and London, 1969), 29–30, n. 12.

 This custom, which became widespread in the sixteenth century, may have arisen from a misinterpretation of a passage in Pliny (cited in n. 11 above); I have found

no classical instances of private portrait busts placed over exterior entrances.

16. On the development of this bust type, see P. Bienkowski, "Note sur l'histoire du buste dans l'antiquité," *Revue archéologique* XXVII (1895): 293–7 (our Fig. 22 is Bienkowski, 294, fig. 1); H. Hekler, "Studien zur römischen Porträtkunst," *Jahreshefte des österreichischen archäologischen Institutes in Wien* XXI–XXII (1922–24): 172–202. Lorenz, *Galerien*, 54, notes that the first bust known to him that is set on a base is a portrait of Caligula.

17. For a brief discussion of the horizontal cut, see B. Schweitzer, *Die Bildniskunst der römischen Republik* (Leipzig and Weimar, 1948), 31.

18. On the development of the portrait herm, *cf.* K. Schefold, *Die Bildnisse der antiken Dichter, Redner und Denker* (Basel, 1943), 196–7; Lorenz, *Galerien*, 54. For such portrait terracottas, *cf.* G. von Kaschnitz-Weinberg, *Ausgewählte Schriften* (Berlin, 1965), II, 16–17, 51; R. Bianchi-Bandinelli, *Storicità dell'arte classica* (Florence, 1950), 100–30 (our Fig. 23 is M. Moretti, *Il museo nazionale di Villa Giulia* [Rome, 1962], fig. 160; see above, n. 11).

19. Our Fig. 24 is Zadoks and Jitta, *Ancestral Portraiture*, pl. XVIIb, an interesting tomb relief in which certain of the figures are distinguished by the inscription "VIVIT."

20. M. Collignon, *Les statues funéraires dans l'art grec* (Paris, 1911, 301–14); O. Vessberg, *Studien zur Kunstgeschichte der römischen Republik* (*Acta Instituti Romani Regni Sueciae*, VIII) (Lund and Leipzig, 1941), 189; A. Giuliano, "Busti femminili da Palestrina," *Mitteilungen des deutschen archäologischen Instituts: Römische Abteilung* LX–LXI (1953–54): 172–83. Our Figs. 25 and 26 are Giuliano, pl. 71 (*cf.* W. Helbig, *Führer durch die öffentlichen Sammlungen klassischer Altertümer in Rom*, 4th ed. [Tübingen, 1963–72], I, 477–8, no. 618).

21. *Cf.* O. Benndorf, "Bildnis einer jungen Griechen," *Jahreshefte des österreichischen archäologischen Institutes in Wien* I (1898): 1–8, *cf.* p. 7; J. Keil, "Hellenistische Grabstele aus Magnesia a. M.," *ibid.*, XVI (1913): 181; Lorenz, *Galerien*, 54.

 Certain bust-length tomb figures from the Greek islands, set in aedicules or on hollowed plinths on sarcophagus covers, are carved in the round (*e.g.*, that from Thera in Athens, *cf.* S. Karovsov, *National Archaeological Museum. Collection of Sculpture: A Catalogue* [Athens, 1968], 190); these are not individualized portraits. I have found no classical example of a life-size portrait bust cut horizontally at the breast line or lower, worked fully in the round, and demonstrably not set in an aedicule or on a base.

22. *Cf.* n. 18 above; S. Ferri, "Busti fittili di Magna Grecia e l'origine dell'erma," *Atti della Accademia Nazionale dei Lincei. Rendiconti*, XVIII (1963), 29–42. Our Figs. 27 and 28 are Bianchi-Bandinelli, *Storicità*, 64, figs. 129, 130; our Fig.

29 is B. M. Felletti Maj, *Museo nazionale romano: I ritratti* (Rome, 1953), no. 48 (there is a large hole in the back left side).

23. *Individuum* appears in writers of the early Christian period as a neuter substantive, meaning a man as a single member of his species: "Cum dico 'Cicero,' iam quiddam individuum certumque significo; cum dico 'homo,' . . . incertum est, quem significem" (Martianus Capellus; *cf.* *Thesaurus linguae latinae* [Leipzig, 1900–13], VII, pt. 1, col. 1208, lines 68–72).

 The first instance cited in the dictionaries in which the word refers to a particular person without any notion of contrast to a class or group dates from the sixteenth century: "Dubitando che per qualche accidente e' non nascesse alcuna differenza tra queste due individui" (Agnolo Firenzuola, 1493–1543; *cf.* N. Tommaseo, *Dizionario della lingua italiana*, 4 vols. [Turin and Naples, 1861–79], II, pt. 2, 1456).

 A further extension occurred in the seventeenth century when the word was applied to the person's self: "Il peccato d'Adamo non solamente condannò l'uomo a conservare il suo individuo con tanta fatica, ma l'abbassò a mantener la sua specie con tanta deformità" (Pietro Sforza Pallivicino, 1607–77; *ibid.*). Compare the obsolete English usage, "As to what concerns my owne poore individuall" (E. Nicholas, 1655; J. A. H. Murray, ed., *A New English Dictionary on Historical Principles*, 10 vols. [Oxford, 1888–1933], V, 224).

24. The Greek word ἰδιώτης focused on the private, as opposed to the public, nature of the person, but not on the person's uniqueness. Modern Greek has an equivalent for "individual," ἄτομο, "undivided," an extension of the ancient word, which was not applied to persons: *Istorikon lexikon tis neas ellenikes* (Athens, 1933 –), III, 268.

25. On herm portraits, see Schefold, *Bildnisse*, 196–7; on the *imago clipeata*, H. Blank, "Porträt-Gemälde als Ehrendenkmaler," *Bonner Jahrbücher*, CLXVIII (1968): 4–12, and R. Winkes, *Clipeata imago* (Bonn, 1969).

 The same is a fortiori true of terms such as *caput* and *vultus* (πρόσωπον), which do have anatomical reference, but not to the protome. It is also interesting that I have found no Renaissance use of *vultus* to mean portrait image, as in antiquity, and no real classical equivalent for the Renaissance use of *caput* (testa) in reference to portrait busts (*e.g.*, the Medici inventory quoted in n. 7 above and the documents concerning Paolo Romano's bust of Pius II in the Vatican, E. Müntz, *L'art à la cour des papes pendant le XVe et le XVIe siècle*, 3 vols. [Paris, 1879–82], I, 276).

 The Greek word προτομή was applied to portraits, but it refers as much to the "front" as to the "upper" part of the body and seems to have been used thus only after the Roman bust type had been developed (H. Stephanus, *Thesaurus graecae linguae*, 10 vols. [London, 1816–28], VI,

2071; H. G. Liddell and R. Scott, *Greek-English Lexikon* [Oxford, 1953], 1536–7; *cf.* L. Robert, "Recherches épigraphiques," *Revue des études anciennes* LXXII [1960]: 320, a reference I owe to Henri Seyrig).

26. *Cf.* Gullini, "Busti fittili," 42.

27. *Ibid.*

28. H. Chirat, *Dictionnaire latin-français des auteurs chrétiens* (Turnhout, 1954), 120.

29. C. du Cange, *Glossarium mediae et infimae latinitatis*, 10 vols. (Niort, 1883–87), I, 793; O. Prinz, ed., *Mittellateinisches Wörterbuch bis zum ausgehenden 13. Jahrhundert* (Munich, 1967), I, col. 1629. Further on the word below, n. 45.

30. On the revival of the bust form in Italy in the thirteenth century, *cf.* H. Keller, "Der Bildhauer Arnolfo di Cambio und seine Werkstatt. II Teil," *Jahrbuch der preussischen Kunstsammlungen*, LVI (1935): 25–32; and *idem*, "Entstehung des Bildnisses," *ibid.*, 269–84. For a tradition of half-length relief figures in niches, *cf.* O. von Kutschera-Woborsky, "Des Giovanninorelief des spalatiner Vorgebirges: Ein allgemeines Beitrag zur Geschichte der Antiken Nachahmung," *Jahrbuch des kunsthistorischen Institutes der K. K. Zentralkommission für Denkmalpflege* XII (1918): 1–43.

31. Fig. 30 is *Reallexikon zur deutschen Kunstgeschichte*, II, col. 656, fig. 15; *cf.* K. M. Swoboda, *Peter Parler*, 2d ed. (Vienna, 1941).

32. *Cf.* G. von Kaschnitz-Weinberg, "Bildnisse Friedrichs II von Hohenstaufen," *Mitteilungen des deutschen archäologischen Instituts: Römische Abteilung* LXII (1955): 48–9; for a view of the bust in its original location, *cf.* R. Delbrück, "Ein Porträt Friedrich's II von Hohenstaufen," *Zeitschrift für bildenden Kunst* XIV (1903): 17, fig. 1; for a view of the back, *cf.* Keller, "Entstehung des Bildnisses," 271, fig. 246.

 In fact, as far as I have been able to determine, none of the bust-length portraits of the period of Frederick II are worked fully in the round (the example formerly in the Brummer Gallery, now in the Metropolitan Museum, New York, is finished at the back, but the head and torso are two separate and different pieces of marble and may not be contemporary; *cf.* J. Deér, *Der Kaiserornat Friedrichs II* [Bern, 1952], 42, pl. XXII, 4).

33. See J. Braun, *Die reliquiare des christlichen Kultes und ihre Entwicklung*, Freiburg i. B., 1940, 413–34.; E. Kovàcs, *Kopfreliquiare des Mittelalters* (Budapest, 1964); our Fig. 32 is *Reallexikon zur deutschen Kunstgeschichte*, III, col. 279, fig. 5.

34. Ernst Kitzinger has called my attention to a remarkable passage in Mesarites's description of the Church of the Holy Apostles at Constantinople, in which the bust-length image of the Pantocrator in the central dome is explained in three ways. These might be defined as metaphorical, the bust alluding to our partial knowledge of the whole divinity; illusionistic, the bust illustrating Christ's arrival from

the heavens at the Second Coming; and physical, the bust representing the portion of the Father's anatomy in which the Son resides. In all three cases the bust is conceived as significant specifically because it refers to more than meets the eye.

The passage is as follows: "This dome shows in pictured form the God-Man Christ, leaning out as though from the rim of heaven, at the point where the dome begins, toward the floor of the church and everything in it, but not with His whole body or in His whole form. This I think was very wisely done by the artist as he turned the matter over in his mind and revealed the very clever conclusion of his intelligence through his art to those who do not observe superficially, because for one thing, I believe, we now know in part as though in a riddle (αἰνίγματι), and in a glass, the things concerning Christ and in accord with Christ, and for another thing the God-Man will appear to us from heaven at the time of his second sojourn on earth, though the space of time until that coming has never yet been wholly measured, and because He himself dwells in heaven in the bosom of His father . . . " (G. Downey, "Nicolaos Mesarites: Description of the Church of the Holy Apostles at Constantinople," *Transactions of the American Philosophical Society*, n. s. XLVII, pt. 6 [1957]: 869–70).

35. At least, a base for it is mentioned only in the sixteenth century, when a woodcarver was paid for making one; H. W. Janson, *The Sculpture of Donatello* (Princeton, 1957), 56–9.

36. *Ibid*, 141–3; *cf*. R. Wittkower, "A Symbol of Platonic Love in a Portrait Bust by Donatello," *Journal of the Warburg Institute* I (1937–38): 260–1. For recent bibliography on the bust see E. Panofsky, *Renaissance and Renascences* (Copenhagen, 1960), 189; P. H. von Blanckenhagen, "Two Horses and a Charioteer," in *Ancients and Moderns*, ed. J. Cropsey (New York, 1964), 92; U. Wester and E. Simon, "Die Reliefmedaillons im Hofe des Palazzo Medici in Florenz," *Jahrbuch der Berliner Museen* VII (1965): 72–3; C. De Tolnay, "Nuove osservazioni sulla cappella medicea," *Accademia Nazionale dei Lincei: Problemi attuali di scienza e di cultura*, Quaderno no. 130, 1969, 7, n. 10.

A variation of the drapery device appears in Mino da Fiesole's profile relief bust of Bernardo Giugni (died 1466) in the Badia of Florence (J. Pope-Hennessy, *The Portrait in the Renaissance* [Washington, D.C., 1966], 79, fig. 81).

37. Oddly enough, leaving function and meaning aside, the closest precedent I know for the Quattrocento type of portrait bust – life-size, cut in a straight horizontal through chest and arms, fully articulated, and finished in the round – is a limestone bust of Akhnaton in the Louvre, a sculptor's model presumably made in preparation for a full-length statue (*cf*. H. Fechheimer, *Die Plastik der Ägypter* [Berlin, 1923], pls. 85–6). In general, *cf*. W. S. Smith, *A*

History of Egyptian Sculpture and Painting in the Old Kingdom (London, 1946), 38–9; W. Wolf, *Die Kunst Aegyptens* (Stuttgart, 1957), 150–1, 456; B. von Bothmer, *Egyptian Sculpture of the Late Period, 700 B.C. to A.D. 100. The Brooklyn Museum* (New York, 1960), 85–6.

The obvious parallel for this sculptured type in Quattrocento painting is the bust-length profile portrait, which is also without real precedent in antiquity; both the front and the back of the figure are shown, yet it is manifestly incomplete: J. Lipman, "The Florentine Profile Portrait in the Quattrocento," *Art Bulletin* XVIII (1936): 54–102; R. Hatfield, "Five Early Renaissance Portraits," *ibid.*, XLVII (1965): 315–34.

38. Manetti's treatise, published at Basel in 1532, is extensively analyzed in G. Gentile, *Il Pensiero italiano del Rinascimento, Opere complete* (Florence, 1968), XIV, 90–113; W. Zorn, *Gianozzo Manetti: Seine Stellung in der Renaissance* (Freiburg, 1939), esp. 22–30; and most recently, C. Trinkhaus, *In Our Image and Likeness* (London, 1970), I, 230–58. Book IV, the best-known part, is published with an Italian translation in E. Garin, *Prosatori latini del quattrocento* (Milan and Naples, 1952), 421–87 (English translation in B. Murchland, *Two Views of Man* [New York, 1966], 63–103).

I quote the concluding sentences of Book III: "Nihil enim aliquid quicumque ei naturae, quam tam pulchram, tam ingeniosam et tam sapientem ac tam opulentam, tam dignam et tam potentem, postremo tam felicem et tam beatam constituerat, ad totem et undique absolutam perfectionem suam deesse putabatur, nisi ut ea per admixtionem cum ipsa divinitate, non solum coniuncta in illa Christi persona cum divina, sed etiam ut cum divina natura una et sola efficeretur, ac per hunc modum unica facta fuisse videretur. Quod neque angelis neque ulli aliae creaturae, nisi homini duntaxat, ad admirabilem quondam humanae naturae dignitatem, et ad incredibilem quoque eius ipsius excellentiam, datum, concessum et attributum esse novimus" (Basel, 1532, 173–4).

39. On Palmieri see the literature cited concerning the painting commissioned by him, attributed to Botticini, in M. Davies, *National Gallery Catalogues: The Earlier Italian Schools*, 2d ed. (London, 1961), 122–7.

40. E. Cassirer, P. O. Kristeller, J. H. Randall, Jr., eds., *The Renaissance Philosophy of Man* (Chicago and London, 1948), 223–54.

41. *Cf*. R. Pfeiffer, *Humanitas Erasmiana (Studien der Bibliothek Warburg, XXII)* (Leipzig and Berlin, 1931), 19–20; E. Schott, *Fleisch und Geist nach Luthers Lehre unter besonderer Berücksichtigung des Begriffs "totus homo"* (Leipzig, 1928), esp. 50–72.

42. Though in a different way, J. Pope-Hennessy has also seen the portrait bust as the creation of an interrelated group of Florentine humanists (*The Portrait in the Renaissance*, 75–7).

43. As in the Medici inventories and documents concerning the bust of Pius II, cited in nn. 7 and 25 above.

44. For an example from near the end of the century in Naples, see E. Pèrcopo, "Una statua di Tommaso Malvico ed alcuni sonetti del Tebaldeo," *Napoli nobilissima*, II, 1903, 10–13 (*cf*. Hersey, *Alfonso II*, 35 and n. 24).

45. *Busto* appears as part of the body, not as a sculpture, in Dante, *Inferno*, XVII, 8. The first instance of the latter use listed in the Italian dictionaries is from A. M. Salvini, 1735 (S. Battaglia, *Grande dizionario della lingua italiana* [Turin, 1961–], II, 465); in fact, I do not find it defined thus in the editions of the Vocabolario della Crusca before Salvini.

46. A. Perosa, ed., *Alexandri Bracci Carmina* (Florence, 1944), 108–9. I am indebted to Ulrich Middeldorf for bringing the poem to my attention.

AD BUSTUM MARMOREUM
Albiera, insigni forma spectanda, viator,
Ut paulum sistas aspiciasque rogat,
Duxerit e Pario tales si marmore vultus
Docta Polycleti Praxitelisve manus.

Ne tamen in terris formosior ulla deabus
Esset, mors iussu me rapuit superum.

I adopt the title from the Turin manuscript of eulogies by various authors on Albiera, which was compiled by her fiancé Sigismondo dell Stufa and which gives the earliest versions of Bracci's epigrams to her (see Perosa and the references cited there). In subsequent manuscript collections of Bracci's poems the more elegant but less precise title AD EIUS MARMOREAM EFFIGIEM is substituted.

On Bracci, who is mentioned among the academicians in 1473, see B. Agnoletti, *Alessandro Braccesi* (Florence, 1901); and A. Della Torre, *Storia dell'accademia platonica di Firenze* (Florence, 1902), 656, 806–7.

47. The bust is presumably identical with portraits of Albiera mentioned in poems by Poliziano, Ugolino Verino, and Mabilio Novato (who names a certain "Morandus" as the artist); *cf*. F. Patetta, "Una raccolta manoscritta di versi e prose in morte d'Albiera degli Albizzi," *Atti della R. Accademia della Scienza di Torino*, LIII (1917–18): 290–4, 310–28.

Familiar Objects: Sculptural Types in the Collections of the Early Medici

John T. Paoletti

R EADING THE HISTORY OF SCULPTURE through its types, their placement, and their function rather than simply as the history of a single sculptor's production or the chronology of objects produced in a single studio or city opens questions about how Renaissance patrons employed sculptural objects both for personal use and for public propaganda.[1] Works of sculpture, like objects in other media, do not and did not exist as discrete, self-contained events in a viewer's visual field, despite the peculiar bias that traditional studies of style and a modern museum culture give to our current seeing. During the fifteenth century in Florence, medium, iconography, and sculptural type were all located not only in specific physical sites having to do with their functional purpose but in the mental traditions of perception as well. The roles assigned to sculpture seem to have been no less prescribed than the roles assigned to human behavior in a hierarchical society where coded visual appearance, such as costume or order of placement in public procession, indicated an individual's role in the society or his or her meaning in the culture. An important and not often discussed corollary to these codified rules of behavior would emphasize that significant departures from prescribed norms were immediately noticeable and indicative of meaning. Thus, in addition to contextual issues of patronage, contemporary history, iconography, and style, any understanding of early modern sculpture depends on knowing the type to which the object belongs, whether the object transgresses the type, and where, in general if not in particular, the object was sited.

The decoration of the personal interior spaces of palaces during the fifteenth century helps to define a large range of sculptural types and their possible manipulation perhaps even more clearly than works of sculpture in public places, although, as Sarah Blake McHam shows in another essay in this volume, the piazza was itself a site fully conscious of its sculptural traditions. Because urban palaces grew larger and in some cases more formal during the expanding economies of the late fourteenth and fifteenth centuries they provide rich resources for charting the histories of sculptural types as owners added new forms of decorative sculpture such as the small table bronze to their interior

environments while they continued to purchase traditional objects such as devotional images of the Madonna and Child.

The Medici Palace in Florence is a case in point. Rich sources of documents and resulting traditions of scholarly research have provided substantial information about the household furnishings owned by the Medici, especially after the family moved into their newly built palace on the Via Larga in the late 1450s. Inventories of their objects can reasonably be compared with ever increasing numbers of comparable lists of art objects held by other families in Florence in order to begin a mental reconstruction of the interiors of Florentine palaces. Of course the vast wealth of the Medici must be taken into account in any comparison of their collections with those of other families. But the number of objects is really not the important issue. Although scholarly history is essentially still at an early phase of reconstructing the domestic spaces of the Renaissance and ascertaining the sculpture that they contained, existing inventories do provide important indications of *categories* of objects that existed in these spaces, of how sculpture adhered to typological conditions, and of how this sculpture might have functioned for the people inhabiting these spaces as a conveyor of meaning.

Before investigating the sculpture of the Medici Palace a caveat is in order. Treating sculptural decoration in Medici interior spaces as a norm for the period is hazardous not only because of the extraordinary buying power attendant to the family's wealth, but because three generations of men in the family – Cosimo (from 1434 to 1464), Piero (from 1464 to 1469), and Lorenzo (from 1469 to 1492) – were essentially the de facto political rulers of Florence although they carefully maintained the fiction of the state as a republic. This special role of disguised rulers (and history's subsequent fascination with them because of it) differentiated the Medici from all the other families in the city and therefore presumably distinguished their artistic patronage as well. On the other hand, comparing the sculpture of the Medici to objects owned by other Florentine families does both clarify the normative role of sculpture in Florence and demonstrate the notable fact that, with the possible exception of devotional works, Medici sculpture seems consistently to have stood outside the bounds of convention.[2] Underlying this comparative study of Medici sculpture is the belief that its atypical aspects were not only the result of artistic invention, brilliantly realized by sculptors like Donatello who were in the Medici employ, but were also part of a consistent program of imagery designed to distinguish the Medici from their fellow citizens, contrary to the family's persistent claims that they were very much like others sharing their socioeconomic status in republican Florence. Thus when Lorenzo the Magnificent asserted, "Io non sono signore di Firenze ma cittadino con qualche auctorità" (I am not the ruler of Florence, but only a citizen with some authority),[3] he clearly indicated the ambiguous nature of Medici meaning, one that their sculptors very cleverly delineated not only by their astonishing innovations but also by their use of the familiar in very unfamiliar ways.

The Devotional Image

Inventories from the fifteenth and sixteenth centuries indicate – not surprisingly – that the domestic interiors were punctuated with numbers of devotional images, most of which probably conformed to a small number of presumably mass-produced types. One of the best known of these is the relief of the half-length Virgin with the Christ Child known in marble, stucco, polychromed terracotta, glazed terracotta, bronze, and even glass examples. The market for reliefs of this type must have been enormous given that so many remain as de rigueur representations of Renaissance sculpture in museums around the world (Fig. 36). The effectiveness of the relief as an object of devotion depended upon its familiarity, like often-repeated prayers. The image is inextricably related to similar painted representations of the Virgin and Child, themselves connected to miracle-working icons. To tamper with the formulaic aspect of the image would have undermined the devotee's ability to read the icon for what it was, a potent symbol of the possibility of divine intervention in human life, and thus its effectiveness. Repetitions of this imagery in more than one room of a palace hardly diminished its potency; rather, it enhanced its power by making the image canonic and at the same time accessible.

Figure 36. Group of Anonymous Florentine *Virgin and Child* Reliefs, Museo Bardini, Florence (Charles Seymour, Jr. Archive)

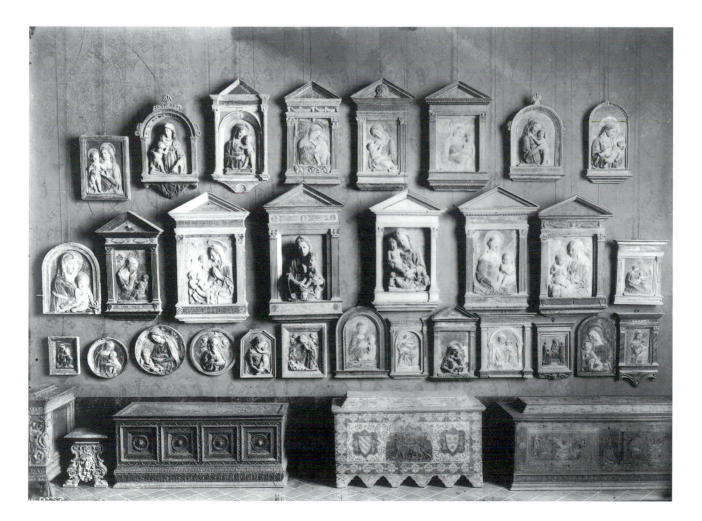

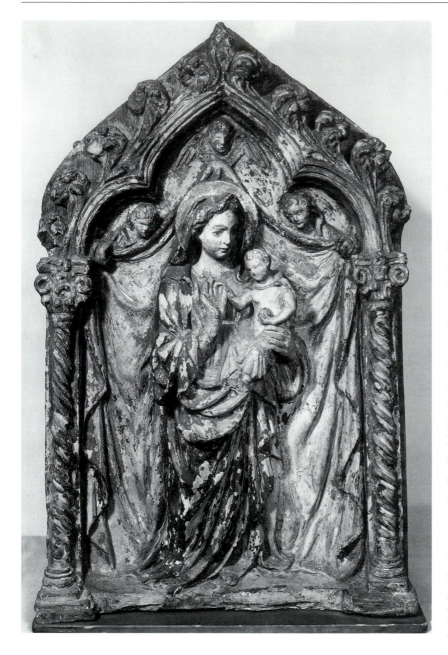

Inventories from the fifteenth century reinforce the sense given by numerous extant Madonna and Child sculptures of the pervasiveness of this type of imagery during the period. An early Medici inventory of 1417/18 lists a small terracotta Madonna,[4] while a later Medici inventory of 1498 includes a gesso Virgin and two other Virgins, one painted and one in relief.[5] Chronologically between these two inventories, another inventory from 1445 of the Inghirami household lists a terracotta Virgin.[6] Although the inventories make it clear that the devotional images could be either freestanding or in relief, the deliberate references to some as painted whereas others are described simply by medium make the issue of pigmentation problematic. More than likely all sculpture in terracotta and stucco was in some way pigmented to suggest a vivid naturalness. However, it is well to remember the glazed terracottas of the Madonna and Child from the Della Robbia shop that often treat the figures as if they were white marble reliefs against a painted ground. In addition to displaying familiar bust-length reliefs of the Virgin and Child, domestic interiors were probably also decorated with reliefs of the standing Virgin and Child set within a tabernacle like those from the workshop of Michele da Firenze (Fig. 37), many of which have additional figures of angels or of flanking saints.[7] The large size of some of these reliefs suggests a more public setting than a domestic interior, but there are enough examples of a modest size to support claims for their existence in family quarters. Such sculptures of the Virgin in terracotta and gesso, like those mentioned earlier, were most likely pigmented naturalistically. The inexpensive nature of terracotta and gesso suggests mass production;[8] their fragile material, however, virtually guaranteed that a very high percentage of those that were actually produced have been destroyed over time.

Without making too much out of formulaic and oftentimes inconsistent scribal descriptions it is possible to note that the operative descriptive terms in

Figure 37. Workshop of Michele da Firenze, *Virgin and Child*, Victoria & Albert Museum, London, mid-15th century (photo: courtesy of the Board of Trustees of the Victoria & Albert Museum)

the references just noted deal with materials ("di gesso"), with finish ("dipinta"), and with form ("di mezo rilievo") as if each were a cue to type, the last perhaps employed to distinguish popular relief images of the Virgin and Child from similar paintings on panel that are sometimes – but certainly not always – described in the inventories as "tavole."[9] Yet other possibilities of form and finish occur in the item listing "two Virgins, one painted and one in half-relief"; here the implication is that the painted Virgin may have been freestanding and that the relief may not have been completely painted.[10]

Possibilities exist for sculpture that could not have been described as "mezo rilievo": the familiar, frontal, bust-length Virgin embracing a Christ Child, sometimes including a base, and the not-so-familiar figurine of the seated full-figure Virgin holding her infant son (Fig. 38). Each of these types employs a composition implying placement against a wall, and each has a more or less flat, unfinished back attesting to its intended position. The downward glance of the Virgin or the Christ Child in virtually all of these quasi reliefs suggests that they were placed above eye level, most likely above the wainscoting of the room, as they appear in the woodcut illustrations to Savonarola's *Arte del Ben Morire*, published after November 1496 when it was given as a sermon.[11]

The Medici inventories carry information about yet another aspect of Virgin and Child imagery. References to two marble Madonnas in the chapel of the villa at Fiesole suggest that when such images were placed within a religious setting they were made in a medium appropriate for the solemnity of the place.[12] Whether these were completely freestanding figures, quasi reliefs like the *Madonna and Child* in Washington, or half reliefs is not clear from the evidence. In any case it seems safe to say that production of devotional images in inexpensive media like terracotta, gesso, stucco, and wood would have guaranteed their presence in the households of others than merely the financial elite.

Inexpensive multiples were not the only devotional images of the Madonna and Child in domestic interiors. The Medici inventories, for example, include a bronze plaque of a Virgin and Child with angels, a small marble relief of a Vir-

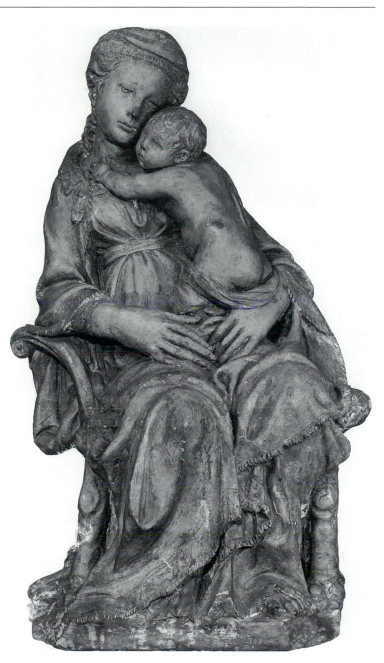

Figure 38. Anonymous Florentine, *Virgin and Child,* Victoria & Albert Museum, London, c. 1400–50(?), (photo: courtesy of the Board of Trustees of the Victoria & Albert Museum)

gin and Child by the hand of Donatello, and a framed gilt bronze plaque of a Madonna and Child also by Donatello.[13] The dimensions of the first of these, at one by two-thirds braccio (nearly 24 × 16 in.), would have made it an impressive and noticeable example of the bronze caster's craft.[14] Small plaquettes of the same subject in bronze and other metals also existed as personal amulets for devotion and must have proliferated throughout the society. What all of these devotional sculpted images of the Virgin and Child indicate – regardless of their medium – is that within the domestic context they presented an iconic rather than a narrative image. Narrative sculpture did appear in major public commissions such as Arnolfo's overdoor sculpture of the *Nativity, Annunciation to the Shepherds*, and *Dormition of the Virgin* then on the facade of Florence Cathedral and Ghiberti's reliefs for his two sets of Baptistry doors. But within a private household, religious narrative apparently was restricted to painted images.[15]

Of course religious imagery of the domestic interior was not restricted to the Virgin and Child, although such figures existed repeatedly within individual households as inventories make abundantly clear. The Medici inventory of 1417/18 lists among the objects in Cosimo's room in the old Medici palace a small wooden Gesuino figure framed in a tabernacle and clothed with a blue velvet dalmatic and a shirt, with a second costume of a deacon's habit.[16] Extant examples of such Gesuino figures (discussed so provocatively by Christiane Klapisch–Zuber in this volume)[17] show the Christ Child either nude or in swaddling clothes, an image of incarnational redemption deriving from St. Francis's first use of the doll-like sculpture at the Christmas Eve mass in Greccio in 1223. For whatever talismanic reasons that it was used within a private dwelling – either in the room of a family member or in the cell of a nun – the Gesuino's purpose was obviously to make present the newly born Redeemer, whose advent was miraculously attested to by shepherd and king alike (thus perhaps explaining its popularity across the society).

Yet the inventory states clearly that the Medici Gesuino was dressed in a dalmatic, in other words, in a type of costume that seems atypical of other such dolls clothed with cloaks or coverings of a more nondescript, albeit luxurious, nature. The dalmatic with which the doll was clothed – and a second one was recorded with the statuette – is the ecclesiastical costume of the deacon; it is not clothing normally, if ever, associated with Christ or with the Gesuino figure.[18] Significantly, however, St. Lawrence, one of the Medici patron saints and specifically the patron of Cosimo's brother, Lorenzo (1395–1440),[19] was a deacon and is always depicted wearing a dalmatic, except in scenes of his martyrdom. How this conflation of images came about or just what apotropaic meaning the Medici intended we will probably never know. Yet even in this seemingly innocent reference to a type of sculpture pervasive in the culture, the Medici apparently manipulated the image in a way that transformed the general meaning of the "bambino nostro signore" as a talisman for birth and blessing to one more particularly tied to their family pantheon and to their neighborhood parish

church of San Lorenzo, whose history changed definitively when Giovanni di
Bicci spearheaded a new cooperative building project there at just the time
when the inventory of his palace was made. This reference is the first docu-
mented example of Medici transformation of a well-defined type – here by
overlaying references to a patron saint onto the traditional Gesuino figure – to
suit their particular needs.[20]

Although the function of the Gesuino and the Madonna and Child figures as
meditative devotional objects in private places seems obvious, there are other
sculptures of a religious subject matter that appear in inventories and that seem
to stand outside such categorizations. A marble St. John is recorded without an
evaluation in the chapel at the villa in Fiesole, for example.[21] And a record of
1499 notes a freestanding marble Baptist in the palace on the Via Larga,[22] as well
as a statue of St. Francis, without an indication of its medium or value, in Piero's
anteroom and a marble Madonna in a gilt wood frame in Lorenzo's room.[23]
Given the high evaluation of 100 *lire* assigned the statue of the Baptist and its
description as "tutto rilievo," this marble statue was presumably carved at nearly
life-size and may have resembled the type of the marble *St. John the Baptist*
attributed to Desiderio da Settignano, now in the Bargello, or of Benedetto da
Maiano's comparable St. John over the doorway of the Sala dei Gigli in the
Palazzo della Signoria.[24] Regardless of who may have carved the Medici statue,
its reference to the patron saint of Florence gives it an unmistakable political cast.
The St. Francis can also be securely thought to refer to a freestanding figure ("di
tutto rilievo"). In a manner familiar but frustrating to readers of Quattrocento
inventories, no indication of size is given for the St. John or the St. Francis, nor
for that matter for the Madonna sculpture, which presumably would not have
been as large as the tabernacle in which the inventory taker found the sculpture.
The St. Francis may have been a polychromed wood figure or perhaps a painted
terracotta, although terracotta figures are normally so indicated in the inventory.
If the figure was of wood, it was most likely life-size.[25] Whether of wood or ter-
racotta, the St. Francis marked an unusual use of freestanding sculpture of a saint.
This type was normally reserved for ecclesiastical interiors – like Donatello's
wood *St. John the Baptist* of 1438 for the Florentine community's chapel in the
church of the Frari in Venice – for the very reason that its coloristic naturalism
was a powerful mnemonic device to make the presence of the saintly figure real
to the devotee. Given Cosimo's patronage of Franciscan sites, especially in the
Holy Land, at Bosco ai Frati, and more locally in the Novices' Chapel at Santa
Croce, it is *not* surprising to see imagery of St. Francis in the Palazzo Medici.
Available inventories from the period, however, indicate that its form was
unusual if not unique for private households, marking it as an appropriation of
ecclesiastical decoration for personal use to imply Francis's special protection for
the Medici through his sacral presence in their palace.[26] Parenthetically, if the St.
Francis is a record of a statuette, it marks a category of sculpture for which no
examples remain extant.

Images of Contemporary History

Losses of sculpture due to continuous remodeling of private dwellings make it difficult to assess how much sculpture might have existed within the Florentine Renaissance palace other than devotional objects such as wood Gesuino figures or polychromed terracotta and plaster of paris reliefs of the Virgin and Child. In fact little historical evidence about the presence of sculpture in the interior spaces of private palaces exists. Much of our information comes from objects dating to the second half of the century, and these are of a sufficiently small number to make general statements suspect. Although small stone sculpture – most often of animals – may have decorated newel posts, and family *stemmi* seem to have appeared on stone fireplace hoods and door lintels early in the Quattrocento, decorative reliefs framing doorways, stone figures flanking fireplaces, and figural reliefs over fireplaces were a later development. Thus the portrait of Piero de' Medici (Fig. 19) must have been a remarkable work when it was made in 1453, not just because of its verisimilitude or because of its supposed revival of an antique form, but because by its presence it introduced a completely new element into the restricted decorative vocabulary of Florentine interior spaces, where sculpture seems to have played a role decidedly subordinate to painting.[27]

Given the numbers of portrait busts in the round from the fifteenth century it is perhaps useful to recall that Mino da Fiesole's marble portrait of Piero de' Medici was the first of its kind. The development over time of this genre of sculpture – starting almost immediately with Mino's portraits of Piero's wife, Lucrezia Tornabuoni, and his brother, Giovanni – and modern discussions of its sources (such as that by Irving Lavin in this volume) should not diminish the extraordinary inventiveness of Piero's portrait.[28] Reading of the extant Medici busts must be done in the context of the other portrait sculpture of the period that no longer exists. An inventory made at the time of Lorenzo's death in 1492 lists a marble head with the features of Cosimo.[29] Although it is impossible to say when this "head" was carved, it may have been part of the ongoing project that produced the busts of Piero, Lucrezia, and Giovanni. It is too easy to fall into the trap of seeing the three extant Medici busts merely as compelling representations of the physical appearances of the three individuals and as a generic mark of their economic status and humanist learning. Yet even a cursory glance at the two male busts suggests different social roles for the brothers. Piero presents himself in contemporary costume, a *vera imago* (true image) as it were of the Florentine citizen-merchant.[30] The classical sources of the portrait bust are overwhelmed by the immediacy and physicality of Piero's person. His brother Giovanni, however, is clothed in an imagined and inventive cuirass, like decorative parade armor, thus more closely recalling the Roman imperial cuirass type. As first son and future head of the Medici family, Piero was careful to have himself portrayed as a citizen, differentiated from the Roman sources perhaps best known through imperial images of rulers. Giovanni, as second son, was apparently freer to experiment with his self-image and chose a theatrical costume that suggests the attire worn

by men of his elevated social status who participated in contemporary parades and tournaments. Thus the two portraits flatteringly, but distinctly, differentiate the individual roles of the two men within their family structure.

Attention to these impressive and important portraits seems unfortunately to have led to scholarly amnesia about other portraits also in the Medici collections. The 1492 inventory lists in a tantalizingly imprecise manner a marble head in full relief, eight marble heads, four large marble heads, and a marble head by Deside-rio da Settignano.[31] An inventory of 1498 notes a child's head taken from nature and painted.[32] Given the specific indication of the head having been made "from nature," this gesso head of a young boy most likely depicted an actual member of the family, one who had grown up and who was thus perhaps not recogniz-able to the persons taking the inventory. The Medici household (and presum-ably others as well) seems to have had even more of these "heads" than the inventories would indicate if the 1496 list of Verrocchio's works for the family drawn up by the sculptor's brother Tommaso can be trusted; it lists twenty masks (*maschere*) "taken from nature" for which the Medici apparently still owed money.[33] All of these heads "taken from nature" were undoubtedly life masks or death masks, modeled on the actual bodies of the people they represented.

As in the case of most items listed in inventories, no dates can be proposed for these heads unless they can be securely connected to existing objects because they are so generically indicated. Although the extant Medici busts are carved from marble and the masks in the Verrocchio records were presumably of wax or gesso, there are also records of a number of portraits in inexpensive materials like terracotta and gesso that must have satisfied the need of families with fewer financial resources than the Medici to respond to the novelty of the portrait bust. Lydecker has found one gesso and two terracotta portraits in inventories of houses of the Brancacci and the Nerli: a gesso figure of Zanobio Brancacci dates prior to the inventory of 1480 in which it is mentioned, and two terracotta heads representing Bartolomeo de' Neri and Mona Chontessina date prior to a 1519 inventory of the house of Alessandro di Giovanni de' Nerli.[34]

Thus evidence indicates that Florentine households contained numbers of busts (and perhaps relief portraits), a type of sculpture apparently new within the private environs of a family palace.[35] The impact of these portrait busts can be seen in a print normally dated to c. 1460 from a sequence showing the months of the year and the activities over which the regnant god or goddess of the month held sway normally. For the month of May, Mercury rules as a classical patron saint of the arts (Fig. 39) over a city clearly intended to represent Florence, with the Loggia della Signoria a focal point in the background and the crenellated facade of the Palazzo della Signoria and the now destroyed church of San Piero Scheraggio at the left rear. In the lower left corner is a goldsmith's and sculptor's shop where a figure is engraving on what appears to be a metal plate and a well-dressed man dis-cusses the purchase of a richly decorated ewer. Plates and belts with metal buck-les are displayed inside the shop. In front of the shop a carver is putting the finishing touches on a marble bust of a woman decorously dressed in contempo-

MERCVRIO E PIANETO MASCHVLINO POSTO NELSECONDO CIELO ET SECHO MAPERCHE LA
SVA SICITA EMOLTO PASSIVA LVI EFREDO CONQVEGLI SENGNI CH SONO FREDDI EVMIDO COG
LI VMIDI ELOGVENTE INGENGNIOSO AMA LRSCIENSIE MATEMATICA ESTIVDIA NELLE DIVI
NASIONE ALLCORPO GRACILE COE SCHIETTO ELDRI SO TTILI ISTATVRA CHONPIVTA DE
METALLI ALARGIENTO VIVO ELDI SVO E MERCOLEDI COLLA PRIMA ORA P IS EZZ
LANOTTE SVA EDELDI DELLADOMENICHA APERAMICO IISOLE PER NIMICO AVENE
RE LASVA VITAOVERO ESALTATIONE EVIRGO LASV MORTE OVERO NVMILIASIONE
E PISCE HA HABITASIONE GEMNI DIDI VIRGO DINOTTE VA E IZ SENGNI IN 78
DI COMINCIANDO DA VIRGO IN ZO DI E Z ORE VA VN SENGNO

Figure 39. Baccio Baldini (attr.), *Mercury*, British Museum, London, c. 1460 (photo: British Museum)

rary costume. In the left corner a male bust (which could be of marble or of terracotta) is much more fancifully costumed with a winged helmet and a cuirass like that worn by Giovanni de' Medici. These two portrait busts are put in the foreground in the print, giving them a prominence over the other arts and perhaps suggesting their novelty among the myriad of artistic endeavors represented in the print.[36]

Through their virtual silence on the matter, inventories for the period indicate that a pervasive form of portraiture at this time, namely, the wax death mask, was not part of the visual field of family dwellings, understandably perhaps given the mask's morbid nature.[37] Lydecker has discovered a reference from 1504 to what appears to be a death mask of Lorenzo the Magnificent placed in a small casket belonging to Cosimo di Lorenzo Bartolini.[38] Despite the numerous wax votive images in public places, most notably the church of SS. Annunziata and the Baptistry, it seems that the commemorative function of the wax death mask, like that of the tomb slab, was isolated in an environment that transformed individual images into civic history. When actual death masks existed in private possession they seem to have been kept in a protective covering, out of open view.

Although the actual death mask was absent from view, the wax effigy could be transformed into a more permanent material and into a form approximating the antique portrait bust. The curious and variously identified bronze portrait bust of a woman, now in the Bargello (Fig. 40),[39] may give some indication of what such "figures" or "teste" looked like. A bronze head of a baby stored in Giuliano's clothing cassone noted in the Medici inventories may denote another of these cast figures,[40] hidden from view in the domestic interior. Although the blank, pinched features of the bronze female head in the Bargello clearly mark it as a reworking of a death mask, not all mask-derived busts of the period are as obviously recognizable. The famous yet enigmatic bronze bust of a youth wearing an ancient cameo around his neck (Fig. 34) most likely also derives from a

mask, given its bland presence and the summary placement over the shoulders of the figure of fringed towels that bear no resemblance to clothing either of the fifteenth century or of the ancient world.

To appreciate the full power of Piero's portrait (and of those of his wife and of his brother),[41] it might be useful to review for a moment who was accorded a "portrait" image and where contemporary Florentines displayed such images. In sculpture the most compelling precedent for Piero's portrait can be found in the tradition of the reliquary bust, although the antique portrait bust must also have been a compelling source. Piero's image, therefore, seen in the context of the visually familiar reliquary image, would have gained an elevated status and, if

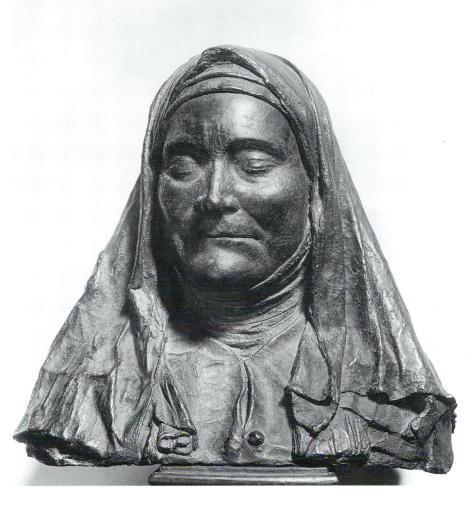

Figure 40. Anonymous Florentine, *Head of a Woman*, Museo Nazionale del Bargello, Florence, 2d half of 15th century (photo: Charles Seymour, Jr. Archive)

not veneration exactly, certainly respect. That the Medici portraits were all placed over doors subsequent to their carving suggests that the family was prepared to sacrifice the particularities of the physiological form for the commemorative status conferred by the overdoor arch. It is useful to ask what the placement of the busts in arches over doors might have recalled to a visually aware contemporary viewer. The overdoor arch recalls the shape of the wall perforations of ancient Roman columbaria in which there were occasionally portrait busts as well as cineraria.[42] More tellingly, such arches recall the forms of Roman funerary stelai, tombstones, and altars in which the deceased – sometimes an individual and sometimes a husband and wife together with a child – appeared bust-length beneath an arch. That these antique images were known during the fifteenth century is evident from the epitaph monument of Stefano and Maddalena Satri in Sant'Omobono, Rome, where the couple appears in bust form under an arch. The epitaph monument was a form designed to extol the accomplishments of the persons represented, an idea of aggrandizement that must have become attached to the Medici busts after they were placed in segmental pediments over doors in the palace.[43] Thus Mino's busts, perhaps moved after the deaths of the individuals portrayed, provided in their new locations a pantheon of revered and praiseworthy ancestors for the subsequent generations of the family.

There is perhaps an even more important source for understanding the appearance of the portrait bust in the Medici Palace and the subsequent proliferation of portrait busts among the elites of Florence and of other cities. This source is the category of state-defined civic portraiture, which is quite distinct from funerary images. An expense account of 1465 lists a head of Petrarch made from an unnamed material and a gesso head of Dante.[44] These two heads sound a delayed echo of a 1396 project of the Opera of the Florence Cathedral to procure the ashes of Dante, Petrarch, Boccaccio, and Zanobi da Strada for burial in the cathedral as a public display of Florence's literary greatness and, by extension, as a mark of the greatness of the state.[45] The honoring of long dead "famosi cives" was renewed in the Quattrocento with the burial of Brunelleschi in the cathedral and with the accompanying commission to Buggiano in 1447 for a cenotaph of the architect. It should be noted that this project predates the Medici busts, making the Brunelleschi bust the earliest of the extant Quattrocento sculpted portraits appearing to be from life. Later commissions produced portrait cenotaphs for Giotto (1490) and the organist-musician Antonio Squarcialupi (1495).[46] These examples seem to indicate that portrait busts were associated with the idea of the "famosi cives" and that Piero may deliberately have tied his own bust to these projects. Medici portrait busts, in other words, can be seen as appropriations of civic iconography by a family whose control over Florence was being severely challenged at just the time that these images were produced. Tellingly, there were in the Medici Palace portraits of nobles of other Italian city-states with whom the Medici were allied politically. These, however, were painted and not sculpted images; they included a painting with the head of the duke of Urbino; another with the head of Duke Galeazzo Maria Sforza by Piero Pollaiuolo in Lorenzo the Magnificent's room (now in the Uffizi); two heads, taken from nature, of Francesco Sforza and of Gattamelata by a Venetian painter;[47] and a head of a Venetian doge in Pierfrancesco's room.[48] Each of these ruler images, albeit on painted panel, supports the conviction that at the time Mino produced his portraits of Piero, Giovanni, and Lucrezia, portraiture in the Medici household – and in the culture at large – was equated with rulership and the power of the state.

The Medici portrait busts are related as well to concurrent private commissions of twelve Roman emperors – themselves a defined group of *famosi* due to Suetonius's *Lives*. The iconographical type of the twelve Caesars is first mentioned in sculpture in a payment of 1455 to Desiderio da Settignano in connection with a commission from Giovanni de' Medici, a commission connected to the marble head by Desiderio in the 1492 inventory.[49] Desiderio's commission was apparently for Giovanni's villa in Fiesole. A Quattrocento relief of this type still exists in the Palazzo Medici, hidden among bits of classical (and forged) sculpture and epigraphy attached seemingly haphazardly to the walls of the courtyard (Fig. 41). The antiquarian cast of these reliefs, comparable to the roundels in the Medici Palace courtyard, represents the earliest Florentine sculptural attempts in a private context to reproduce Roman iconography in a stylistic form that could be read as antique, deriving as it does in this case from

Roman coins. Despite the modest size of these reliefs they do seem a daring use of imperial imagery – Suetonius's great emperors – by the Medici (and others) in a republican city-state.[50] It is no whim of patronage that centered the commissions for sculptures of the twelve emperors within a private sphere rather than in civic contexts where their imperial iconography would have appeared contradictory to the notion of a republic.

This Roman imperial imagery seems quickly to have captured the imagination of other patrons even if they could afford only gesso versions of the emperors, as a record of expenses for purchases for his palace made by Lorenzo di Matteo Morelli in 1465 demonstrates.[51] Morelli listed a polychromed gesso head of Hadrian among the other objects for his household. That the head was made from gesso suggests replication and perhaps even a proliferation of such imperial imagery in domestic decoration toward the latter part of the century.

Figure 41. Anonymous Florentine, *Head of a Roman Emperor*, north wall of courtyard, Palazzo Medici, Florence, after 1455 (photo: author)

The Biblical and Mythological Image as Civic Metaphor

Although the Medici Palace seems to have maintained a severe interior architectural vocabulary there are enough records and remains of the sculpture that decorated the palace to indicate that the decorative program belied the conservative nature of the actual architectural frame.[52] This is most clear in the use of large-scale marble – and more particularly bronze – sculpture throughout the Medici Palace. For obvious reasons, life-size sculpture does not seem to have penetrated the interior spaces of the normal Renaissance palace. The spaces either were used for too many different functions or were too small to accommodate an immovable object, even one relegated to a wall niche. The Medici's transformations of traditional palace spaces by sculpture, therefore, must have been immediately evident to contemporaries upon entering their palace. In the palace courtyard, itself an unusually large, open, and symmetrical space, the Medici placed Donatello's bronze *David* (Fig. 7). Perhaps the most famous – yet still the most puzzling – of the Medici commissions, the *David* most likely faced on axis the main *portone* of the building.[53] For its time, it is unusual in its medium, novel in its iconography, and provocative in its sensuality. These aspects of its appearance have provoked a barrage of recent studies of the figure that is as daunting to modern readers as was Goliath to the Israelite army. Whether or not the statue is the first freestanding male nude since classical antiquity, however, is really of minimal interest without some sense of how it plays with the accepted traditions of sculpture of its type.

The simplest interpretations of the *David* place it in an iconography that is distinctly civic. After all, Donatello's marble *David* of 1408–9, originally carved for one of the buttresses of the north tribune of the cathedral, was placed in the Palazzo della Signoria in 1416, an appropriate symbol of a republic successful – or hopeful of success – in repulsing its enemies. Lorenzo and Giuliano de' Medici sold Verrocchio's bronze *David* to the Signoria in 1476, beginning an augmentation of Davidian imagery at the Palazzo della Signoria that was to cul-

minate with the placement of Michelangelo's *David* at its entrance in 1504. What is not emphasized in the literature is that Verrocchio's *David* had stood in some Medici location for some time before 1476; whether or not it had been in the Palazzo Medici, the statue would have been associated with Donatello's bronze *David* in the courtyard, providing a repeated Davidian iconography in the Medici household in a medium that itself had civic overtones. In deaccessioning Verrocchio's *David*, Lorenzo and Giuliano both disembarrassed the Medici Palace of a state image and sited the statue more appropriately as a symbol of Florentine civic freedom on the landing by the entrance to the Sala dei Gigli.[54] At the same time they reinforced the civic overtones of Donatello's bronze *David* in the courtyard of the Medici Palace by establishing its companion image at the town hall, a pairing that equated their private palace with the site of legitimate governance.[55]

An interpretation based on iconography alone, however, tells only part of the complicated tale of Donatello's *David*. The medium of bronze is extraordinary for a commission in a private palace. Its costliness made it exclusively a medium for public, civic commissions, like Ghiberti's bronze doors for the Baptistry or like the various equestrian statues of the period that were either state commissions or controlled by the state. Moreover, the first record of the statue appears as part of a description of the wedding of Lorenzo the Magnificent in 1469. It indicates that the *David* was placed on a column, as statues had often been in the Roman Empire. Use of this type in the dwelling of a private citizen is also noteworthy, especially because the statue would have been the first image visible from the main gate and the *androne* of the palace. Recent discussions of the statue have seen it as part of an overall decorative program, a magnetic pole that drew meaning to it from the entire environment in which it was placed.[56] The formal vocabulary of that unusually large and symmetrical courtyard framing for the *David* is overtly classical, with its elaborate Corinthian column capitals and its large relief roundels, deriving from ancient gems and cameos, on the walls above the arches. In a way not yet encountered in Florentine palaces at the time, the Medici courtyard would have read as a deliberate, even if somewhat chilly, reconstruction of an ancient Roman interior, quite distinct, it should be added, from the exterior of the palace, which was seen as thoroughly traditional.

The *David* has references outside the courtyard as well, particularly to Donatello's *Dovizia*, erected in 1431 in the Mercato Vecchio (Fig. 62).[57] To be sure the column support of the *David* was not nearly as tall as that of the *Dovizia*, but the two statues are unmistakably of the same type. Wilkins has detailed the histories of column figures at the Mercato Vecchio, indicating that a Roman inscription from a statue base found near the *Dovizia* also records a personified figure of the Genius of the Roman Florentine colony. Insofar as Roman Genius figures are nude males, this reference is a telling one for the bronze *David*.[58]

But even more interesting is Luca Landucci's comment in his diary that criminals were chained to the *Dovizia* column as a form of public humiliation after they had been condemned.[59] Thus, like the bronze equestrian statue of Marcus

Aurelius (Fig. 16) then in the area of the Lateran Palace in Rome before which criminal sentences were rendered, the *Dovizia* column must have functioned as a symbol of justice, of the state maintaining order and protecting its citizens. This meaning of justice then would have existed alongside the meaning of abundance and civic charity implied by the *Dovizia*. The bronze *David* in the Medici courtyard, therefore, not only employed the civic imagery of David in the palace of a private citizen, it also used a compositional format or type that echoed the only other extant column statue in Florence, thus giving a share of the meaning of justice and charity to the private palace of the Medici.[60]

The bronze group of *Judith and Holofernes* (Fig. 65) continued in a more direct way – by means of a recorded inscription – the placement of civic imagery within the Palazzo Medici. Like the *Dovizia* the *Judith* was also a column statue, a female personification of virtue to pair with Donatello's civic image in the Mercato Vecchio. As if to ensure that viewers make the connection between the two, they are similarly posed with right hand raised high and left hand lowered in front of the torso, in the earlier figure cradling a cornucopia, in the later, grasping the hair of Holofernes's partially severed head. A marginal note in a copy of a letter of condolence to Piero di Cosimo on the death of his father in 1464 indicated that the column supporting the Judith bore an inscription: Regna cadunt luxu surgunt virtutibus urbes caesa vides humili colla superba manu.[61]

The glossator also indicated that the statue was in an "aula," or courtyard, of the palace, without specifying its location further. The term "aula" is puzzling in the context of the Medici Palace, because it normally refers to a formal reception hall, suggesting perhaps that in this case the courtyard was intended to represent the carefully ideated iconography of the family to a public audience. What is clear is that in medium, in type, in placement, and in the civic implications of its meaning the *Judith and Holofernes* is similar to the *David*. But more than being a female counterpart to the *David* the *Judith* – like the *David* – must be seen in relation to a very specific iconographic tradition. Read together the two statues recall that Judith and David were among the figures represented in *uomini famosi* groups in painting, the most extensive Florentine group being the now lost series of paintings in the Sala dell'Udienza of the Palazzo della Signoria with inscriptions by Coluccio Salutati.[62] The *uomini famosi* paintings were meant to establish a lineage of exempla and to lend prominence to the state or to the prince commissioning them. Vasari indicates that Giovanni di Bicci had a set of *uomini famosi* painted for the old palace of the Medici by Lorenzo di Bicci,[63] thus establishing a tradition of this iconography within the family patronage that was revisited in Roman guise by Desiderio's reliefs of the twelve Caesars for Giovanni di Cosimo and by the *Judith* and the *David*.

At least one other Florentine family could boast comparable sculpture in its palace, although, like the Medici examples, the dating and original placement of their works are problematic. The marble *St. John* in the Bargello mentioned earlier was in the Martelli Palace, a location that also apparently housed the marble *David* now in the National Gallery in Washington.[64] The temporal relationships

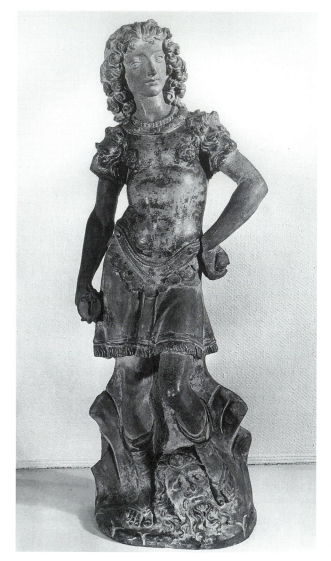

Figure 42. Master of the St. John Statuettes, *David*, The Art Museum, Princeton University, Princeton, late 15th century (photo: The Art Museum)

between the Martelli and the Medici statues may never be clarified, but the presence of large-scale figures of the Baptist and of David in palaces hints at the "secularization" of civic imagery in the latter part of the century. In this particular instance it also suggests that the very close relations between Roberto Martelli and the Medici lie behind the duplication of imagery in the two family palaces. This does not mean that the sculptures' religious content or efficacy in stirring devotion had diminished, but that publicly scaled figures had moved from sacral sites such as churches, civic buildings, and piazzas to private dwellings. The proliferation of civic icons in private palaces is manifest by the numbers of terracotta statuettes of St. John the Baptist and David patently derivative of the larger scale examples just mentioned (Fig. 42).[65] The miniaturization and medium of this imagery may reflect market economics, but they also underscore the unusual nature of the sculpture in the Palazzo Medici and how it undermined the potency of Republican civic imagery by thinning it across the society and by removing its exclusivity as state imagery located in sites of ecclesiastical, governmental, or corporate power.[66]

Medici sculpture differs from that of the Martelli family in its repeated use of bronze, a material normally reserved for monumental civic sculpture because of its cost. Thus although the iconography of Medici sculpture may be the same as sculpture in other palaces, the medium of the *David* and the *Judith* and *David*'s placement on a quasi-public visual axis within the courtyard suggest that the Medici were differentiating their commissions from those of other private citizens and were assuming what might be termed an iconography of medium to transform their environment into a site that would be simultaneously personal and civic.

A second cryptic and tantalizing reference to what was apparently yet another potent civic image in the Medici household appears in the 1492 inventory. A standing nude figure in marble with a club stood in the main room of Lorenzo's living quarters.[67] Like the figure itself, its sculptor is unnamed. The size of the statue is unfortunately also not indicated. The figure is, moreover, unevaluated, as if the inventory taker did not know what value in *lire* to put on it. Its lack of identification indicates that the figure was not a saintly one; most saints – like the inventoried St. Francis in Piero's anteroom – would have been recognizable. The description does, however, clearly point to Hercules as the subject because he is often represented holding a club, although the figure is without the lion skin that was usually his identifying feature in sculpture and painting of this period.[68]

A small table bronze datable to the end of the Quattrocento (Fig. 43) shows one variation of this type with Hercules resting his club on the ground while holding the apples of the Hesperides in his extended left hand. Other figures datable to the same time in Florence show Hercules leaning on a long club, essentially nude but for a decorative swag of drapery (rather than a lion skin) slung from under the right arm around his back to the left hand.[69] It is tempting to see such figures as reductions in bronze of the marble "standing nude figure . . . with a club" in the 1492 inventory. The scribe's failure to name the figure in the inventory (if he did recognize it without the lion's skin) may have to do with his awareness that Hercules had been a state symbol for the city of Florence at least since the end of the Dugento, when Hercules with his club – and lion's skin – began to appear on the state seal of the city. Were the "standing nude figure with a club" a Hercules, the Medici would clearly have been appropriating a state symbol – like the *David* and the *John the Baptist* – for their own. The figure would have been a further example, the only one in marble, of the Hercules imagery that was so prominent in the Palazzo Medici, most particularly in the large paintings by Pollaiuolo of the Labors of Hercules.[70]

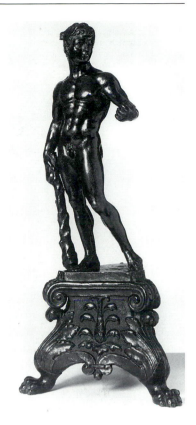

Figure 43. Anonymous Florentine, *Hercules*, Victoria & Albert Museum, London, c. 1500 (photo: Courtesy of the Board of Trustees of the Victoria & Albert Museum)

The Imago Contrafacta

If either of the small bronze variants captures the actual marble statue of the inventory, the Medici sculpture could not have been antique, for no antique figure is known with the poses and gestures of these statuettes. Although it is a truism that antiquity played a substantive role in the collecting and manufacture of works of art in the Medici environs, the deliberate blurring of the boundaries between actual antiquities and reconstructions – if not outright forgeries – of antique works has been little commented upon.[71] Perhaps the most famous example of Medici re-presenting antiquity is the red marble *Marsyas* now in the Uffizi. On the basis of a list of works that Andrea del Verrocchio had completed for the Medici, which includes mention of a "red nude," it has long been thought that Verrocchio had been responsible for the restitution of the Uffizi figure by attaching limbs to the fragmentary extant torso of this second-century sculpture so seamlessly that it is still difficult to differentiate the boundaries of the antique and the "restorations" in the sculpture.[72] Recent study by Francesco Caglioti indicates that the statue was repaired as early as c. 1465 and that it was one of four figures of Marsyas that the Medici eventually owned.[73] For all intents and purposes the additions to the Marsyas torso constitute a "forgery" of the antique, just as Michelangelo's later *Bacchus* and *Sleeping Cupid* were to trick their viewers into believing that the works were ancient sculptures. But sculpture of a comparable nature seems to have been made at least since the middle of the century if the relief heads of the twelve Caesars or the roundels in the courtyard of the Palazzo Medici (echoing the Hadrianic roundels in the Arch of Constantine) are considered as early manifestations of this effort to replicate the antique. This purposeful ambiguity between ancient Roman art and contempo-

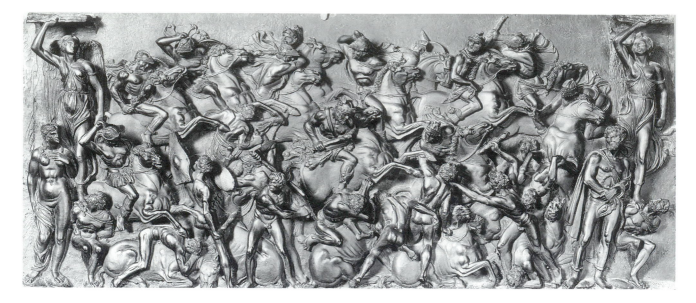

Figure 44. Bertoldo, *Battle Relief*, Museo Nazionale del Bargello, Florence, late 1470s (photo: Charles Seymour, Jr. Archive)

rary manufacture may explain why modern attempts to attribute authorship of these reliefs have been so unconvincing; artists would deliberately have submerged their own styles to make the replicas more convincing.

Among works in the Medici household that can be read as intentional "counterfeiting" of antiquity is Bertoldo's undated bronze relief of a battle (Fig. 44), first recorded in an inventory of 1492 as being over a fireplace in the living quarters of Lorenzo the Magnificent.[74] The *Battle Relief* derives from a ruined Roman battle sarcophagus in the Camposanto in Pisa. Bertoldo replicated *on a reduced scale* the extant features of the sarcophagus and recreated its missing sections, using another battle sarcophagus now in the Museo delle Terme in Rome for additional inspiration. Although the game of art historical priority is problematic both historically and methodologically, Bertoldo's *Battle Relief* is nonetheless the first extant – or recorded – fireplace relief in Florence. The relief is modest in size (45 × 99 cm; 17¾ × 39 in.), but given that it was in a little room ("saletta"), it may have extended the length of a small fireplace, similar to contemporary and later marble fireplace reliefs. Tellingly for the Medici, the relief utilizes a vocabulary that derives from ducal or princely commissions like those of the Este court in Ferrara and the Montefeltro court in Urbino.[75] It differs from its contemporary examples by shifting the medium of the Roman relief to bronze, which both distances it from its antique sources and, at the same time, places it firmly in contemporary traditions of public or civic art.

Perhaps most importantly, just as its relief type has a source in the contemporary decoration of a ducal palace, its subject matter of the battle has an equally precise reference, disguised for modern viewers by the usual discussion of the relief merely as an antique copy or a stylistic pastiche. Its unidentified Herculean battle with the main protagonist at the center of the relief parallels the subject matter and the focus of Uccello's paintings of the *Battle of San Romano* (P/R illus. 5.17) above the wainscoting in Lorenzo's adjacent sala. The Uccello paintings are themselves a direct use of a specific type of historical representation reserved at this time to main rooms in Tuscan town halls where

they depicted the victorious military exploits of the town and its army's lead-
ers. Thus Bertoldo's relief must in its own time have been read as a classicizing
echo of contemporary civic history paintings of which Michelangelo's *Battle of
Cascina* and Leonardo's *Battle of Anghiari*, designed later for the Palazzo della
Signoria, are the most famous.[76] Given the relationship of the *Battle Relief* to
communal messages of state control of the military it is not surprising that its
one imitator – Michelangelo's *Battle of the Centaurs* (Fig. 92) – remained unfin-
ished and apparently unsold, staying in the hands of the Buonarroti throughout
Michelangelo's lifetime.[77] The reason for this relief being an *unicum* lies less in
its expensive medium than in the implications of its iconography: by appropri-
ating communal imagery, regardless of its disguising antiquarian style, the
Medici had confirmed in symbolic visual terms their actual appropriation of the
leadership of the state. The confusing of civic and personal imagery throughout
the Palazzo Medici is also suggested by the presence, seemingly innocuous, of
seven shields with arms of the Comune and of the house of the Medici in the
"sala grande" of the palace.[78] This is hardly the vocabulary of a citizen banker
or for that matter of the leader of a republican state "con qualche auctorità."

The table bronze – recalling the tradition of antique bronzes so extensively
discussed in antiquity by Pliny and in this volume by Joy Kenseth – was perhaps
the most self-conscious replication of the antique during the Quattrocento in
Florence. Championed by the Medici the small bronze resonates with civic
meaning despite its placement in a private environment. The bronze statuette
(Fig. 43) can be thought of as sculpture on a reduced scale. The 1492 inventory
of the Palazzo Medici notes a number of examples: a bronze nude, c. 24 inches
high, with a gold ball in his hand (a Hercules with the apple of the Hesperides?)
and a bronze Hercules and Antaeus c. 8 inches high,[79] as well as a bronze nude
with a broken arm, another bronze nude c. 18 inches high called the "nude of
fear" (a Marsyas), a bronze draped nude with wings at his head c. 8 inches high,
another Hercules, without legs, a bronze nude c. 24 inches high, another bronze
nude with a fish and a snake in his hand, a bronze equestrian figure, and a bronze
centaur by Bertoldo.[80]

It is common to discuss these bronzes in terms of their attribution and their
recuperation of an antique vocabulary for the Quattrocento. But is that all that
can be said about these statuettes? Is there something more that the bronzes can
reveal, even in the somewhat disembodied state of the inventory list? Their small
scale, duly noted by the scribe in a number of cases, lends the statuettes an aura
of preciousness, the feel of the art object to be observed carefully at an intimate
distance much like the antique gems and coins so assiduously collected by the
Medici and others. They are clearly meant for personal reflection, their messages
lost at any distance. Yet their subject matter – insistently classical – speaks of the
heroic. The humanist lessons of moral exemplars drawn from ancient literature
are given shape for contemplation and dialogue in these small bronzes, *ut sculp-
tura poesis.*[81] Yet they also contain resonances outside their strictly humanist
interpretation. Normally discussed within the context of the revival of antiquity,

these table bronzes had other roles to play in the interior spaces for which they were made, as we might guess from the description of the small bronze nude holding a gold "palla," snatched as it were from a Medici *stemma*. Pollaiuolo's *Hercules and Antaeus* (Fig. 53) has been associated with the reference in the 1492 inventory, even though it is more than twice the height indicated for the very small figure group in the inventory. Whether or not the Bargello statuette is the same as the one mentioned in the inventory, it must give some indication of the type of small bronzes, clearly variously scaled, that the inventory catalogues.

If bronze statuettes are isolated as a genre whose only reference is to antique bronzes of a similar size, there is a risk of forgetting that, like some antique bronzes that replicated famous large-scale sculpture in miniature or like Bertoldo's *Battle Relief*, they are of a type that recalls large-scale freestanding sculpture. Because most large-scale sculpture of this period in Florence was religious, the predominantly antique subject matter of small bronzes establishes another iconographic tradition, one that the Medici themselves had clearly begun to establish with the bronze *David* in the palace courtyard, a figure simultaneously Old Testament hero and classical idolino. Owners of the bronze statuette could bring the *statua virile* into the private contexts of their palaces, but they did so by changing the scale and by employing classical mythological rather than Christian subjects. At a time when large-scale antique sculpture was still a rarity in Florence, commissioners of the bronze statuette could "collect" classical antiquities through these surrogates.

The Medici were apparently not alone in having miniature figures of classical heroes in their palaces. In 1472 Lorenzo di Matteo Morelli traded a small gesso Hercules as part of the purchase price for a large mirror for his new palace.[82] There is no indication of when Morelli had acquired this small gesso figure of Hercules or from whom, although he did have business dealings with the Pollaiuolo brothers in 1472 in connection with his marriage.[83] Whether this statuette was a sculpture (a bozzetto?) by a contemporary sculptor or a cast copy from an antique statuette is of little matter because it would most likely have been read the same way in either case. This gesso Hercules, paired with the polychromed gesso bust of Hadrian that Morelli also owned, suggests that collections of "antiquities" could be built not only with original sculpture, but with casts or copies in inexpensive materials; they would, therefore, mark the beginnings of the collections of plaster casts associated with much later academies. In either case, the gesso Hercules suggests a penetration of the iconography and type of the small table bronze much more widely in the culture than extant numbers of small bronzes from this time would indicate.

Other uses of sculpture by the Medici are instructive about the possibilities of use for the medium during the Quattrocento. The Medici's collections of antique gems and coins were famous in their own time, and the family's use of medallic art deriving from antique examples is fascinating for what it tells of contemporary understanding of this genre of sculpture and its particular language. Two Medici medals are especially instructive: the medal of Cosimo (Fig. 45),

Figure 45a (far left). Anonymous Florentine, Portrait of Cosimo, obverse of *Medal of Cosimo de' Medici Pater Patriae*, National Gallery of Art, Washington, D.C., Samuel H. Kress Collection, c. 1465 (photo: National Gallery of Art)

Figure 45b. Anonymous Florentine, Personification of Florence, reverse of *Medal of Cosimo de' Medici Pater Patriae*, National Gallery of Art, Washington, D.C., Samuel H. Kress Collection, c. 1465 (photo: National Gallery of Art)

most likely commissioned by his son Piero in 1465, and Bertoldo's medal of Lorenzo and Giuliano commemorating the Pazzi Conspiracy of 1478 (Fig. 46). On the obverse of the earlier of these two medals Cosimo is shown in profile, a conventional portrait depiction in medallic art. Cosimo's medal most likely coincides in date with the Signoria's posthumous conferral on him in 1465 of the honorific title of Pater Patriae, inscribed on the obverse of the medal. The civic terminology of PAX LIBERTAS QUE PUBLICA inscribed on the reverse is in keeping with that event. Accompanying this inscription is a clearly labeled personification of Florence. Reverses of medals during this period canonically show an allegory of Virtue descriptive of the person shown on the obverse. In the case of Cosimo, however, the image is an allegory of the state, a blatant equation between Cosimo and Florence. Such imagery appears appropriately on medals of rulers, such as the 1446 example of Sigismondo Malatesta, with the lord of Rimini on the obverse and an image of the Castello of Rimini (read Rimini) on the reverse, or the medal of Philip II, which shows the Spanish king on one side and a personification of India (i.e., the Indies, or what the obverse calls the New World in the West),[84] but hardly so on coins of persons claiming to be private citizens.

On the reverse of the Cosimo medal Piero and his medallic artist even invented a new female iconography for Florence (*Florentia*) whose civic images – David, Hercules, the Marzocco – had been predominantly male. The *Dovizia* is the one notable exception to this male iconography of the state, and the

Figure 46a (far left). Bertoldo (?), *Lorenzo de' Medici (1449–92), il Magnifico, and the Pazzi Conspiracy*, National Gallery of Art, Washington, D.C., Andrew W. Mellon Fund, 1478 (photo: National Gallery of Art)

Figure 46b. Bertoldo (?), *Giuliano I de' Medici (1453–78) and the Pazzi Conspiracy*, National Gallery of Art, Washington, D.C., Andrew W. Mellon Fund, 1478 (photo: National Gallery of Art)

Medici seem to have tied themselves to the imagery of that statue as well. Florentia echoes the state imagery of the seated Justice so prevalent in Venice, but with her own unique band of symbols. She is seated on a faldstool, a symbol of imperial rulership since antiquity. In her right hand Florentia holds an orb, a standard symbol of royal power, in this case easily read as well as a Medici *palla*; its ambiguous reading confers power both on the state and on the Medici. The leafy branch that Florentia cradles in her left hand is too small to be identified specifically but may refer to an olive branch, illustrating the inscription at the edge of the medal. There can be little doubt from a reading of the medal that the state and Cosimo are one and that peace and liberty result from Cosimo's governance. This is extraordinary imagery for a man who stipulated – unsuccessfully – that he be buried privately without elaborate civic ceremony.

The unusual form and iconography of Cosimo's medal and its clear message that the power of the state was vested in the individual reappear again in the medal coined to honor Lorenzo and Giuliano de' Medici after the Pazzi Conspiracy. Most likely designed and cast first by Bertoldo (and then restruck by others like Andrea Guacialoti who in a letter of 1478 to Lorenzo mentioned four that he himself had cast), the medal shows a disembodied head of Lorenzo floating above the choir of the cathedral of Florence on one side and a comparable image of Giuliano on the other. In the lower third of each side of the medal Bertoldo depicted the attack on the two brothers that left Giuliano dead of multiple stab wounds.[85] There is no way to employ the terms "obverse" and "reverse" for this medal because the imagery for each of the brothers is similar, making the medal a *unicum* and thus even more challenging to interpret. Clearly, Bertoldo set the brothers apart from other medallic portraiture of the time, itself worthy of note. The uniqueness of the imagery is nonetheless firmly within the tradition of Medici self-fashioning. On this point it is useful to remember that from Cosimo's first instances of patronage he consistently commissioned works of art with his brother, Lorenzo, ensuring that both their names appeared on the finished product, as they do, for example, on the tomb of Giovanni di Bicci and Piccarda de' Bueri in the Old Sacristy.[86] This fraternal union established family rather than individual as a dominating trope and undermined what politically sensitive contemporaries knew, namely, that one man in each generation governed the family's activities both in the household and over the state.

More telling is the use of historical narrative as part of the medal. Although these depictions seem an obvious way to record the event that this medal commemorates, medallic art of the time, in fact, reserved the use of historical narrative for the reverses of medals struck for rulers. A medal of Frederick III of 1469, also attributed to Bertoldo, provides an example. The reverse shows the emperor creating 122 knights on the Ponte Sant'Angelo before Pope Paul II during his state visit to Rome in 1468–69. This image of an actual event is comparable to the representation of the attempt on Lorenzo's life and the murder of Giuliano on the Medici medal. It should be emphasized that no Florentine patrons other than the Medici depicted a particular historical scene on his or

her medal, as if there was a common understanding of the princely prerogatives of this type of imagery.

Consideration of the commemorative medal of the Pazzi Conspiracy raises other issues critical for the history of sculpture in Florence during the Quattrocento. Size notwithstanding, the medal is composed of narrative history of a contemporary event. But there is no sculpture of secular narrative histories in Florence – or for that matter in the Tuscan region – during the Quattrocento. The nearest extant example is the program of narrative reliefs on the tomb of Bishop Guido Tarlati in the cathedral of Arezzo, dating to c. 1329–32 (P/R illus. 2.31 and 2.32); in that instance the Tarlati family had virtual control over the city, making the tomb reliefs imperial presentations of historical events, a mode of presentation appropriate to Tarlati's designs for power. The reliefs on the *Arco Alfonso* in Naples recording Alfonso of Aragon's triumphal entry into the city in 1443 are perhaps the best known contemporary historical reliefs; but in this example Alfonso was the king of Naples, again suggesting that historical relief was the language of the ruler (P/R illus. 5.55). The tomb of Doge Pietro Mocenigo (1476–81) has two reliefs on the sarcophagus showing the victory of the Venetian forces in Scutari and Caterina Cornaro's entry into Cyprus; it is thus as much a monument to the state in the person of the doge as it is a monument to the individual.

The association of narrative history with absolutist political power – going back to Roman imperial reliefs – was obviously strong enough that attempts by humanist scholars to use the Roman relief on their own tombs resulted in a curious hybrid between history and allegory. This awkwardness is clear in Michelozzo's tomb for Bartolomeo Aragazzi in Montepulciano where one panel shows the deceased bidding farewell to his family but surrounded by partially nude, toga-clad males and nude putti. The uneasy mix of contemporary personages and classical figures also appears in Riccio's tomb for Girolamo and Marc Antonio della Torre in Verona where the deceased is shown transported into an antique world populated by ancient gods and goddesses. With very few other exceptions, occurring mostly in Lombardy, the only other examples of elaborated historical narratives in sculpture appear on saints' tombs where the power exerted by the honored figure was presumed to be spiritual and not temporal.[87] Thus the narrative relief in the medal of the Pazzi Conspiracy marks an important moment in the iconography of relief sculpture as well as in medallic art and Medici propaganda.

But the issue of meaning is more complex yet, since one scene shows what could easily be called a "martyrdom" while the other shows an attempted martyrdom. In contemporary paintings of saints' lives scenes of martyrdom, like miracle scenes, are presented as a way of documenting the sanctity of the individual saint and of proving his or her worthiness of veneration. The medal of the Pazzi Conspiracy repeats this type of imagery and establishes the brothers as civic icons whose miraculous apparitions hover over perhaps the most important ecclesiastical site in the city and by extension lay claim to its cultic power, just as their family had claimed control of the *salus publica*.[88]

Medici sculpture, whether in the small medal or the large-scale figure, artic-
ulates both normative practice and a consciousness of how transformations of the
norm could be read in the fifteenth century. The Medici, although bound to
convention, transformed virtually all of their images – in ways no other family
could – through displacement, appropriation, scale, or medium, to suggest their
anomalous role in the city as citizens "con qualche auctorità."

Notes

I want to thank Sarah Blake McHam for her usual judicious
and helpful comments on the penultimate draft of the text. I
also want to acknowledge Gary Radke's very close and criti-
cal reading of the draft. The text is better because of the spir-
ited generosity of these two mentors.

References to archival sources are given in the usual form
in the notes; Florence, Archivio di Stato, the fondo of *Medici
avanti il Principato* is indicated as MAP, followed by the volume
number.

1. To isolate a medium like sculpture from the entire artistic
 matrix of fifteenth-century Italy seems counter to inclusive
 approaches to the history of the early modern period now
 predominating in historical practice. This focus on sculp-
 ture might even have seemed curious to Renaissance sculp-
 tors who more often than not worked in more than one
 medium. Although Michelangelo's name may be the first
 to come to mind, one could think of Orcagna, Ghiberti,
 Verrocchio, Leonardo, Francesco di Giorgio, Vecchietta,
 and Michelangelo as sculptors who also painted or claimed
 to have painted. The list could be extended by adding the
 names of sculptors who were also architects, starting with
 Arnolfo di Cambio and including Brunelleschi, Leon Bat-
 tista Alberti, Giuliano da Sangallo, Andrea Sansovino, and
 the ubiquitous Michelangelo. Yet sculpture as a medium
 has been so little studied outside of general histories of the
 arts of the period or outside of the artistic monograph that
 its extraordinary range and presence within Renaissance
 society, its codified typological patterns, and its function as
 a conveyor of meaning are still not well understood. Thus
 this volume of essays.

2. One of the difficulties involved in the study of Medici
 patronage is establishing sufficient comparanda to cast the
 works in the Medici environments in relief among all the
 arts of this period. J. K. Lydecker's *The Domestic Setting of
 the Arts in Renaissance Florence* (Ann Arbor, Mich., 1987)
 (hereafter cited as Lydecker, *The Domestic Setting*), provides
 critically important information deriving from fifteenth-
 and sixteenth-century inventory lists that give the begin-
 nings of a base for study of objects, object type, media, and
 imagery within the Florentine domestic interior. A.
 Guidotti, "Pubblico e privato, committenza e clientela:

Botteghe e produzione artistica a Firenze tra XV e XVI
secolo," *Ricerche storiche* XVI, 3 (1986): 535–50, importantly
widens the lens for viewing patronage of works of art
beyond the upper classes. See also *idem*, "Gli Arredi del
Palazzo nel tempo," in *Il Palazzo Medici Riccardi di Firenze*,
ed. G. Cherubini and G. Fanelli (Florence, 1990), 244–61.

This study considers only sculpture in the interior envi-
rons of Florentine palaces, most particularly the Palazzo
Medici. It would be instructive to know when the first
stemmi (coats-of-arms) appeared on palace facades and the
consistency of their placement on major urban visual axes.
One of the most notable examples of such placement is the
large *stemma* on the southeast corner of the Palazzo Medici
which is directed down the Via Larga towards the Baptistry
so that it functions as a clear identifying agent of Medici
presence to anyone moving north on the street from the
city center.

3. Lorenzo's comment appears in a letter to Pierfilippo Pan-
 dolfini dated 26 November 1481; see Lorenzo de' Medici,
 Lettere (N. Rubinstein, ed.) (Florence, 1977–), VI, 100.
 Lorenzo's use of this double role of citizen/authority has
 been most recently discussed by M. Hegarty, "Laurentian
 Patronage in the Palazzo Vecchio: The Frescoes of the Sala
 dei Gigli," *Art Bulletin* LXXVIII (1996): 264–85.

4. "Una figura di nostra donna picola di terra cotta," Florence,
 ASF, MAP 129, fol. 59; see J. K. Lydecker, "Il patriziato
 fiorentino e la committenza artistica per la casa" in *I ceti
 dirigenti nella Toscana del Quattrocento*, ed. D. Rugiadini
 (Impruneta, 1987), 210, n. 3 (hereafter cited as Lydecker,
 "Il patriziato fiorentino") for an excerpt from the 1417–18
 inventory that includes these references and others men-
 tioned below.

 It is not clear just what "picola" might mean in the
 1417–18 inventory other than smaller than life-size. It was
 probably not as small as French gothic ivory figures of the
 Madonna and Child because the terracotta material would
 have been too fragile at that scale and perhaps also too
 coarse to incise details.

5. "1ª vergine maria di gesso" and "ij vergine marie, 1ª dipinta
 e 1ª di mezo rilievo"; ASF, MAP 104, fol. 366; the first of
 these Virgins was listed at the Medici villa at Castello, the
 others in the palazzo in Florence. The record books of Neri

di Bicci, a Florentine painter and the owner of a prolific Florentine workshop, are littered with references to gesso and terracotta reliefs of the Virgin, indicating considerable mass production of these objects; see Neri di Bicci, *Le Ricordanze*, ed. B. Santi (Pisa, 1976), *passim*.

6. "1ª Vergine Marie di terra orata"; Lydecker, *The Domestic Setting*, 70, n. 96. Examples of a standing or seated Virgin holding a Christ Child exist in stucco and terracotta and have been dated to somewhat later in the century; see P. Schubring, *The Work of Donatello* (New York, 1921), 172. Once early attributions of such works were removed from the oeuvre of major sculptors like Donatello they fell into an art historical limbo. It is time to rescue them, to separate out the forgeries, and to reassess their role in the cultic and social life of fifteenth-century Florence.

7. For such tabernacles see J. Pope-Hennessy, assisted by R. Lightbown, *Catalogue of Italian Sculpture in the Victoria and Albert Museum* (London, 1964), I, 65–70, and III, 44, 45. This catalogue is a particularly rich source for imagery relevant to the domestic interior. Neri di Bicci (*Ricordanze*) also lists a number of these reliefs set within architectural frames in his record books.

8. A. Guidotti has begun a systematic survey of such records in articles such as "Gli smalti in documenti fiorentini fra XIV e XV secolo," *Annali della Scuola Normale Superiore di Pisa, Classe di lettere e filosofia* XIV, 2 (1984), 621–88, and his research promises to open new possibilities for understanding mass production during the fourteenth and fifteenth centuries.

The shop records of Neri di Bicci (*Ricordanze*) are the most famous documentary sources for workshop production in Quattrocento Florence as a result of their publication. Of equal importance, however, are the shop records of Maso di Bartolomeo, which have been preserved in two manuscripts: Prato, Biblioteca Roncioniana, #388, RV14; and Florence, Biblioteca Nazionale, Fondo Baldovinetti 70. They have appeared in fragmentary form in the literature and are now being prepared for publication by Harriet McNeal.

The references to figures of "our Lady" or to a "Virgin" or a "Virgin Mary" in the inventory may provide clues that a whole category of sculpture may have disappeared from view. On the other hand, the simple reference to the Virgin is most likely merely secretarial shorthand for "Virgin and Child" because there are no extant figures or reliefs from the Quattrocento of the Virgin alone; it is in that sense that I treat such references in this paper.

9. The 1498 inventory (ASF, MAP 104, fol. 366) lists "1ª vergine con nostro signore in 1° tondo" and "1ª vergine maria piccola in 1ª tondo," which are most likely paintings rather than sculpture. Lydecker, *The Domestic Setting*, 65, n. 85, lists a number of such objects on painted panel and in gesso and terracotta from various inventories after 1482.

10. In fact, in another redaction of this inventory these figures are indicated as "Dua Vergine Marie, una dipinta in lignamo, l'altro di mezo rilievo"; see J. Shearman, "The Collections of the Younger Branch of the Medici," *Burlington Magazine* CXVII (1975): 12–27, esp. 25. Shearman transcribes ASF, MAP 129, a copy from 1499 of a 1498 inventory made of the possessions of Lorenzo di Pierfrancesco de' Medici and the heirs of Giovanni di Pierfrancesco, his brother. Perhaps the inventories imply throughout the possibility of unspecified painted figures being made of wood because there are explicit references in inventories of other households which list such objects as "1ª Verginne Maria dipinta i'legniame" and "1ª Verginne Maria di legniame hon isportelli"; see G. Cantini Guidotti and A. Guidotti, "Proposte per una schedatura elettronica di fonti d'archivio utili per la storia delle arti: Gli inventari di beni mobili," *Bollettino d'informazione del Centro di Elaborazione Automatica di dati e documenti storico-artistici*, IV (1983), 135, 136. These references are from an inventory of 1431 of the possessions of the goldsmith Cambio di Tano Petrucci.

11. See G. Rolfi, L. Sebregondi, and P. Viti, eds., *La Chiesa e la Città a Firenze nel XV secolo* (Florence, 1992), 157.

12. " . . . nostra donna dj marmo con ornamento" and "la madonna di marmo" in ASF, MAP 104, fol. 175v.; see also Shearman "The Collections," 27.

13. "quadro di Nostra Donna chol bambino in braccio e agnoli, tutta di bronzo, di br[accio] uno lungha e largha br[accio] 2/3," "Una tavoletta di marmo, di mano di Donato, entrovi una Nostra Donna chol bambino in chollo," and "uno quadro di bronzo dorato, entrovi la Nostra Donna chol banbino in braccio, chornicie adorno, di mano di Donato"; M. Spallanzani and G. Gaeta Bertelà, eds., *Libro d'inventario dei beni di Lorenzo il Magnifico* (Florence, 1992), 20, 33 (hereafter Spallanzani and Bertelà). Curiously, the room containing the last two objects was inventoried twice; *ibid.*, 57. For examples of these small (and smaller) bronzes see Schubring, *Donatello*, 94–5.

14. As a comparison, Ghiberti's panels for the *Gates of Paradise* are 1/3 braccia square.

15. This point has bearing on a number of disputed works such as the partially gilt relief of the Crucifixion in the Bargello that J. Pope-Hennessy ("The Medici Crucifixions of Donatello," *Apollo* CI [February 1975]: 82–7), and C. Avery (*Donatello* [Florence, 1991], 121–2) have tried to rehabilitate as a work by Donatello. That the Bargello sculpture appears in none of the inventories of the Medici households during the fifteenth century should be a strong caveat against its Quattrocento dating. There is nothing in Medici correspondence that would connect this relief to Donatello or to the 1450s. Such narrative reliefs, particularly prevalent in the Donatello literature, should perhaps be approached anew, not from the point of view of style (alone), but from a closer reading of the inventories and

conventions of media and iconography of the period. Virtually the only narrative to appear in these domestic reliefs is the Nativity, where, nonetheless, the infant Jesus is presented as an object of devotion for his parents.

The Medici household also boasted of a number of comparable small luxury devotional objects such as a gold enameled tondo of the Virgin and Child, a rectangular gold and enameled "tavoletta" of God the Father on one side and John the Baptist in the desert on the other, and another small gold and enameled panel with St. Catherine of Alexandria on one side and the Virgin and Child on the reverse (Spallanzani and Bertelà, 43). Although these panels are strictly speaking more paintings than sculptures, their medium relates them to the plaquettes and gilt reliefs so often mentioned in the inventories. Their subject matter also raises an important point about devotional reliefs within the domestic context: all of the records that indisputably refer to sculpture indicate an iconic rather than a narrative presentation.

16. "uno tabernacolo da legno Entrovi uno bambino nostro signore con dalmatica in dosso di velluto azzurro e camisce e altro habito da dyicono"; see n. 4.

17. See also G. Previtali, "Il 'Bambin Gesù' come 'immagine devozionale' nella scultura italiana del Trecento," *Paragone*, XXI (1970): 31–40.

18. Lydecker, "Il patriziato fiorentino," does not speculate on the meaning of these clothes.

19. Lorenzo's birth date appears in a ricordanza of Piero di Cosimo's; see Florence, ASF, MAP 163, fol. 1v.

20. By 1492 there were three of these Gesuino figures in the sacristy of the chapel in the Palazzo Medici; one of these was elaborately clothed in a covering of gold and pearls, but of a generic nature. They are listed in a 1512 copy of an inventory made at the time of Lorenzo's death in 1492 (ASF, MAP 165: "Tre bambini di tutto rilievo, che ve n'è uno cholla vesta di raso chermisi chom perle e oro atorno" (fol 12v.); see Spallanzani and Bertelà,17). There is also a curious reference in this inventory to "Uno bambino di bronzo di peso di lib[bre] 28" (*ibid.*, 101), which may refer to a Gesuino figure, but which simply may also denote the head of a very young, unidentified child deriving from a mask (see below).

21. "1° sco. Giovanni di marmo"; *ibid*. This figure may have been a relief similar to the stucco tondo by Donatello in Giovanni di Bicci's Sacristy (the Old Sacristy) at San Lorenzo.

22. "1° santo giovanbatista di marmo di tutto rilievo"; see ASF, MAP 104, fol. 366 and Shearman, "The Collections," 25.

23. "una fighura di sancto Francesco, di tutto rilievo," and "colmo di legname intagliato e messo d'oro, alto br[accio] 4½ [c. 9 ft. high], largho br[accio] 2½ [c. 5 ft. wide], entrovi una Nostra Donna di marmo"; see Spallanzani and Bertelà, 94, 26.

24. See n. 3.

25. For a discussion of wood sculpture for this period see my "Wooden Sculpture in Italy as Sacral Presence," *Artibus et Historiae* XXVI (1992): 85–100.

26. Giovanni di Bicci had a brother named Francesco and Cosimo's brother Lorenzo named his first son Francesco, so it is not inconceivable that this statue represented the patron saint of a member of the Medici family because in each generation the family lived communally.

27. Even a cursory look at recent publications on Renaissance sculpture (see n. 1) indicates both that sculpture was present mainly in the public environment and that historians have concentrated on that sculpture at the expense of more modest works in the interior spaces of the Renaissance palace. The only exceptions to this last historically constructed blinder would be portrait busts and table bronzes.

28. For an important recent discussion of the evolution of the portrait bust see S. Zuraw, "The Medici Portraits of Mino da Fiesole," in *Piero de' Medici "Il Gottoso" (1416–1469): Kunst im Dienste der Mediceer/Art in the Service of the Medici*, ed. A. Beyer and B. Boucher (Berlin, 1993), 317–39.

29. "Una testa di marmo della 'mpronta di Cosimo'"; ASF, MAP 165, fol. 9; see Spallanzani and Bertelà, 17. This sculpture does not appear in other, later, inventories. However, no one making an inventory could have mistaken Cosimo's appearance, so the work may have been moved or destroyed after the restitution of the Republic in 1494 when Cosimo's tomb in San Lorenzo was also defaced by the erasure of his name. Because the bust was in the "camera de' cancellieri" on the ground floor of the palace it would have been more immediately accessible than other objects in the building.

30. The border of Piero's clothing is embroidered with his personal device of the diamond ring. Medici inventories list numbers of items of clothing which indicates that such decoration was not unusual in personal vestments and that, furthermore, the Medici occasionally wore the *imprese* of their allies: "Uno taglietto di velluto chermisi brochato d'oro chon bronchoni et grillande, entrovi in ogni ghirlanda l'arme de' Medici," "Una giornea alla dovisa del ducha Francesco [Sforza], chiamata giornea del chane," "Nove giornee di panno alla dovisa di Piero di Chosimo, richamate," and "Tre ghonnellini alla dovisa, di velluta pagonazzo e biancho et col bromchone et lettere e stampati dallo inbusto in giù" (Spallanzani and Bertelà, 120, 122).

31. "Una testa di marmo di tutto rilievo," "Otto teste di marmo . . . ," "Quattro testaccie di marmo," and "Una testa di marmo di tutto rilievo, di mano di Desidero"; *ibid.*, 18, 19, 20, 79. The "testaccie" recall the large terracotta heads in roundels that decorated the facade of the Banco Mediceo in Milan and that date from the early

1460s; see my "The Banco Med...eo in Milan: Urban Politics and Family Power," *Journal of Medieval and Renaissance Studies* XXIV (1994): 199–238.

32. "Una testa di uno fanzullo de giesso, al naturale e dipinta"; ASF, MAP 129, fol. 515v. The 1498 inventory is apparently lost, but there are a number of copies, the first of which is dated 1499. For a careful analysis of these copies and their contents and for a transcription of the 1499 copy see Shearman, "The Collections," 12–27. There are other references in the 1498/99 inventory to figures of John the Baptist, indicating that when the sculptor intended that specific figure it was clearly readable from the image. In a variant redaction of the 1498 inventory (ASF, MAP 104, fol. 366) this reference is abbreviated to "1ª testa di 1° fanc[i]ullo di gesso dipinta." There is no reason to maintain as some writers have done that extant examples of children's heads – like that recorded in the inventory – represent the Christ Child or St. John the Baptist unless particular iconographic attributes are present.

33. C. Seymour, Jr., *The Sculpture of Verrocchio* (Greenwich, Conn., 1971), 174–75.

34. "fighura di Zanobi [Brancacci] . . . di gesso" and "2 teste di terra cotta ritratte Bartolomeo [de' Nerli] e Mona Chontessina" in Lydecker, *The Domestic Setting* 66–7, 67, n. 89. Lydecker has also suggested (64, n. 90) that nonspecific inventory references to "heads," such as the "testa di uomo di terra" in a 1514 inventory, may also refer to portraits. Extant terracotta portraits assigned to the fifteenth century, such as the *Bust of a Young Warrior* attributed to Pollaiuolo in the Bargello, are all problematic; see L. D. Ettlinger, *Antonio and Piero Pollaiuolo* (Oxford, 1978), 152. More than likely, these terracotta and stucco portraits resembled those in marble. A 1503 copy of a 1498 inventory of the chapel of the Medici villa in Fiesole lists two terracotta figures of a member of the Medici family ("2 figure di terra cotta dj *[illegible]* de' medici"; ASF, MAP 104, fol. 175v.; Shearman, "The Collections," 26, 27, lists these heads under the chapel in Florence in his redaction of the 1499 copy of an inventory of 1498 of the possessions of Lorenzo di Pierfrancesco de' Medici and the heirs of Giovanni di Pierfrancesco. There they appear as "2 figuruzze di terra cotta di ave [?]/verdino [?] de' Medici." Shearman could not read the name clearly because of damage to the paper, but tentatively suggested Averardo di Lorenzo di Pierfrancesco (born 1488) as the person represented. The siting of the figures in a chapel may indicate that these two terracottas were commemorative images rather than portraits from life, although it is not possible to generalize to the whole category of terracotta and gesso portraits. Sculpted portraits may have been more common in fifteenth-century chapels than tomb sculpture at first indicates. Samuel Cohn has found a 1411 reference in which a woolworker indicated his wish to have a portrait carved for his funerary chapel; see "Piété et commande d'oeuvres d'art après la Peste Noire," *Annales: Histoire, Sciences Sociales* III (May/June 1996): 561. And of course there were countless surrogate portraits, representing individuals in the guise of their patron saints as the marble St. John in the chapel of Giovanni di Cosimo's villa at Fiesole indicates (see n. 21).

35. All examples of this early portraiture indicate that it was restricted to interior spaces. Irving Lavin has indicated that the bust of Matteo Palmieri was in a niche over the main portal of the subject's palazzo; although this is where the bust was found in the nineteenth century, there is no certainty that it had been there in the fifteenth, especially because busts over exterior doors did not become the fashion in Florence until the sixteenth century.

36. It might be noted that a youthful apprentice in the shop holds another bustate figure towards the purchaser. If the prayerful gesture of this figure indicates a saint (and perhaps a reliquary) then the printmaker has cleverly indicated one of the sources for the portrait bust immediately below it.

37. The standard work on wax masks is still J. von Schlosser's "Geschichte der Porträtbildnerei in Wachs, *Jahrbuch der kunsthistorischen Sammlungen der allerhöchsten Kaiserhauses* XXIX, 3 (1911): 171–258. For a Florentine shop concentrating on the production of wax masks see G. Masi, "La ceroplastica in Firenze nei secoli XV–XVI e la famiglia Benintendi," *Rivista d'arte* IX (1916): 134–43.

38. Lydecker, *The Domestic Setting*, 67, n. 89, and 70–1: "la testa di Lorenzo de' Medici in 1ª cassetta." He also records (p. 191) the commissioning of a death mask of Lorenzo Morelli by his son, Leonardo, in 1528 from the waxworker Il Borrana; he also paid for the gesso to make the mask. The document does not indicate where the mask was to have been kept.

39. The bust has been identified as Contessina de' Bardi (Cosimo's wife), Lucrezia Tornabuoni (Piero di Cosimo's wife), Ginevra Cavalcanti (Giovanni di Cosimo's wife), and Caterina Sforza (Giovanni di Pierfrancesco's wife); it is pointless to speculate on the identity of the woman represented without securely identified comparanda.

40. "testa di bambino di bronzo . . . nel chassone di panni di Giuliano . . . "; Spallanzani and Bertelà, 100.

41. The placement of the busts of Lucrezia and Piero over doors in the Palazzo Medici is recorded in the 1512 copy of the 1492 inventory. They appear in the "Camera della sala grande," and a bust of Piero's brother Giovanni appears in the "Camera di monsignore, dove sta Giuliano":

> Una testa di marmo sopra l'archo dell'uscio di chamera ritratto al naturale mona Lucrezia
>
> Una testa di marmo sopra l'uscio dell'antichamera dell'mpronpta di piero di Cosimo
>
> .

Una testa di marmo sopra l'uscio dell'antichamera di tutto rilievo ritratto al naturale di Giovannj di Cosimo de'medici

See Spallanzani and Bertelà, 27, 72. Lydecker, *The Domestic Setting* 71, suggests that in the "earlier Renaissance" images such as portrait busts were commonly placed over doors; but all his documented examples date from 1480 or later, that is, long after the 1453 completion of Mino's portrait of Piero. Based on the refined details of the carving and the finish of the busts at the back, Shelley Zuraw ("Medici Portraits") has suggested that the busts were originally intended to be seen closer to eye level. It is important to note that the 1453 date for Piero's bust predates the completion of the new Medici palace and that its installation over a door could have occurred any time between the completion of the palace and the 1492 inventory.

42. For a discussion of these columbaria as a source for the arcosolium tomb type see A. Butterfield, "Social Structure and the Typology of Funerary Monuments in Early Renaissance Florence," *RES* XXVI (Autumn 1994): 64–7; Butterfield's fig. 22 shows a modern "reinstallation" of busts and cineraria in the columbarium niches.

43. For a brief introduction to the epitaph monument see Panofsky, *Tomb Sculpture* (New York, [1964]), 69. The placement of the Medici busts under arches over doors might also be compared with the bust-length Madonna and Child relief in the lunette of the tomb of John XXIII in the Florentine Baptistry where the figures have a similar placement and form.

44. "1ª testa di messer Francesco Petrarcha dipinta per Livio orafo e dipintone in un quadretto di legnio . . . " and "1ª testa di Dante di gesso e cholorite . . . "; see Lydecker, *The Domestic Setting* 283. Given the date of the ledger the two "heads" postdate the Piero bust by something more than a decade, but priority of type (rather than individual object) cannot be stated with certainty. It is important to note that the date of this purchase coincides with the commissioning of a painting of Dante from Domenico di Michelino for the Duomo (see below); for the documents on this painting see G. Poggi, *Il Duomo di Firenze*, ed. M. Haines (Florence, 1988), nos. 2132, 2133. The cenotaph of Dante was, according to the documents, on the north wall of the cathedral, near the Porta della Mandorla; *ibid.*, nos. 876, 878, 2074.

45. M. M. Donato, "Famosi Cives': Testi, frammenti e cicli perduti a Firenze fra Tre e Quattrocento," *Ricerche di storia dell'arte* XXX (1986): 27–42, esp. 33ff. For the document recording this project see Poggi, *Il Duomo*, no. 2082.

46. Poggi, *Il Duomo*, nos. 2076, 2077 for the Brunelleschi project, nos. 2096, 2423, 2424 for the Giotto project, nos. 2097, 2098, 2100, 2101 for the Squarcialupi project, which was not completed until 1519.

47. " . . . quadro dipintovi la testa del duca d'Urbino . . . "; " . . . quadro dipintavi la testa del duca Ghaleazzo [Maria Sforza], di mano di Piero del Pollaiuolo"; "dua teste al naturale, cio[è] Francesco Sforzo et Ghattamelata, di mano d'uno da Vinegia"; Spallanzani and Bertelà, 12, 33.

48. "testa d'uno doge Vinitiano e in camera dove abita pie[r]francesco"; ASF, MAP 104, fol. 237.

49. "testa di marmo di tutto rilievo di mano di Desidero"; for the documents see G. Corti and F. Hartt, "New Documents Concerning Donatello, Luca and Andrea della Robbia, Desiderio, Mino, Uccello, Pollaiuolo, Filippo Lippi, Baldovinetti and Others," *Art Bulletin* XLIV (1974): 155–67, and for a discussion of sculptures of the twelve Caesars see U. Middeldorf, "Die zwölf Caesaren von Desiderio da Settignano," *Mitteilungen des Kunsthistorischen Institutes in Florenz*, XXIII (1979): 297–312. This commission apparently also involved Mino da Fiesole who was responsible for the Medici portrait busts; see Zuraw, "Medici Portraits," 325–7.

50. These heads for Giovanni perhaps shed some light on the references to antique figures in the rooms of Lorenzo: "Una tavoletta di marmo sopra l'uscia dello schrittoio chon cinque fighure antiche" and "Una tavoletta di marmo chon fighure antiche," although it is impossible to tell from the inventory whether these reliefs are from the Quattrocento or are ancient; see Spallanzani and Bertelà, 33.

51. "per 1ª testa di gesso d'Adriano inperatore dipinta e per 1ª chatelano fornito.per tutto s[ugelli] iii larghi cioe f[iorini] v larghi e f[iorini] v"; see Lydecker, *The Domestic Setting*, 284; I am interpreting the two sums in *florins* as respectively referring to each of the items listed. The term "chatelano" is a puzzling one; Lydecker interprets it as a chain, but it is unclear whether this "chain" was placed around the statue's neck or whether it had some other function. The date at the top of the ledger reads 1463–1479; it seems likely that the purchase of the head was actually made in 1465 and that the list of expenses was made as they occurred. An inventory list made by Agnolo di Bernardo de' Bardi in 1512 lists an ancient bust, but it is impossible to tell when the object entered Agnolo's collection and thus how it might relate to the developing presence of ancient busts in Florentine households. The same is true for an estate inventory of Giovanni di Francesco Inghirami of 1513, which lists "4 teste antiche di gesso" that, in any case, could simply be old heads rather than heads of antique figures. For these inventories see Lydecker, *The Domestic Setting* 143, 71, n. 94.

It is tempting to see an inventory reference to a "tavoletta di marmo sopra l'uscio dello schrittoio chon cinque fighure antiche" (Spallanzani and Bertelà, 33) in the anteroom of the "camera grande" of Lorenzo the Magnificent as a row of high-relief Roman funerary portrait busts like the relief illustrated by Lavin; but "antiche" can also sim-

ply mean "old," so there is no way to ascertain what these figures actually were.

52. Parenthetically, it might be useful to remember that well-known architectural sculpture such as foliated door frames, fireplace hoods decorated with foliage or garlands and putti, and high-relief figures acting as decorative frames on fireplaces seem to have appeared first outside of Florence, and in princely palaces. The standard examples used in most discussions of this architectural sculpture are from Federico da Montefeltro's palace in Urbino, perhaps because there are so few others. Although the dating for much of this work is still problematic, it seems as if it first enters Florence through civic programs such as Benedetto da Maiano's door for the Sala dei Gigli of 1476–81 (see n. 3) in the Palazzo della Signoria, suggesting that such richly ornamented forms were connected with the power of rulership and may have been seen as inappropriate frames for private citizens.

53. The importance of the placement of this statue was confirmed by Baccio Bandinelli when he placed his *Orpheus* (c. 1519) for Giulio de' Medici in the courtyard on axis with the main entrance to the Palazzo Medici. In 1570 the Martelli *David*, now in the National Gallery of Art, Washington, was placed in a niche opposite the main portal of the Martelli Palace at the wishes of Luigi Martelli (see Lydecker, *The Domestic Setting*, 201). These statues united the interior family courtyard with the exterior city, stressing both the connection between citizen and city and the separation of private and public.

54. See Hegarty, "Laurentian Patronage," 265–6.

55. The Verrocchio *David* is 125 cm high and the Donatello *David* is 158 cm tall. That they are only approximately nine inches different from one another in height further reinforces the need to consider them as a pair.

56. Francis Ames-Lewis first renewed the idea of the *David* as "an integral part of the scheme of decoration of the Palazzo Medici courtyard" in his "Art History or *Stilkritik*?: Donatello's Bronze *David* Reconsidered," *Art History* II (1979): 129, an idea he pursued in his "Donatello's Bronze *David* and the Palazzo Medici Courtyard," *Renaissance Studies* III (1989): 235–51, where he associated the *David* particularly with the Daedalus and Icarus relief on the northwest wall of the courtyard. Susan McKillop has, in lecture, placed David both in a Solomonic context and as a figure who explains the gemlike reliefs of the courtyard. C. Baskins, "Donatello's Bronze *David*: Grillanda, Goliath, Groom?" *Studies in Iconography* XV (1993): 113–34, situates the David within the festivities of Lorenzo the Magnificent's marriage to Clarice Orsini, when the women would have looked down on the statue from their positions on the piano nobile.

57. D. G. Wilkins, "Donatello's Lost *Dovizia* for the Mercato Vecchio: Wealth and Charity as Florentine Civic Virtues," *Art Bulletin* LXV (1983): 401–23, and S. Blake Wilk [McHam], "Donatello's *Dovizia* as an Image of Florentine Political Propaganda," *Artibus et Historiae* XIV (1986): 9–28.

58. This connection with the Roman Genius figures is also telling for small fountain or garden figures of presumably nude putti, which appear in the Medici inventories as "idolino" figures standing on balls ("palle"), the latter a reference to the Medici family *stemma* of gold balls on a red ground. In 1516 one of these figures was recorded in the garden of their palace at the time of the division of properties between Pierfrancesco di Lorenzo and Giovanni di Giovanni de' Medici: "Nell'orto: 1ª pila di marmo e un idolo di sotto in su una palla" (ASF, MAP 104, fol. 237v.). This reference is repeated later in the document: "1ª pila murate (?) di marmo con una palla e 1° idolino di sopra" (*ibid.*, fol. 344v.). Whether the figure would have been referred to as an "idolo" or "idolino" in the second half of the Quattrocento is moot, especially because a reference presumably to this same figure in Tommaso del Verrocchio's list of debts owed to his brother by the Medici calls it a "bambino di bronzo."

59. See Wilkins, "Donatello's Lost *Dovizia*," 402, where the Landucci reference is mentioned.

60. For a Renaissance palace the word "private" has little meaning because spaces had multiple uses. The word's use throughout this essay refers merely to the interior spaces defined by the physical property limits of the palace. The politicized meaning of the *David* would certainly be true from the time of its erection in the Medici courtyard. Whether the bronze figure was commissioned for this site or for another, its meaning by the time of its first appearance in the literature in 1469 must have been associated with that of the *Dovizia*. If I am correct in asserting this carryover of meaning from the earlier statue to the bronze *and* if it is also true that the dating for the statue is very late in Donatello's career, it is telling that Piero asserted issues of justice and charity so prominently at the palace near the time of the coup attempt of 1466 when he himself acted generously to the perpetrators of the coup. For another, supporting view of the late dating of the *David* to c. 1466 see now R. J. Crum, "Donatello's Bronze *David* and the Question of Foreign versus Domestic Tyranny," *Renaissance Studies* X (1996): 441–50.

61. "Kingdoms fall through luxury, cities rise through virtues; behold the neck of pride severed by the hand of humility." For the references to this inscription see H. W. Janson, *The Sculpture of Donatello*, 2d ed. (Princeton, 1963), 198, and F. Caglioti, "Donatello, i Medici e Gentile de' Becchi: Un po' d'ordine intorno alla 'Giuditta' (e al 'David') di Via Larga, 1," *Prospettiva* LXXV/LXXVI (July–October 1994): 14–19.

62. N. Rubinstein, "Classical Themes in the Decoration of the Palazzo Vecchio in Florence," *Journal of the Warburg*

and Courtauld Institutes L (1987): 29–43. See also n. 45. Baskins, "Donatello's Bronze *David*," 125–6, has connected the *David* to the Orsini Montegiordano frescoes of the *uomini famosi* as an appropriate reference to Lorenzo at the time of his wedding.

63. G. Vasari, *Le vite de' più eccellenti pittori scultori ed architettori*, ed. G. Milanesi (reprint, Florence, 1981), II, 50, on the life of Lorenzo di Bicci: "Giovanni di Bicci de' Medici . . . gli fece dipigner nella sala della casa vecchia de' Medici (che poi restò a Lorenzo fratel carnale di Cosimo vecchio . . .) tutti quegli uomini famosi che ancor oggi assai ben conservati vi si veggiono."

64. The attribution of this statue is contested. Janson, *The Sculpture of Donatello*, 191–6, bravely reintegrated the statue into the catalogue of Donatello's work, although his attribution has not been widely accepted. The statue is now generally – but not completely convincingly – attributed to Desiderio da Settignano. A provocative unpublished manuscript by John White in the files of the National Gallery suggests on the basis of chisel marks that the statue went through two campaigns of carving, the second not until the sixteenth century.

65. For the most succinct discussion of these statues see Pope-Hennessy and Lightbown, *Catalogue of Italian Sculpture*, 191–3. The difficulty of assigning a date and an artist to these statuettes attests to their mass production.

66. This placement of civic imagery functions differently from the dispersal of religious icons such as the Virgin and Child reliefs discussed earlier because it marks a change in the locus of appearance of the civic iconography and because these images, unlike the religious subject, were not the focus of devotion, but the frame legitimizing the actions of the state.

67. "figura gnuda, ritta, chon uno bastone, di marmo, di tutto relievo"; Spallanzani and Bertelà, 27.

68. Figures of idealized nude shield-bearing males holding clubs in the Liechtenstein Collection in Vaduz and in the Frick Collection in New York have been identified with the Wild Man (*uomo selvatico*) of medieval folklore. Although these bronzes (at least one of which seems genuine) provide an example of sculpture that seems to match the description in the inventory, their identification as the Wild Man seems unlikely because virtually all examples of this mythic man show him with a shaggy coat of hair covering his entire body. See J. D. Draper, *Bertoldo di Giovanni: Sculptor of the Medici Household* (Columbia, Mo., 1992), 146–53, for a discussion of these figures. See also R. Bernheimer, *Wild Men in the Middle Ages* (Cambridge, Mass., 1952), esp. 148–9, who illustrates only one example of purported Wild Men with hairless nude bodies, Israel von Meckenem's engraving of nude men and women climbing the flower of love; the inscription on the print, however, does not in any way tie the figures to Wild Men.

Moreover, it should be pointed out that the inventory does not identify the figure as a shield-bearing figure, which is the type represented by the Liechtenstein and Frick figures.

The bronze sculptor Antico produced a statuette of Mercury leaning on a club (c. 1520, Vienna, Kunsthistorisches Museum), but this seems to be the earliest version of this iconography for Mercury. Despite the importance of Mercury in Medicean iconography, this example is too late and too unusual to associate it with the marble statue listed in the Medici inventory. Other bronze statuettes from the beginning of the Cinquecento show Mercury nude, but holding a purse in his right hand in the antique fashion and a [missing] caduceus in his left. It is unlikely that a caduceus would have been mistaken for a "bastone." See H. Beck and P. C. Bol, eds., *Natur und Antike in der Renaissance* (Frankfurt, 1985), 431–5.

69. See *ibid.*, 393–6. Both of these figure types are imaginative variants of the colossal bronze Hercules found in Foro Boario during the reign of Sixtus IV and taken to the Palazzo dei Conservatori where it is now part of the Capitoline collections; see P. Pray Bober and R. Rubinstein, *Renaissance Artists and Antique Sculpture* (London, 1986), 164–5.

70. For the Hercules as a state symbol see M. von Hessert, *Zum Bedeutungswandel der Herkules-Figur in Florenz: Von den Anfängen der Republik bis zum Prinzipat Cosimos I* (Cologne, Weimar, and Vienna, 1991), and L. D. Ettlinger, "Hercules Florentinus," *Mitteilungen des Kunsthistorischen Institutes in Florenz* XVI (1972): 119–42. Although it is reasonable to suggest that the marble in the room of Lorenzo was of contemporary manufacture, who the sculptor might have been must remain moot. Statuettes of this type, however, have been reasonably connected with Michelangelo's lost *Hercules*, formerly in Fontainebleau; recent reconstructions of that work suggest that the traditional lion's skin may not have been specifically indicated, having been supplanted by a drapery like that on the table bronze in Braunschweig, which left the figure essentially nude. The clearest reconstruction of the history and meaning of Michelangelo's *Hercules* has been given by A. Perrig, "The Male Nude on Louvre Sheet No. 685-R and Michelangelo's Hercules Statue" in his *Michelangelo's Drawings: The Science of Attribution* (New Haven, 1991), 111–17, esp. 112, and by J. Cox-Rearick, *The Collection of Francis I: Royal Treasures* (New York, 1995), 302–12. But see also P. Joannides, "Michelangelo's lost Hercules," *Burlington Magazine* CXIX (1977): 550–3, and *idem*, "A Supplement to Michelangelo's Lost Hercules," *Burlington Magazine* CXXIII (1981): 20–3 (with relevant earlier bibliography), who also presents proposals for the early history of this statue before its disappearance sometime between 1714 and 1731.

71. An important opening wedge into new discussions of "forgeries" has been provided by P. Parshall in his compelling "Imago Contrafacta: Images and Facts in the Northern Renaissance," *Art History* XVI (1993): 554–79, where he indicates that the term "counterfeit" was used in a positive sense in a number of European languages to verify an image's accurate replication of an earlier form and the relationship between the counterfeited image and "nature." My comments about the "counterfeits" or reconstructions of antiquities in the Medici environs is deeply indebted to this seminal study. By the end of the fifteenth century any such discussion would have to include issues of economics and the burgeoning art market, the *paragone*, and outright attempts to deceive, in other words, both the positive and the negative aspects of counterfeit.

 For a discussion of a possible reading of the *Bacchus* as a "forgery" see E. Wind, *Pagan Mysteries in the Renaissance* (New Haven, 1958), 147–57. For the mocking forgery of the *Sleeping Cupid* see A. Condivi, *The Life of Michelangelo*, trans. A. Sedgwick Wohl and ed. H. Wohl (Baton Rouge, 1976), 19–20, and for Michelangelo's deliberate aging of a "copy" of a head see *ibid.*, 10.

72. See n. 33.

73. F. Caglioti, "Due 'restauratori' per le antichità dei primi Medici: Mino da Fiesole, Andrea del Verrocchio e il 'Marsia' rosso degli Uffizi," *Prospettiva*, LXXII (October 1993): 17–42 and LXXIII/LXXIV (January/April 1994): 74–96. Caglioti has proposed that Mino da Fiesole was responsible for the "restorations" of the statue now in the Uffizi.

74. ASF, MAP 165, fol. 38, and Spallanzani and Bertelà, 71: "Una storia di bronzo sopra il chammino, di più chavagli e gnudi, cioè una battaglia lungha br. uno e ⅔, alta br. ⅔." For the most recent discussion of the work see Draper, *Bertoldo di Giovanni*, 133–42.

75. M. Lisner, "Form und Sinngehalt von Michelangelos Kentaurenschlacht mit Notizen zu Bertoldo di Giovanni," *Mitteilungen des Kunsthistorischen Institutes* XXIV (1980): 299–344, pointed out the connections of the iconography to the Este court, prompted by the lion skin worn by the central horseman in the relief, establishing him as Hercules. The connection to Urbino is given some support by Bertoldo's undraping of the figures at the lower left and right of the relief, much as the fireplace figures of Hercules and Iole flanking the fireplace in the Sala della Iole in Federico's palace are nude, although of course both sculptors could have looked at similar sources.

76. For the clearest presentation of historical battle scenes as civic imagery see E. Carter Southard, *The Frescoes in Siena's Palazzo Pubblico, 1289–1539: Studies in Imagery and Relations to Other Communal Palaces in Tuscany* (New York, 1979).

77. Relief friezes over fireplaces like that by Benedetto da Rovezzano for the Palazzo Borgherini (c. 1495; Florence, Bargello) do not seem to have come into fashion in Florence until the 1490s, that is, after Lorenzo's death. The relief of *Praelium* in the courtyard of the Palazzo Scala is often associated with Bertoldo's *Battle*, which is understandable given its compositional similarities. Yet that relief is in a courtyard and is also part of a series, both of which differentiate its meaning from Bertoldo's work.

78. "[s]ette schudi chon più armi di chomune e di casa"; Spallanzani and Bertelà, 26

79. "uno ignudo di bronzo alto 1° braccio con una palla d'oro in mano"; "uno Erchole che schoppia Anteo di bronzo tutto alto br[accio] 1/3; *ibid.*, 72

80. "Uno gnudo di bronzo che ha rotto uno braccio"; "Uno gnudo di bromzo [*sic*] di tutto rilievo, tondo, d'alteza de br[accio] 3/4 incircha, vochato lo gnudo della paura"; "Uno gnudo di bromzo chon panno armachollo e alaia in chapo, altro br[accio] 1/3 incircha"; "Un altro gnudo, fighura d'Erchole sanza ghambe"; "Uno gnudo di tutto rilievo, alto br[accio] uno, di bromzo tutto"; "Un altro gnudo di bronzo com uno pescie e una serpe in mano"; "Una fighura di bronzo a chavallo"; and "Uno centauro di bronzo di mano di Bertoldo"; *ibid.*, 22, 52, 79, 81. For the most thorough discussion of the bronze statuette, including some mentioned on this list, see Beck and Bol, *Natur und Antike*.

81. See R. W. Lee, *Ut Pictura Poesis: The Humanistic Theory of Painting* (New York, 1967), for an exposition of the connections made in artistic theory between poetry and the arts as carriers of meaning.

82. "1ª ercholetto di gesso ebbe da me"; Lydecker, *The Domestic Setting*, 120–1.

83. *Ibid.*, 118.

84. For these two medals see S. K. Scher, *The Currency of Fame: Portrait Medals of the Renaissance* (New York, 1994), 64, 74–6, and 166–7. The medal of Sigismondo is the first since classical antiquity to show architecture on the reverse as a declaration of place of rulership. The Philip II medal most closely approximates that of Cosimo in the depiction of the personification of place and of the attributes of the place.

85. See Draper, *Bertoldo di Giovanni*, 86–95, particularly for his description of the resonances of conspiracy resident in the image of a temple deriving from Roman coins.

86. See my "Fraternal Piety and Family Power: The Artistic Patronage of Cosimo and Lorenzo dei Medici," in *Cosimo "il Vecchio" de' Medici, 1389–1464*, ed. F. Ames-Lewis (Oxford, 1992), 195–219.

87. The reason for the lack of narrative relief sculpture of secular history has not been explained. The reason could be as simple as a belief that painting could record the myriad details of history more completely, accurately, and illusionistically than sculpture, or it could be connected to the

notion of relief as tied to imperial histories, which would be beyond the bounds of decorum in Republican city-states.

88. Lorenzo's father, Piero, had attempted to stamp this site with his own patronage in 1447, but his intervention was rejected by the Arte della Lana; see my ". . . ha fatto Piero con voluntà del padre . . . " Piero de' Medici and Corpo-rate Commissions of Art," *Piero de' Medici "Il Gottoso,"* 224. Piero was successful in taking control of two other major pilgrimage sites in the city, however: the miracle-working image of the Annunciation at SS. Annunziata and the miraculous speaking cross of St. John Gualbert in San Miniato.

Holy Dolls: Play and Piety in Florence in the Quattrocento

Christiane Klapisch-Zuber

THE BORDERLINE BETWEEN devotional practices and play activities is a narrow one. Historians of toys have noted the similarity between medieval marionettes or dolls and devotional figurines of that epoch, and it is not always easy for archaeologists or ethnologists to classify the objects they find into one category or the other.[1] Small modeled or molded statuettes in terracotta, sometimes mass produced and found in abundance in the four corners of Europe,[2] pewter, tin, or earthenware objects that the manufacturers of household utensils and bric-a-brac added to their displays,[3] marionettes to enliven preachers' sermons or to present sacred dramas[4] – all these ambiguous objects, both those representing the divine and those used for play activities, reveal a confusion of attitudes toward the sacred and toward play on the part of those who were to manipulate them.[5] Florence in the Quattrocento offers one example of a type of sacred image with a dual purpose. These objects were considered a practical means to open up the way to God to women and children by exciting their imaginations (ingenuously or deliberately). By the contemplation of these objects, by their manipulation in play, ritual, or dramatic fantasizing, these souls of "weaker" and more "malleable" constitution were led to a spiritual vision of the sacred verities. Play, dream, and rite were three facets of a drama that was played out between the believer and his God, in which the former gave life to the image of the latter, set it up as a sentient actor, and conversed directly with it.[6]

What devotional toys are we speaking about? A scholar of the last century, Giuseppe Marcotti, noted that "a *bambino* [a child doll] with a damask dress embroidered with pearls" figured in the wedding trousseau of the young Nannina Medici, sister of Lorenzo the Magnificent, in 1466.[7] In an article on the new domestic architecture of the fifteenth century, Richard Goldthwaite also expresses surprise to a see a similar doll that was given in 1452, not to a young bride, but to a sixteen-year-old nun who had entered a convent five years earlier, the daughter of a wealthy Florentine, Francesco Giovanni.[8] Nor are these two examples totally isolated. The trousseau inventories listed in Florentine *ricordanze* between 1450 and 1520 occasionally include mention of these dolls given to young brides by their parents and even, as in the case cited by Goldthwaite, to girls entering a convent.[9]

In most instances these *bambini* were effigies of children; male babies that were not nude but generally richly dressed. Some of them seem completely nonreligious in character, such as the one owned by Nannina Medici, or another "child with pearls" that figured in the trousseau of Jacopo Pandolfini's second wife in 1483,[10] or the "child dressed in brocade and pearls" that Tommaso Guidetti received from his father-in-law in his wife's wedding basket in 1482.[11] In 1505 Tommaso's daughter Maddalena entered a convent, taking with her the "child dressed in crimson velvet, in a little coat of green brocade, with the sleeves of its dress embroidered with pearls, that her mother had brought to her wedding; the value of this was at the time . . . *fiorini*."[12]

Most of the time, however, the dolls that belonged to Florentine girls had a more evidently Christian personality. In 1486 Antonia, the daughter of Bernardo Rinieri, received with other items in her two wedding baskets "a child dressed in fine linen in the image of Our Lord."[13] Marietta, the daughter of Filippo Strozzi (who built the family palace), had in her trousseau in 1487 "one Messire Lord God with brocade robe and crown of gold and pearls."[14] Similarly, in 1515 Francesca, the daughter of Carlo Strozzi, brought a "Messire Lord God, fully dressed, with pearls."[15]

A few of the female saints of the Christian pantheon made a timid appearance among these richly dressed figures of the infant Jesus. In 1493 "one saint Margaret, with a dress of gold brocade, with gold lace and pearls and gold buttons on top," followed Andrea Minerbetti's first wife into his house,[16] and a "saint Mary Magdalen dressed in red satin with pearls" arrived in 1499 in one of the three baskets containing the trousseau of Giovanni Buongirolami's wife.[17]

When the identity of the dolls is not specified, we can still infer from the preceding examples and from the nature of the objects that accompanied them that these *bambini* had a religious function. The doll sent in 1452 by Francesco Giovanni to his daughter, Sister Angelica, was "made of wood, with two robes, one of crimson satin with a pearl clasp and the other of Alexandria velvet with gold trimming, a crimson velvet bonnet, [and] a garland with a wide red fringe; it is accompanied by a tabernacle of painted wood, with a small altar and altar ornaments, cloths and other small objects for this altar."[18] All this pious apparatus, therefore, surrounded a *bambino*, which, like others more expressly designated, very probably represented a "Messire Lord God" as an infant. One last text explicitly attests to the purpose of one of these holy dolls. In 1459, in his wife's trousseau, Bernardo di Stoldo Rinieri found "a large pine box containing one of those *bambini* that are set up on altars." It was perhaps this same doll that followed one of his daughters, Antonia, when she went to her husband in 1486 — a doll characterized, as we have seen, as "in the image of Our Lord."[19]

To tell the truth, the existence of these effigies of the infant Jesus is less surprising than their presence in women's trousseaux in the fifteenth century. Historians of art or religion have in fact found many examples in the plastic arts of devotion to the divine child before the seventeenth century, and at that time the cult spread with the popularity of the multiperson crèche, or *presepio*, presenting

the baby Jesus naked, swaddled, and lying in a crib.[20] Unlike the Germanic countries and northern Europe, Italy gives few examples of the full manger scene before the seventeenth century, and anything more than Jesus in the cradle is rare.[21] Prominent in Tuscan art of the fifteenth century was an image of the Christ Child standing in triumph – an image that was placed on the altar during the important feast days, particularly at Christmas, or integrated into the new tabernacles of the Holy Sacrament. Otto Kurz has studied the variants of this baby Jesus, the glorious bearer of the symbols of the Passion, emerging from a chalice, and he has described them in terms of the technical and iconographic problems that the liturgy of the Eucharist posed to artists in the fifteenth century.[22] Artists of the time were invited to conceive receptacles worthy of the host and to integrate them into the high altar. Their efforts led, after 1450, to two solutions devised by Desiderio da Settignano: the wall tabernacle and the free-standing *tempietto*, prototypes for a great number of works up to the sixteenth century. Indeed, Desiderio's sculpted wall tabernacle in the church of San Lorenzo in Florence repeats and enhances the very ancient motif – more literary than iconographical – of the infant Jesus arising from a chalice, a miraculous and symbolic prefiguration of the Passion. This infant was to have an enormous vogue at the end of the fifteenth century.

Vasari reports that during his day this handsome infant had been removed from its place on the tabernacle "and is now wont to be set upon the altar on the feast of the Nativity, as an extraordinary thing; and in its stead another was made by Baccio da Montelupo, also in marble, which stands constantly on the tabernacle of the Sacrament" (Fig. 47).[23] Baccio was known as a Savonarolan,[24] and it is probable that Savonarola and his followers were primarily responsible for the substitution. Pseudo-Burlamacchi reports that in the great procession of February 1497, the Dominican's "boys" carried all through Florence, hoisted "on a portable altar borne by four very beautiful angels . . . a most holy *bambino*, full of splendor, standing, on a gilded base, [and] giving a blessing with his right hand and with his left displaying the crown of thorns, the nails, and the cross: a work of remarkable beauty which was from the hand of the most excellent sculptor Donatello."[25] The infant sculpted by Desiderio corresponds to this description in almost all particulars, whereas no analogous work of Donatello's is known.

The immediate success of Desiderio's *bambino* (the book of *ricordanze* of the painter Neri di Bicci mentions the tinting of three *bambini di rilievo* ordered for two nuns and one monk)[26] is attested by the many copies of it that can be found in museums in Florence, in other Italian cities, and in foreign countries and, more generally, of this sort of devotional statuette. The custom of setting up an infant Jesus on the altar at Christmas seems to have spread at the end of the fifteenth century. And because Florentines did not possess relics as precious as the *Santo Bambino* of the church of the Ara Coeli in Rome (Fig. 48), miraculously transported across the sea in 1591 and "shown to the people on the day of Christmas," the kidnapping of Desiderio's precious marble child and its innu-

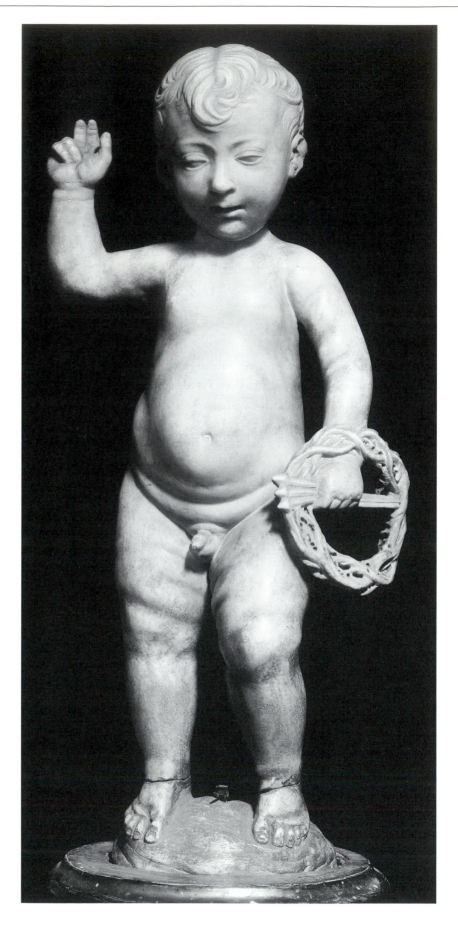

Figure 47. Baccio da Montelupo, *Standing Christ Child*, Museo dell'Opera del Duomo, Prato, early 16th century (photo: author)

merable copies in stucco, wood, and *carta pesta* obviously responded to the expectations of the followers of the divine infant; a passage from a book of *ricordanze* cited earlier refers to "one of those *bambini* that are set up on altars" (Fig. 49).[27]

The *bambini* included in Florentine trousseaux are important because they widen the area of this form of devotion to include the private houses of middle-class families. They also show that the cult of the infant Jesus may have spread earlier than had been thought on the basis of the few instances documented by historians of art. But what can we surmise of the use those young wives and those nuns behind their convent walls made of their holy dolls? Were the dolls exposed temporarily on certain important holy days, for moments of contemplation and worship that were widely separated in time and of brief duration? Did laywomen and nuns make use of them in the same ways? By what learning processes were their emotions and their ritual behaviors shaped and turned toward devotion of the divine child? And what do the dolls teach us about this devotion?

According to our texts, these "dolls" were intended for and, it seems, owned by women: the statuettes went from one woman – lay or religious – to another. The mother transmitted her *bambino* to her daughter,

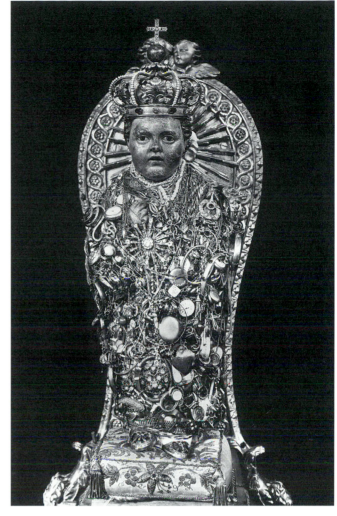

Figure 48. Anonymous, *Christ Child (Santo Bambino)*, S. Maria in Aracoeli, Rome, 15th century (photo: Alinari/Art Resource)

whether the daughter entered a monastery (as with the Guidetti doll, between 1482 and 1505) or moved under the authority of a husband (as with the Rinieri doll, between 1459 and 1486). The dolls were notable items in a girl's trousseau, often listed among the things appraised by a professional.[28] The *bambini* were always associated with women; it is always women who appear as owners or potential users of these divine or saintly figures. They were given not to little girls but to young women, and at the moment at which their matrimonial destiny was decided, either as terrestrial spouses or *sponsae Christi*. Thus their wedding, of the flesh or mystical, had to have been celebrated before they could receive their wood-and-brocade "child." The holy dolls were the "toys" of adult women delivered up to a spouse.

In 1881 Giuseppe Marcotti advanced a hypothesis, which we should examine, to explain the *bambino Gesù* discovered in the trousseau of a Medici daughter. "The custom of giving wives a beautiful wax, sugar, or plaster doll," he says, "can also be explained by something other than devotional purposes: that is, by the belief that the woman would engender a child analogous to the image that she keeps before her eyes during her pregnancy."[29] The magical function assigned to the nuptial doll, according to this theory, was aimed at transferring

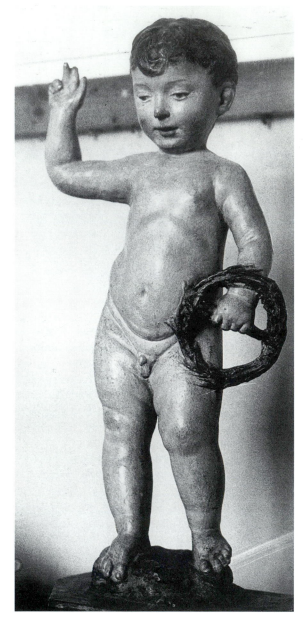

Figure 49. Benedetto da Maiano (attr.), *Standing Christ Child*, Museo Bardini, Florence, late 15th century (photo: Amanda Lillie)

the virtues of the object contemplated during the delicate period of gestation to the woman looking at it or to the child she was carrying. The future mother, in other words, would be impregnated, by visual contemplation, with the power and the qualities of the magical object. To this day the custom of placing a richly dressed doll on the conjugal bed is probably meant to insure the fertility of the couple and the material success of the children. These practices would include the infant Jesus, the St. Margaret the major patron saint of childless women and of women in childbirth), and, more oddly still, the Mary Magdalen of our Florentine trousseaux, among the magical agents of the fertility rites associated with the celebration of weddings.[30] The hypothesis is not implausible. Van Gennep cites many examples of French country marriages at which, during the wedding banquet or that night, at the bedding of the newlyweds, a doll was presented to the couple, to be swaddled and embraced by the woman, and sometimes even fictively baptized.[31] These propitiatory anticipations of a more recent folklore seem to find an echo in the appearance of a child in Florentine nuptial ritual of the fourteenth century. The Florentine practice is well documented: sumptuary statutes in 1388 regulating wedding procedures prohibited the servant who brought the coffer containing the husband's presents to his wife from being accompanied by or carrying "a small child, boy or girl, of any age whatsoever," or the family would incur a fine of 10 *fiorini*.[32]

Might the real child of flesh and bones – promise of fertility and forbidden by the authorities – have been replaced by a wooden, stucco, or wax doll that played the same role? There are two objections to this hypothesis. First, the *bambino* did not appear among the husband's gifts but was included in the trousseau sent by the bride's parents. A shift of this sort should make us hesitate at the idea of a simple substitution of a simulacrum for a child playing a ritual role.[33] Furthermore, even if the dolls did not have a religious identity, could it have been normal that they were included, as a fertility object, in the equipment of a young nun? Thus it seems to me implausible that the dolls were a simple substitute for a magical practice carried on during the wedding period. I would retain one part of Marcotti's hypothesis, however: the idea of a magical transfer of virtues and forces from the effigy to its user. An effigy is never innocent when the person looking at it knows how to put the right questions to it.

How did our Florentine women – whether they took the veil or remained in the world – play with their wedding dolls? What attitudes had been inculcated in them? How had they been taught since childhood to regard sacred images?

"Set up on altars," the *bambini* went to embellish a family oratory, like the *Nostra Donnas* or *Domeniddios* so often listed as part of the furnishings of the master bedroom, described in the inventories of Florentine dwellings.[34] This was where the devotions of all who lived in the house were concentrated: this was where the devotional image allowed exchanges with the realm of the sacred. Such exchanges were based on a virtue that the Church traditionally granted to the image: "to excite feelings of devotion, these being aroused more effectively by things seen than by things heard."[35] One work, written in 1454, taught young girls the paths to devout emotion. While they contemplated the scenes and the actors in the image, they were to try to give an affective "charge" to the picture by imagining familiar landscapes, situations, and figures. Then, concentrating their thoughts on the mental images that moved them most strongly, they could hope to enjoy those states of *dolcecia e divotione* (enchanting sweetness and devotion) to which the sacred image was supposed to lead.[36] Devotional painting, then, which underwent such extensive development in Tuscany in the fourteenth century,[37] was not directed at adults alone. The apprehension of the sacred through images was taught children from their earliest years by the example of their elders' spontaneous attitudes, but also by adults' conscious efforts. The advice of the conservative Dominican pedagogue Giovanni Dominici to one mother of upper-class Florentine society at the beginning of the fifteenth century is well known, but the text deserves to be cited once again. According to Dominici, the mother should place representations of child saints before her babies, "pictures . . . in which your child . . . may take delight . . . Jesus nursing, sleeping in His Mother's lap or standing courteously before Her while they look at each other. So *let the child see himself mirrored* [emphasis added] in the Holy Baptist clothed in camel's skin. . . . " This pictorial program was addressed particularly to boys, but it was completed by an iconography reserved for girls.[38]

By means of such representations – some of which, like the slaughter of the Innocents, were frankly negative – even babies in their cradles were to be led to identify with the figures in the icon. Is it fair to accuse our Dominican of unrealistic attitudes and pious dreams? When he aroused the child's imagination in this manner, he was playing on the same reactions that inspired devotion in the adult, simply choosing images that corresponded to the child's sensitivities. Dominici proves more innovative in this than many humanist thinkers and accords greater respect to the unique characteristics of childhood. Certain texts reveal in unexpected ways that his recommendations rested on fairly consistent practice and that pious images may have been present in private houses to satisfy the needs of children. Such texts do, in fact, illustrate a kind of devotional pedagogy. In 1482, for example, Niccolò Strozzi lent one *fiorino* to his servant woman, who wanted to acquire a "Virgin Mary." Two years later (although she still owed him the *fiorino*) the good woman left him the image, which, as he says, "she left in my house, thinking to give pleasure to the children."[39] Thus the sacred image was to satisfy the needs of less-cultivated spirits in the household, from the servant woman to the young; it was to "instruct the ignorant," as the

Church would say, and to become a prop for a female or childish devotion that the father judged, apparently, with some condescension.

This passive, visual impregnation of the child or the woman was completed by more active educational behaviors. Sometimes, in fact, private altars were used for a real apprenticeship in devotion through play. Again, Dominici's pedagogical advice, which might seem theoretical or somewhat stuffy, finds an echo in real practices that can be confirmed, here and there, by other texts. Giovanni Dominici wanted the mother to incline her son toward religion by keeping him occupied around a domestic altar, which he should decorate, illuminate, and serve like a real acolyte. The child should even learn to mimic the priest in front of the altar – after observing him in church – by ringing a bell, singing, saying mass, and preaching. The priest's "good example" justified the make-believe suggested by our Dominican, who saw no irreverence in it. He also had suggestions for decorating the altar at which the child was to officiate. "Sometimes they may be occupied in making garlands of flowers and greens with which to *crown Jesus* [emphasis added] or to decorate the picture of the Blessed Virgin, they may light and extinguish little candles, etc."[40] Here is a familial Jesus, then, and we can imagine him in this context of women's and children's devotions depicted as a young child, like the *bambini* that belonged to the mothers of these apprentice Christians (Fig. 50). A few decades later, Savonarola, when he was still a little boy – *fanciulletto* – "amused himself enormously all by himself, busying himself setting up little altars and [engaging in] other devotions of the same sort."[41] The fully equipped altar that accompanied the *bambino* sent in 1452 to Francesco Giovanni's daughter seems at first sight to fit in with this type of religious education through play and imitation.

Identification and participation thus underlay the devotional practices proposed to Florentines from early infancy. When the emotions of the worshipper reach a certain intensity, the force of the image – the infant Jesus, "Our Lady,"

Figure 50. Anonymous, *Recumbent Christ Child*, Museo Bardini, Florence, late 15th century (photo: Amanda Lillie)

or the crucifix – becomes effective and transfers some of its power to the worshipper.[42] A Florentine recluse of the beginning of the thirteenth century, the blessed Umiliana dei Cerchi, was in the habit of losing herself in prayer before an image of the Virgin, and it was the pressure exerted on the image that induced the miracle when the spent flame revived in the lamp burning before the icon.[43] The same pious effusion can be seen in confraternities at the end of the fifteenth century that joined together "around the little Jesus before whom [their members] offered their prayers, not without shedding many tears."[44] In offering sacred images of young saints to the offspring of the Florentine bourgeoisie and in appealing to their imaginations, Dominici was acting exactly like the spiritual leaders of the lay and religious communities who, from the thirteenth century on, had invited Christians to participate in biblical dramas by acting with, or taking the place of, their sacred participants.[45] The Franciscan author of the *Meditations on the Life of Christ*,[46] and his fourteenth-century imitators,[47] opened up to the pious souls and to artists a huge repertory of attitudes and emotions that made the image into the Christian's immediate partner. The author of the *Meditations*, directing the devotions of a Poor Clare, tells her:

> You also kneel and adore your lord God, then his mother, and salute the holy and venerable Joseph respectfully. Then kiss the feet of the infant Jesus who is laid in his bed, and ask Our Lady to give him to you and allow you to pick him up. Receive him and hold him in your arms. Look at his face with attention and kiss it with respect, take joy in this with confidence . . . Then give him back to his mother and look well how she suckles him, cares for him, and serves him in all things with solicitude and wisdom. Thus, you also, keep yourself ready to help her if you can . . . serve Our Lady and the child Jesus as much as you can.[48]

The mental image ends here in a fantasized manipulation of the sacred figure. Some surprising applications of these devotions can be found in the ritual life and the fantasy life of the faithful.

There is evidence that these spiritual behaviors were quite often dramatized and simulated in the fifteenth century by pious confraternities and religious communities. The most common ritual practice was the exposition of the infant Jesus, not only on the altar, standing in triumph, but lying in a cradle or a crib at Christmastime. The faithful came to adore him and to kiss his feet.[49] There is one of these figures of Jesus of the fifteenth century in the Museo Bardini in Florence, a chubby baby whose right foot has been worn away by the kisses of the devout (Fig. 50). This custom was sometimes enlarged into a real theatrical production that permitted the entire congregation to relive evangelical scenes. In this way the reformed Dominican monasteries of San Marco in Florence, Fiesole, and Prato, under the guidance of Savonarola, played the Journey of the Magi and the Adoration of the infant Christ during Epiphany in 1498. The procession ended in a direct contact between each one of the friars and the effigy of the divine child, which was lifted out of the manger and placed on a portable altar inside the church, kissed by all, one after the other, on its feet, its hands, and its mouth.[50]

These infant Jesus figures used at Christmas, which recall the *repos de Jésus* of northern Europe, inspired other rites of mothering that were much more elaborate and increasingly widespread in the convents of Europe of the time.[51] The worshippers were not satisfied with cradling their Jesus; occasionally, they bathed him, dressed him, and made him new clothes, thus taking literally the spiritual recommendations that encouraged the Christian to prepare his or her soul for these humble services. Nuns all over Europe, identifying with the Mother of God, gently tended an effigy of Jesus at liturgical feasts. One confraternity was even created in seventeenth-century Italy to care for, wash, swaddle, and cradle the newborn Christ.[52] Here the effigy was not only interpreted and adored, but handled, coddled, and taken for walks through the convent, purifying the entire community by its gaze and its presence. The image truly came to life and became an actor in a drama played by all, bringing tears to the participants' eyes. The objects that served as a property for these rituals, the *bambini*, were made in the convents of Lucca, and after 1600 they were exported to the four corners of the world, accompanied by the maternal rites so characteristic of this new form of devotion. But the commerce in holy dolls did no more than diffuse practices and a cult that were already thriving at the end of the fifteenth century, when Savonarola denounced nuns' adulation of their *bambini* as smacking of idolatry.[53]

Rite and sacred imagery were not the only ways the child Jesus crossed the barriers of art to enable the faithful to see, or rather to feel and to relive, his childhood and his vulnerability. The exhortations of their confessors so imbued female mystics with the sort of images we have been discussing that these nuns elaborated on them and lent them reality in their visions. Many a saintly nun, after long orisons before the holy image, merged with the mother of Christ and changed places with her for the duration of her ecstasy. Umiliana dei Cerchi so ardently desired to see Jesus at the age of three or four years old "with her corporeal eyes" (like St. Francis)[54] that one day a *bambino* of that age visited her in her cell, and began to play. Like the Wise Man of later paintings, the saint dared to kiss his foot.[55] According to her biographer, this apparition was exceptional even among miracles because (in the first half of the thirteenth century) it was usually angels that God sent to saints rather than his only son. Later, with the diffusion of devotional practices analogous to those recommended in the *Meditations* or by Ludolphus, Franciscan and Dominican convents in Italy were to see more frequent apparitions of the holy child. Around 1310, St. Sibylline, a Dominican nun from Pavia and blind from the age of twelve, is visited by the infant Jesus. In her vision she attempts to seize him and embrace him, but he always escapes her, and from that very frustration an immense joy is born in her that even the memory of her vision is enough to revive for the rest of her life.[56] At about the same time St. Agnes of Montepulciano ardently desires to see Jesus "face to face" and to "find joy in his embraces." Mary appears to her at last, and she gives Agnes the child, but an hour later Agnes refuses to give him back "in spite of the flatteries and the threats" of the Virgin. The true mother and the temporary mother, transformed

into tigresses, quarrel fiercely over the baby, pulling him back and forth until Agnes is bested. All that she manages to keep from this adventure is a small cross, a precious relic that the child wore around his neck.[57]

Narrations of these ecstatic visions, from which the visionary often awakened with appalling violence,[58] follow the details of texts like the *Meditations*, reinforced at each stage by devotional paintings. The endearments, the kisses, the fondling, and the loving attention that the mystics pour out toward the divine child echo the hypermaternal attitudes that the devotional texts attribute to the Virgin herself. Spiritual service of the infant Jesus, the quintessential *bambino*, takes on forms that seem just as down-to-earth as the rituals of mothering. At Christmas 1540, when the Virgin appears to St. Caterina de' Ricci, a Florentine nun in Prato, and lends her the infant Jesus, the saint is astonished to find him dressed: from the time of St. Francis, the poverty, nudity, and humility of Our Lord at his birth had been celebrated in the adoration of the newborn Christ. In her vision, Caterina hears the Virgin answer that "it is indeed the swaddling cloths, the bands, and the cloak that she [Caterina] made for him by her Advent prayers" that have clothed him.[59] One year later the Virgin returns: this time the child is nude. The saint plays with him in her bed, then returns him to his mother, who pulls some cloths from a basket and diapers him, "saying that these were the swaddling cloths and the diapers that the nuns of the convent had prepared by their prayers during Advent."[60]

Nuns or laywomen, these women appealed to a contact – visual or physical – with sacred images in order to have immediate access to the child Jesus. Whether they were actresses or visionaries, their doll play had an evident cathartic role. Some used the ritualized manipulation of a wooden, papier-mâché, or plaster simulacrum; others, the exaltation of ecstatic delirium. These play activities permitted young women, shut up from childhood on in a convent[61] or subjected to a distant husband[62] and separated from their own newborn children at birth,[63] to identify with the mother of Christ and transmute their frustrations and tensions. The language of these mystics when they speak of their visions also shows that the husband so desperately absent was hidden in the baby of their dreams. Later the child dolls brought by nuns in Germanic countries to their convents were to be called *sponserl*, "little husbands."[64] In dreaming of themselves as the servants and nurses of the Christ Child, these "brides of Christ" attempted to see and to feel their spiritual husband physically, to bear him in themselves and to suckle him (like Marguerite Ebner), to touch him and to "embrace" him, to "find joy in his embraces." This language reaches toward the spiritual, but at the same time it translates the total overwhelming of all the senses. St. Agnes of Montepulciano levitates up to the crucifix placed on the altar and remains there, hanging on it, "kissing and hugging it, seemingly clinging to her beloved, so that all can see in manifest fashion the spiritual union of her internal unity with Christ through her embrace with a material image, and so that all can understand the elevation of her spirit as they consider the miraculous suspension of her body."[65]

Many a nun, in fact, entered into a mystical alliance, under the auspices of the Virgin – a great matchmaker for souls – with these infant Jesuses of their visions and returned from the experience with a finger encircled by a ring invisible to others.[66] The mystical union, the "embrace" and the ineffable "joy" that made saintly women who experienced it fall panting or writhing in pain when it ended – these overwhelming experiences were certainly attenuated, but not eliminated, when their love for an adult "husband" was shifted to the child Jesus. In fact, the infant Jesus allowed the recluse her primary social function – the maternal function – and put her desire and frustrations within limits that her male confessors recognized and could accept. The child-husband allowed these women an experience that their secluded life condemned them never to know.

It is not my intention to limit the cult of divine infancy to the maternal and sexual frustration of more or less secluded women and young girls, however. This devotional practice also awoke profound resonances in a male public, religious and lay. In the processions and the dramatizations that he put on for the friars and the young novices of San Marco, Savonarola used similar emotional means, and when the friars called the Virgin "their mother," they were doing no more than repeating and inverting the relations between mother and son that the nuns cultivated in their attitude toward their *bambino*.[67] After all, in the biographies of male saints one finds ecstatic effusions of a holy man with a baby: the "Legend of the Miracles" of St. Anthony of Padua established a prototype for male baby coddling long before St. Joseph, guardian of the holy infancy, was to be presented as a rival model.[68] Is it possible that the common denominator of the exploitation of the emotions on which these images, visions, and new rites were based might be a new open-mindedness, a loss of blindness concerning childhood, reflected in the chubby forms of our *bambini*?[69]

Noting the presence of one of these dolls among the belongings of a nun, Richard Goldthwaite attributes the unusual intrusion of a doll in a convent to "a new sense of domesticity and fascination with children,"[70] and he interprets this as a sign of a profound mutation that affected familial structures and ways of thinking. Might not the *bambino* bring into the cloister an echo of new feelings that had matured within the bourgeois – and "conjugal" – family of the end of the Middle Ages?

I wonder, in fact, whether the inverse is not true. At the root of this appetite for childhood, which the taste for *putti* engendered by the Renaissance was to leave unsatisfied, is it not the idea of the humility, nudity, and frailty of the new-born child, lying in a crib, that we find rather than an exaltation of the bourgeois baby, which was sent off to a nurse immediately after birth and which, if it died in her care, would never even have been known to its parents? And when painters removed the Virgin of Humility from her throne and placed her on a cushion on the ground,[71] did they not do more to rehabilitate maternity and its humble nursing tasks[72] than had all the rehashed preachings of doctors and moralists who from antiquity had lauded the benefits of maternal nursing, or the reflections of a few humanists writing on conjugal relations and the role of the

woman in marriage? Perhaps we should invert the accustomed reading of the relations between the reality of childhood and its representation in images. Florentines may have begun to take a better look at their own flesh-and-blood babies because their practice in the sphere of the sacred had led them to cuddle plaster and papier-mâché figures of Jesus. Paradoxically, it would then be among cloistered women and in the ritualization of their desire for a child that we would have to seek the origin, not only of a pedagogy of pious practices, but of an apprenticeship in what we call maternal attitudes.

To specialists in the history of dolls, our Florentine *bambini* may not seem to be very representative of the species. This is because they stand at the confluence of many needs; they spin threads, less tenuous and less futile than may at first appear, that bridge the gap between behavior patterns not usually assigned to the level of mere play. In the hands of a young Christian or of a nun, mimicking gestures foreign to them, under the eyes of a simple worshipper or of an actor in a sacred representation, the *bambini* broke down the transparent wall that separates reality from its figuration — just as the doll of childhood does. When we play, there is always an image involved, and if the game is played to the limit, it is the image that ends up manipulating us.

Notes

This research was originally presented as a paper at the international colloquium of humanistic studies at Tours, July 1980. It was published first as "Les saintes poupées: Jeu et dévotion dans la Florence du Quattrocento," in *Les Jeux à la Renaissance*, ed. J.-C. Margolin and P. Ariès (Paris, 1983), 65–79, and then in revised form in C. Klapisch-Zuber, *Women, Family, and Ritual in Renaissance Italy*, trans. L. Cochrane (Chicago and London, 1985) 310–29; (I am grateful to the press for permission to republish it here in an updated revision – ED). (French translation: C. Klapisch-Zuber, *La Maison et le nom: Stratégies et rituels dans l'Italie de la Renaissance* [Paris, 1990].)

My thanks to Richard C. Trexler for his generous guidance on the paths of Florentine religious history to which the dolls led me. By permitting me to read several chapters of his book in proof, he enabled me to put certain of my overingenuous hypotheses into perspective. My thanks also to Daniela Lamberini and Amanda Lillie for their invaluable help – photographic, bibliographic, and iconographic.

1. H. R. d'Allemagne, *Histoire des jouets* (Paris, 1902), 98–9. M. Manson, "Introduction," *Histoire de la poupée*, exh. cat., Musée Roybet-Foulé, Courbevoie, 1973–74; Manson, "La poupée française," in *Histoire de la poupée*, 1980, 5–6.
2. D'Allemagne, *Histoire*, 149–50; C. van Hulst, "La storia della divozione a Gesù Bambino nelle immagini plastiche isolate," *Antonianum* XIX (1944): 33–54; R. Berliner, *Die Weihnachtskrippe* (Munich, 1955), 157, n. 25.

3. D'Allemagne, *Histoire*, 149.
4. P. Jeanne, *Bibliographie des marionnettes* (Paris, 1926); C. Magnin, *Histoire des marionnettes en Europe* (Paris, 1862), 57; C. Sezan, *Les poupées anciennes* (Paris, 1930), 133, 136–9.
5. See Max von Boehn, *Puppen und Puppenspiele* (Munich, 1929).
6. R. C. Trexler, "Florentine Religious Experience: The Sacred Image," *Studies in the Renaissance* XIX (1972): 7–41; idem, "Ritual Behavior in Renaissance Florence: The Setting," *Medievalia et humanistica: Studies in Medieval and Renaissance Culture*, n.s. IV (1973): 125–44; idem, *Public Life in Renaissance Florence* (New York, 1980), esp. chap. 3, "Exchange."
7. G. Marcotti, *Un mercante fiorentino e la sua famiglia nel secolo XV* (Florence, 1881), 90. The citation is repeated by Aby Warburg in "Florentinische Bildniskunst und florentinisches Bürgentum. 1: Domenico Ghirlandaio in S. Trinità," *Gesammelte Schriften* (Leipzig, 1932), I, 342.
8. R. A. Goldthwaite, "The Florentine Palace as Domestic Architecture," *American Historical Review* LXXVII, no. 4 (October 1972): 1011. The *ricordanze* of Francesco di Tommaso Giovanni, 1422–58, are found in the Archivio di Stato, Florence (henceforth ASF), *Strozziane*, 2d ser., 16 and 16 bis; the doll is described in 16 bis, fol. 16v. Sister Angelica, baptized Gostanza, was born 5 July 1436; she entered the order of St. Clare of Monticelli in 1446 and made her final vows 8 February 1450 (*ibid.*, fol. 5). Dates are given in modern style.

9. *Ricordanze*, which were both account books and personal journals, were written by the entire Florentine bourgeoisie and even by artisans. The dozen or so that I cite here are the work of merchants and jurists who belonged to the wealthier strata of society: their daughters' dowries averaged around 1,500 *fiorini* and ranged between 1,000 and 2,000 *fiorini*. Their daughters who entered the religious life brought an "alms" of 100 *fiorini* and a trousseau evaluated at about 30 *fiorini*, or one-tenth the amount of that of their sisters who married.

10. Archivio degli Innocenti, *Estranei*, 648, fol. 173 (1 November 1483).

11. ASF, *Strozz.*, 4th ser., 418, fol. 4v (31 January 1482).

12. *Ibid.*, fol. 51v (19 August 1505).

13. ASF, *Conventi soppressi*, 95, no. 212, fol. 169v (1 February 1486).

14. ASF, *Strozz.*, 5th ser., 41, fol. 169 (3 February 1487).

15. ASF, *Strozz.*, 4th ser., 76, fol. 150 (23 February 1515). See also in the trousseau of Gostanza Benci in 1518 "una fighura di rilievo rapresentativa di Cristo in pueritia bello, coperto di taffettà rosso et verghato" (a fine figure representing Christ in beautiful infancy, dressed in striped red taffeta) (ASF, Carte Gondi, 264, no. 34); on this trousseau, see L. Pagliai, "Una scritta nuziale del secolo XVI," in *Nozze Schiaparelli-Vitelli* (Florence, 1904). My thanks to Diane Cole Ahl for this citation.

16. Biblioteca Laurenziana, *Acquisti e Doni*, 229, 2, fol. 2v (23 June 1493). The same doll reappears in the trousseau of her daughter Gostanza in 1511, with "uno tabernacolo per la santa" (*ibid.*, fol. 81r and 82r).

17. ASF, *Strozz.*, 2d ser., 23, fol. 131 (7 August 1499). Another saint Mary Magdalen appears in the trousseau of Fiammetta, Filippo Strozzi's daughter (ASF, *Strozz.*, 5th ser., 59, fol. 13v [5 July 1493]).

18. ASF, *Strozz.*, 2d ser. 16 bis, fol. 16v (June 1452). See also the mention in 1417, in a Medici inventory (ASF, Mediceo avanti il Principato, henceforth abbreviated MAP, 129, fol. 59), of "uno tabernacolo di legno, entrovi uno bambino Nostro Signore con dalmatica in dosso di velluto azzuro e camisce e altro habito da diacono" (a wooden tabernacle in which an infant Our Lord wearing a blue velvet cassock and robe and other deacon's vestments) found in the bedchamber of Cosimo (I owe this notation to the kindness of K. Lydecker). Also see the mention of "uno bambino, venne da Madonna Nibia (?), fornito di perle con una crocetto di perle, valeva fior. 10 e piu i' una zana" (a child doll, which came from Madonna Nibia, complete with pearls with a little pearl cross, worth over 10 *fiorini* in a basket) (Innocenti, *Estranei* 633, Ricordi di ser Andrea di Cristofano Nacchianti, fol. 94v). These objects followed a young nun to the convent.

19. ASF, *Conventi Soppressi* 95, 212, fol. 154 (31 January 1459) and fol. 169v (1 February 1486).

20. On the cult of the *presepio* and its antecedents in the thirteenth to sixteenth centuries, see van Hulst, "La storia della divozione," 38–44; Berliner, *Die Weihnachtskrippe*, 14–18; and D. C. Shorr, *The Christchild in Devotional Images in Italy during the XIVth Century* (New York, 1954).

21. See also the examples of cribs cited in Berliner, *Weihnachtskrippe*, 156, nn. 24 and 25, and by van Hulst, "La storia della divozione," 42–4. A misinterpretation of a letter of St. Catherine of Siena makes her the founder of the *bambini* industry in Lucca (see below, n. 50) that was to develop and spread widely during the second half of the sixteenth century and to flourish in the seventeenth century. See the recumbent *bambino* from the Museo Bardini, Florence, reproduced as Fig. 50.

22. On the eucharistic miracle of the Christ Child inside the chalice appearing to worshippers, a theme dating from the twelfth century, and on the cult of the Eucharist, see P. Browe, *Die eucharistischen Wunder des Mittelalters*, Breslauer Studien zur historischen Theologie, n.s., IV (Breslau, 1938). On devotional images, see C. Bynum, *Fragmentation and Redemption: Essays on Gender and the Human Body in Medieval Religion* (New York, 1991); U. Schlegel, "The Christchild as Devotional Image in Medieval Italian Sculpture: A Contribution to Ambrogio Lorenzetti Studies," *Art Bulletin* LII, no. 1 (March 1970): 1–10; O. Kurz, "A Group of Florentine Drawings for an Altar," *Journal of the Warburg and Courtauld Institutes* XVIII (1955): 35–53; and Giovanni Previtali, "Il 'Bambin Gesù' come 'immagine devozionale' nella scultura italiana del Trecento," *Paragone* XXI, no. 249 (1970): 31–40 and figs. 21–9. During the fourteenth century, Tuscan and Umbrian statues of the *bambino Gesù* gradually shifted from the standing, "triumphal" position to the lying position more frequent in the fifteenth century.

23. G. Vasari, *Le vite de' più eccellenti pittori, scultori, ed architettori*, ed. G. Milanesi (Florence 1878–1906), III, 108, and *Lives of Seventy of the Most Eminent Painters, Sculptors, and Architects*, ed. E. H. and E. W. Biashfield and A. A. Hopkins (London, 1897), II, 127–8. In any event the substitution took place before 1510. (Kurz, "A Group of Drawings," 49, n. 3.) See G. Richa, *Notizie istoriche delle chiese fiorentine divise ne' suoi quartieri* (Florence, 1754–62), V, pt. 1, 28, on the later destiny of the *bambino*. Berliner, *Die Weihnachtskrippe*, 18 and 160, nn. 51–3, cites inventories of the sacristy of San Lorenzo dating from 1453 and 1677 that mention a richly dressed *bambino* destined to be displayed on the altars at Christmas, before and after the period in which the Jesus of Desiderio was used for this purpose.

24. According to Pseudo-Burlamacchi, *Vita del beato Jeronimo Savonarola*, edition attributed to P. Ginori Conti (Florence, 1937), 201–2.

25. *Ibid.*, 131. See Kurz, "A Group of Drawings," 49.

26. A sampling made by D. Lamberini and A. Lillie in the analytical files of the Kunsthistorisches Institut of Florence brought out no fewer than eleven of these variants of the *bambino* by Desiderio (Florence: Acton Collection, Museo Bardini, and Palazzo Davanzati: see Figs. 47 and 49; Naples, Milan, New York, Detroit, Paris, Berlin, and Cambridge have other examples). Kurz, "A Group of Drawings," 49, notes other copies in Fiesole and Amsterdam. Comparable statuettes attributed to Benedetto da Maiano and Francesco di Simone are found, respectively, in Arezzo and Monteluce. Neri di Bicci, *Ricordanze*, ed. B. Santi (Pisa, 1976), 170–1 (9 June and 28 September 1461), 192 (19 January 1463) relates that he put colors on various wooden "banbini" [sic] for monks and nuns.

27. Van Hulst, "Storia della divozione," 42–3. For the *ricordanze* cited earlier, see n. 19.

28. In two out of eleven cases, these dolls count among the *donora* expressly called *non stimate*, and, in a third case, the family journal does not specify whether the doll was appraised with the rest of the trousseau. The reason for this difference in treatment for the moment escapes me.

29. Marcotti, *Un mercante*, 121, n. 43. The author cites A. de Gubernatis, *Storia comparata degli usi natalizî in Italia e presso gli altri popoli indo-europei* (Milan, 1869) and D. G. Bernoni, *Credenze popolari veneziane* (Venice, 1874). A. Warburg, "Florentinische Bildniskunst," in *Gesammelte Schriften*, I, 342, refers in turn to the other work of A. de Gubernatis, *Storia . . . degli usi nuziali* (Milan, 1878), 175, on magic for alliance and fertility.

30. A. van Gennep, *Manuel de folklore français contemporain* (Paris, 1972), I, pt. 1, 116, nn. 6 and 7; bibliography, *ibid.*, III, 488–9. According to the Golden Legend, Mary Magdalen aided a sterile couple to conceive a child, watched over the child's survival, and resuscitated the mother, who had died in childbirth. She is associated with the infant Jesus as a sort of older sister in several regions of France.

31. Van Gennep, *Manuel*, I, pt. 2, 516–17 and 581. See H. Bächtold-Stäubli, *Handwörterbuch des deutschen Aberglaubens* (Berlin and Leipzig, 1927), s. v. "Bild, Bildzauber," I, cols. 1282–1306. Y. Verdier, in *Façons de dire, façons de faire* (Paris, 1979), 278 and 289, mentions these farcical rites in Burgundy today.

32. The *ordinamenta* of July 1388 were published by D. Salvi in an appendix to G. Dominici, *Regola del governo di cura familiare* (Florence, 1860), 221–37; the passage cited can be found on p. 233. The custom is, in fact, corroborated by the *ricordanze*; see ASF, *Strozz.*, 2d ser., 4, Ricordi di Paolo di Alessandro Sassetti, fol. 70 (1384): "per dare al fanciullo posto in collo" (to give to the little boy put in [her] arms). Ser Lapo Mazzei, *Lettere d'un notaio a un mercante del sec. XIV*, ed. C. Guasti (Florence, 1880), II, 247, notes the same custom in November 1407 (one *fiorino* "per dare a uno fanciullo che si pone in collo alla donna novella" or "to give to a little boy who is put in the arms of the new wife").

33. On the exchange and circulation of gifts on the occasion of marriages in Tuscany, see Klapisch-Zuber, *Women, Family, and Ritual*, 213–46, "The Griselda Complex." When Tommasa Delli marries Giovanni Niccolini 1 June 1353, her trousseau is brought by a servant "with a little boy" to whom Giovanni gives one *fiorino* (G. Niccolini da Camugliano, *The Chronicles of a Florentine Family, 1200–1400* [London, 1933], 64, 66). Here the child went – as did the dolls – from the house of the bride's father to the house of her husband. The substitution thus seems more plausible.

34. The *ricordanze* of the Florentine, Tribaldo dei Rossi, give one example in 1481 of a painting of *Nostra Donna* ordered immediately after marriage to decorate the conjugal chamber (Biblioteca Nazionale Centrale, Florence, henceforth BNF, 2, 2, 357, fols. 4, 5). On family prayers, see Trexler, *Public Life*, 160, 353.

35. M. Baxandall, *Painting and Experience in Fifteenth Century Italy* (Oxford, 1972), 41.

36. *Ibid.*, 46. He is speaking of the *Zardino di Oration*, written in 1454.

37. On these tendencies in Italian painting, see F. Antal, *Florentine Painting and Its Social Background* (London, 1947), 133–287; M. Meiss, *Painting in Florence and Siena after the Black Death* (Princeton, 1951; reprint, New York, 1964), 125–6.

38. For the complete quotation, see Klapisch-Zuber, *Women, Family, and Ritual*, 94–116, "Childhood in Tuscany" Dominici, *Regola*, 131–2 (quoted trom A. B. Coté, trans., *On the Education of Children*, [Washington, D.C., 1927] 34). See J. B. Ross, "The Middle-Class Child in Urban Italy, Fourteenth to Early Sixteenth Century," in *The History of Childhood*, ed. L. de Mause (New York, 1975), 204–11. On the relation between childhood and sanctity, see A. Benvenuti Papi and E. Giannarelli, eds., *Bambini santi: Rappresentazioni dell'infanzia e modelli agiografici*, (Turin, 1991).

39. ASF, *Strozz.*, 4th ser., 71, fols. 78v and 79 (1 June 1484): "per una Vergine . . . la quale lasciò in casa, ritenneva per contento di fanciugli."

40. Dominici, *Regola*, 146 (Coté trans., *Education*, 42).

41. G. F. Pico della Mirandola, *Vita R. P. Hieronimi Savonarolae* (Paris, 1674, 6); Pseudo-Burlamacchi, *Vita*, 6.

42. Trexler, "The Sacred Image," 16–24. See also his analysis of the spiritual exercises of Giovanni Morelli (whose motto was *fammi partecipe* – Let me share) in *Public Life*, 174–85.

43. "De vita beatae Aemilianae seu Humilianae viduae," *Acta sanctorum*, Maii IV, 395–418.

44. Pseudo-Burlamacchi, *Vita*, 95.

45. On the influence of the Dominicans and the Franciscans on

Italian art, see Antal, *Florentine Painting*, 65–83; Meiss, *Painting*, 125–31. St. Clare of Assisi first introduced dolls of the Christ Child into convents of her order. Fourteenth-century inventories of Franciscan convents in Germany sometimes mention "images of the infant Christ our Lord in a cradle." One of them, which belonged to Marguerite Ebner, is preserved at the Maria Mödingen convent in Bavaria; a cradle from the same convent is preserved in Munich; see E. Vavra, "Bildmotiv und Frauenmystik: Funktion and Rezeption," in *Frauenmystik im Mittelalter*, ed. P. Dinzelbacher and D. Bauer (Osfildern, 1985), 201–30.

46. Long attributed to St. Bonaventura and then to Giovanni da Calvoli. I quote from the anonymous edition of St. Bonaventura, *Meditationes vitae domini nostri Jesu Christi* (Arras, 1884).

47. Particularly Ludolphus the Carthusian, a Saxon prior at Strasbourg, who wrote during the first third of the fourteenth century a *Vita Jesu Christi*, ed. L. M. Rigollot (Paris and Brussels, 1878) that often follows the text of the *Meditations* word for word. There are many versions of the latter in the vernacular, in rhymed verse, etc., on which see Meiss, *Painting*, 125–6.

48. *Meditationes*, 60; Ludolphus, *Vita*, I, 77–8.

49. Berliner, *Die Weihnachtskrippe*, 160, n. 53. Previtali, "Il Bambin Gesù," 37, emphasizes the "double use of the statuette (standing, in a tabernacle and lying in a manger of the *presepio*) planned from the start."

50. Pseudo-Burlamacchi, *Vita*, 117–20. See Trexler, *Public Life*, esp. 189–90.

51. Berliner, *Die Weihnachtskrippe*, 15–18.

52. *Ibid.*, 160, n. 48. An English clergyman also noted this in 1674.

53. Van Hulst, "Storia della divozione," 43–8. When a "bambino di legno bellissimo" (a most beautiful wooden infant) was discovered in the Philippines at the end of the sixteenth century, some thought it the one that Pigafetta had offered to the queen of Cebu on the occasion of her conversion in 1521 by Magellan (see A. Pigafetta, *Primo viaggio intorno al globo*, ed. C. Amoretti, Milan [1800], 88–9). On the figures of Jesus of the seventeenth century, see van Hulst, "Storia della divozione," 48–53. Savonarola's criticisms of nuns can be found in his *Prediche sopra Amos e Zaccaria*, ed. R. Ridolfi (Florence, 1955), I, 373: "Lasciate, monache, li vostri bambini, che sono gl'idoli vostri, venite e cercate me" (Nuns, leave off your infant [dolls], which are your idols, and come to find me).

54. According to the "Vita prima" of St. Francis written by Thomas of Celano, the saint introduced an ox, a donkey, and a manger into the church of Greccio in 1223, but without placing the child in the manger, and it was only some of his followers who had the vision of a *bambino* lying there. See also the "Vita altera s. Francisci" of St. Bonaventura, *Acta sanctorum*, Oct. II, 706–7, 770.

55. "Vita," *Acta sanctorum*, Maii IV, 397. See D. Herlihy and C. Klapisch-Zuber, *Les Toscans et leurs familles* (Paris, 1978), 568. Satan also understands her "desire" to see the Virgin and Child and one day makes them appear diabolically before the saint ("Vita," 390). Vavra, "Bildmotiv," demonstrated that German nuns associated visions and images.

56. "De sancta Sibyllina de Papia," by Thomas of Bozolesto, *Acta sanctorum*, Martii III, 69. For a Lacanian presentation of desire among Christian mystics and ecstatics, see J. N. Vuarnet, *Extases féminines* (Paris, 1980), and its bibliography.

57. "De s. Agnete virgine ord. sancti Dominici Montepolitiani," *Acta sanctorum*, Aprilis II, 797. Similarly, Margherita da Faenza refused to give Jesus back to his mother. In her autobiography Margery Kempe described several times the ways in which she helped the Virgin and the infant Christ; see M. Kempe, *Le Livre: Une mystique anglaise au temps de l'hérésie lollarde* (Paris, 1987).

58. When she awoke, St. Agnes of Montepulciano "post magnos et horrendos clamores in terram ejulando decidit semimortua" (after great and horrendous shouting, wailing on the floor, fell half-dead) (*Acta sanctorum*, Aprilis II, 797). The same was true of Angela di Foligno (see Vuarnet, *Extases*, 80). See also E. A. Petroff, *Medieval Women's Visionary Literature* (Oxford, 1986).

59. Serafino Razzi, *La vita della ven. Madre suor Caterina de' Ricci*, ed. G. M. Di Agresti (Florence, 1965), 108–9.

60. *Ibid.*, 119–20. Should we see in the offerings that the faithful, even today, leave by the *bambino* displayed at Christmastime a symbolic offering toward his spiritual clothing, as D. Lamberini has suggested to me?

61. According to a small sampling of nuns known through the *ricordanze*, Florentine women took the veil between 8 and 12 years of age (average of 24 cases: 10 years, 6 months) and pronounced final vows between 14 and 18 years of age (average of 9 cases: 16 years, 1 month). This last figure is close to the one (16 years, 11 months) obtained by J. Kirshner and A. Molho, "The Dowry Fund and the Marriage Market in Early Quattrocento Florence," *Journal of Modern History* L (1978): 422, table 5, for fifteen girls who became nuns after 1430.

62. See Herlihy and Klapisch-Zuber, *Les Toscans*, 395–400, 594–5, 603–5.

63. See Klapisch-Zuber, *Women, Family, and Ritual*, 132–64. Nearly half of the children that Florentine parents put out to nurse outside of Florence went to their *balia* before they were six days old.

64. Van Hulst, "Storia della divozione," 52. Childless couples gave dolls called *Sponsele* (little brides) to religious communities, with a dowry and a trousseau (see one example from the seventeenth century in the Musée Alsacien of Strasbourg).

65. *Acta sanctorum*, Aprilis II, 794. See C. Opitz, *Evatöchter und Bräute Christi. Weiblicher Lebenszusammenhang und Frauenkultur im Mittelalter* (Weinheim, 1990).

66. They evidently were following the example of St. Catherine of Alexandria, whose mystical marriage with the infant Jesus was a theme widely developed around the first third of the fourteenth century; see Meiss, *Painting*, 108–11. Catherine of Siena had the same experience, according to the "Miracoli della beata Catherine," in R. Fawtier, Sainte *Catherine de Sienne: Essai de critique des sources*, I, *Sources hagiographiques*, (Paris, 1921), 219. Her later and more official biographer, Raimondo of Capua, substitutes a more probable adult Jesus for the infant Jesus (*Acta sanctorum*, Aprilis III, 881–2). Caterina de' Ricci also entered into a mystical marriage with the *bambino Gesù* (S. Razzi, *Vita*, 129–30). On the body of saints, see A. Vauchez, *La sainteté en Occident aux derniers siècles du Moyen-Age* (Rome, 1981). On forms of female religiosity, see the many studies of A. Benvenuti-Papi, especially "*In castro poenitentiae*": *Santità e società femminile nell'Italia medievale* (Rome, 1990).

67. Pseudo-Burlamacchi, *Vita*, 46. See Trexler, *Public Life*, 88–9, n. 8.

68. "Liber miraculorum b. Antonii," *Acta sanctorum*, Junii II, 729. The Provençal saint Elzéar de Sabran and his wife Delphine were reported to have worshipped a wooden effigy of the baby Jesus in the cathedral of Apt during the fourteenth century. Later legends turned the effigy into the guardian of the chastity of this holy couple, who were said to have placed it between them in their bed (*Acta sanctorum*, Sept. VII, 572, 582).

69. See P. Ariès, *L'enfant et la vie familiale sous l'Ancien Régime*, 2d ed. (Paris, 1973), chap. two, "La découverte de l'enfance"; Herlihy and Klapisch-Zuber, *Les Toscans*, 568–70.

70. Goldthwaite, "The Florentine Palace," 1010.

71. On the Virgin of Humility, see Meiss, *Painting*, 132–56.

72. What better indication of this motivating role of sacred images than the wonder expressed in the *Meditationes*, 81, before the Virgin tenderly suckling Jesus: "O quam libenter eum lactabat! Vix fieri potuit, quin magnam etiam, aliis foeminis inexpertam dulcedinem in talis filii lactatione sentiret" (Oh! What joy the Virgin had in suckling! Surely it is impossible that in nursing such a son she not have felt delights unknown to other women!; quoted from Klapisch-Zuber, *Women, Family, and Ritual*, 132).

The Virtue of Littleness: Small-Scale Sculptures of the Italian Renaissance

Joy Kenseth

NOT LONG AGO, while musing on his collection of souvenir buildings, the architecture critic Paul Goldberger noted how there is a "curious joy that comes from seeing anything you like in miniature. In its surprising tininess it becomes containable, manageable, in a way that the real thing is not." Little skyscrapers, a 9-inch Tower of Pisa, a United States Capitol that is also a jewel box, and one hundred or so other toy buildings now occupy several shelves and an entire counter top in Mr. Goldberger's house: they are, as he says, "seductive."[1]

No doubt the first great collector of the Renaissance, Piero de' Medici, also was seduced by smallness. His famous studio was crammed full of little treasures, and as Antonio Filarete reported in 1465, Piero used to while away his time there admiring his vases, engraved gems, and effigies in silver and bronze and gold.[2] So Piero must have experienced that "curious joy" when, in the same year, Filarete sent him a miniature replica of *Marcus Aurelius*, the celebrated antique statue then standing near the Lateran Palace in Rome (Fig. 51; cf. Fig. 16). The earliest signed and dated bronze statuette of the Renaissance, it paid homage to the grand equestrian monument but at the same time transformed it into something manageable, a delightful object that could be held in the hand and enjoyed in the private and intimate setting of the home. From the time Piero received his gift to the end of the sixteenth century, Italy saw an extraordinary rise of interest in and demand for sculptures that, like Filarete's *Marcus Aurelius*, were rendered in small scale. Statuettes, medals, plaquettes, cleverly designed utilitarian objects, and various other little sculpted works were produced in impressive numbers then and were prized by patrons from many different walks of life and many different social classes. They were coveted as collector's items, enjoyed as conversation pieces, and proudly displayed as ornaments for the tables, desks, cabinets, and shelves of their owners. This essay considers a variety of these sculptural types, with a view to learning some of the reasons for their appeal and to showing how their very smallness and the implications of their scale made them so alluring to the patrons and collectors of the time. In general, the discussion that follows is concerned with the aesthetic of the small scale and miniaturization. An aesthetic clearly esteemed by

the culture of Renaissance Italy, it pertained to painting as well as to sculpture, and it related in interesting ways to ideas that underlay the formation of Renaissance collections.

The taste for small sculpted objects that emerged in Italy in the fifteenth century had its foundation in the culture's reverence for the art of classical antiquity. Nothing illustrates this regard for ancient art better than the favor accorded the miniature replicas that evolved as revivals of small classical bronzes such as had survived

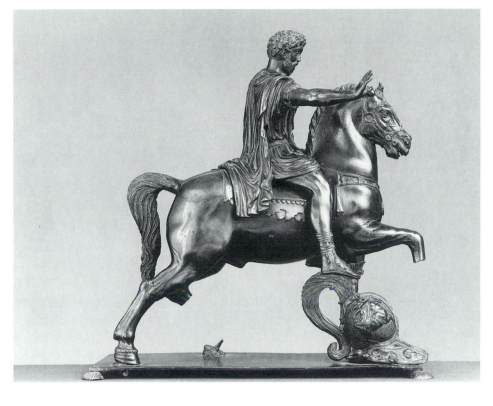

Figure 51. Filarete, Statuette of *Marcus Aurelius*, Staatliche Kunstsammlungen-Skulpturensammlung, Dresden, c. 1440–45 (photo: Staatliche Kunstsammlungen-Skulpturensammlung, Dresden)

Greco-Roman times and had been described by ancient authors. Florentine artists, including Filarete and Bertoldo di Giovanni, created the earliest statuettes of this type, but the first to specialize in their manufacture was the Mantuan Pier Jacopo Alari-Bonacolsi, a connoisseur and restorer of antiquities as well as a sculptor who went by the apt nickname Antico.[3] Around the year 1500 he made for Bishop Ludovico Gonzaga a series of exquisite bronzes after famous ancient statues, including the little version of the *Apollo Belvedere* (Fig. 52). Objects of this type appealed to those who had antiquarian interests and who, either through firsthand experience or by way of prints or drawings, knew of and developed an admiration for the great classical monuments, especially those in Rome. This certainly was true for the bishop's relative through marriage, Isabella d'Este, the marchioness of Mantua. As she admitted to one of her agents in Rome, she had an "insatiable desire for antique things," and, in fact, she devoted a considerable part of her adult life to acquiring antiquities and modern works done *all'antica* for her personal collection.[4] One can well imagine her pleasure therefore when, in 1519, Antico provided her with copies of the statuettes he had made earlier for Bishop Ludovico. For Isabella and other collectors of the time, miniature Laocoöns, Meleagers, Apollo Belvederes, and the like were acceptable substitutes for the ancient masterpieces; indeed, the little statuettes made it possible for these collectors to "possess" objects they otherwise could never own.

Ancient writers, as the Renaissance well knew, frequently spoke in glowing terms about miniature sculptures: they admired the tiny forms that dramatically reduced the scale of large things; they extolled diminutive statues that evoked great

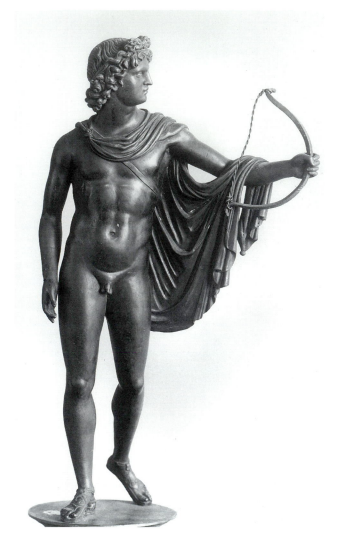

Figure 52. Antico, Statuette of the *Apollo Belvedere*, Cà d'Oro, Venice, c. 1500 (photo: Boehm)

subjects and ideas. Probably the most vivid expressions of appreciation for the miniature came from the Roman poets Martial and Statius. In lengthy poetic *ekphrases*, the two writers describe a little bronze statue by Lysippos, a *Herakles Epitrapezios* (Hercules on the table), belonging to Novius Vindex but made originally for Alexander the Great. As the following passage from the poem by Statius reveals, the statue elicited a wholly enthusiastic response:

> Among these [Vindex's treasures] was the genius and tutelary deity of his pure table, the son of Amphitryon [Herakles], who greatly captures my heart; nor was my eye satiated by looking at him long. So great was the dignity enclosed within the narrow borders of the work; so great its majesty. A god he was, a god! He granted, Lysippos, that the impression of himself which was produced by your art should be this – to be seen as small but to be thought of as enormous. And although this marvellous work is contained within the measure of a foot, nevertheless there will be an urge to cry out, as you cast your glance over his body: "On this chest the Nemean ravager was throttled; those the arms which bore the deadly oak-club and broke the Argo's oars!" And its size! How great is the deception in that small form! What controlled skill! How great was the experience that learned artist had in the details of art, in that he had the ingenuity to fashion a table ornament but at the same time to conceive a colossus.[5]

The wonderful paradox of greatness in miniature that Statius celebrates was emulated over and over again in the Renaissance – in the miniature replicas of large-scale statuary, in small bronzes of "heroic" animals such as horses, lions, and bulls, and above all in numerous statuettes representing the mythical hero Hercules. An early and brilliant revival of this conceit is the little bronze of *Hercules and Antaeus* made by Antonio Pollaiuolo in the late fifteenth century for Piero de' Medici's son, Lorenzo the Magnificent (Fig. 53). Like the famous sculptor of ancient Greece, Pollaiuolo by means of his ingenuity and skill created an artful deception wherein what is suggested exceeds that which has been done. The vital and muscular figures of Pollaiuolo's composition are only 14 inches high, yet their small scale paradoxically draws attention to the greatness of Hercules' achievement – the moment when, by means of his superhuman strength, the mythical hero lifts the giant wrestler Antaeus from the ground and simultaneously squeezes his breath, and life, out of him. Pollaiuolo achieved the same effect in his miniature paintings *Hercules and Antaeus* and *Hercules and the Hydra*. By compressing the figures in both pictures into a format of tiny dimensions, the artist paradoxically emphasized the immensity of the hero's exertions.[6]

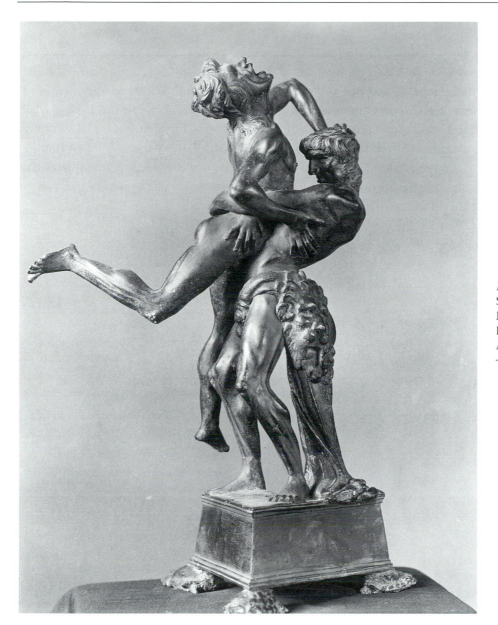

Figure 53. Antonio Pollaiuolo, Statuette of *Hercules and Antaeus*, Museo Nazionale del Bargello, Florence, c. 1475–80 (photo: Alinari/Art Resource, N.Y.)

As we know from a variety of sources, the exploitation of the small form to emphasize the large or gigantic was appreciated in painting as much as it was in sculpture. In his *Natural History* of the first century A.D., Pliny the Elder describes how the artist Timanthes, in his small panel painting of a sleeping cyclops, represented some satyrs measuring the giant's thumb with a thyrsos. The little painting is an example of the artist's ingenuity, Pliny tells us, for "more is suggested than is actually painted."[7] A similar sentiment was expressed in the mid-sixteenth century by Annibal Caro, who remarked while praising the paintings of Giulio Clovio that "even a miniature, with extremely small figures, may represent Giants."[8] Clovio's miniatures characteristically show greatly reduced versions of figures from paintings done in the "grand manner," such as Michelangelo's *ignudi* from the Sistine Ceiling. Clovio's great masterpiece, the *Book of Hours* made in 1546 for Cardinal Alessandro Farnese (P/R illus. 8.53; *cf.* P/R illus.

7.28), contains many of these miniaturized colossi, and it was because of them that Giorgio Vasari, in his *Lives of the Artists*, called Clovio the "new and little Michelangelo" and one of "the marvels of Rome."[9] Vasari was effusive in his praise for Clovio's "infinite most rare miniatures" and said of the *Book of Hours* that it was "something divine not human." Vasari loved the technical virtuosity and refinement of the miniatures and was particularly charmed by their tininess. "It is a great thing," he wrote, "that in many of these works [Clovio] has made some little figures no larger than very small ants, with all the members so express and so distinct that more could not have been done in figures large as life."[10]

Vasari's eulogy of Giulio Clovio's miniatures easily brings to mind ancient authors' admiring descriptions of tiny works of art. According to Pliny, miniature works in marble secured renown "for Kallikrates, whose ants have feet and limbs too small to be distinguished by the human eye," and "for Myrmekides, whose four-horse chariot and charioteer could be covered by the wings of a fly."[11] Varro also recognized the wondrousness of Myrmekides' tiny sculptures, saying that to be seen properly they had to be placed on black silk.[12] And, as Julian wrote in another account: "The wise Phidias was known not only for his statues in Olympia and in Athens, but also for having condensed a work of great art in a small gem, as they say he did with his grasshopper and bee, and if you please, with a fly. And each of these though its nature was of bronze, came to life through his art."[13] The Renaissance fascination for works of art rendered in the tiniest scale was stimulated by descriptions such as these as well as by the great many cameos and engraved gems (or intaglios) that had come down from ancient times. Collectors had a passionate interest in these little antiquities, and some families, like the Medici, Gonzaga, and Farnese, accumulated them in huge quantities.[14] To understand how much they were treasured, we need only recall that in the inventory of the Medici collection, taken after the death of Lorenzo the Magnificent in 1492, the average estimated value of a single cameo was 300 *florins,* or an amount equal to the total value assigned to the six large-scale paintings made for Lorenzo's chamber, including the three battle pictures by Uccello. In the same inventory, the famous *Tazza Farnese,* a large cameo made from sardonyx, was said to be worth a whopping 10,000 *florins.*[15] Sometimes collectors would go to extraordinary lengths to acquire such works. Pope Paul II, for example, was reported to have offered privileges, large sums of money, and even the financing for a new bridge to the city of Toulouse in exchange for the Roman cameo known as the *Gemma Augustea.*[16]

The obsessive interest in antique cameos and engraved gems ultimately gave rise to the production of like works in the Renaissance. As Vasari relates in his *Vite,* many artists became famous for their superb imitations of the ancient prototypes. Accomplished and diligent craftsmen all, they received his unstinting praise. Giovanni delle Corniole, Domenico de' Cammei, and Luigi Anichini are described by Vasari as having made "the most rare" and "marvelous" little intaglios and cameos. Valerio Vicentino, he informs the reader, made "little intaglios with such polish and facility that they were something not to be

believed." Even at the age of seventy-eight, Vicentino, Vasari goes on to say, was able to make the "most stupendous miracles" in this miniature art. In yet another instance, he reports how Matteo dal Nassaro acquired a beautiful piece of green jasper shot through with red speckles. On this Nassaro engraved a scene of the Deposition of Christ, and what made the piece so thrilling was the way the artist exploited the red speckles of the stone to show the Savior's bleeding wounds.[17]

Closely related to cameos and gems were the microsculptures Renaissance artists made out of walnuts, cherry stones, and other intriguing natural materials. These little works of art were often found in the collections of the time and invariably provoked wide-eyed amazement.[18] Vasari speaks about such works in his life of Madonna Properzia de' Rossi. One of the very few women artists of the Renaissance, she gained renown by making minuscule carvings in nuts and the stones or pits of various fruits like the one showing more than a hundred microscopically small heads on the surface of a cherry pit (Fig. 54). Another of her works, representing the Passion of Christ on a peach stone, included an "infinite number of figures besides the crucified ones and all the apostles." As her biographer remarked, "It was certainly a marvel to see [such a thing represented] upon a nut so small."[19] Like Properzia, the artist Il Raggio also was known for making extraordinary microsculptures. According to Vasari, he cut a relief on a conch shell showing the whole of Dante's Inferno, complete with all the circles and *bolgi* and all the figures that the poet had described in his epic poem.[20] Despite his exaggerated claims that an "infinite number of figures" and that "all" the characters of Dante's poem had been represented by these two artists, Vasari makes it clear to the reader what he appreciates about their works:

Figure 54. Properzia de' Rossi, Carved Cherry Pit in Jeweled Mount, Museo degli Argenti, Florence, early 16th century (photo: Gabinetto Fotografico, Florence)

the unusual miniature sculptures were worthy of admiration because their creators managed to compress an astonishing number of figures into very limited spaces. As such, they were demonstrations of extraordinary technical skill and of the uncanny ability of the artists to achieve the seemingly impossible. These microsculptures as well as cameos and engraved gems appealed to Vasari and his contemporaries because they represented the artist's triumph over natural materials. It was expected that works of art be rendered flawlessly and so when the artist had the skill to fashion without fault figures from exceptionally fragile or extremely hard materials, he or she was all the more deserving of praise. Moreover, when an artist made clever use of the special characteristics of a natural material, as Nassaro did with his piece of jasper, it was a sure sign of his *ingegno* – his wit, genius, ingenuity, or talent. *Ingegno* could not be acquired through experience but was instead inborn. An imaginative capacity or "marvelous force of intellect" that was God given, it was always applauded by Vasari and his contemporaries.[21]

Demonstrations of technical virtuosity and artistic imagination were, as we know, prized in most forms of small-scale statuary. Like Statius when he gazed on the bronze Hercules by Lysippos, Renaissance patrons were drawn to statuettes that were skillfully executed and cleverly conceived. Much of the charm of Pollaiuolo's *Hercules and Antaeus* (Fig. 53), for instance, derives from its convincing representation of the figures' anatomies in tiny scale. In the case of Antico's *Apollo Belvedere* (Fig. 52), the exquisite rendering of its minuscule parts and the superiority of its casting make it all the more rewarding to the beholder's sight. No less significant, as Bishop Ludovico Gonzaga very likely appreciated, Antico's little statue ingeniously "reconstructed" and "enriched" the partially damaged antique model. Antico had replaced its missing arm and bow, provided silver inlays for the eyes, and gilded such details as the sandals, drapery, and hair.

The artist most commonly identified with the making of superbly crafted and elegant statuettes, however, was Giambologna. Throughout his long service to the Medici grand dukes in the second half of the sixteenth century, he produced works that characteristically showed superb casting, exquisite rendering of details, and a high finish. As Vasari emphasized, it was critical that a sculptor seek to achieve "polish, and absolute perfection" in his works and that he master the "elusive" and "detailed refinements, which constitute the greatest achievement of art."[22] Exceptional skill in the technique of bronze sculpture was of paramount importance. To Vasari's mind, such skill was not evident in the art of the past. "But what is indeed a cause for wonder in our own times is the excellence of casting of both large and small figures, many of the masters achieving such perfection that no tools have to be used to finish them . . . from which it may be seen that this art has now reached a greater state of excellence than ever it did in antiquity."[23] Giambologna's statuettes display the skills and refinements that were so prized in his time. His little figure of *Venus Urania* (also called *Astronomy*), for example, is a work of the utmost refinement and elegance: its details have been exquisitely rendered, and its surfaces have been smoothed to perfec-

tion (Fig. 55). Moreover, Giambologna deliberately molded the figure's torso and limbs into a series of fluid and rounded shapes that made the figure pleasing from every point of view and especially well suited as an object that could be turned in the hand. Acutely sensitive to how his statuettes would appear to the connoisseur's eye, and understanding full well that his little objects would be handled, the artist paid extra attention to making their surfaces sensuously appealing. He gave them lustrous black, golden red, or chocolate brown patinas or, on occasion, like the *Venus Urania*, covered them entirely in gold.

Given the beauty and preciosity of Giambologna's statuettes, it is easy to understand why they were prized by the Medici and why, additionally, the Medici regarded them frequently as ideal diplomatic gifts. Even in the years following Giambologna's death, casts made from his molds by artists such as Antonio Susini and Pietro Tacca were given away in the interest of diplomatic relations. These luxury objects were gladly accepted by those to whom they had been sent, and in one notable instance, we know that they elicited an extraordinary emotional response from the recipient. In 1612, the grand duke of Florence and Tuscany, Cosimo II de' Medici, sent as a gift to Henry, Prince of Wales, a set of fifteen superbly crafted bronze statuettes, all of them made from Giambologna's models. Cosimo hoped that the statuettes would induce the eighteen-year-old Henry to marry his sister Caterina de' Medici, thereby forging an Anglo-Florentine alliance. The young Prince received the statuettes on 27 June, and as a letter of that date reports, he was so delighted when he saw them that he actually "kissed the first that he picked up." He handled them all many times, studying, admiring, and praising their every part, every detail. And when it was suggested to him that one of the statuettes might be appropriate for his younger brother, the duke of York, he replied: "No, no, I want everything for myself."[24] Even though, as it turned out, the statuettes did not achieve the desired union (young Henry died, alas), the story clearly illustrates the powerful allure that such works could and often did have.

No less appealing in the Renaissance were small sculptures of minor subjects, and to judge from the many examples that still survive, they were immensely popular. Among the most interesting of these works were the bronzes of little animals and of mythical woodland figures such as the satyrs made by Riccio and his workshop in Padua. The animal sculptures were particularly varied (crabs, toads, lizards, snakes, and other small creatures were represented), and most, like the *Crab* from the beginning of the sixteenth century, had been cast from actual specimens (Fig. 56).[25] A technique known to have been practiced in antiquity, it was described in the late fourteenth century by Cennino Cennini in his *Libro dell'Arte*. A cast can be made after a "bird, a beast, and any sort of animal, fish and other such things," he said, "but they have to be dead, because they have neither the natural sense nor the rigidity to stand still and steady."[26] The little casts made by the Paduans preserved the tiniest details of the deceased animals' outward appearances, but at the same time, the careful arrangement of the specimens beforehand gave the impression that they were alive. Once again, we

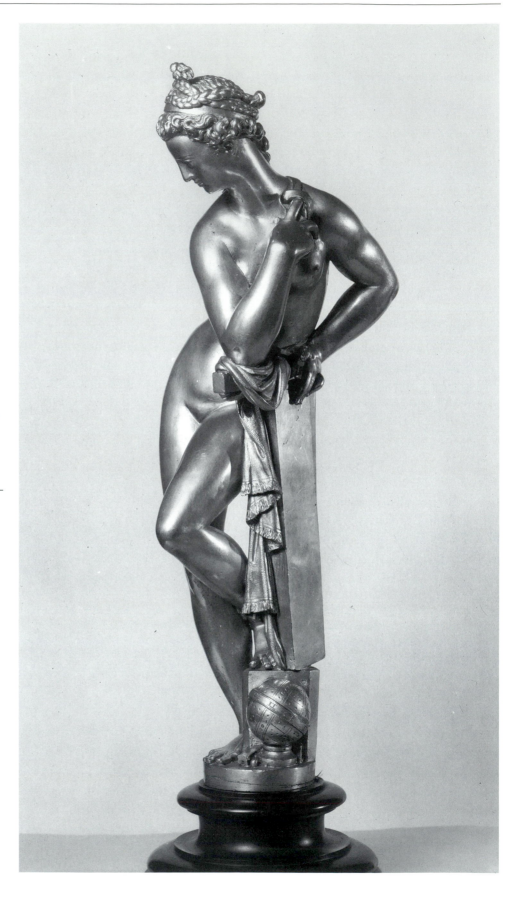

Figure 55. Giambologna, *Venus Urania*, or *Astronomy*, Kunsthistorisches Museum, Vienna, 1570s (photo: Kunsthistorisches Museum)

encounter those signs of virtuosity and ingenuity that the
Renaissance cared about so much. As Julian had said about
Phidias's grasshopper, fly, and bee, "though [their] nature
was of bronze, [they] came to life through . . . art." The
frogs, crabs, and other creatures used for the casts had died,
but in the artists' creative hands they were born again and
given new life as sculpture.

Figure 56. North Italian, probably
Paduan, *Crab*, Kunsthistorisches
Museum, c. 1500 (photo:
Kunsthistorisches Museum)

It was not a coincidence that the production of animal
bronzes flourished in Padua. A university city and a cen-
ter for the study of medicine and the natural sciences,
Padua's intellectual climate was especially favorable to
works of art that represented subjects from nature and that had a striking real-
ism.[27] The bronzes of animals and other natural forms, as well as the little sculp-
tures of satyrs, nymphs, and fauns, appealed to persons who had scholarly
interests and often served as accessories for their desks. Besides being of interest
as representations of the natural world, many of these small works had utilitar-
ian purposes, functioning in very witty ways as inkwells, paperweights, pen-
holders, oil lamps, candelabra, or containers for sand. The *Crab*, for instance, was
actually an inkwell (the top of its shell could be opened), whereas a splendid
Satyr by Andrea Riccio seems to have done double duty as candleholder and
inkpot (Fig. 57). As has been observed in the past, usually in connection with
the pagan figures by Riccio, these sculptures often carried multiple meanings,
symbolizing most notably the wild or untamed forces of nature.[28] Yet even as
they celebrated this theme, they paradoxically expressed another, contrasting,
idea championed in the Renaissance – *Natura potentior ars* (art is more powerful
than nature). Because the pagan figures had been miniaturized and because both
these figures and the animals had been rendered in the permanent medium of
bronze, the wild and unruly nature they symbolized had in a sense been brought
under control. Indeed, it had been tamed by art to serve reading and writing --
supremely civilized activities.

Utilitarian objects that were at the same time small-scale figurative sculptures
also included a wide range of serving dishes, tureens, and cups made for ban-
quets, especially the lavish court banquets held for weddings and other special
occasions. The idea of treating table service as diverting works of sculpture was
an old one. Pliny reports that little drinking cups in the shape of chefs had been
made by the artist Pytheas.[29] Pliny the Younger, his nephew, describes similarly
amusing works made for his outdoor dining table, in the center of which was a
basin of water. "The preliminaries and main dishes," he writes, "are placed on
the edge of the basin, while the lighter ones float about in vessels shaped like
birds or little boats."[30] Although figurative table service is known to have been
created in the later 1400s, it was not until the sixteenth century that the manu-
facture of such objects became a flourishing business. In their service to the
courts, Giulio Romano, Salviati, Il Rosso, and Perino del Vaga, for example,
provided a host of remarkably fanciful designs for silver ewers, bowls, saltcellars,

Figure 57. Andrea Riccio, *Satyr Holding a Shell*, Museo Nazionale del Bargello, Florence, c. 1510 (photo: Alinari/Art Resource, N.Y.)

and other vessels for the table or sideboard. Vasari says that Rosso made "infinite designs" for such things, and so also did Giulio Romano during his employment to the Gonzaga in Mantua.[31] Pitchers were fashioned into men or fish; cups were made to look like birds; platters took the form of grape leaves. Frequently, serving dishes became the occasion to create elaborate works of sculpture. A ewer conceived by Rosso was formed into a composition of the three Graces, a satyr, and some harpies. A tureen designed by Giulio Romano was turned into a little scene of three goats on a rocky island covered with trailing vines. In yet another instance, this same artist envisioned a saltcellar (or perhaps a dish for serving eggs) as a vignette from ancient mythology – the moment when the twins Castor and Pollux are hatching from their eggs. Table service transformed into miniature boats were especially popular, obviously because the real large-scale vessels also were conveyors of goods. One miniature boat came equipped with a sail and paddle; another, after a design by Rosso, had a deck that could be opened to reveal silverware and a napkin stored in its hold.

 Among the most ingenious tablewares were those designed in rock crystal and other hard stones by the Saracchi and Miseroni workshops in Milan. They produced a wide range of fantastic objects for the courts of Europe, and many of their artisans were summoned to Florence to work for the Medici.[32] The vessels they made in rock crystal – galleys, exotic birds, monstrous fish, and other assorted animals – often displayed extraordinary inventiveness. One of these,

made for the Medici, is a covered cup in the form of an egret (Fig. 58). A fantastic bird to be sure, the cup nonetheless also makes ingenious references to the egret as it is in nature. Its wings are spread in a way characteristic of such waterfowl when they dry themselves in the sun; moreover, and most enchantingly, tiny pearls dangle from its wing tips in allusion to waterdrops falling off an egret's feathers.[33] It is hard to imagine how vessels like these or the even more complicated designs made for tazzas, ewers, and bowls actually could have been put to use. Indeed, sometimes the artists themselves were not sure whether such table pieces were meant to be functional. In 1550, for instance, the rock crystal carver Jacopo da Trezzo wrote to Cosimo I de' Medici asking him to clarify whether a vessel he had commissioned was meant to be "a cup to drink from or only to look well."[34]

Figure 58. Saracchi Workshop, Rock Crystal Cup in the Shape of an Egret, Museo degli Argenti, Palazzo Pitti, Florence, mid-16th century (photo: Alinari/Art Resource, N.Y.)

The desire to transform items for the table into miniature sculptures eventually also included napkins. Perhaps the earliest examples of "soft sculpture," they were folded into the shapes of birds and boats and other figures, all for the delight of the diners.[35] Even more interesting, however, were the transformations of food into small-scale works of art. We hear of such culinary sculptures, for example, in Vasari's discussion of the Company of the Kettle and the Company of the Trowel. These two companies were informal social groups made up of artists, musicians, and writers, and their friends, who regularly dined at each other's homes. For these dinners, the company members were required to make a "bella invenzione" and present it to their host. The dishes they brought, as Vasari enjoys relating, were capricious and amusing in their design and thus entirely in keeping with the spirit of these occasions. One dish that was delightful to see and that "tasted good" too represented an adventure of Ulysses in the medium of pastry and boiled capon. Another, made by Andrea del Sarto, was a miniature temple that looked like the Florentine Baptistry raised on columns. The tiled pavement was made of differently colored gelatins, the porphyry

columns were big, fatty sausages, and the capitals and bases of the columns were carved from Parmesan cheese. Sugar paste was molded to make the cornices, and chunks of marzipan created the tribune. In the middle of this wondrous concoction, Andrea placed a music stand made of cold veal. On top of this rested a lasagna hymnal, the lyrics and musical notes of which had been made with grains of pepper. Finally, he arranged behind the music stand a choir of little roasted songbirds who were dressed in tiny vests and robes (or surplices) fashioned from the delicate meshlike membrane that encloses pork brains.[36] Nature's edibles could not escape the reforming power of art! They too gave the artist an opportunity to show off his ingenuity, his imagination, his inventiveness, and the marvelous acuity of his wit.

Better known than the dishes made by the Company of the Kettle and the Company of the Trowel were the sugar paste figures created for elegant court banquets. Known as *trionfi* (from *trionfare*, meaning to triumph, exult, or celebrate), they usually were made as table decorations for wedding banquets. Sometimes offered to guests as "party favors" at the end of the dinners, they represented a broad range of subjects taken from heraldic imagery, the Bible, mythology, the world of nature, and ancient as well as contemporary epic poetry.[37] Works of this type already were being fashioned for wedding celebrations in the last quarter of the fifteenth century, and by the late sixteenth century, when sugar had become a common and easily gained foodstuff, they were produced frequently for such festivities. We know that numerous sugar sculptures were made for the weddings of Maria de' Medici in 1600 and Prince Cosimo de' Medici in 1608. Pietro Tacca and perhaps Giambologna himself were called upon to produce these works, and, according to contemporary accounts, these sugar sculptures either had a snowlike whiteness or were embellished with colored paints and gold. Although some of these confections may have been modeled free-hand, most apparently were "moulded in forms, possibly of lead or plaster, made from casts of Giambologna bronzes."[38] On the occasion of Cosimo's wedding in 1608, for instance, more than forty sugar statuettes were made after "the most beautiful sculptures which exist in this state," such as Giambologna's *Mercury* and *Hercules and the Centaur.*[39] Set up on the banquet tables and credenzas (or sideboards), these sculptures in sugar supplemented the actual bronze statuettes by Giambologna, which, having been moved from their normal locations, also were on display for these occasions.

Banquets at court were wonders to behold, and everywhere the artist's urge to make miniature sculptures was in evidence: in the table service made from silver or gold, in the cups and ewers made from rock crystal and glass, in folded napkins and molded foods, in sugar paste figures and bronze statuettes. Such elaborate decorations, it has been noted frequently, were meant to impress — to show off the wealth and power of the hosts to the assembled guests. But as the humanist Giovanni Pontano argued in the late fifteenth century, the patronage of such objects was a proper use of wealth and fully justified because it promoted what he identified as the social virtues of splendor and conviviality. Splendor was

a quality that a person could achieve through personal possessions and, in Pontano's view, it had a moral dimension because it revealed the intelligence, the civility, the refinement, and the aesthetic sensibilities of an individual. Conviviality, on the other hand, applied specifically "to the civility of being in the company of others at table."[40] The many forms of sculpted objects that appeared on the tables, as well as such things as forks and individual plates for each diner, created an atmosphere of elegance and went a long way to promoting good manners, good taste, and probably good conversation too.

The decorations for banquet tables, as one contemporary observer recorded, were superb and represented every type of figure.[41] In a sense, the remarkable variety and number of these miniature figures can be seen as elaborate extensions of the single but wonderful ornament that Statius described as being on the table of Novius Vindex – the *Herakles Epitrapezios*. Besides numerous statuettes of Hercules, late-Renaissance tables were laden with representations of pagan gods and goddesses and of animals of every sort, as well as of the heros and heroines of modern literature. Like the Hercules by Lysippos, they were conceived as objects to be "on the table"; but as the Renaissance surely understood, *epitrapezios* also meant "at the table," and thus it would have seemed that all the figures represented were also "in attendance" at the lavish banquets, joining in the festivities and sanctioning them as well.[42] No less significantly, the artists who made the miniature sculpted objects for these lavish affairs had as their great ancient model Lysippos who, as Statius said, ingeniously fashioned a table ornament while simultaneously conceiving a colossus. Each miniature figure, whether of Hercules, an ancient deity, or of an animal, evoked something larger than itself – a god, a hero, a sculptural monument, or a great theme or idea. And when these small sculpted objects were arranged in tableaux, as often seems to have been the case, they became little worlds or microcosms evoking the macrocosm.[43] Such effects appear to have been created on writing tables too, for patrons could have sets of desk accessories in which the larger world of nature was replicated by a wide range of miniature animal and pagan figures. In fact, the ensembles of little sculpted figures for banquet tables, sideboards, and desks reflected a general tendency in the Renaissance to represent the larger cosmological order in manageable and concrete form.

The clearest expressions of the culture's desire to create microcosmic replicas of the macrocosm were the collections and the early museums or cabinets of curiosities that were formed in ever increasing numbers during the sixteenth century. The proliferation of these collections was a manifestation of the period's inquisitiveness and its preoccupation with understanding all aspects of the physical world – the world of nature, the world of art, and the achievements of the ancient past as well as those of the present. Behind the creation of these collections was the humanist aspiration for comprehensive knowledge, a belief that in the course of a lifetime a person could know everything. Characteristically, in these early encyclopedic collections, specimens of nature and works of art were displayed together. Oftentimes, moreover, the installations invited comparisons

between modern and ancient works of art, usually to the advantage of the modern achievements.[44] Isabella d'Este's collection, installed in the room she called her "Grotta," was one early example. Here the visitor could see, together with the antique marbles and cameos and the bronze statuettes made by Antico and other artists, such things as coral branches, snails' shells, a "unicorn horn" (actually, a narwhal tusk), various fossil remains, and pieces of amber in which insects and other natural forms had been trapped. Modern works of art and antique statuettes were shown side by side on a ledge that circled the room, and in a little niche, a small *Sleeping Cupid* by Michelangelo (which Isabella purchased when she learned it was famous) was compared to a sculpture of the same subject attributed to Praxiteles.[45]

Other collectors were even more ambitious in their efforts to assemble as many objects as possible for their collections. In the second half of the sixteenth century, Ulisse Aldrovandi, a professor of natural history at the University of Bologna, conceived his museum of natural and ethnographic objects as a place where one could investigate, comprehend, and document the full extent of the natural world.[46] In Florence, around the same time, the Medici grand dukes accumulated a wealth of natural and artificial objects for their collections. The Studiolo of Francesco I was a microcosm adorned with pictures referring to what was concealed in cabinets behind them – pearls, coral, diamonds, and other precious and semiprecious specimens of nature. In this room also, a series of bronze statuettes by Giambologna and other sculptors was on display. Representations of ancient deities that also symbolized the elements, they were themselves microcosms of the natural world. Later, with the construction of the room in the Uffizi known as the Tribuna, the greatest treasures of art and nature in the Medici collection were brought together. Exceptional gemstones and other rare and "ingenious" products of nature were shown off in this room, as were such supreme examples of artistic ingenuity as silver statuettes of Hercules' labors by Giambologna, paintings by Raphael and Michelangelo, and precious marble statues made in classical antiquity. All of the painted and architectural decorations of the Tribuna moreover were based on a cosmological scheme that, deliberately playing on the name Cosimo, suggested that the power of the Medici grand dukes was an integral part of God's universal order.[47] Indeed, the room asserted the belief in man's privileged status in the world and his capacity to acquire comprehensive knowledge. This belief was expressed long before the creation of the Tribuna and in the most eloquent way by the humanist Giovanni Pico della Mirandorla. In his famous *Oration on the Dignity of Man*, first published in 1496, Pico describes how God, after creating the celestial regions and a world teeming with animal life, "longed for a creature which might comprehend the meaning of so vast an achievement, which might be moved with love at its beauty and smitten with awe at its grandeur." God placed man at the center of the world, Pico declares, because from that vantage point he could more easily survey all that the world contains.[48] Through their museums, especially those of the powerful and wealthy, the owners expressed

their preeminence and their favored position within a larger cosmological scheme. Within the limits of a room, collectors were able to place themselves in the middle of a world of their own making, one that in the abundance and variety of its objects reflected the macrocosm in miniature and gave insight into the perfect order and wondrousness of God's design. It was a world that collectors could possess, a world over which they had control and in which they could experience firsthand the manifold forms of nature and the marvelous objects fashioned by artists' hands.

It seems fitting to look finally at a work of art in miniature that encapsulates many of the ideas that have been discussed here and that was arguably one of the greatest table pieces produced in the Renaissance – the saltcellar by Benvenuto Cellini (Figs. 59 and 60). Designed for the cardinal of Ferrara, Ippolito d'Este, it eventually was made for the king of France, Francis I. Cellini described it on two occasions, in his *Autobiography* and again in his *Treatise on Goldsmithing*, and in characteristic fashion he boasted of his achievement, emphasizing that with the making of this object he had set himself an impossible, a Herculean, task. When, as he reports, he submitted the wax model for Ippolito d'Este's approval, one of the cardinal's attendants cried out, "It will take the lives of ten men to finish: do not expect, most reverend monsignor [Ippolito], if you order it, to get it in your lifetime."[49] As we know, the final work delivered to the king of France was even more elaborate than the original design. A utilitarian object of extraordinary richness and complexity, the saltcellar is made of hammered gold, colored enamels, and ebony. A prime example of technical virtuosity and the artist's mastery over his materials, it reveals Cellini's ability to turn formless natural elements into something "bella e graziosa" and to render exceptionally minute details in the most accomplished manner. Cellini was justifiably proud of its design and of the *concetto* that underlay it, for it clearly surpassed any table piece that had been done before.

The saltcellar's ingenious design comprises two main figures, symbolizing the Sea (Neptune) and Earth (Terra), whose legs are interlaced, Cellini says, "to suggest the interminglement of land and ocean."[50] A fantastic boat next to Neptune served as a container for salt, and an Ionic temple beside Terra functioned as a pepper box. Neptune rides a seahorse, and in the wavy ocean below him appear a turtle and "choice kinds of fishes," or dolphins. The figure of Terra is seated on an elegantly caparisoned elephant, and a lion and a hound as well as fruits of the earth are represented nearby. Around the ebony base, Cellini fashioned allegorical figures of the times of day and cherub heads symbolizing either the winds or the four seasons. Alternating with these figures are tiny reliefs showing various marine emblems (coils of rope, tridents, an anchor, an oar, and sail) and objects relating to agriculture and hunting (a scythe, spade, pruning fork, and bow and arrow). Additionally, the base is embellished with a relief of musical instruments and sheet music that symbolize the arts as well as the concept of harmony. In effect, the saltcellar, with its references to earth and sea, to the times

Figure 59. Cellini, Saltcellar (view of broad side with temple), Kunsthistorisches Museum, Vienna, c. 1540–44 (photo: Foto Marburg/Art Resource, N.Y.)

of day and the seasons, and to nature and human industry and the arts, is a whole world compressed into a tiny form no more than 10¼ inches high and 13¾ inches wide.[51] A microcosm that can be likened to the collections and early museums of Renaissance Italy, it also intermingled natural and artificial elements and was encyclopedic in its intent. Like the Tribuna, the tiny universe Cellini created ultimately exalted the person for whom it was made, for appearing at the center of the composition, at the point where Earth and Sea meet and about which all the elements of the composition can be said to rotate, is a tiny salamander, the personal emblem of the king. Indeed, the king could literally manipulate and move this world around, because Cellini had inserted tiny ivory balls (or casters) beneath its base.[52]

Throughout Cellini's composition, references are made to and comparisons made between the art of the ancients and the art of Cellini's own time. Specifically, the figures of the times of day are miniature replicas of Michelangelo's allegories from the Medici Chapel, and the miniature temple, with its minuscule statues of Hercules and the Venus-like figure of Abundance, recall masterpieces of antique art and are done *all'antica*. Like the *Herakles Epitrapezios* that belonged to Novius Vindex, Cellini's little figures paradoxically draw attention to the greatness of the gods and to the greatness of the art of Michelangelo as well as of the ancients. It would seem that the poem by Statius may have been in Cellini's mind when he made the saltcellar, for just as the ancient poet noted how his eye was not "satiated by looking at [the little bronze Hercules] long," so Cellini remarked that when he showed his master-

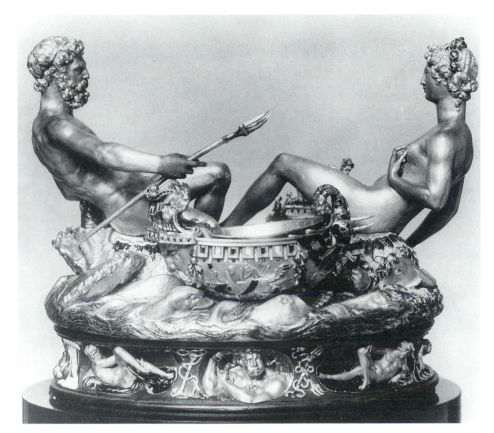

Figure 60. Cellini, Saltcellar (view of broad side with ship), Kunsthistorisches Museum, Vienna, c. 1540–44 (photo: Foto Marburg/Art Resource, N.Y.)

piece to Francis I, the king "could not satiate his eyes with gazing at it."[53] Like Lysippos, Cellini mastered the details of art and "had the ingenuity to fashion a table ornament but at the same time to conceive a colossus." Clearly though, Cellini's little invention surpassed the ancient example, for the colossus he conceived and rendered so exquisitely was not merely a great hero but a universe – a universe where art and nature intermingle and where nature is celebrated but where, in the end, Cellini's art and the art of sculpting in miniature are triumphant.

Notes

1. P. Goldberger, "Seductive Smallness," *The New York Times*, Sunday, 12 September 1993, section VI, 100.

2. A. A. Filarete, *Antonio Averlino Filaretes Tractat über die Baukunst (Trattato dell'architettura)*, ed. W. von Oettingen (Vienna, 1890), 666–9. For a discussion of Piero de' Medici as a collector and patron of the arts, see the essay "The Early Medici as Patrons of Art," in E. H. Gombrich, *Norm and Form: Studies in the Art of the Renaissance* (Chicago, 1985), 35–57.

3. It is generally believed that Donatello was the first to make statuettes of this type, but no surviving works can be attributed to him with certainty. However, J. Pope-Hennessy, "Donatello and the Bronze Statuette," *The Study and Criticism of Italian Sculpture* (Princeton, 1980), 129–34, suggested that a bronze statuette of a *Pugilist* may have been done by Donatello sometime in the 1420s or 1430s. On the sculpture of Bertoldo, see J. D. Draper, *Bertoldo di Giovanni: Sculptor of the Medici Household* (Columbia, Mo., 1992). For discussions of the small bronzes by Antico, see H. J. Hermann, "Pier Jacopo Alari-Bonacolsi, genannt Antico," *Jahrbuch der Kunsthistorischen Sammlungen des Allerhöchsten Kaiserhauses* XXVIII (1909–10): 202–88; and A. Radcliffe, "Antico and the Mantuan Bronze," *Splendours of the Gonzaga*, ed. D. Chambers and J. Martineau (London, 1981), 46–69. The classic comprehensive study of small-scale Italian bronzes is W. von Bode, *The Italian Bronze Statuettes of the Renaissance*, 2d ed., ed. and rev. by J. D. Draper (New York, 1980). See also L. Planiscig, *Piccoli Bronzi Italiani del*

Rinascimento (Milan, 1930); and the shorter but illuminating account of statuettes in J. Pope-Hennessy, *Italian Renaissance Sculpture* (New York, 1958), 99–106.

4. For Isabella d'Este's correspondence and a fine account of her collecting habits see C. M. Brown and A. M. Lorenzoni, "The Grotta of Isabella d'Este, Part I," *Gazette des Beaux-Arts*, LXXXIX (May–June 1977): 155–71; and *idem*, "The Grotta of Isabella d'Este, Part II," *Gazette des Beaux-Arts* XCI (February 1978): 72–82.

5. Statius, *Silvae* IV, 6, lines 32–47. I have used the translation by J. J. Pollitt, *The Art of Greece, 1400–31 B.C. (Sources and Documents)* (Englewood Cliffs, N.J., 1965), 149–50. The complete poem by Statius can be found in F. P. Johnson, *Lysippos* (Durham, N.C., 1927), 290–6. The relevant passage from Martial's poem is cited in E. Bartman, *Ancient Sculptural Copies in Miniature* (New York, 1992), 147–8. Chapter 6 of this volume, "The Conceit of the Small: The Hercules Epitrapezios," offers excellent insights into the subject of ancient statuettes. My thanks to Ada Cohen who kindly steered me to Bartman's interesting book. Another study focusing on the subject is F. de Vischer, "Héraklès Epitrapezios," *L'Antiquité Classique* XXX (1961): 67–129.

6. The figures of Pollaiuolo's statuette together with their base measure 45 cm (17½"). The figures alone are approximately ⅘ (or 14") of the statuette's total height. The bronze *Hercules and Antaeus* and the related paintings showing the adventures of Hercules are discussed by L. D. Ettlinger, *Antonio and Piero Pollaiuolo* (New York, 1978), 51–2, 141–2, and 147. For the special significance Hercules had for the Florentines, see L. D. Ettlinger, "Hercules Florentinus," *Mitteilungen des Kunsthistorischen Institutes in Florenz*, XVI (1972): 119–42.

7. The description comes from Book XXXV of Pliny the Elder's *Naturalis Historiae*. I have used the edition by K. Jex-Blake and E. Sellers, *The Elder Pliny's Chapters on the History of Art* (New York, 1896), 117, as well as Pollitt, *Greece*, 162.

8. As cited in the interesting study of Giulio Clovio's miniature paintings by W. Smith, "Giulio Clovio and the 'Maniera di Figure Piccole,'" *Art Bulletin* XLVI, no. 3 (September 1964): 398.

9. G. Vasari, *Le Vite de' più eccellenti pittori, scultori ed architettori*, ed. G. Milanesi (Florence, 1906), VII, 564 and 569.

10. Vasari, *Vite*, VII, 560, 563, and 568.

11. Jex-Blake, *Pliny*, 215. A similar, if not the same, work is described earlier (p. 69) by Pliny when he says that "Theodorus . . . also cast a portrait of himself in bronze . . . The right hand holds a file, while three fingers of the left hand support a tiny team of four horses, which is now at Praeneste, so small that the team, marvellous to relate, with chariot and charioteer could be covered by the wings of a fly, which the artist made to accompany it."

12. Marcus Varro, *De Lingua Latina*, VII, i. See the comment in Jex-Blake, *Pliny*, 215 n.10.

13. Julian, *Epistola* 67 (377 A, B) as cited in Pollitt, *Greece*, 123.

14. On the collecting of cameos and gems, see Gombrich, *Norm and Form*, 51–2; N. Dacos, A. Giuliano, and U. Pannuti, *Il tesoro di Lorenzo il Magnifico, I: Le gemme* (Florence, 1973); E. Müntz, *Les collections des Médicis au XVe siècle* (Paris, 1888); E. Müntz, "Les collections d'antiques formées par les Médicis au XVIe siècle," *Mémoires de l'Académie des Inscriptions et Belles-Lettres*, XXXV, 2 (Paris, 1895), 143–4; M. A. McCrory, "Some Gems from the Medici Cabinet of the Cinquecento," *Burlington Magazine* CXXI, no. 917 (August 1979): 511–4; A. Luzio and R. Renier, "Il lusso di Isabella d'Este, Marchesa di Mantova," *Nuova antologia di scienze, lettere ed arti*, 4th ser., LXIV (16 July 1896), 294–324; C. M. Brown, "The Farnese Family and the Barbara Gonzaga Collection of Antique Cameos," *Journal of the History of Collections* VI, no. 2 (1994): 145–52; C. Riebesell, *Die Sammlung des Kardinal Alessandro Farnese: Ein "Studio" für Künstler und Gelehrte* (Weinheim, 1989); and C. Robertson, *"Il Gran Cardinale," Alessandro Farnese, Patron of the Arts* (New Haven, 1992), 49–50.

15. Müntz, *Les collections des Médicis*, 1888, 60, 66–70.

16. R. Weiss, *The Renaissance Discovery of Classical Antiquity* (Oxford, 1969), 187–8.

17. Vasari, *Vite*, V, 367–91.

18. I have written about these works previously: J. Kenseth, ed., *The Age of the Marvelous* (Hanover, 1991), 45–6.

19. Vasari, *Vite*, V, 75. A discussion of some of Properzia de' Rossi's miniature sculptures appears in G. Bianconi, *Descrizione di alcuni minutissimi intagli di mano di Properzia de' Rossi* (Bologna, 1840). For more recent studies of this artist, see V. Fortunati Pietrantonio, "Per una storia della presenza femminile nella vita artistica del cinquecento bolognese: Properzia De Rossi 'schultrice,'" *Il Carrobio: Rivista di Studi Bolognesi* (1981), 167–77; and F. Jacob, "The Construction of a Life: Madonna Properzia de' Rossi 'Schultrice' Bolognese," *Word and Image* IX (1993): 122–32. I thank Sheryl Riess for these citations and Mario Carniani for obtaining the photograph in Fig. 54.

20. Vasari, *Vite*, III, 463.

21. E. Tesauro, *Il cannocchiale Aristotelico* (Turin, 1670); August Buck facsimile edition (Berlin, 1968), 82–3. The concept of *ingegno* is discussed in Kenseth, *Marvelous*, 38.

22. Vasari, *Vite*, IV, 10. Among the many studies that give significant attention to Giambologna's small-scale sculptures are J. Holderbaum, *The Sculptor Giovanni Bologna* (New York, 1983); E. Dhanens, *Jean Boulogne – Giovanni Bologna Fiammingo* (Brussels, 1956); C. Avery and A. Radcliffe, *Giambologna Sculptor to the Medici* (London, 1978). Excellent essays on many of Giambologna's statuettes appear in M. Leithe-Jasper, *Renaissance Master Bronzes from the Collection of the Kunsthistorisches Museum Vienna* (London, 1986).

23. Vasari, *Vite*, I, 163.

24. The document referring to this gift is published in the essay by C. Avery and K. Watson, "Medici and Stuart: A Grand Ducal Gift of 'Giovanni Bologna' Bronzes for Henry Prince of Wales (1612)," in C. Avery, *Studies in European Sculpture* (London, 1981), 95–111.

25. See the major study by L. Planiscig, *Andrea Riccio* (Vienna, 1927). Casts made after actual animals continued to be made in the late sixteenth century, as described by F. Baldinucci, *Notizie de' professori del disegno* (Florence, 1681); ed. F. Ranelli (Florence, 1846), IV, 454.

26. C. Cennini, *The Craftsman's Handbook "Il Libro dell'Arte,"* trans. D. V. Thompson, Jr., New Haven, 1933 (reprint: New York, 1954), 129.

27. As has often been pointed out, humanism and the study of pastoral poetry by ancient and modern writers flourished as well in Padua and also deeply influenced the small bronzes that were made there. Among the most recent examinations of bronzes and other works of art in this cultural milieu is *Natur und Antike in der Renaissance*, ed. H. Beck and P. C. Bol (Frankfurt am Main, 1985).

28. For a summary of the many ways in which Riccio's figures were interpreted see the essay by D. Blume, "Beseelte Natur und ländliche Idylle," in *Natur und Antike in der Renaissance*, 173–97.

29. Jex-Blake, *Pliny*, 5–7.

30. Pliny the Younger, *The Letters of the Younger Pliny*, trans. B. Radice (Baltimore, 1963), 143. The dining table was located at the Younger Pliny's famous villa in Tusculum.

31. Vasari, *Vite*, V, 170. J. F. Hayward, *Virtuoso Goldsmiths and the Triumph of Mannerism, 1540–1620* (London, 1976), provides an exhaustive account of the tableware made by Renaissance craftsmen. Most of the works to which I refer are illustrated in this volume. Another, more detailed look at some of these works is in J. F. Hayward, "Ottavio Strada and the Goldsmiths' Designs of Giulio Romano," *Burlington Magazine* CXII, no. 802 (January 1970): 10–14.

32. See Hayward, *Goldsmiths*, 155–7, for a discussion of the Miseroni and Saracchi; and B. Heinzl-Weid, "Studi sull'arte della scultura in pietre dure durante il rinascimento: I fratelli Sarachi," *Antichità Viva* XII, no. 6 (1973): 37–58.

33. C. Piacenti Aschengreen, *Il museo degli argenti a Firenze* (Milan, 1968), 28, briefly describes this work as well as other elegant objects made in hard stones and crystals for the Medici. Two very similar rock crystal egrets are in Vienna. See M. Leithe-Jasper and R. Distelberger, *The Kunsthistorisches Museum Vienna: The Treasury and the Collection of Sculpture and Decorative Arts* (London, 1982). The authors state (p. 91) that the rock crystal birds originally had real aigrettes (egret feathers) attached to their heads, thus making the relation between the artificial and natural even more striking and amusing.

34. Cited in Hayward, *Goldsmiths*, 45. Extremely complicated designs for works made in glass – tazzas, ewers, table fountains, and so forth – were made by artists employed by the Medici grand dukes. A detailed and well-illustrated study of this art form was published by D. Heikamp, "Studien zur Mediceischen Glaskunst: Archivalien, Entwurfszeichnungen, Gläser und Scherben," *Mitteilungen des Kunsthistorischen Institutes in Florenz* XXX, 1/2 (1986): 11–423.

35. Illustrations of designs for folded napkins were published in a treatise by M. Giegher, *Trattato sul modo di piegare ogni sorta di panni lini: Cioè salviette e tovaglie e d'apparecchiare una tavola,* (Padua, 1639). A few of these are reproduced in S. Bertelli, *et al., Le corti italiane del rinascimento* (Milan, 1985), 204–5. Earlier treatises concerned with such table decorations and the proper setting of the table include C. Messisbugo, *Banchetti, composizioni di vivande et apparecchio generale* (Ferrara, 1549).

36. Vasari, *Vite*, VI, 609–19. Andrea del Sarto's ingenious use of sausages for porphyry columns (porphyry is a purple stone mottled with white crystals) recalls Nassaro's use of the piece of jasper as well as the later immensely entertaining paintings by Arcimboldo, which show human faces composed out of vegetables, flowers, fish, etc. All are perfect illustrations of the view that ingenuity implied an ability for finding resemblances between apparently dissimilar things.

37. These observations and those that follow are based on the interesting essay by K. J. Watson, "Sugar Sculpture for Grand Ducal Weddings from the Giambologna Workshop," *Connoisseur*, CLXXXIX (September 1978): 20–6.

38. Watson, "Sugar Sculpture," 24.

39. As described by C. Rinuccini, *Descrizione delle feste fatte nelle nozze de' Serenissimi Principi di Toscana D. Cosimo de' Medici e Maria Maddalena* (Florence, 1608), 23, 78–81. Part of Rinuccini's description of the table decorations for this occasion is published in Heikamp, "Studien," 249.

40. R. A. Goldthwaite, *Wealth and the Demand for Art in Italy, 1300–1600* (Baltimore and London, 1993), 209 and 245. As the final three chapters of Goldthwaite's superb and very readable book show, Giovanni Pontano's *I trattati delle virtù sociale* was but one of several Renaissance treatises concerned with these issues.

41. These observations were made by Rinuccini, *Descrizione*. See Heikamp, "Studien," 249. Images of banquet tables with the full array of sculpted dishes, glassware, etc., are also published in Heikamp's article (pp. 248–9).

42. The double meaning of *epitrapezios* is discussed by Bartman, *Ancient Sculptural Copies*, 151.

43. The creation of such tableaux is mentioned, for instance, by Watson, "Sugar Sculpture," 22. Hayward, *Goldsmiths*, 129, also describes how "vast table centers usually combined with a fountain . . . gave a visual summary of human knowledge."

44. These comments are based on my earlier and longer dis-

cussion of the early museums. See Kenseth, *Marvelous*, 81–101.

45. An account of Isabella d'Este's collection and diagrams showing the original location of objects in her "Grotta" appear in Brown and Lorenzoni, "The Grotta of Isabella d'Este," pt. I, 161–5.

46. For an excellent account of museums of mostly natural objects and of Aldrovandi's encyclopedic aspirations and activities as a collector, see P. Findlen, *Possessing Nature: Museums, Collecting, and Scientific Culture in Early Modern Italy* (Berkeley, 1994).

47. The programs designed for the rooms housing the Medici collections, especially for the Tribuna, are discussed at length by D. Heikamp in "Zur Geschichte der Uffizien – Tribuna und der Kunstschränke in Florenz und Deutschland," *Zeitschrift für Kunstgeschichte* XXVI (1963): 193–268, and in "La Tribuna degli Uffizi come era nel cinquecento," *Antichità Viva* III (1964): 11–30. See also the article by P. Corrias, "Don Vincenzio Borghini e l'iconologia del potere alla corte di Cosimo I e di Francesco I de' Medici," *Storia dell'arte* LXXXI (1994): 169–81.

48. G. Pico della Mirandola, *Oration on the Dignity of Man*, trans. A. R. Caponigri (South Bend, Ind., 1962), 5–8, 34, 43–4.

49. B. Cellini, *The Autobiography of Benvenuto Cellini*, ed. C. Hope and A. Nova (New York, 1983), 113.

50. *Ibid.*

51. The most recent discussion of the iconography and style of the Saltcellar appears in J. Pope-Hennessy, *Cellini* (New York, 1985), 85–7, 101–16. Another detailed account of this work appears in E. Plon, *Benvenuto Cellini, orfèvre, médailleur, sculpteur* (Paris, 1883), 168–79. A thorough description of the Saltcellar's construction can be found in E. Kris, *Goldschmiedearbeiten des Mittelalters, der Renaissance und des Barock* (Vienna, 1932), 24–8.

52. B. Cellini, "The Treatise on Goldsmithing," in *The Treatises of Benvenuto Cellini on Goldsmithing and Sculpture*, trans. C. R. Ashbee (New York, 1967), 59.

53. Cellini, *Autobiography*, 141.

Public Sculpture in Renaissance Florence

Sarah Blake McHam

Introduction

To ACCOMPANY A LETTER to the editor about the city's shortage of apartments, the *New York Times* chose a cartoon (Fig. 61) showing the Statue of Liberty bedecked with a rental advertisement. As a universally recognized symbol, the statue was used to make a social comment. Just as today the democratic ethos is represented by the large bronze lady holding a torch above New York harbor, the fifteenth- and sixteenth-century Florentine sculptures that are the concern of this essay marked a new view of public monuments that emphasized their embodiment of civic or dynastic ideals.[1] The essay's focus is on the Renaissance's rediscovery of the dynamic power, known in antiquity, of a public monument to crystallize interpretations of cultural identity in visual form and to influence the citizenry's perception of them.

The development in Florence in the postantique world of freestanding public statues spurred the long tradition of this type of statuary in Europe and America. Five hundred years ago, in Renaissance Florence, the emphasis was on statuary as part of the "symbolics of power" for the main rivals seeking to control the city – the Republic and the Medici faction.[2] To appreciate this role, we must turn to the novel features that made these sculptures so adaptable to political purposes.

The extraordinarily rapid evolution in the semiotic possibilities of public sculpture in fifteenth- and sixteenth-century Florence has affected the appearance of public spaces ever since. Inspired by descriptions of ancient Greek and Roman cities and by the physical evidence of their ruins, secular patrons realized that the strategic placement in outdoor public spaces of durable stone or bronze sculpture could promote a desirable image for their city. These sculptures could also help to shape the public's perception of that identity more effectively than any literary or other artistic medium or any type of public ritual. Other types of art were less tangible and were geared to a self-selected audience; public ritual, although it involved the crucial feature of regular group participation, was by definition transitory. Naturally, the commissioners of public monuments

Figure 61. Barrett, Statue of Liberty Cartoon (photo: courtesy of the artist)

were Florence's ruling elites, who guarded closely the privilege of erecting monuments at the city's center, in keen appreciation of the effectiveness of those monuments as what today is called propaganda.

This essay traces the rapid exploration of sculpture's technical and expressive potentials in commissions at the Mercato Vecchio and Orsanmichele, Florence's major markets, and then focuses on how successive Florentine governments exploited public sculpture in the Piazza della Signoria, the open area around the city's town hall, to proclaim their messages. The powerful physical presence of this new form of sculpture, whether mounted on architecture, where it was installed at the level of the passerby (Orsanmichele), or, as became the norm, mounted on independent bases in Florence's piazzas, meant that it existed in the world of the spectator. The association of sculpted monuments with religious and patriotic rituals imparted to the monuments continuous accretions of vivid meanings in the minds and memories of the populace. As Florentines could encounter these public statues incidentally while performing everyday errands or even lean against them while resting from those chores, they were constantly reminded of their messages. In these ways, the sculptures imprinted themselves on the collective self-consciousness of the people and helped to shape citizens' and visitors' image of the city.

Background

Earlier large-scale sculpture had been employed almost exclusively to ornament the exterior architecture of churches, where its primary role was to emphasize the church – its physical structure and metaphysical messages – thereby encouraging people to enter the building and to participate in the religion. Hence sculptural decoration was generally located around church portals as either reliefs representing narratives or statues of saints, the Virgin, and Christ in niches on the exterior walls. Both types of sculpture visually became part of the architecture they complemented.[3]

The Florentine development has limited precedents in two important categories of public monuments erected in late medieval Italy: the fountain and the column-statue. Of the few examples of fountains carved with sculpture, Perugia's Fontana Maggiore, erected by Nicola Pisano in the thirteenth century, and Siena's Fonte Gaia by Jacopo della Quercia of the early fifteenth century (P/R illus. 4.66 and 4.67), are the most important.[4] By virtue of their function, fountains epitomize the beneficent powers of civic government because they provide life-giving water. The fountains' location in their cities' principal public spaces,

adjacent to the center of government, underscores this point. The decoration of fountains with patriotic reliefs and statues of patron saints and legendary founders link the government in power to the fundamental legends and heroes of the city's identity.

The second group of statues, of patron saints or legendary founders atop columns, is considerably more common.[5] Column-statues were a staple feature of ancient Roman cities, often functioning to support sculptures of emperors or pagan gods. When column monuments were reintroduced during the Middle Ages, they were at first used exclusively as the base for Christian, nonfigurative symbols, such as the monumental Crosses in seventh-century Ireland. Their pagan associations gradually waned, and examples of human or animal sculptures, usually representing saints, began to appear on columns by the thirteenth century. The piazzetta in Venice offers examples of both, in a column-statue honoring St. Theodore, the city's early patron, and that elevating the lion symbol of St. Mark, who supplanted Theodore as the city's prime saint. They stand in front of the seat of government, the Palazzo Ducale, and symbolize the connection between the state and the saints protecting it.

Equestrian monuments form a special subcategory of the column-statue type. The ancient example of the *Regisole*, located at Pavia until its destruction in the 1790s, was well known in the Renaissance.[6] In Florence, a similar equestrian statue of the city's legendary founder, Mars, presumably a Roman monument, is claimed to have once stood atop a column inside the city's oldest and most venerable building, the Temple of Mars, before it was converted to Christian use as the Baptistry of Florence. Of course, we now know that construction of the Baptistry did not begin before the eleventh century, but the lore intermingling the city's Christian and Roman history made the equestrian statue of Mars a significant marker of Florentine identity. The column-statue was moved to the Ponte Vecchio and destroyed when it fell into the Arno in 1333.[7]

The Destroyed Dovizia in the Mercato Vecchio

Of crucial interest to this study is the revolutionary column-statue known as *Dovizia*, erected in Florence between c. 1428 and 1430 to honor the Republic's largesse toward its citizens. The sculpture, unfortunately destroyed and reconstructable only in general terms, was carved by Donatello in limestone. A fifteenth-century Italian painting, now in the Walters Art Gallery, Baltimore, illustrates an imaginary ideal city (Fig. 62). Its four column-statues represent different virtues of the city and its government. The column-statue second from the right probably imitates Donatello's *Dovizia* most closely, but all four monuments are inspired by it.

The *Dovizia* was the first column-statue since ancient times to represent a subject directly linked to the pagan world, a personification of Abundance represented as a large-scale female figure with a basket of fruit on her head and carrying a cornucopia, depicted just as she had been on many coins minted by

Figure 62. Anonymous, *View of an Ideal Cityscape*, late 15th century, Walters Art Gallery, Baltimore (photo: Walters Art Gallery)

the Roman emperors. The sculpture was a remarkable invention because it had no overt Christian content, although implicitly its symbolism connoted the Christian virtue of charity. But Donatello's statue made an unprecedented break with the Christian pattern of subsuming pagan emblems and disguising their origin. Instead, the sculptor trumpeted the statue's derivation by using conventions copied directly from Greco-Roman art: it was a column-statue of a human figure personifying virtuous government rendered in the idealized realism that epitomized ancient art. The taboo against pagan idols had been broken!

Dovizia stood high above the central market square of Florence (the Mercato Vecchio) until the early eighteenth century, when it was replaced by a freshly carved version of the theme, probably because the soft limestone of Donatello's original had badly deteriorated.[8] In the nineteenth century, urban renewal leveled the Mercato Vecchio, transforming it into the modern Piazza della Repubblica. Today's visitor to the piazza sees only a copy of the eighteenth-century replacement sculpture atop a copy of the original column in a space to which its symbolism is no longer relevant. The sad later history of the *Dovizia* encapsulates the problems of outdoor sculptural monuments. They are prey to erosion (accelerated by the pollution of the environment in this century), to urban redesign, and as we shall see, to image makeovers. Even though the original sculpture and column have been destroyed, Donatello's statue should be reintegrated into our mental image of Florentine Renaissance public monuments as the first to promulgate the Republican government's virtues, in this case its wealth and charity to citizens.[9]

Even before the radical invention of the *Dovizia*, there were significant changes in how the most traditional form of sculpture, that decorating exterior architecture, was interpreted in Florence. These changes mark a crucial stage in

the development of independent sculpted monuments in the city. To follow the evolution, we must turn to Orsanmichele, once the city's grain exchange.[10]

Orsanmichele

Orsanmichele's name derives from the building's location on the site of a medieval oratory to St. Michael. Constructed largely in the fourteenth century, it was composed of an open-air loggia on the ground floor, where commercial transactions took place, and floors of granaries above.

In the late fourteenth century, Orsanmichele was restructured to accommodate the important cult that developed around a painting of the Madonna and Child, which began to work miracles and was located inside the loggia (P/R illus. 3.34). To render the secular space more suitable to its new function as one of Florence's most venerated shrines, the open arches of the loggia were filled in with stained glass windows, making its exterior piers continuous external walls. Some guilds, associations of often influential professionals and craftsmen who were involved in Florentine politics, were given the privilege of commissioning statues of patron saints to be put in niches on the exterior walls. Others were accorded the right to order altarpieces and frescoes of their patrons for the interior walls and piers of the building.

Several sculptures were commissioned in the late fourteenth century, but intensive activity began only in the early fifteenth century, when legislation was passed requiring the guilds to initiate work on their patron saints or forfeit the right to their assigned space (P/R illus. 4.36).[11] A series of statues was ordered from the city's most prominent artists, including Donatello, who provided *St. Mark* (P/R illus. 4.38) for the Linen-Weavers' and Peddlers' guild (1411–15), *St. George* for the Armorers' and Swordsmiths' guild (c. 1415–17), and *St. Louis of Toulouse* (c. 1422–25; P/R illus. 4.41) for the Guelph Party (not a guild at all, but then the Republic's most powerful political association). Ghiberti cast bronze statues of *St. John the Baptist* (P/R illus. 4.40) for the Wool-Finishers' guild (c. 1412–16), *St. Matthew* for the Bankers' guild (1419–22), and *St. Stephen* (1425–29) for the Wool-Workers' guild. The third major sculptor, Nanni di Banco, carved during the 1410s the *Four Crowned Saints* (Fig. 77) for the guild of Stonemasons and Woodworkers, the *St. Eligius* for the Blacksmiths' guild, and the *St. Phillip* for the Cobblers' guild. A photograph (Fig. 63) shows the relationship of *St. George* to the spectator and to the other sculptures at Orsanmichele's northwest corner.[12]

The terms of the commissions and the physical arrangement of the building contributed to a new emphasis on sculpture in relationship to the surrounding architecture. Each guild hired its own artist. The statues are approximately the same size and fit into separate, elaborately ornamented niches constructed for them in narrow strips of unornamented brown stone wall (the former piers). Each statue is isolated from the others by the wide window arches, so that they are not only physically separate but are barred from participating in the sorts of

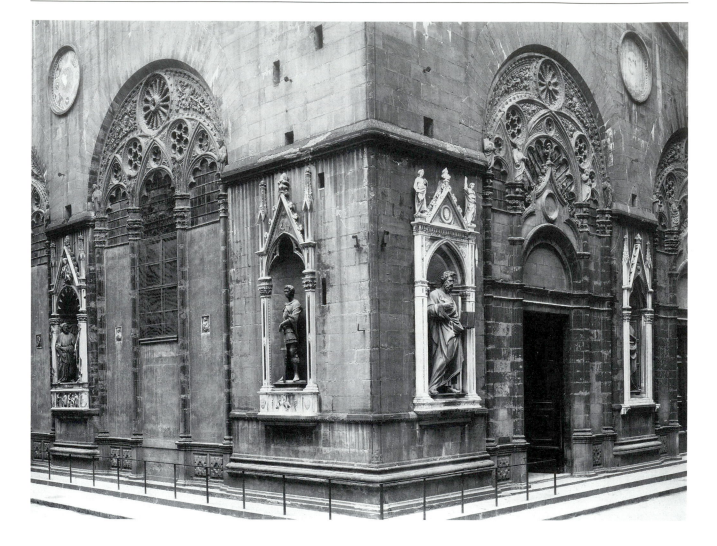

Figure 63. View of Northwest
Corner of Orsanmichele,
Florence, 14th–15th centuries
(photo: Charles Seymour, Jr.
Archive)

narrative or compositional interrelationships that can be observed in previous
sculpture on churches.

 The impact of the statues is further enhanced by their large scale (more than
life-size) and their positions just above the heads of passersby, rather than as part
of ensembles around the portal or higher on the wall as had been typical earlier.
In addition, the statues are all very three-dimensional and seem placed in the
niche, rather than an integral part of the architecture as low-relief architectural
sculpture invariably appears. Their lifelikeness is increased by the emotional and
psychological characterization of many of them. Because all the statues face out
of their niches into the spectator's space, their emotions seem directed at the
passerby and promote empathetic reactions. For all these reasons, the sculptures
do not seem to be symbolic adjuncts decorating the architecture but sentient
beings who demand our attention and who dominate their architectural setting,
making it a foil for their vibrant presence.

 An analysis of one of these sculptures, Donatello's *St. George* (Fig. 64),
demonstrates how these general characterizations mold our impression. St.
George, a medieval Christian knight, is poised for battle. His head is turned to
the side as though watching for danger, his brow is deeply furrowed and the

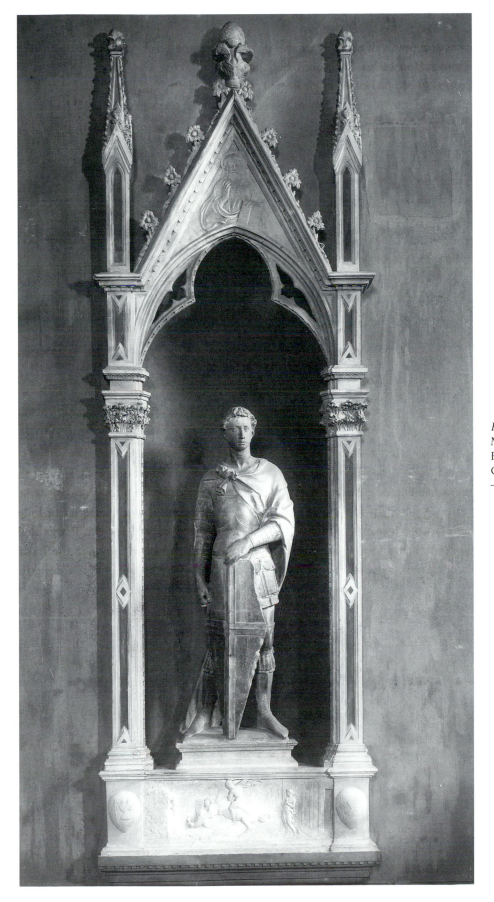

Figure 64. Donatello, *St. George*, Museo Nazionale del Bargello, Florence, c. 1415–17 (photo: Charles Seymour, Jr. Archive)

irises and pupils of his eyes are carved to convey the ferocity of his focused gaze. Examination of his discolored right hand reveals that George originally held a bronze sword or lance that projected out of the niche, puncturing the onlooker's space. He also wore a bronze helmet, the dark color of which, shining in the Florentine sun, must have contrasted dramatically with the off-white of the marble figure, and the brown stone blocks of the architecture, to catch the eye of pedestrians. His shield and armor, once complemented by helmet and sword or lance, identify the warrior saint as George to all spectators, literate or not. His watchful, tense expression and slender youthful body prompt them as fellow humans to comprehend his courageous resolve.

Any possible confusion as to the statue's identity was clarified by the small relief, just below the niche and even closer to the spectator, that illustrated one of St. George's heroic feats, his slaying of a dragon to rescue a young princess. This is one of the earliest instances in Renaissance art of a relief sculpture accompanying a statue. The combination adumbrates what we shall find later in freestanding sculptures. The details of narrative reliefs closer to the viewer on the base of a monument expand a statue's range of meaning and increase the ensemble's visual interest by forcing the passerby to stop and examine the entire presentation to glean the total content of the narrative.

The later history of the *St. George* confirms that it was perceived as a powerful independent sculpture. The techniques of carving that created George's alert intense expression and emphatic turn of the head inspired Michelangelo's interpretation of *David* (Fig. 80) almost a century later. Donatello's statue was the subject of the first treatise ever devoted to a single work of art from an earlier period, written by Bocchi in the late sixteenth century after the series of independent monuments, which it helped inspire, was carved for the Piazza della Signoria.[13] And to cite one incident from its modern history, in 1938 the Italian dictator Mussolini actually moved a copy of *St. George* onto a pedestal along the route of a Fascist parade. No doubt, by associating himself with a famous emblem of Florence's great historic past, Mussolini was attempting to capitalize on his fellow citizens' attachment to their cultural heritage and to suggest that, like George, he was a heroic Christian soldier fighting for the country's glory.[14]

Donatello created the lost *Dovizia* in the decade following the *St. George*. Fortunately, his next freestanding sculptures are both well preserved. Although there is no documentary evidence, the bronze *David* (Fig. 7) was probably cast for the Medici family in the late 1430s, just after Cosimo de' Medici took over as de facto head of Florentine government in 1434.[15] Donatello's bronze *Judith and Holofernes* (Fig. 65) was most likely created for the palace constructed for the Medici family by Michelozzo, on the Via Larga in the 1450s. As fully three-dimensional statues made to be installed on freestanding pedestals, they are the earliest preserved examples of this new form of sculpture. For decades the *David* stood in the center of the courtyard and the *Judith and Holofernes* in the enclosed garden just behind it. Although the exact dimensions and details of their pedestal bases are still debated, it is clear that they were considerably shorter than the col-

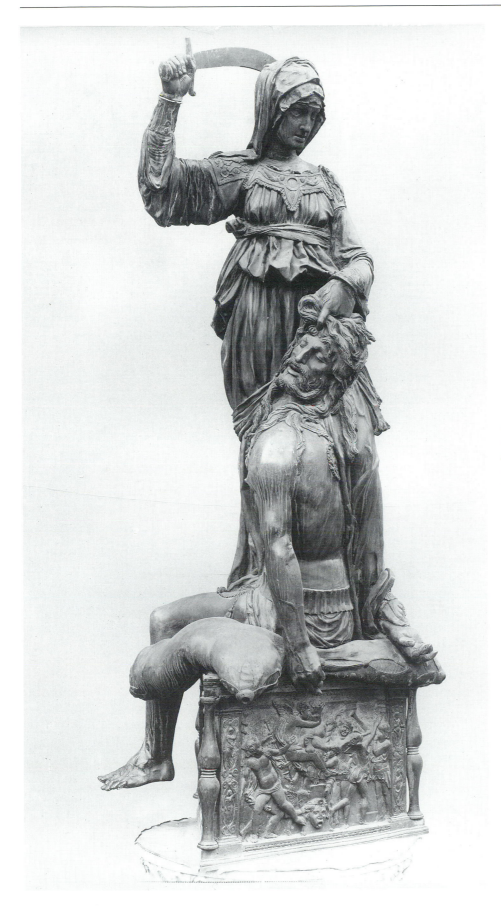

Figure 65. Donatello, *Judith and Holofernes*, Palazzo Vecchio, Florence, c. 1446–50 (photo: Alinari/Art Resource, N.Y.)

umn base of the *Dovizia*. They combined the three-dimensional impact of the *Dovizia* with the proximity to the spectator of the niche sculptures at Orsan-michele.

When the Medici were expelled from Florence in 1494 and the Republic reinstated, the palace was sacked and its treasures looted. Both sculptures were appropriated by the victorious Republic. The *David* was erected at the center of the interior courtyard of the town hall of Florence,[16] and the *Judith and Holofernes* was relocated on the podium platform (*ringhiera*) in front of the palace and overlooking the vast, irregularly shaped piazza surrounding it. It was the first of a long and significant series of figural sculptures to be installed in the largest outdoor space at the heart of Florence, to which we shall now turn (Fig. 66).

Piazza della Signoria – Early Development

Figure 66. View of the Piazza della Signoria, Florence, 13th–16th centuries (photo: Charles Seymour, Jr. Archive)

To understand the significance of the group of figural sculptures in Florence's Piazza della Signoria in relation to their site,[17] we must first review the historical and cultural meanings attached to the buildings that the piazza surrounds. The town hall of Florence, variously known in the fourteenth and fifteenth centuries

as the Palazzo dei Priori or Palazzo della Signoria, had been built in the late thir-teenth century as a meeting place and residence of the priors and the gonfalonier of justice, the governing officials of the Florentine Republic.[18] (It is now usually referred to as the Palazzo Vecchio.)

Its official functions were extended out-of-doors by the erection in 1323 of the *ringhiera*, a raised stone platform along the town hall's west side. The piazza became the public theater in which the Republic's power was enacted. From the *ringhiera* podium/reviewing stand, officials took their oaths of office, announced governmental decrees, and supervised official functions like *parla-menti*, or assemblies of the populace. The most prestigious foreign visitors were met at the gates of Florence, but the majority rode to the Piazza della Signoria, where a protocol based on their status dictated the distance from the *ringhiera* at which they were required to dismount before being greeted.[19] In the 1370s the ceremonial context of the piazza was enhanced by the construction of the Log-gia dei Lanzi adjacent to the palazzo, to provide an enclosed outdoor space for assembled officials and dignitaries.[20]

Important religious rituals, such as the display of miracle-working relics and paintings and the celebration of mass, also took place on the *ringhiera*. For exam-ple, the highly venerated painting of the Madonna from Impruneta was enshrined there in times of famine or war so that her aid could be beseeched by the entire citizenry.[21] The city's major religious processions, such as those hon-oring the Impruneta Madonna or the city's patron, St. John the Baptist, either began or ended in the piazza or paraded through it, and the elaborate fireworks celebrating the feast of the Baptist took place there as well.

From the late thirteenth century until its ouster in 1434, the Republic of Flo-rence rarely commissioned statuary for the piazza.[22] It relied instead on the sym-bolic legacy and language of the site and its buildings and their decoration to convey an idealized image of the city: a Florence virtuous and trimphant, claim-ing to be the successor to the ancient empire's capital, a new Christian Rome. Although many Italian city-states attempted to aggrandize themselves through this sort of rhetoric, Florence was particularly effective in establishing its con-nection to the venerable city.[23] The identification of Florence as a new Rome, first articulated in an anonymous chronicle of c. 1200, became a staple in late medieval histories of the city.[24]

The mythic notion of Florence as Rome reincarnate seems to have shaped the creation of its prime public buildings and civic space, which deliberately recall ancient Roman precedent. Vitruvius's description of the Roman fora pro-vided a justification for the piazza's irregular shape, which grew into its present form through a series of decisions to raze private dwellings and churches.[25]

The first step was the destruction of the consortium of the rebel Uberti clan, who were Ghibellines, supporters of the Holy Roman Emperor, in Guelph Florence, where most citizens supported his adversary, the pope. The razing of the Uberti buildings established the piazza's space as a triumphal zone for the Republic.[26] Vit-ruvius's account of how ancient civic centers included a prison, a mint, and a build-

Figure 67. Anonymous, *Execution of Savonarola*, Museo di S. Marco, Florence, 16th century. The *Marzocco* statue is indicated by the arrow on the left; Donatello's *Judith and Holofernes* is indicated by the arrow on the right (photo: Alinari/Art Resource, N.Y.)

ing for governmental administration matches the complex of buildings originally around the piazza.[27] The particular pattern of the Palazzo Vecchio's rustication matches that on a wall believed to have been part of the Palace of Caesar in Rome, and the Loggia dei Lanzi imitates the three-bayed barrel vault construction of the then-visible cross-section of the partly ruined Basilica of Maxentius.[28]

The only statue commissioned in this early period was a destroyed *Marzocco*, the lion of Mars, one of Florence's supposed founders, that had become a symbol of the city. The original sculpture, probably dating from the fourteenth century, represented the lion victorious over a wolf. It was apparently placed on the northwest corner of the *ringhiera* as a symbolic guardian and later replaced by a seated lion proudly holding a shield decorated with the Florentine lily, just visible in one early sixteenth-century painting (Fig. 67).

The *Marzocco* was placed prominently on the *ringhiera* balustrade. The statue differed from preceding versions of the theme, which were all smaller-scale architectural decorations. Its near life-size scale and location close to the dignitaries on the *ringhiera*, rather than high atop a column, as animal symbols of cities generally had been, made it a powerful physical presence. So, too, did the existence of live lions in cages just behind the Palazzo Vecchio, making the correlation between those pacing beasts and their lifelike symbol in the piazza all the more potent. The *Marzocco* played an important symbolic function during major civic and religious celebrations such as the festival of John the Baptist, when it was ritually crowned; the inscription on the crown lauded Florence and liberty. Smaller versions of the *Marzocco* were placed in subject cities of the Florentine territories as emblems of triumph. Other rituals, such as compelling prisoners from defeated cities to kiss the statue's rear, confirmed this meaning.[29] The vibrant associations of the *Marzocco* with Florentine civic consciousness are powerfully evoked by the opening lines of one of Savonarola's sermons, in which he addresses his listeners as though he were speaking to the *Marzocco*.[30]

The bitter struggle for control of Florentine government during the fifteenth century waged between powerful families, some supporting the continuation of a republic, others the Medici family's domination, necessarily affected the buildings and piazza. Once Cosimo de' Medici had gained control of the Republic in 1434, he transferred many official functions to the newly built Medici family palace on the Via Larga, about a mile away from the piazza (P/R illus. 5.12).[31] Cosimo and his direct successors preferred power to emanate from the Palazzo Medici, not the town hall. When Medici rule was overthrown in 1494 and again in 1527, a new, more inclusive, Republic was in power for two brief intervals (1494–1512 and 1527–30). In the late 1490s the interior of the palace was reconfigured to create the huge assembly hall necessary for the large numbers of citizen representatives of Republican government and was redecorated with images of Christ, who was named the king of Florence. Many other changes were made to eradicate any reminder of the period of Medici rule.[32]

The public space of the piazza was enlisted after the exile of the Medici in a way unique to Florence in the Renaissance – by the choice and manipulation of statues installed there. As control of the city seesawed back and forth between opposition factions in the early sixteenth century, succeeding governments commissioned or moved into the piazza monuments that articulated their messages and displaced or coopted those connected to their predecessors.

Again, the inspiration for the placement of a number of large-scale independent sculptures in a public exterior space derives from the example of ancient cities, known in Renaissance Florence through travel (particularly to Rome), but above all in the accounts of Roman authors, especially Vitruvius and Pliny.[33] Knowledge of these sources can be demonstrated through reflections of their descriptions in influential treatises by Ghiberti, Alberti, and Pomponius Gauricus, to cite fifteenth-century and early sixteenth-century authors only.[34] The sculptures in the piazza seem to represent a deliberate evocation of ancient precedents to embody the civic myth of Florence as the new Rome.

The earliest precise articulation of deliberate emulation of Greco-Roman precedents in the piazza is apparently in the funeral oration for Cosimo I in 1574, where the eulogist claims that the deceased duke intended to make the Uffizi and its surrounding area like the fora of Rome and the agora of Athens, public spaces embellished by statues commemorating heroes of their cities.[35] But numerous analogies between these ancient civic spaces and the Piazza della Signoria suggest that the goal existed much earlier.

The fora and agora are described by Vitruvius, Pliny, and other well-known authors as public spaces in which monumental statues honoring their cities' gods and heroes were erected. Their characterizations of the statues include similar information.[36] The statues were emblems of triumph and victory that provided eternal testimony to the memory of great men and to the power of the gods (including, indirectly, the men and institutions they supported). The statues were commissioned so that the citizenry would be impressed by their beauty and by the wealth and power of their commissioners. The authors stressed the effec-

tive role that life-size, three-dimensional statues of worthy subjects could play in engaging passersby and inspiring in them the desire to emulate the models of achievement represented by the statues' subjects. They pointed out that many of the sculptures were colossi, all the better to stimulate awe-filled responses. These themes are reiterated by the most prominent Renaissance theoretical writers who deal with sculpture.[37]

The Judith and Holofernes

The addition of the next statue to the piazza's space, days after the populace assembled there and decided to reinstate the Republic in 1495, inaugurated a long series of figural sculptures installed in the piazza during the sixteenth century. The *Judith and Holofernes* was also placed on the *ringhiera*, near the *Marzocco* (Fig. 65). As we have seen, this figure group was transferred to the piazza after the expulsion of the Medici. Its inscription was changed to "An example of the public welfare put in place by the citizenry," reusing the form of the inscription that Piero de' Medici had carved on the sculpture's pedestal when it stood in the garden of the family palace, but pointedly changing its content.[38] Repositioning a statue long associated with the defeated Medici family before the renewed center of Republican government and recutting its inscription proclaimed that the sculpture was a trophy of the new Republic's victory over the Medici. Furthermore, the statue's move and transformation galvanized around the successor to the pre-Medicean Republic the triumphal traditions of the site created by the earlier Republic.

The meaning of the group's unprecedentedly complex and dynamic action readily adjusted to its new situation. Judith's killing Holofernes represents moral victory because the inherently weaker woman could have slain the powerful warrior only by the grace of God. By placing the sculpture in their garden, the Medici family had intended that Judith's symbolic virtues be linked to them. Installing the statue before the revitalized center of Republican government inverted the sculpture's former meaning: the Republic solicited instead an interpretation that, like the virtuous Judith, it had overcome the rule of the oppressive Medici family because God had willed it.[39] A corollary political meaning, the moral supremacy of Republican government over tyranny, is emphasized by the new site. The murder of Holofernes, which resulted in the routing of a bellicose tyrant's armies, was achieved by a young woman's selflessly risking herself for the good of her people.

Even though the statue had not been created for the site in the Piazza della Signoria, its innovative technical features and interpretation served its new purpose forcefully. The *Judith and Holofernes* is the first multifigure freestanding group cast in bronze in the Renaissance. The medium's flexibility allowed Donatello to create a pair of figures dramatically enacting a woman murdering a man. Not only are the figures immediately identifiable as Judith slaying Holofernes, but they are much more emotionally involving than any single ani-

mal symbol or human figure could be. The former could not make a human bond as effectively, and the latter would have to rely on the indirect narrative devices of props and small-scale relief sculpture. Such bold gestures as Judith's lifting the scimitar high above her head as she gathers strength to slice through Holofernes's neck one more time or Holofernes's limbs dangling limply from his unconscious body vividly convey the tyrant's loss of life. The gilding of the scimitar and other details of the sculpture (just visible in Fig. 67) must have blazed in the sun and riveted attention on them.

The dramatic posing and bronze color of *Judith and Holofernes* were exploited by its position as the only figural sculpture on the *ringhiera*, dominating the expanse. The threatening gesture of Judith's raised sword, silhouetted against the dark stone of the town hall, symbolized the Republic's righteous rule across the vast public space. To onlookers in the piazza Judith must have seemed to watch over the Republic's officials during their meetings and to emblemize and validate their official judgments, such as the decision to burn Savonarola at the stake, in 1498, on a temporary extension of the *ringhiera* (Fig. 67).

Furthermore, some members of the Republican government must have realized that installing in the piazza a bronze sculpture of monumental scale depicting tyrannicide would connect the *Judith and Holofernes* with the famous ancient group of the *Tyrannicides*, which, like the Donatello sculpture, was life-size, freestanding, in bronze, and erected in the central civic public space of the agora in ancient Athens. The heroes commemorated in the *Tyrannicides*, honored as the founders of Athenian democracy, were famous throughout the ancient world. Their statue was described by Pliny,[40] whose account is repeated in abbreviated form by both Ghiberti and Alberti.[41] The group was carried off by the Persians when they defeated Athens in 480 B.C. So important was it as a civic symbol that the Athenians immediately commissioned a replacement group. When the original group was returned to Athens decades later, it was displayed, along with the second version, in the agora.[42] The same pattern of robbing the defeated foe of his symbol and reerecting it in the victor's territory seems to have been followed by the Republic (and, as we shall see, later by the Medici). The repetition of this symbolic victory and the installation of the Old Testament tyrannicide in the piazza suggested to the knowledgeable viewer the link between the reinstated Republic and this most venerable precedent of representative government.

The notion of installing statues to define the civic center with emblems that create an idealized identity of the government and promote patriotic feelings may have been spurred by contemporary renovations taking place in Rome as well as by the literary descriptions of ancient Roman authors. In the 1480s Sixtus IV donated a group of ancient sculptures to the Capitoline in Rome. Sixtus seems to have been motivated to reestablish the prestige of the city's governmental center and the site of ancient Roman triumphal processions so as to make clear that in his day this critical location was controlled by the Christian papacy. Unlike the statues in the Piazza della Signoria, those Sixtus entrusted to the

Capitoline were all ancient, not recently created sculptures, and they were mainly set up indoors.[43]

The theme of Judith's murder of Holofernes could also be construed in terms of other civic meanings. Her brave act saved the Jews and warded off a threatened second destruction of the Temple in Jerusalem, where she instead hung the cloth from the seduced general's bedstead in triumph. Her statue's position before the palazzo transfers Judith's protection to Florence and symbolically proclaims Florence as the new Jerusalem. That trope had long been a key theme in prophecies that foresaw Florence as the next center of Christian renewal.[44] Like the claims about Florence as a new Rome, these also first appeared in the thirteenth century; their messages are repeated in unpublished manuscripts through the late fifteenth century and recur frequently in the sermons of Savonarola.[45] Judith's symbolic identification of the city as the new Jerusalem was reinforced by the installation of the next statue added to the piazza, Michelangelo's *David*, which was erected flanking the entrance to the palazzo.[46]

David

The decision taken in 1504 to put Michelangelo's *David* (Figs. 68 and 80) in the place of the *Judith* on the *ringhiera* (*Judith and Holofernes* was transferred to the adjacent Loggia dei Lanzi) meant that another Old Testament hero who had delivered the Jews stood before the seat of government symbolically ready to protect Florence, the new Jerusalem.[47] Like Judith, David was an unlikely victor whose triumph over Goliath was made possible by God, so his placement in front of the town hall reinforced the Republic's message of its divine protection.

Furthermore, the colossal size of the statue, the first on such scale since Roman times, imitated the awe-inspiring dimensions of ancient colossi, frequently described by Greek and Roman authors as the wonders of the ancient world.[48] One of the most spectacular of these giant sculptures, the *Colossus of Rhodes*, stood 105 feet tall and bestrode the breakwaters of Rhodes's harbor. To appreciate the fascination such monuments have exerted throughout history, we need only to return to the Statue of Liberty, a colossal bronze created almost two millennia after her inspiration at Rhodes, which looms over the harbor of New York to welcome (and impress) visitors and immigrants. The statue, like the *Dovizia*, is an idealized female figure personifying an abstract concept considered paramount to the ruling government.

The vivid accounts of colossi by Greek and Roman authors were known by the fifteenth century and repeated in contemporary treatises by Ghiberti and Alberti. Their description of how colossi were often sited in the fora of ancient cities seems to have been imitated by the installation of the *David* in the piazza;[49] the presence of the *Dioscuri* or *Horse-Tamers* on the Capitoline Hill in Rome, guarding the governmental center and overlooking the city, confirmed their account of the siting of colossi and provided an extant inspiration to the Flo-

rentines. The contemporary description in Luca Landucci's diary of moving the *David* the half-mile from Michelangelo's workshop to the piazza gives an idea of the practical problems such giant sculptures entailed.[50] And they were much less challenging than the creative and technical difficulties involved in sculpting on such a scale!

The *David* is the first Renaissance sculpture to be set on an undecorated low socle in the fashion of ancient statuary. The base does not compete with the sculpture for our attention by its ornamention and height and hence does not define the sculpture as a decorative object. Instead, it positions the colossal figure much closer to us than does the base of the *Judith and Holofernes*. This radical change means that the proximity of the sculpture combines with its scale to emphasize the physical presence of the sculpture to such a degree that its convincing human hugeness amazes the viewer.[51]

The theme of the victorious David immediately connects the colossus to the three earlier versions of the subject

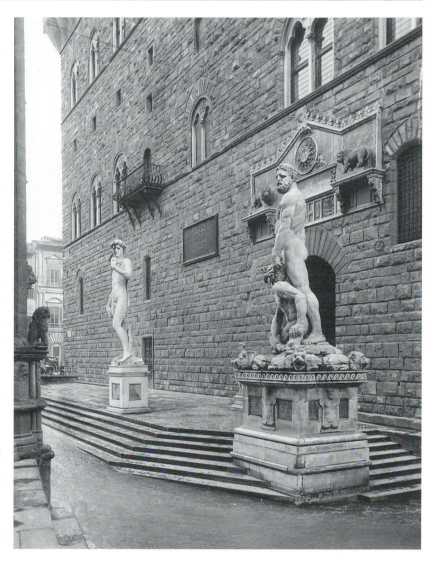

Figure 68. Michelangelo, *David* (copy), 1501–4, and Bandinelli, *Hercules and Cacus*, c. 1525–34, Piazza della Signoria, Florence (Charles Seymour, Jr. Archive)

inside the palazzo and activates their Republican resonances.[52] But unlike the earlier ones Michelangelo's *David* has not already killed Goliath. The choice of depicting David as intensely concentrating in wary anticipation of battle is calculated to communicate his tension and involve the viewer in his upcoming confrontation, just as with Donatello's *St. George* (Fig. 64). Michelangelo's statue was installed so that the *David*'s twisting head faces Rome, suggesting perhaps that the next threat to the Republic will come from Medici partisans grouped there. But because the encounter with Goliath is not explicitly depicted, the viewer can define the statue in personal terms and thus become even more engaged by David's emotions and inspired by his heroic model. In part, Michelangelo's innovative interpretation may be considered his imaginative response to the challenge of public sculpture in the ancient world, which its historians characterized as recording individuals who deserved immortality by their distinction and whose statues were commissioned so that citizens would "have always before their eyes so that they might not only remember but imitate the worthy actions they had done."[53]

Bandinelli's Hercules and Cacus

When the Medici defeated the Republic again in 1512, they made the Republic's ceremonial space a prime arena for rituals that stressed the family's control of the city. The triumphal procession of Pope Leo X (Giovanni de' Medici) into his native Florence paraded through the piazza as did the later wedding corteges of Cosimo I and his two sons.[54] All along the parade routes of these Medici dynastic celebrations, architectural stage sets and sculptures made of papier-mâché and other temporary materials covered the city's real buildings with symbols lauding Medici rule. These public ceremonies and rituals were ephemera. Nevertheless, as anthropologists and political historians have recognized, such pageantry and stage sets made a considerable impression on the citizenry and were important aspects in the Medicean "symbolics of power." For later generations, they are reconstructable through documents, chronicles, and sometimes paintings or prints of the events. The Medici attempted to preserve a historical record of the flattering but complex allegories honoring them by having booklets published, often illustrated with prints, that described each series of decorations.

After the final defeat of the Republic in 1530, the Medici grafted their identity onto that of the Republic by systematically appropriating its symbols. The former town hall became the living quarters of the family and the site of their court. The Loggia dei Lanzi gradually became an outdoor museum for their sculpture collections. Under their aegis, the Uffizi, a second, even grander palace than the town hall, was constructed adjacent to it by Giorgio Vasari between 1560 and 1580 (P/R illus. 8.36). Now the city's foremost museum of painting and ancient sculpture, it was built to house various administrative offices and to centralize Medici control over the guilds of Florence. The piazza's space was extended to the banks of the Arno by the regular porticoed facade which wraps around the Uffizi.

In 1534 Bandinelli completed for Alessandro de' Medici, the member of the family reinstated as ruler of Florence in 1530, a group of *Hercules and Cacus* (Fig. 68). The statue was calculated to stand as a pair to Michelangelo's *David* on the other side of the steps leading into the palace, and by this twinning, to link the former Republican emblem to Medici meaning. The colossal marble block was itself a painful reminder to Republican partisans of the Medicean triumph. Michelangelo, an ardent Republican, had originally been hired by the Republic to carve it. The vituperant reactions of Florentines to Bandinelli's creation, which they covered with insulting epigrams, are no doubt in part evidence of smoldering resentment safely displaced from politics to aesthetics.[55]

Hercules looked straight ahead across the piazza, defiantly confronting its entrance from the Via Por S. Maria, where all civic and religious processions and state visitors entered the piazza. The *Hercules and Cacus* matched the *David* and its base in a number of ways, such as in aspects of the pose and anatomy of Hercules and the shape and decoration of the socle. Its doubling of figures and

widened socle combined with colossal scale to enhance the impact on the viewer of the sculpture's explicit depiction of Hercules' triumph over Cacus, who crouches abjectly below.

Hercules and Cacus was the first nonreligious figural statue installed in the piazza; with it, the Medici appropriated to their public imagery the most important mythological hero of Republican identity. In Florentine myth Hercules had traditionally been considered the city's founder. In the late Middle Ages he appeared on Florentine coinage and in the fourteenth century on public monuments such as the Campanile of the cathedral.

For these reasons, the Medici had made Hercules a target for amalgamation to their family imagery from the fifteenth century on and completed their takeover by commissioning this permanent symbol for the city's prime civic arena.[56] Paintings and sculptures of the hero had been commissioned for the private spaces of their family palace in the fifteenth century,[57] but the most impressive public monument had been Michelangelo's earlier statue of the demigod. Many of the Florentines who watched the unveiling of Bandinelli's sculpture could remember the colossal marble statue of *Hercules*, which, according to some scholars, the young Michelangelo had carved in 1492 in honor of the death of Lorenzo de' Medici, his first patron. It stood in the courtyard of the Strozzi Palace until 1530 when it was sold to the king of France. As part of the ensemble of elaborate temporary decorations made to celebrate the triumphal entry of Leo X, the first pope in the Medici family, into Florence, a colossal pseudo-bronze sculpture of *Hercules* was set up in the Loggia dei Lanzi in 1515.[58] Continuing the paradigm of actual or figurative appropriation of the defeated enemy's emblems that we have traced to the precedent of the *Tyrannicides*, the first public civic monument, Cosimo I later put the ancient semigod on his own official seal and commissioned several cycles of Hercules, including the Camera d'Ercole, in the redecoration of the town hall as the living quarters and center of Medicean government.

The choice of Hercules' murder of the cattle thief Cacus, one of the hero's most rarely represented "labors," is significant. It is the only labor that took place in Rome, and it allowed the city's peaceful settlement, just as the altar that Hercules erected after his victory established religion there. The episode underlines that Hercules was a founder of Rome as well as of Florence. Bandinelli's sculpture is purposefully located along the Vachereccia, or ancient cattle route, in Florence, just as the statue of Hercules erected to commemorate his defeat of Cacus was located in the cattle forum of ancient Rome. Pliny singled out that statue as an exemplar of Roman sculpture, noting that it was called the triumphant Hercules because it was ritually draped during the celebration of Roman victories.[59] A colossal gilded statue of Hercules, probably that described by Pliny, was unearthed at that site during the pontificate of Sixtus IV and was the most spectacular of the sculptures donated by that pope to the Capitoline. It was installed there during the pontificate of Leo X. For these reasons, the commission for Bandinelli's *Hercules and Cacus* in Florence's

civic center seems a direct response to the placement of the famous ancient sculpture in the civic center of Rome.[60] In symbolic language it announces that Florence is the new Rome, that the city has superseded the ancient capital (and its descendant on the Tiber) as a dynamic artistic and political center, and that the Medici family triumphantly controls, and has assumed the symbolic legacy of, Florence.

Probably Alessandro de' Medici intended as well that the traditional meanings of Hercules as an exemplar, particularly of a virtuous ruler, be associated with him and his family. Exemplars like Hercules were supposed to be studied by the prince so that he might learn from their worthy model. The defeated Cacus seems to enact this connotation by looking toward the town hall as though asking the "good prince" for clemency. The moralizing literature about the ideal education for a ruler popular in the late Middle Ages and Renaissance made the connection, and the extremely popular emblembook by Alciati, first published in 1531, included it.[61] By erecting a statue of Hercules in the piazza, Alessandro promoted the message that his subjects should consider him a good prince. But many of them read it instead as a symbol of Medici domination, as is proven by the vituperative poems attached to the statue. That they were correct is confirmed by Alessandro's imprisonment of their authors.[62]

A second stage in the Medici family's continuing rivalry with the reestablishment of the Capitoline as the symbolic center of Rome is seen in the plan launched in the mid-1540s for Michelangelo to create an equestrian statue for the Piazza della Signoria. Cosimo I also solicited the artist's advice about plans to make the piazza's dimensions more regular and hence more stately. These initiatives were taken just after the decision in 1538 that Michelangelo move the equestrian statue of Marcus Aurelius to the Capitoline's empty piazza, carve a new base for it, and rebuild the piazza and surrounding buildings in a grand, architecturally unified manner (P/R illus. 8.47 and 8.48).[63] The competition with the magnificent refurbishing of Rome's center was spurred by Cosimo's decision to reestablish Florence's town hall as the center of Medicean government and the official residence of the family. Shortly after he took over from the murdered Alessandro in 1537, he elected to transfer his court from the family residence on the Via Larga into the traditional governmental center of Florence at the Piazza della Signoria.

Most of the rest of the sculptures for the Piazza della Signoria were commissioned during the long reign of Cosimo I (1537–74). Not surprisingly, there were no further ideas for sculptures of Old Testament subjects; the identification of Florence as the new Jerusalem had become a vital theme of the Republic through the sermons of Savonarola in the 1490s. The almost evangelical atmosphere of the short-lived restored Republic of 1527–30, which elaborated the imagery of the earlier Republic of 1494–1512, made the new Jerusalem analogy still too intensely Republican for its conquerors to try to subsume it. Instead, most of the rest of the sculptures executed for the piazza conveyed their political messages through themes drawn from Greco-Roman mythology. In this way

they continued the other, less inflammatory, theme of the Republic, Florence as the new Rome.

Cellini's Perseus and Medusa

Cellini's *Perseus and Medusa* (Fig. 69), executed between 1545 and 1554, is the first bronze group actually commissioned for the Piazza della Signoria, thus conforming to Pliny's description of the Romans' preference for bronze statues of their gods.[64] Like the piazza itself and all the sculptures animating it, the *Perseus* is an emblem of triumph. Perseus holds up by her snaky hair the decapitated head of Medusa, the horrifying gorgon whose gaze turned onlookers into stone. The hero's ingenuity – avoiding her petrifying gaze by using his metal shield to reflect her image – allowed him to vanquish what had seemed an invincible threat to civilization.

From the beginning, the statue was intended for its present site in the easternmost bay of the Loggia dei Lanzi as a counterpart for the *Judith and Holofernes* (Fig. 65), which then stood in the westernmost bay. Its conscious imitation of the *Judith* in material, composition, and theme made it a corrective to the earlier statue. The reversal of the sexes of the murderer and victim rectified what had been considered the *Judith*'s evil augur, even during the Republic. When the citizens' committee met in 1504 to decide where to erect the *David*, one member suggested that *David* replace the *Judith*, as the latter had been installed under an evil sign, and "it was not fitting that a woman kill a man."[65]

The Republican associations of the *Judith*, which had been moved to the piazza when the Medici were overthrown in 1494, were countered by the *Perseus*'s thinly veiled allegory of the triumphant Cosimo I. Whereas Judith was chastely dressed and transfixed by the horror of the murder she was committing, Cosimo as Perseus is an idealized heroic nude male warrior who has already slain a monstrous woman and holds her head aloft. The blood dripping from Medusa's head would have reminded onlookers of the notorious event that launched the young Cosimo's political career. He had established the Medici dukedom by defeating the Republicans exiled from Florence at the battle of Montemurlo in 1537. To cement his victory, he had had a number of prisoners decapitated in the Piazza della Signoria.[66]

Perseus and Medusa is the first sculpture in the piazza to have an elaborately decorated base, the height of which approximates that of the statue of Perseus, making the base visually as important as the figure. Elegant bronze statuettes of the various gods who protected Perseus as he undertook his heroic deeds stand in elaborately decorated niches on the four sides of the marble base. Above each, identifying the god, is a poetic inscription composed by the court intellectual Benedetto Varchi. The combination purposefully insists on the divine sanction given Perseus's (read Cosimo's) actions.

For the main side of the base, that facing the piazza, Cellini cast a bronze relief of another of Perseus's heroic deeds, his slaying of the sea monster who threat-

ened the beautiful Andromeda, Perseus's intended bride. The combination of sculptures and inscriptions elaborating the narrative implications of the statue follows a system suggested by the precedent of ancient sculpture;[67] Cellini's *Perseus* is one of the earliest monumental statues in the Renaissance to adhere to that model.

Unlike David and Hercules, Perseus had no history as a symbol of Florence, and this is not another instance of the Medici grafting their identity onto a long-standing symbol of the vanquished Florentine Republic. Nevertheless Perseus's allegorical allusion to Cosimo seems to have been well understood. It was rein-forced by the statue's ceremonial unveiling on the anniversary of the institution of the Medici dukedom.

Cellini's allegory of Cosimo I stands facing the piazza, symbolically warding evil away from Florence,[68] following the model of Ovid's description of Perseus's defeat of Phineas, Andromeda's other suitor, by confronting him with the head of Medusa and turning him to stone. The statue evokes not just the real historical event of Cosimo's bloody triumph at Montemurlo, but more abstract meanings, drawn from political theory and Christianized interpretations of pagan mythology. Like Hercules, Perseus is a symbol of the wise prince, specifically of his establishment of concord in his kingdom. Alciati's emblembook included a print of a prince's sarcophagus, emblazoned with a Medusa's head, to warn that death overtook not just subjects but also the unwise prince who did not keep the peace.[69]

Poems written to honor the statue's installation acknowledge Perseus as a sur-rogate for the duke.[70] One, by Varchi, who provided the verse inscriptions on the statue's base, plays on the Medusa's petrifying powers to another end. It claims that spectators, stupefied by the wondrous artistry of Cellini's statue, turned to stone at the sight of it. Other poems tout Cellini as the equal of the greatest sculptors of Greece and Rome. They intermingle artistic and political identities to claim that Florence is the greatest city because it is the proud site of the *Perseus*.[71] The underlying message is that Florence's prominence is made pos-sible by Cosimo I.

The allegorical link between Perseus and Cosimo I was reinforced in the minds of Florentines by later court celebrations. As part of the temporary deco-rations erected for the wedding of Cosimo's son Francesco de' Medici in 1565, images of the Medusa and Fury (derived from the yelling figure of Phineas in the relief on the statue's socle) were displayed prominently on the doors of the town hall. In the next decade, a seated portrait statue of Cosimo I, which seems to have been carved for the facade of the Uffizi, was converted into a figure of Perseus by adding a dragon.[72] The statue was installed in the Boboli Gardens behind the Pitti Palace, the palace converted into a grand Medici residence on the other side of the Arno (1558–70) once the Medici were sufficiently entrenched in power to leave Florence's symbolic civic center. Thereafter, the historic Palazzo della Signoria became known simply as the Palazzo Vecchio (the old palace).

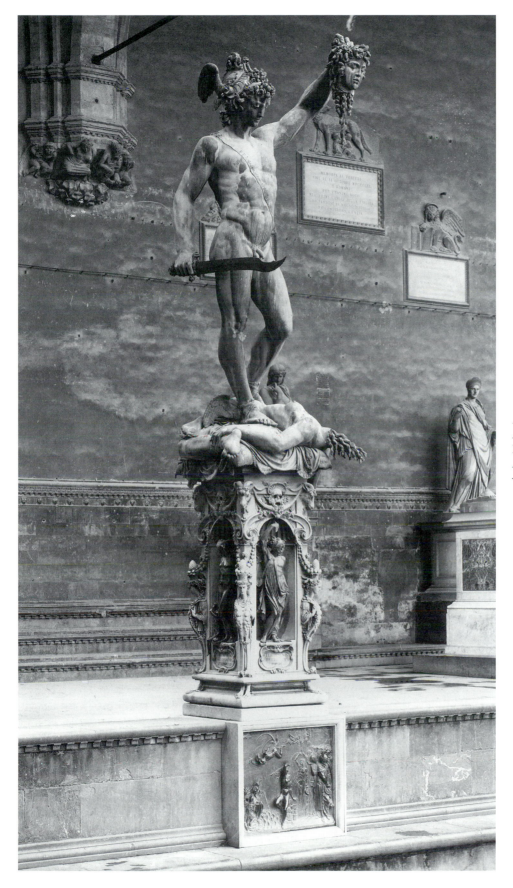

Figure 69. Cellini, *Perseus and Medusa*, Loggia dei Lanzi, Florence, 1545–54 (photo: Alinari/Art Resource, N.Y.)

Fountain of Neptune

The huge Fountain of Neptune by Ammanati (Fig. 70) erected at the north corner of the *ringhiera* between c. 1559 and 1575 enhances the traditional symbolism that fountains convey of beneficent rule by specific allusion to Duke Cosimo's provision of new sources of water for Florence by the construction of an aqueduct to the city. Cosimo is evoked in the guise of Neptune to recall to the citizenry the duke's draining of malarial marshes throughout Tuscany, the territorial empire he conquered for Florence. That enlarged state included the coast, where Cosimo established Livorno as the port of Florence and Tuscany. Hard-won access to the sea gave him the chance to create the first Florentine navy. Cosimo is aggrandized by association with Neptune to advertise and consolidate in the minds of Florentines all these triumphs involving water.[73]

The fountain also commemorates the marriage of Francesco de' Medici to Joanna of Austria in 1565. Their zodiac signs are carved on the wheels of Neptune's chariot. Specific details celebrate this dynastic alliance and its hoped-for progeny. The marine gods balancing on the basin's rim carry shells and coral, symbols of Venus, the goddess of love. A contemporary panegyric about the fountain identifies the female nude on the side of the basin nearest the Loggia dei Lanzi as Doris, a marine god of marriage. She holds up a conch shell as though toasting Francesco's marriage to Joanna. In addition, she links the fountain to Cellini's statue of *Perseus*, which she faces. Doris's only significant role in mythology took place in the story of Perseus and Andromeda and so she seems to be toasting their marriage as well.[74] Thus the Fountain of Neptune honors not only Cosimo but the Medici dynasty.

Rape of the Sabine

In 1582, after Francesco I had succeeded his father as grand duke, he arranged that a colossal marble sculpture by Giambologna of the *Rape of the Sabine* (Fig. 71) be moved into the Loggia dei Lanzi. It replaced the *Judith*, which was transferred away from the piazza side of the loggia to the bay overlooking the recently completed Uffizi. Raffaele Borghini, an associate, recounted that Giambologna had begun the sculpture "without selecting any subject," that he had intended to represent solely "a proud youth seizing a most beautiful girl from a weak old man." According to Borghini, Giambologna was forced to come up with a name for the sculpture when the grand duke Francesco decided that it was so beautiful it should be placed in the loggia! So, just prior to unveiling it the following year (1583), Giambologna cast the bronze narrative relief the *Rape of the Sabines* for the piazza side of the statue's base that "identifies" the straining marble figures.

Its substitution for the *Judith* made Giambologna's three-figure group the new pendant to the *Perseus* (Fig. 69). Borghini tells us that Giambologna at first planned to make their relationship explicit by identifying his group as Perseus's

Figure 70. Ammanati, Fountain of Neptune, Piazza della Signoria, Florence, c. 1559–75. The arrow indicates Doris (photo: Charles Seymour, Jr. Archive)

bride, Andromeda, abducted by Phineas while her aged father tried unsuccessfully to protect her. Finally, Borghini claimed that he persuaded Giambologna that the Rape of the Sabine would be a much more suitable subject.[75] Borghini introduced the story with the phrase, "So solely to prove his excellence in art . . . ," and art historians, following his cue, have read it as evidence that Giambologna began his sculpture interested solely by the technical challenge of carving three nameless figures in a choreographed struggle. The anecdote has become one of the paradigms for considering mannerism as "art for art's sake" and Giambologna's sculpture as the epitome of the style.[76]

Nevertheless, we can better appreciate the sculpture's multiple levels by acknowledging that its generic theme, given the protagonists' interaction, must always have been an abduction, and implicitly a rape.[77] Whatever mythical identity he assumed, the proud youth would have been understood as a symbol for Francesco de' Medici, seizing Florence and its territories, victorious over opponents. Contemporary poems identified the sculpture's meaning in this way and praised its success in adding to the sequence of Florentine political allegories already in the piazza.

Today's viewer may be surprised at the choice of an abduction scene to flatter the grand duke. But we should recall that absolutist political philosophy was

formulated in the sixteenth century by writers like the Florentine Machiavelli, who advanced the theory that princely rulers were above the law. These treatises sometimes articulated the prince's relationship with the state in the gendered terms of his taking possession of her. Such thinking is reflected in decorative programs like those designed by Vasari earlier for the Palazzo Vecchio's interior. As Vasari himself explained in the guide he composed for the Sala di Giove, each of the sexual conquests of Jupiter, king of the gods, corresponded to a particular triumph or attribute of his patron, Duke Cosimo I.[78] Whereas such erotic allegories were acceptable inside the palace, where the duke controlled visitors' access, it was necessary to join sexual triumph to more elevated, selfless motives in the public space of the piazza, where sculpture was viewed by an unselected audience not enjoying Vasari's tutelage. Even the absolute rule of the duke was made easier if viewers were influenced favorably!

Duke Francesco's identification as the male Roman carrying off a Sabine seems a deliberately chosen subject, despite Borghini's claim, because it entails other levels of meaning. The abduction of the Sabine women was above all a political legend that legitimated the foundation of Rome. The Romans, we are told, did not act out of lust: they carried off marriageable Sabine women to marry them, not to rape them. Their goal was to conceive legitimate children who would populate Rome. The legend has a second major point, that this act of violence, recast as justified civic disruption, resulted in the foundation of a stable and law-abiding people. The abducted Sabines intervened to stop the battle when their fathers and brothers came to take them back. They implored all their male relatives to make peace for their sakes and their children's. Their appeal to reason led to their fathers' recognizing their marriages and the peaceable reconciliation of the two kingdoms.[79]

So the decision to make Giambologna's group a *Rape of the Sabine* and install it in the loggia gave public expression to a complex of meanings: Florence, or the Sabine, is again identified as a new Rome, carried off by the Medici grand duke in triumph, and this (foreordained and legitimate) takeover by the duke results in a new and stronger state and the reconciliation of opponents to the benefits of his rule. It further suggests that future generations of Florentines will recognize and be grateful for the transformations that Medici dynastic rule brought to the city. Comparison with the foundation of Rome also implies that Medici domination of the city will result in a Florentine state as long-lived and powerful as the Roman Empire.

Despite these lofty connotations, couching the allegory in terms of sexual conquest was possible comfortably only after Cosimo I's conquest of a large, secure territorial state that included Siena and his elevation to grand duke of Tuscany (1569). The theme had been represented before only in small-scale painting for private commissions and had nothing to do with appropriated imagery of the Florentine Republic or moralizing literature and emblems about princely rule.[80]

The sculpture's bold presentation of the nude Sabine (or Florence) being

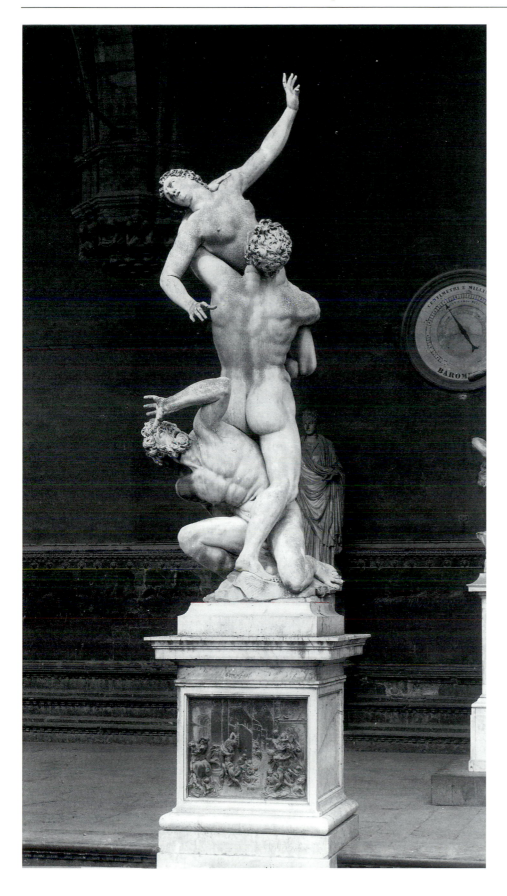

Figure 71. Giambologna, *Rape of the Sabine*, Loggia dei Lanzi, Florence, c. 1581–83 (photo: Charles Seymour, Jr. Archive)

taken as a trophy does relate, however, to other symbols of triumph that the Medici family displayed at the time. They purchased and installed a number of ancient statues in public spaces in Florence in the 1580s and 1590s, including symbolic trophies in the Roman style (cuirasses, helmets, arms) and female prisoners taken as trophies of battle. Two ancient Roman pillars carved with 800 representations of trophies that had been found near the Church of Santa Sabina in Rome were shipped to Florence in 1588 and set up in the Uffizi. A marble depicting a female personification of Victory with a kneeling captive and trophies of arms and armor was purchased by Francesco in 1584 and installed in the Boboli Gardens.[81]

Again, Francesco's interest in this sort of triumphal imagery parallels the installation of ancient sculptures representing trophies of arms and armor on the balustrade of the Capitoline in Rome.[82] These public emblems of victory had a precedent in the more private space of the Palazzo Vecchio. In the 1540s, after the family moved in, Cosimo I commissioned Francesco Salviati to paint a cycle of the Roman general Camillus in the Sala di Udienza. The main scene was full of trophies and captives and was understood as a political allegory equating the spoils and territories won by Cosimo with those of the Roman Empire.[83] The next appearance of the motifs was in temporary decoration. To celebrate the marriage of Francesco into the imperial house of Austria in 1565, more than a dozen triumphal arches, adorned with all sorts of encomiastic imagery honoring the Medici family, were constructed to mark the processional route of the bride to the Palazzo Vecchio. The bride and her entourage proceeded through the arches in a theatrical reenactment of the triumphal processions of the Roman emperors.[84] By the 1580s the Medici domination was sufficiently absolute that the family could proceed to the next stage and install many permanent trophies equating their triumphs with Rome's in the public space of the city.

The construction of the Uffizi (1560–80) created a new zone of triumphal imagery. Cosimo I had intended to install a series of portrait statues of famous Florentines in the niches of its ground-level porticoes, a scheme derived from precedents in the fora of ancient Rome, as Bernardo Davanzati reminded listeners in his funeral oration for Cosimo.[85] Francesco took the plan in a more imperial direction than his father had been willing to do by installing a standing figure of Cosimo as the emperor Augustus (P/R illus. 8.37) over the triumphal arch on the cross-arm at the Arno end of the building. From there the statue of Cosimo seemed to look over and rule the whole piazza.[86] In the 1580s Francesco next commissioned Giambologna to replace this frankly imperial image with a standing portrait of the grand duke, which in a different way was just as imperial an image. After over one hundred fifty years of fierce political conflict, the figure of Cosimo was the first undisguised depiction of a government leader in the piazza's symbolic space. That Cosimo's identity was not veiled in allegory is an indication of the Medici dynasty's absolute control of Florence and disregard of her Republican traditions: the statue was not a representation of the city or its government, but an encomium to the person of the ruler, Cosimo.[87]

Equestrian Statue of Cosimo I

The final sculptural addition to the piazza was the equestrian statue of Cosimo I (Fig. 72), which Ferdinando, his son and Francesco's successor, hired Giambologna to execute (1587–94). The type of monument, a colossal bronze portrait on horseback, had been the exclusive preserve of the Roman emperors in the ancient world and was becoming reassociated with the most powerful rulers of Europe in the sixteenth century.[88] Such a portrait had the effrontery to put Cosimo I, who was only a grand duke, in their ranks.

Although Florentine sculptors had designed almost all the great equestrian statues of the Renaissance, none of them had been for Florence. Donatello's monument to Gattamelata was erected in Padua (Fig. 15), and Verrocchio's to Colleoni in Venice. Leonardo's two monuments, neither of which was completed, were to have been in Milan (P/R illus. 6.69 and 6.72), and Daniele da Volterra, assisted by Michelangelo, had recently designed for Catherine de' Medici an equestrian monument honoring her husband, Henri II, king of France, for Paris. The only equestrian images executed in Florence during the fifteenth and sixteenth centuries were in the much cheaper material of fresco, namely, Uccello's painting of a monument to Sir John Hawkwood (P/R illus. 5.6) and Castagno's of Niccolò Tolentino, both in the Duomo, Florence. The colossal bronze by Giambologna ostentatiously redressed this lack.[89]

Giambologna's sculpture also recalled in the minds of Florentines one equestrian monument that had been destroyed and several notable temporary equestrian monuments made as part of the ephemeral architecture and sculptural decoration of the city for earlier sixteenth-century celebrations, and its impact was enhanced by these resonances. The lost actual monument was that of Mars, the only other bronze equestrian monument ever erected in the public space of Florence.[90] Thus the founder of the Medici dukedom was symbolically linked to the city's legendary founder. Cosimo's permanent colossal bronze must have evoked as well the equestrian monument, made of wood and clay covered with tinfoil, of the Holy Roman Emperor Charles V that had been erected to honor the emperor's triumphal entry into the city in 1536, symbolically associating the Grand Duke Cosimo I with his powerful overlord.[91] It called to mind as well the temporary equestrian statue of Cosimo's father, constructed as part of the decorative apparatus of Cosimo's wedding to Eleanora da Toledo in 1539.[92]

Most of all, the colossal bronze must have reminded Florentines of the most recent simulated bronze monument. Cosimo I riding a rearing horse about twenty feet tall had been a major component of the temporary decorations transforming Florence during his son Francesco's marriage a few decades earlier. Contemporary accounts had interpreted the rearing horse trampling a female-snake hybrid, or emblem of fraud, as an allegory of the victorious Cosimo, the good ruler, and his "Herculean virtue."[93] The statue's location in the Piazza San Apollinare, where criminals of state were executed, reinforced what the writers described as the identification Cosimo had forged between his will and the law of the state.[94]

Giambologna's portrait of Cosimo eschews the drama of the rearing horse for the more stately image of the ruler who is in total control of his walking mount (as he is of his subjects). This feature, and many others, are meant to relate Duke Cosimo to the Roman emperor, then usually thought to be Constantine and now recognized as Marcus Aurelius, whose equestrian monument had been reinstalled on the Capitoline Hill in Rome by Michelangelo (Fig. 16). The equestrian image of Cosimo is a considerably more assertive homage to the person of the ruler than his portrait statue on the Uffizi facade, not only because of the associations of the equestrian portrait but also because it is at ground level, colossal, freestanding, and a much more recognizable likeness of the grand duke.

The base, imitated from that constructed by Michelangelo for the Marcus Aurelius, is ornamented with three bronze reliefs commemorating critical events in Cosimo I's reign. The image of Cosimo I as absolute ruler is extended by these permanent markers of his consolidation of power. In addition, a prominent, lengthy inscription across the front of the statue's socle eulogizes the memory of the grand duke. These two devices of bronze narrative reliefs representing specific events and a literary description paying homage to the ruler are a logical expansion of the cult of his person and are new features among public monuments of the day; they are possible only in a city under the ruler's absolute control. This was the first monument in which the Medici dared to follow Pliny's account of how the memories of men in the ancient world were made immortal by inscriptions on the bases of their statues.[95] Contemporary monarchs all over Europe took note of Giambologna's design and rushed to hire him and the sculptors he trained to convey their absolute power and majesty in equestrian portraits.

Conclusion

The statuary chosen by the changing sequence of Florentine governments to populate the public space of the city, especially the Piazza della Signoria, remains as a permanent record of their different definitions of the city's image. The constant visibility, universally understood imagery, imposing physical presence, and durable materials of sculpture made it the most effective vehicle to convey the images that visualized and shaped Florentine identity in the minds of its citizens and visitors.

Assembled in the piazza are some of the most important works of art created in Italy during the fifteenth and sixteenth centuries: Donatello's *Judith and Holofernes*, Michelangelo's *David,* Bandinelli's *Hercules and Cacus*, Cellini's *Perseus and Medusa*, Ammanati's Fountain of Neptune, and Giambologna's *Rape of the Sabine* and Equestrian Monument of Cosimo I.[96] We encounter them today as a group, but that group existed only as of the 1590s. For more than a century the *Marzocco* was alone on the *ringhiera*. The reinstated Republic's decision of 1495 to make the *Judith and Holofernes* a public emblem of its triumph over the Medici faction is the first such use of contemporary sculpture in the postantique world. It was inspired by the descriptions of public monuments in the ancient world and the few extant examples. These precedents had already influenced those

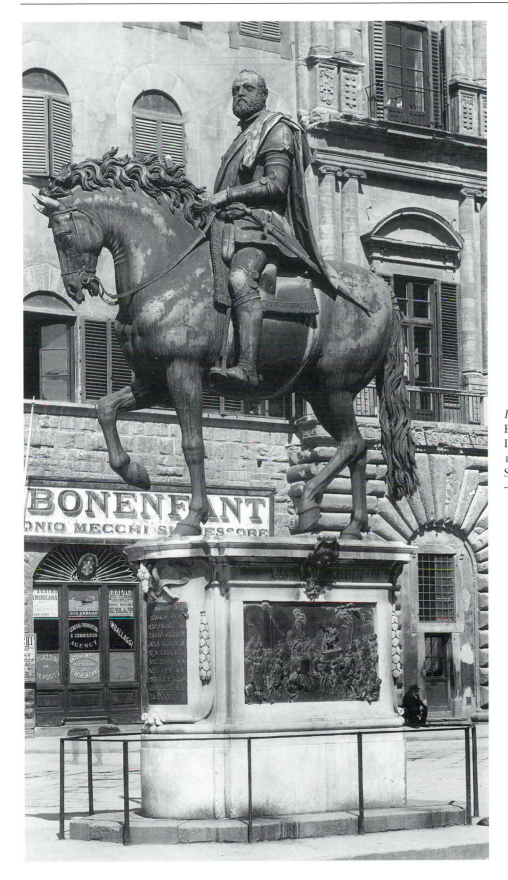

Figure 72. Giambologna, Equestrian Monument of Cosimo I, Piazza della Signoria, Florence, 1587–94 (photo: Charles Seymour, Jr. Archive)

technical and expressive developments in fifteenth-century Italian sculpture that made the medium effective in conveying universally understood meanings.

The redecorations of the Piazza della Signoria were also stimulated by the contemporary refurbishing of Rome's governmental center. The installation of ancient sculptures on the Capitoline Hill followed a more traditional pattern of displaying artifacts from another culture or considerably earlier period as emblems of triumph. The difference is that in sixteenth-century Florence, Republic and Medici alike commissioned for display in the prime civic space almost a dozen different large-scale sculptures that proclaimed a partisan political message, usually couched in allegory but understandable to all but the most ignorant citizen. These newly created emblems of triumph were conveyed in imagery that went far beyond the limited impact of animal symbols or figures of patron saints that had served to visualize civic identity in earlier periods.

And the political message became bolder during the sixteenth century. The first sculptures in the piazza, like the *Judith* and the *David,* were biblical figures whose actions galvanized attention and could be interpreted allegorically as analogous to various aspects of Florentine identity. Religious themes gradually yielded to secular subjects drawn from Greco-Roman mythology and legend. This idea was the Republic's, but the Medici family seized on it after its restoration to power in 1530.[97] Finally, under the autocratic rule of Cosimo's sons, Francesco and Ferdinando de' Medici, indirect allusion was replaced by emphatic eulogy in undisguised portraiture to the person of their father, the deceased grand duke who had reestablished the dynasty.

The impact of the sculptures was enhanced in the civic consciousness by the cumulative recollection of earlier ceremonies decorated by temporary monuments the sculptures resembled, by rituals in which they played a role, and by political and personal events that took place around them over time. Furthermore, the installation of new statues in the piazza created a dialogue with the sculptures already there that purposefully altered or nuanced their range of meanings.

The commissions for the outdoor space of Renaissance Florence, particularly for the Piazza della Signoria, developed and exploited the possibilities of public sculpture in a fashion unique in medieval or Renaissance Italy. This essay has reconstructed some of the ways in which these sculptures projected an idealized image of the prevailing government and has suggested that the rest of Europe and, ultimately, *Liberty* in New York Harbor, followed with alacrity this exciting Florentine innovation.

Notes

1. On the history of the Statue of Liberty, one of the most important public sculptures of the nineteenth century, see M. Trachtenberg, *The Statue of Liberty,* 2d ed. (New York, 1986).

2. My approach has been influenced by the work of political historians such as D. Kertzer, *Ritual, Politics, and Power* (New Haven, 1988), and of the historians whose essays are collected in *Rites of Power: Symbolism, Ritual, and Politics since the Middle Ages,* ed. S. Wilentz (Philadelphia, 1985), and D. Cannadine and S. Price, eds., *Rituals of Royalty:*

Power and Ceremonial in Traditional Societies (Cambridge, 1987). I thank Thomas DaCosta Kaufmann for bringing these references to my attention.

Their research in part developed from the methodology of cultural anthropologists, particularly Clifford Geertz. In essays like "Centers, Kings, and Charisma: Reflections on the Symbolics of Power" (*Culture and Its Creators: Essays in Honor of E. Shils*, ed. J. Ben-David and T. N. Clark [Chicago and London, 1977]), and in his collected writings, *The Interpretation of Cultures* (New York, 1973), Geertz explored the reciprocal means by which cultural identity is determined and influences human behavior. Political historians have begun to explore what Geertz described as the "master fictions," or cultural frames, by which all polities are ordered and governed and from which their political rhetoric is invented and perpetuated.

Political historians and cultural anthropologists alike have focused on ritual's role in the expression of cultural identity. R. C. Trexler, *Public Life in Renaissance Florence* (New York, 1980), was the first historian to focus attention on the role rituals played in Florence during the Renaissance. His ground-breaking research has been extremely influential. So far, only R. Starn and L. Partridge, *Arts of Power: Three Halls of State in Italy, 1300–1600* (Berkeley, 1992), have applied this approach to Florentine works of art. Their stimulating discussion includes an analysis of the painting cycles commissioned by the Medici for the Palazzo della Signoria in the sixteenth century (pp. 155–259). To my knowledge, the role of Italian Renaissance public sculpture in creating cultural identity has been overlooked even though it was a turning point in the use of art for such purposes. However, J. Shearman, *Only Connect . . . Art and the Spectator in the Italian Renaissance*, Bollingen Series XXXV, 37 (Princeton, 1992), considered an aspect of what this essay addresses in his important evaluation of audience response to Renaissance works of art, including some of the sculptures in the Piazza della Signoria.

3. Sometimes this type of sculptural embellishment was applied to secular architecture as well. A representative example is the Piazza di San Marco in Venice, where sculpture is found on the facades of the state church of San Marco; the adjacent Palazzo Ducale, the center of government; and the Loggetta, another government monument. For photographs of these buildings, see P/R illus. 3.21, 5.63, 5.64, frontispiece (pp. 374–5) and 8.2. For more photographs and discussion, see M. Muraro and A. Grabar, *Treasures of Venice* (Geneva, 1963), 20–38, 77–110, and 160–6.

4. On the extensive relief sculpture of the Fontana Maggiore and its complex symbolism, see J. Pope-Hennessy, *Italian Gothic Sculpture: An Introduction to Italian Sculpture*, I, 3d ed.

(New York, 1985), 6–7, 169–74, 274. On the Fonte Gaia, see A. Coffin Hanson, *Jacopo della Quercia's Fonte Gaia in Siena* (Oxford, 1965), and J. Beck, *Jacopo della Quercia* (New York, 1991), I, 81–94, II, 161–8.

The Fonte Gaia, now sadly ruined and replaced by a copy in Siena's main square, originally had a standing statue atop each of its ends, one a full-sized figure of the mother of Siena's legendary founders, Romulus and Remus, carrying the young babies, and the other their foster mother. Both groups of women carrying babies repeat a standard imagery of charity and may symbolize the government's beneficence in that way as well, as Beck argues. Although these statues were freestanding only in a limited sense, they are significant precursors to the development of independent sculpture in Florence.

5. The fundamental study of this statue type is by W. Haftmann, *Das italienisches Saülenmonument* (Leipzig and Berlin, 1939), who traced their origin in the column statues of gods, emperors, and heroes in ancient Rome. Haftmann also charted their reintroduction in the Middle Ages and Renaissance.

6. See the discussion of this statue and its influence on later equestrian monuments in the essay by H. W. Janson in this volume.

7. On the Baptistry, see A. Paolucci, *Il Battistero di S. Giovanni a Firenze* (Modena, 1994), and on the statue of Mars, see L. Gatti, "Il mito di Marte a Firenze e 'la pietra scema'; memorie riti e ascendenze," *Rinascimento* XXXV (1995): 201–30.

8. See D. Wilkins, "Donatello's Lost 'Dovizia' for the Mercato Vecchio: Wealth and Charity as Florentine Civic Virtues," *Art Bulletin* LXV, no. 3 (September 1983): 401–23. The original replacement statue by Foggini is today displayed in an office of the Casa del Risparmio, Florence.

9. See *ibid.* and S. Blake Wilk [McHam], "Donatello's *Dovizia* as an Image of Florentine Political Propaganda," *Artibus et Historiae*, XIV (1986): 9–28.

10. The four Evangelist sculptures (P/R illus. 4.33, 4.34, and 4.35), commissioned to fill niches on the facade of the cathedral in the first decade of the fifteenth century, also play a role in this development; see Pope-Hennessy, *Italian Gothic Sculpture*, 43–4, and *Italian Renaissance Sculpture: An Introduction to Italian Sculpture*, II, 3d rev. ed. (New York, 1985), 5–6, 250–1, 348.

11. F. Hartt, "Thoughts on the Statue and the Niche," *Art Studies for an Editor: Twenty-Five Essays in Memory of Milton S. Fox*, ed. F. Hartt (New York, 1975), 99–116, perceptively recognized the new technical and expressive features of the statues at Orsanmichele and related them to what he deemed the Republic's response to the threat of Milanese attack.

12. The photograph was taken before the transfer of the orig-

inal marble sculpture indoors earlier in this century to prevent its further deterioration. Donatello's statue is now displayed in the Museo Nazionale del Bargello, and a copy, curiously in bronze rather than in marble, replaces it in the niche on Orsanmichele. The long-standing plan to replace all the original sculptures on the exterior of Orsanmichele with copies and to transfer the originals into an exhibition space on the building's upper floors was recently inaugurated. *St. Mark* and Verrocchio's *Christ and the Doubting Thomas* are installed in the museum and replaced by copies outside. See Verrocchio's *Christ and St. Thomas: A Masterpiece of Sculpture from Renaissance Florence*, ed. L. Dolcini (New York, 1992), for essays about the sculpture's condition and cleaning. Other sculptures like Ghiberti's *St. John the Baptist* have been moved indoors but, as of early 1997, not been replaced by copies.

Many controversial issues surround the practice of replacing original sculptures with copies. On the one hand, it is necessary. Despite the durable properties of stone and bronze, surface staining and deterioration even of these materials are marked only a few years after their restoration. Cleaning at frequent intervals is costly. Florence has hundreds of culturally important statues and a very inadequate budget for restoration. Then, too, irreversible damage to the sculptures is inevitable over time. For these reasons, most authorities agree that the original sculptures should be removed from outdoor locations and put in the protected environments of museums.

But the production of high-quality copies is also very expensive and the original sculptures are emblems of a city. Many citizens and visitors are enraged by the idea of the original sculpture not being in its expected site, although most are mollified if the copy is of sufficient artistry to convey the impact of the original sculpture. Decisions such as changing the material of the original sculpture, as in the substitution of a bronze copy of *St. George* for the original marble by Donatello, are hard to justify because they profoundly alter the visual impression of Orsanmichele.

13. F. Bocchi, *Eccellenza della statua del San Giorgio di Donatello . . .* (Florence, 1584).

14. The parade was photographed by Arnold von Borsi; a print is in the Kunsthistorisches Institut's files (#124520).

15. The most recent addition to the vast bibliography concerning the sculpture summarizes the previous bibliography and arguments about it. See F. Caglioti, "Donatello, i Medici e Gentile de' Becchi: Un po' d'ordine intorno alla 'Giuditta' (e al 'David') di Via Larga. III," *Prospettiva* LXXX (October 1995): 15–41. His research enhances the authoritative comprehensive account in H. W. Janson, *The Sculpture of Donatello*, 2d ed. (Princeton, 1979), 77–86.

16. Donatello's early marble *David* (P/R illus. 4.32) had been moved to the interior of the town hall in 1416; see Janson,

Donatello, 3–7. Its interpretation as a symbol of the Republic, victorious through the grace of God, was intensified by the transfer of the bronze *David,* a former Medici possession, into the palace's courtyard.

17. Most of these sculptures have been studied within the context of their sculptors' careers only. This pattern of scholarship, and the complicated history of many of the sculptures, created for another site or replacing an earlier sculpture, have diverted historians from consideration of the complex as a whole. Very few studies address more than one of the sculptures. The major exceptions are the excellent analyses by M. A. A. Fader, V. Bush, and K. Weil-Garris. Fader's *Sculpture in the Piazza della Signoria as Emblem of the Florentine Republic* (New York, 1977) examines the sculptures commissioned for the piazza by the Republic from the late fourteenth through early sixteenth centuries. V. Bush's *Colossal Sculpture of the Cinquecento* (New York, 1976), which is the first study to recognize the importance of the piazza's sculptures for their deliberate revival of the scale of famous ancient statues, evaluates these sculptures and other contemporary colossi in light of that precedent. Weil-Garris's "On Pedestals: Michelangelo's *David*, Bandinelli's *Hercules and Cacus*, and the Sculpture of the Piazza della Signoria," *Römisches Jahrbuch für Kunstgeschichte* XX (1983): 377–415, discusses in detail Michelangelo's and Bandinelli's sculptures and their socles and original installation. She contributes as well many important new observations about the other sculptures.

18. The building was first called the Palazzo dei Priori because the priors met and lived there; this name was gradually replaced by the Palazzo della Signoria, which referred to the priors and gonfalonier of justice together, or the Signoria. The name most commonly used today, the Palazzo Vecchio or "Old Palace," originated in the sixteenth century when the Medici family moved into their newly built palace, the Palazzo Pitti, on the other side of the Arno. On the palazzo, see G. Lensi Orlandi, *Il Palazzo Vecchio di Firenze* (Florence, 1977), E. Allegri and A. Cecchi, *Il Palazzo Vecchio e i Medici* (Florence, 1980), and N. Rubinstein, *The Palazzo Vecchio, 1298–1532: Government, Architecture, and Imagery in the Civic Palace of the Florentine Republic* (Oxford, 1995).

19. The significance of the rituals that took place on the *ringhiera* is developed in Trexler, *Public Life*, 49–50, 258–9, 315–23, 356–8, 485–7, and 522–30.

20. The fundamental study on the loggia is by K. Frey, *Die Loggia dei Lanzi zu Florenz* (Berlin, 1885). F. Vossilla, *La Loggia della Signoria: Una galleria di scultura* (Florence, 1995), complements it by focusing on the history of the sculpture displayed within the loggia and on its architecture.

21. Matteo Palmieri described such a ritual in 1432: "Since the plebs was burdened with a great scarcity of food and the imminent dangers of war, it was decided to placate God

through supplications. Therefore all religious [persons] were ordered to process through the city for ten days and to intercede for the salvation of the city . . . And when finally the *popolo* had . . . returned to the Piazza dei Signori, it was such a multitude that every space was densely packed, so that many children and women were breathless from the density and could not stand erect." (Quoted from Trexler, *Public Life*, 357–8.)

22. Above the portals of the town hall and elsewhere on the facade were carved reliefs of lions suggesting the *Marzocco* or lion symbol of the city; see Rubinstein, *Palazzo Vecchio*, 17–18. The Loggia dei Lanzi has small-scale versions of them at the bases on its columns (see Fig. 68), as well as seven large quartrefoil reliefs of seated personifications of virtues (P/R illus. 3.37); on the latter, see Pope-Hennessy, *Italian Gothic Sculpture*, 197.

23. On this myth making, see W. Hammer, "The New or Second Rome in the Middle Ages," *Speculum* XIX (1944): 50–62, J. K. Hyde, "Medieval Descriptions of Cities," *Bulletin of the John Rylands Library, Manchester*, XLVIII (1966): 308–40, and C. Frugoni, *A Distant City: Images of Urban Experience in the Medieval World* (Princeton, 1991).

24. For an analysis of the development of these themes in early Florentine chronicles, such as those by Giovanni Villani and Goro Dati, see C. Davis, "Topographical and Historical Propaganda in Early Florentine Chronicles and in Villani," *Medioevo e Rinascimento* (1988): 33–51, and L. Green, *Chronicle into History: An Essay on the Interpretation of History in Florentine 14th Century Chronicles* (Cambridge, 1972), 136–43.

25. Vitruvius explained that because gladiatorial shows were held in the fora of Italian cities, the shape of Italian fora did not follow the regular square form of squares in ancient Greece (*De architectura*, Book V, Ch. 1). The treatise is translated as *The Ten Books on Architecture* and available in a convenient paperback edition translated by M. H. Morgan (New York, 1960).

26. *Cronica di Giovanni Villani a Miglior Lezione Ridotta . . .* , ed. F. Dragomanni, 4 vols. (Florence, 1844–45), Bk. VIII, ch. 26.

27. Vitruvius, *De architectura*, Book V, ch. 2.

28. M. Trachtenberg, "Scénographie urbaine et identité civique: Réflexion sur la Florence au Trecento," *Revue de l'Art* CII (1993): 16.

29. The history of the *Marzocco* sculptures in the Piazza della Signoria is summarized by Janson, *Donatello*, 41–3, where the Donatello version of the *Marzocco* is illustrated. Donatello's sculpture has been moved indoors to the Museo Nazionale del Bargello; a copy replaces it in front of the Palazzo Vecchio.

30. Savonarola, the ascetic reactionary of the late fifteenth century, usually eschewed any non-Christian references. For the sermon, see Savonarola, *Prediche italiane ai fiorentini*,

III.2, Quaresimale del 1496, ed. R. Palmarocchi (Florence, 1886–8), Sermon 31 (18 March 1496).

31. On the Palazzo Medici, see *Il Palazzo Medici Riccardi di Firenze*, ed. G. Cherubini and G. Fanelli (Florence, 1990).

32. See Rubinstein, *Palazzo*, 40–6, 70–8.

33. Pliny's descriptions of Greek and Roman art from his *Natural History*, finished by A.D. 77, are collected in *The Elder Pliny's Chapters on the History of Art*, trans. K. Jex-Blake and ed. E. Sellers (London and New York, 1896; reprint, Chicago, 1968). His account of the origin of public statuary gives a clear idea of its popularity in the ancient world: "The Athenians were, I believe, introducing a new custom when they set up statues at the public expense in honour of Harmodios and Aristogeiton, who killed the tyrants. This occurred in the very year in which the kings were expelled from Rome. A refined ambition led to the universal adoption of the custom, and statues began to adorn the public places of every town . . . " (14–15). Vitruvius, *De architectura*, the only comprehensive treatise on architecture to survive from the Greco-Roman world, discusses civic architecture and decoration in Book V. Both authors were known throughout the Middle Ages and Renaissance.

34. For example, Pliny described why statues were made: "The ancients did not make any statues of individuals unless they deserved immortality by some distinction . . . the memories of men were immortalized, and their honors were no longer merely graven on their tombstones, but handed down for posterity to read on the pedestals of statues" (Jex-Blake and Sellers, *The Elder Pliny's Chapters*, 14–15).

Leon Battista Alberti, *De re aedificatoria*, Book VII, ii (*Ten Books on Architecture*, trans. James Leoni, 2d reprint ed. [London, 1955], 159), wrote: "The use of statues was the most excellent of all, for they will ornament sacred and profane and public and private buildings, and preserve a wonderful memory of men and actions." For an excellent analysis of Alberti's arguments about public sculpture, see J. B. Riess, "The Civic View of Sculpture in Alberti's *De re aedificatoria*," *Renaissance Quarterly* XXXXII (1979): 1–17. See also Lorenzo Ghiberti's *Commentaries*, in J. von Schlosser, *Lorenzo Ghibertis Denkwürdigkeiten*, 2 vols. (Berlin, 1912), I, 8–11; Pomponius Gauricus, *De Sculptura*, trans. and ed. A. Chastel and R. Klein (Geneva and Paris, 1969), 149.

35. The relevant portion of Bernardo Davanzati's speech follows: "Volendo poi, come tenero di essa Giustizia amadore . . . fece quella gran fabbrica de' magistrati, l'anestò al Palagio suo, e voleva nelle nicchie di que' pilastri metter le statue de' cittadini illustri, e quasi in nuova Ceramico Ateniense e Foro Romano, magnificare e con generosa, e nobil dirittura distribuire a suoi autori la gloria della cittadinanza antica." (Wishing therefore, as an indi-

cation of his love of Justice itself . . . he had constructed that large building of the magistrates as an annex to his own palace, and he wanted to place in its niches statues of famous citizens, as in the new Athenian Agora or the Roman Forum, in order to aggrandize, and with a generous and noble rectitude, confer upon [Florentine] heroes the glory granted famous men by the populace of the ancient world.) (Quoted in K. Forster, "Metaphors of Rule: Political Ideology and History in the Portraits of Cosimo I de' Medici," *Mitteilungen des Kunsthistorischen Institutes in Florenz* XV (1971): 86, n. 72.)

36. On these themes, see Jex-Blake and Sellers, *The Elder Pliny's Chapters*, 14–15, 22–7, 30–3, and Plutarch, *Moralia*, trans. W. W. Goodwin (Boston, 1871), 496.

37. Alberti, *De re aedificatoria*, Book VII, ii; Book VIII, i, iv, vi, offers the fullest treatment, but see also the sculptor Lorenzo Ghiberti's comments about how lifelike monuments heroically presented and in durable materials in public places inspired the people (Schlosser, *Denkwürdigkeiten*, I, 8–11; Gauricus, *De Sculptura*, 149; and G. Vasari, *The Lives of the Most Eminent Painters, Sculptors, and Architects*, trans. G. de Vere [London, 1912–15], III, 182–3) on statues of great men with inscriptions honoring their deeds placed in public spaces to inspire posterity.

38. The Latin on the pedestal is abbreviated as: "Exemplum Sal Pub Cives Pos MCCCCXCV." The inscription, while the sculpture was in the garden of the Medici Palace, had read: "Salus Publica. Petrus Medices Cos. Fi. libertati simul et fortitudini hanc mulieris statuam quo cives invicto constantique animo ad rem pub. redderent dedicavit" (Piero Son of Cosimo Medici has dedicated this statue of this woman to that liberty and fortitude bestowed on the republic by the invincible and constant spirit of its citizens).

The repetition of "Salus Publica" and the change from "Petrus Medices Cos. Fi." to "Cives" make clear that the citizens themselves had the statue reinstalled in the piazza. The crisp brevity of the second inscription emphasizes its message that the citizens of the Republic work on their own behalf and rejects the association that Piero had claimed with the Republic.

The effaced inscription that had been on the pedestal while the *Judith* was in the Medici Palace garden is recorded in contemporary sources, for which see Janson, *Donatello*, 198–205, and the recent articles by F. Caglioti, "Donatello, i Medici e Gentile de' Becchi: Un po' d'ordine intorno alla 'Giuditta' (e al 'David') di Via Larga. I," *Prospettiva* LXXV/VI (July–October 1994): 14–49, and "Donatello, i Medici e Gentile de' Becchi: Un po' d'ordine intorno alla 'Giuditta' (e al 'David') di Via Larga. II," *Prospettiva* LXXVIII (April 1995): 22–55.

39. This is the most explicit instance of how the semiotics of a sculpture are completely altered by its transfer to a new location with another set of symbolic associations where it

addresses a different audience. The recut inscription in abbreviated Latin changing the dedication makes this explicit but is secondary to the impact of these factors, which could be understood by everyone.

40. See n. 33.

41. Schlosser, *Denkwürdigkeiten*, 11, and Alberti, *De re aedificatoria*, Book VII, ch. xvi.

42. For a succinct account of these statues and their legacy (with bibliography), see S. P. Morris, *Daidalos and the Origins of Greek Art* (Princeton, 1992), 297–308, 349–51. More detailed analysis is found in S. Brunnsåker, *The Tyrant-Slayers of Kritios and Nesiotes* (Lund, 1955).

43. T. Buddensieg, "Die Statuenstiftung Sixtus IV. im Jahre 1471," *Römisches Jahrbuch für Kunstgeschichte* XX (1983): 34–73, and E. Parlato and A. Cavallero, *Da Pisanello alla nascità dei Musei Capitolini* (Milan, c. 1988).

44. Donald Weinstein first defined this patriotic rhetoric in Florentine writings in his ground-breaking essay, "The Myth of Florence," in *Florentine Studies: Politics and Society in Renaissance Florence*, ed. N. Rubinstein (London, 1968), 15–44, and extended its implications in *Savonarola and Florence* (Princeton, 1970), esp. 27–66, 145–7, 309–12.

45. Weinstein, *Savonarola*, esp. 27–65 and 156–84.

46. An aborted project by Michelangelo for a group of Samson and the Philistines would have buttressed this connection between Florence and Jerusalem. On this commission, see C. de Tolnay, *Michelangelo, III, The Medici Chapel*, 2d ed. (Princeton, 1970), 98–104.

47. In the late nineteenth century a copy replaced Michelangelo's *David* in front of the Palazzo Vecchio. The original was moved into the Accademia, another of the city's museums. There is still a controversy about the intended site of the *David* – atop one of the Duomo's exterior buttresses or in front of the Palazzo Vecchio. For these arguments, see C. Seymour, Jr., *David: A Search for Identity* (Pittsburgh, 1967), and Weil-Garris, "Pedestals," 383–4. On the history of David as a symbol associated with Florence, see Seymour, *David*, and L. D. Ettlinger, "Hercules Florentinus," *Mitteilungen des Kunsthistorischen Institutes in Florenz* XVI (1972): 119–42.

48. For the historical circumstances of the commission and its artistic importance, see Seymour, *David*.

49. See the summary of ancient authors' accounts of colossi and the influence of the precedent in the Renaissance in Bush, *Colossal Sculpture*.

50. L. Landucci, *A Florentine Diary from 1450 to 1516 . . .*, I. del Badia, ed. (London and New York, 1927), 213–14: entry for 14 May 1504: "It went very slowly being bound in an erect position and suspended so that it did not touch the ground with its feet. It took four days to reach the piazza . . . moved by more than forty men. Beneath it fourteen greased beams changed from hand to hand. It took until 8 July to place it on the *ringhiera* where the *Judith* had been."

Landucci also describes the powerful reaction the *David* stirred in the crowds of onlookers, some of whom threw rocks at it. He does not opine as to their motives; we can only speculate that the rock throwers may have been members of the Medici faction or followers of the dead Savonarola (who had railed against pagan-looking images), or they may have been simple folk frightened by the statue's magical realism.

51. Weil-Garris, "Pedestals," 381–93, carefully reconstructs the *ringhiera* and analyzes perceptively the effect it and the base of the statue made on the viewer's appreciation of the statue.

52. In addition to Donatello's marble and bronze figures, Verrocchio's bronze of David standing on the decapitated head of Goliath had been moved there in 1476; see the essay by John Paoletti in this volume.

53. Plutarch, *Moralia*, 496.

54. For a description of the triumphal entry of Leo X and the stage sets of colossal statuary and full-scale architectural facades erected along the parade route, including a giant "bronze" *Hercules* in the Loggia dei Lanzi, see Landucci, *A Florentine Diary*, 278–85, and the analysis by J. Shearman, "Entrata of Leo X, 1515," *Journal of the Warburg and Courtauld Institutes* XXXVIII (1975): 136–54.

55. See G. Vasari, *Vita de Baccio Bandinelli scultore fiorentino*, ed. D. Heikamp (Milan, 1964), and D. Heikamp, "Poesie in vituperio del Bandinelli," *Paragone* CLXXV (1964): 59–68. On contemporary reactions in verse to the statues in the piazza, particularly in relation to their models in Greco-Roman epigrams, see Shearman, *Only Connect*, 50–8.

56. See Ettlinger, "Hercules Florentinus," 119–42.

57. On the coded messages of Medici private commissions, see John Paoletti's essay in this volume, which deals with a group of images of Hercules; on the small bronze *Hercules and Antaeus* by Pollaiuolo, see also the essay by Joy Kenseth.

58. J. Cox-Rearick, *Dynasty and Destiny in Medici Art: Pontormo, Leo X, and the Two Cosimos* (Princeton, 1984), 146–53, and above, n. 54. Alessandro de' Medici had also commissioned a medal of himself with the image of Hercules concluding his labors on its reverse, establishing another correlation between the family and the hero. See J. Pope-Hennessy, *Cellini* (New York, 1985), 168. On the *Hercules* by Michelangelo, see now J. Cox-Rearick, *The Collections of Francis I: Royal Treasures* (Antwerp, 1995), 302–13.

59. Jex-Blake and Sellers, *The Elder Pliny's Chapters*, 26–7. See Weil-Garris, "Pedestals," 393–407, for a thorough analysis of the statue and its base.

60. On the history of the Roman sculpture of *Hercules*, now in the Conservatori Museum, Rome, see P. P. Bober and R. O. Rubinstein, *Renaissance Artists and Antique Sculpture: A Handbook of Sources* (New York, London, and Oxford, 1986), 164–5, cat. no. 129.

61. See V. W. Callahan, "The Mirror of Princes: Erasmian Echoes in Alciati's *Emblematum Liber*," *Acta Conventus Neo-Latini Amstelodamensis*, Proceedings of the Second International Congress of Neo-Latin Studies, August 1973 (Munich, 1979), 183–96, and E. Verheyen, "Alciato's Hercules Emblem (no. 138) and Related Scenes: Questions of Interpretation," *Andrea Alciato and the Emblem Tradition: Essays in Honor of Virginia Woods Callahan*, ed. P. M. Daly, AMS Studies in the Emblem no. 4 (1988), 47–57. Verheyen notes (p. 49) that the labors of Hercules are first illustrated by a print of the standing Hercules in a 1546 edition of the often reprinted and translated text by Alciati. That illustration postdates Bandinelli's statue, but the literary tradition on which it depends does not. The practice of representing a ruler as Hercules began in the late fifteenth century when a broadside of the Holy Roman Emperor Maximilian as "Hercules Germanicus" was printed (p. 51).

62. See Shearman, *Only Connect*, 53. The cycle of Hercules painted in the 1550s in the Palazzo Vecchio was more in the tradition of the "mirror of princes," as it was located inside what was by then the residence of the Medici. Only a limited number of people outside the family and court saw the paintings. Vasari, who supervised the painting, repeatedly alluded to the "mirror of princes" in describing the cycle. For example, he wrote about the scene of Hercules and Cacus, "Nor should you believe, Lord Prince, that the combat with Cacus is other than the just contempt that the best Princes constantly [experience] in regard to the nature of robbers and malefactors" (*Ragionamenti sopra le inventioni da lui dipinte in Firenze nel palazzo di Loro Altezze Serenissime* [Florence, 1588], 62).

Vasari alludes to the people's negative reaction to the sculpture in his biography of Bandinelli (*The Lives*, VII, 68 and 72), although he makes it sound as though their response was motivated by dislike of Bandinelli and his art. But he recounts that Duke Alessandro delayed installing the statue in the piazza because he heard reports of hostility from citizens. He describes how crowds jammed the piazza for two days to see the sculpture and how everyone criticized it, many by writing witty poems that they attached to it. As Vasari puts it, Duke Alessandro's imprisoning them "stopped the mouths of the critics" (p. 75).

63. See J. Ackerman, *The Architecture of Michelangelo*, 2d ed., (Chicago, 1986), 136–71. For the consultation of Michelangelo about the Piazza della Signoria, see Borsook, *Companion Guide*, 36. Bush, *Colossal Sculpture*, 179, discusses the plans for him to create an equestrian sculpture there.

64. Jex-Blake and Sellers, *The Elder Pliny's Chapters*, 12–13. For an exciting account of Cellini's casting of the bronze, see *The Autobiography of Benvenuto Cellini*, ed. C. Hope (Oxford, 1983), 177–85 (an edition with photographs and

up-to-date commentary). A translation of Cellini's trea-
tises was prepared by C. R. Ashbee, *The Treatises of Ben-
venuto Cellini on Goldsmithing and Sculpture* (London, 1888).
A clear and insightful summary of the sculpture's history
and a complete corpus of photographs are provided in the
most recent monograph on the artist by Pope-Hennessy,
Cellini, 163–213.

65. Seymour, *David*, 140–57, publishes the committee pro-
ceedings. In patriarchal societies, such inversions where
women are seen in the superior position can be read as
challenges to the social order; see N. Zemon Davis,
"Women on Top: Symbolic Sexual Inversion and Polit-
ical Disorder in Modern Europe," in *The Reversible
World: Symbolic Inversion in Art and Society*, ed. B. Bab-
cock (Ithaca, N.Y., 1978), 147–89. For a feminist inter-
pretation of *Judith*'s symbolism as a cause for the statue's
repeated moves, see Y. Evan, "The Loggia dei Lanzi: A
Showcase of Female Subjugation," *Woman's Art Journal*
XII (1991): 10–14.

66. See T. Hirthe, "Die Perseus-und-Medusa-Gruppe des
Benvenuto Cellini in Florenz," *Jahrbuch der Berliner Museen*
XIX/XX (1987/88): 197–216, who convincingly argues
that the unprecedented choice of the theme for a monu-
mental work derives from allegorical associations between
Perseus and Cosimo I.

67. Jex-Blake and Sellers, *The Elder Pliny's Chapters*, 15. Its
revival should be credited to Bandinelli in sculptures erected
outside the piazza. See Weil-Garris, "Pedestals," 406–11.

68. The Medusa head became the archetypal apotropaic
emblem on shields, first on that of Athena (who gave
Perseus the polished metal shield that enabled him to kill
Medusa; Perseus rewarded her by giving her the head),
and then on those of Hercules and Aeneas. Bandinelli's
sculpted portrait bust of Cosimo I depicts him in a cuirass
adorned with Medusa heads. They were also common
apotropaic emblems on the exterior of Greek and Roman
temples.

69. See P. M. Daly, "Alciato's Emblem 'Concordiae Sym-
bolum' A Medusa's Mirror for Rulers?" *German Life and
Letters* XLI, no. 4 (July 1988): 349–62. Boccaccio's famous
and very influential treatise on the pagan gods, *De Genealo-
gie Deorum*, was the most immediate source for a Chris-
tianized interpretation. He called Perseus's victory over
Medusa a triumph over sin and likened Perseus to Christ.
See D. C. Allen, *Mysteriously Meant: The Rediscovery of
Pagan Symbolism and Allegorical Interpretation in the Renais-
sance* (Baltimore, 1970), 217.

As a result of these readings, representing rulers as
either Hercules or Perseus became quite common by the
late sixteenth century; see C. Vivanti, "Henry IV, the Gal-
lic Hercules," *Journal of the Warburg and Courtauld Institutes*
XXX (1967): 176–97. On euhemeristic connections
between the pagan gods and contemporary leaders, consult

generally J. Seznec, *The Survival of the Pagan Gods: The
Mythological Tradition and Its Place in Renaissance Humanism
and Art* (3d ed., Princeton, 1995).

70. More than twenty poems were posted on the screens pro-
tecting three sides of the sculpture prior to its total unveil-
ing. Some of them are published in *I trattati dell'oreficeria e
della scultura di Benvenuto Cellini*, ed. C. Milanesi (Florence,
1857), 403–14. Their authors were probably aware of the
earlier links established to Perseus by the Medici family. A
painting of *Perseus and Andromeda* had been commissioned
by Filippo Strozzi, a Medici partisan, and Alessandro de'
Medici had struck a medal with Perseus holding the head
of Medusa on its obverse; see Hirthe, "Perseus," 204 and
214. The Medusa symbol seems to have had personal
meaning for Alessandro, perhaps linked to his reacquisition
of the famous cameo called the "Tazza Farnese." It was
prominently decorated with a Medusa head. The cameo,
the most prized ancient object in the collections of his
great-grandfather Lorenzo the Magnificent, had been
appropriated by the Republic in 1495; see Bober and
Rubinstein, *Renaissance Artists*, 104–5, cat. no. 68.

71. See *I Trattati*, 403–14. On the relationship between nature,
or here the flesh-and-blood world of the spectator, and the
ideal beauty of sculpture, which was already implicit in
Ovid's account of the Perseus myth, and the responses it
occasioned among sixteenth- and seventeenth-century
artists, see J. B. Scott, "The Meaning of Perseus and
Andromeda in the Farnese Gallery and on the Rubens
House," *Journal of the Warburg and Courtauld Institutes* LI
(1988): 250–60.

72. Vasari's elaborate description of the celebrations explained
that they symbolized the discord vanquished by the
Medici (*The Lives*, X, 98). The statue of Cosimo was
recarved in the 1570s so that he sat atop a dragon to make
his identification with Perseus obvious. See Hirthe,
"Perseus," 210–11.

73. Vasari describes how the fountain was hurriedly installed
as part of the decorations celebrating the marriage of
Francesco de' Medici. He calls Neptune a "benign protec-
tor" and notes the representation on his chariot of the two
ascendant signs of the duke Cosimo and the prince
Francesco, the capricorn and Aries. (*The Lives*, X, 96.) On
Ammanati, see the general account (with bibliography and
photographs) in Pope-Hennessy, *Italian High Renaissance
and Baroque Sculpture: An Introduction to Italian Sculpture*, III,
3d rev. ed. (New York, 1985), 372–7 and 459, and *Bart.°
Ammannati, Scultore ed architetto*, ed. Niccolò Rossolli Del
Turco (Florence, 1995).

74. On the complicated symbolism linking the Fountain of
Neptune, the *Perseus and Andromeda*, and the dynastic
alliance between the Medici and the Hapsburgs of Austria,
see C. Mandel, "Mythe, mariage et métamorphose Piazza
della Signoria," in F. Siguret and A. Laframboise,

Andromède ou le héros à l'épreuve de la beauté (Paris, 1996), 367–85. I would like to thank Betsy Rosasco for bring this article to my attention.

75. R. Borghini, *Il Riposo* (Florence, 1584; reprint, Milan, 1967), 72–4, describes how he persuaded Giambologna. The veracity of what is apparently an eyewitness account has never been challenged, but its rhetorical role in establishing the aesthetic concerns of Giambologna as paramount should not be underestimated.

 The choice of the Phineas and Andromeda theme would have explicitly connected Giambologna's sculpture to Cellini's and to the Fountain of Neptune by introducing an obscure incident in the legend, perhaps even by inventing one. In the standard account Perseus, at his wedding to Andromeda, confronts Phineas and his companions with the head of Medusa, and they are turned into statues.

76. This pithy definition was coined by J. Shearman in his influential *Mannerism* (Harmondsworth, 1967).

77. The following argument is developed from the provocative essay by M. D. Carroll, "The Erotics of Absolutism: Rubens and the Mystification of Sexual Violence," *Representations* XXV (Winter 1989): 3–30. I thank Mariët Westermann for bringing it to my attention.

78. See *ibid.* for the references to Vasari's *Ragionamenti*.

79. N. Bryson, "Two Narratives of Rape in the Visual Arts: Lucretia and the Sabine Women," in *Rape*, ed. S. Tomaselli and R. Porter (Oxford and New York, 1986), 152–73. This interpretation of the legend was emphasized in the various sixteenth-century sources from marriage treatises to Castiglione's *Courtier*; see A. B. Barriault, *Spalliera Paintings of Renaissance Tuscany: Fables of Poets for Patrician Homes* (Univ. Park, Pa., 1994), 130–1.

80. See Barriault, *Spalliera Paintings*, 130–1, for a painting of the Sabines on a marriage chest. Giambologna's own small bronze of the subject for Ottavio Farnese, the duke of Parma, finished in 1579, is almost the only previous sculpted example. See *Giambologna, 1529–1608: Sculptor to the Medici*, ed. C. Avery and A. Radcliffe (London, 1978), 105–7.

81. Another group of six over-life-size figures identified as Sabine women in the sixteenth century was bought by Ferdinando de' Medici in 1584 and installed in the Villa Medici in Rome. In the eighteenth century, later Medici rulers of Florence had them moved to the Loggia dei Lanzi. In addition, a sarcophagus thought to represent the *Rape of the Sabines* was sold to the Medici in 1584. On these sculptures, see Bober and Rubinstein, *Renaissance Artists*, 161, 197–9, and 205–6.

82. For these sculptures, see *ibid.*, 205–6.

83. I thank Elizabeth Pilliod for reminding me of this.

84. The ephemeral decorations erected to celebrate the marriage are fully described in Vasari, *The Lives*, XX, 37–170.

85. See above, n. 35, and G. Kauffmann, "Das Forum in Florenz," *Studies in Renaissance and Baroque Art Presented to Anthony Blunt* (London and New York, 1967), 37–43. The statues of the city's heroes were not executed until the nineteenth century.

86. The statue, carved by Vincenzo Danti in the early 1570s, is now in the Museo Nazionale del Bargello. For its history, see J. D. Summers, *The Sculpture of Vincenzo Danti* (New York, 1979), 305–7. It was carved to substitute for an earlier seated figure of the duke by Danti, apparently commissioned by Cosimo himself in the 1560s; this statue was never put in place because of Cosimo's second thoughts about erecting a public portrait statue of himself (*ibid.*, 169–74). This is the statue converted into a Perseus and installed in the Boboli Gardens. H. Th. Van Veen argues Cosimo changed his mind because he had squashed all Republican opposition to his rule by the 1560s, clearing the way for a program of imagery that stressed his regime's continuity with Florentine Republican traditions and its fulfillment of their expectations; see his "Republicanism in the Visual Propaganda of Cosimo I de' Medici," *Journal of the Warburg and Courtauld Institutes* LV (1992): 200–9. See also the excellent comprehensive article by R. Crum, "'Cosmos, the World of Cosimo': The Iconography of the Uffizi Facade," *Art Bulletin* LXXI (1989): 237–53.

87. See *ibid.* and H. Keutner, "Über die Entstehung und die Formen des Standbildes im Cinquecento," *Münchner Jahrbuch der bildenden Kunst*, 3d ser., VII (1956): 138–68, for background on monuments with standing figures.

88. See the essay by H. W. Janson in this volume for the august tradition of the equestrian monument as a symbol of the ruler. Ironically, its revival as public independent sculpture, which took place in fifteenth-century Italy, was primarily associated with memorials to military leaders, not heads of state, as in the case of the Gattamelata, Colleoni, and Trivulzio monuments.

89. See *ibid.*

90. See above, at n. 7.

91. For a description of the temporary decorations, see Vasari, *The Lives*, VII, 12–13. The emperor had shortly before agreed to marry his daughter to Cosimo's predecessor, Duke Alessandro de' Medici. This prestigious marriage did not take place because Alessandro was murdered the next year, and Cosimo took power as duke.

92. *Ibid.*, 29, where Vasari describes that the horse had his forelegs in the air, rearing above wounded and dead men.

93. The rider on rearing horse, recreated in these two statues, derives from Alciati's emblem 35 "On him who does not

know how to flatter," first illustrated in this way in the edition published in Lyons in 1551. In unillustrated earlier editions, the emblem had already been interpreted as an image of the good ruler. The epigram accompanying the emblem explained that the high-spirited horse threw off whoever did not rule it well. See *Andreas Alciatus. II. Emblems in Translation*, ed. P. M. Daly and S. Cuttler (Toronto, 1985).

94. See Summers, *Danti*, 228, 234.

95. Jex-Blake and Sellers, *The Elder Pliny's Chapters*, 14–15: " . . . the memories of men were immortalized, and their honours were no longer merely graven on their tomb-stones, but handed down for posterity to read on the pedestals of stone." The authoritative analysis of both

sculptures by Giambologna is by J. Holderbaum, *The Sculptor Giovanni Bologna* (New York, 1983), 149–94, who first identified them as symbols of the absolute ruler.

96. Like the *David*, Donatello's *Judith and Holofernes* (and his *Marzocco* as well) are replaced by copies. Donatello's bronze is displayed inside the Palazzo Vecchio and his *Marzocco* has been moved to the Museo Nazionale del Bargello.

97. Michelangelo had been commissioned at first by the Republic to carve a group of Hercules and Cacus from the block of marble that Bandinelli took over for the same subject. The second time the Republic had control of the block (1527–30), the subject was changed to Samson and the Philistines; see Tolnay, *Michelangelo, III*, 98–104.

Looking at Renaissance Sculpture
with Vasari

Paul Barolsky

GIORGIO VASARI WAS an accomplished architect, a fluent draftsman, and a prolific, if uninspired, painter, but, above all he was a great writer. His *Lives* of the artists, first published in Florence in 1550 and reprinted in amplified form in 1568, is one of the masterpieces of Italian Renaissance culture, a book that proudly takes its place alongside the writings of Dante, Boccaccio, Petrarch, Ficino, and Machiavelli and alongside the very masterpieces of art by Giotto, Botticelli, Leonardo, and Michelangelo of which he speaks so eloquently. It is also the single most important contemporary source we have for the understanding of Italian Renaissance art. Vasari compiled biographies of every major artist (and many minor ones) active between the late thirteenth century and his own day. But we cannot read his *Lives* as a straightforward factual account. Vasari often invents, and his inventions are in many cases telling indications of the attitudes of his own period. Because he wrote at the height of the Counter Reformation, when the Church was vigorously defending its interpretations of Christianity against Protestant reformers, his comments frequently offer insight into the content of religious art and its meaning for patrons and worshippers alike. Furthermore, as an artist who belongs to the tradition of which he writes, Vasari has an intimate knowledge of the work he describes, of its materials and techniques, of its theory and practice, of its subjects and purposes, of its patrons and circumstances. Vasari is an uncommonly lively writer with an exceptional sympathy for his subjects. No matter how often one returns to his book one can always learn something new from it, and this is certainly true of what he has to say about sculpture. This essay examines several of the principal examples of sculpture from the Renaissance described by Vasari to discover what his commentaries reveal about Renaissance art and the world in which it was both made and described.[1]

The focus here is on Florentine sculpture, on works by Donatello and his followers, including his greatest emulator, Michelangelo. Referring to Donatello as "Donatus Bonarrotum," combining the Latin form of Donatello with Michelangelo's family name, Buonarroti, Vasari wishes to suggest that the "spirit" of Donatello passed into Michelangelo, that Donatello's art anticipated Michelan-

gelo's in important respects. In Vasari's broad view, Michelangelo brought to "perfection" what Donatello had invented. Nowhere are the origins of Michelangelo's art more vividly seen than in the sculpture with which Vasari begins his biography of Donatello, the *Annunciation* at Santa Croce commissioned by the Cavalcanti family, probably in the 1430s (Fig 73).[2] Vasari says that the sculpture is adorned with a composition *alla grottesca*, in "the grotesque manner," by which he means the details in the frame surrounding the central narrative: the richly carved, scrolled pediment, with its festoon and elaborate dishlike tondo; the massive entablature filled with giant egg forms and smaller wheel-like shapes; the pilasters, which are vivified by the little heads of the capitals, the scales of the shafts, and the lion paws of the pedestals; the flowery ornaments of the Virgin's lectern and the door behind her; and the winged garland below. The whole surface of Donatello's work pulsates with life. Stone has been metamorphosed into living form – human, animal, and vegetal – all unified in a rich and harmonious poetic compound. Appreciating Donatello's "grotesque," this marble chimera, if you will, Vasari celebrates a poetic fantasy that would later be emulated and embellished by Michelangelo in the Medici Chapel at San Lorenzo (c. 1519–34) (Fig. 81). Michelangelo's ornamental details are often overlooked as one contemplates the awe-inspiring life-size figures of Giuliano and Lorenzo de' Medici and the allegorical nudes atop their sarcophagi. However, the chapel's architectural articulation in gray limestone (*pietra serena*, a local Florentine stone), animated by vividly convincing masks whose grimacing faces simultaneously alarm, entrance, and delight the viewer, is equally fascinating. Michelangelo's poetic inventions are grounded in the very "grotesque" manner of Donatello so aptly appreciated by Vasari.

Vasari is attentive to the six terracotta putti at the top of Donatello's tabernacle who, he says, embrace each other because they are "afraid" of heights. Whether these little fellows are indeed "afraid" or not, I am not prepared to say. What does seem clear is that they elaborate Donatello's narrative by responding to it. Indeed, two of the putti at the right look directly down and react to the momentous event enacted below. If Vasari employs a poetic license in his description of the putti's fear, we soon learn why, because he next describes the Virgin as "afraid" at the very moment when the angel suddenly and miraculously appears to her. Vasari thus links the putti to the Virgin through their shared emotion of fright.

In his description of this shared fear, Vasari also indirectly guides our attention to the extraordinary technical innovations introduced by Donatello in this narrative relief that stimulate this response. The sculptor has carved the stone very deeply so that the figures are seemingly three-dimensional. Only when we look at the figures from the side can we see how their incomplete forms are attached to the background slab and realize that they are not figures fully in the round. In addition, Donatello constructed the relief so that the side of the frame on which the putti are perched obscures the angel's leg, making it seem as if the angel is just arriving to convey the message of the Incarnation to Mary. Both

innovative features emphasize the
angel's startling physical presence,
underscoring the significance of
Mary's miraculous impregnation
with Christ, who is dramatically
made incarnate at this very
moment. Vasari's account is calcu-
lated to stimulate our own awe
and fear by leading us to identify
with the putti and the Virgin and,
through the evocation of these
emotions, to heighten our under-
standing and devotional response
to its subject.[3]

Describing Mary, who appears
to us with a certain "sweetness,"
or *dolcezza*, that would convert
any worshipper to "reverence,"
Vasari observes the loveliness of
Donatello's graceful figure and her
power to inspire devotion. As
Vasari so aptly says, employing the
language of Tuscan lyric poetry,
she is a figure of both "sweetness"
and "most beautiful grace," *bellis-
sima grazia*. Donatello's Mary is
suave in her gentle turning motion
away from the angel, but Vasari

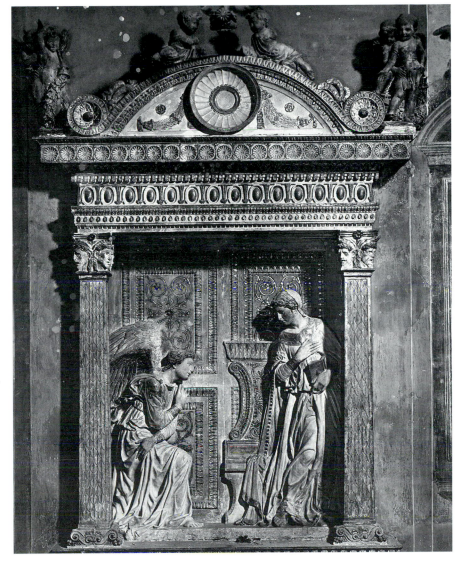

Figure 73. Donatello, *Cavalcanti Annunciation*, S. Croce, Florence, 1430s (photo: Charles Seymour, Jr. Archive)

means something more when he employs the word "grace." He says that Mary
exhibits "gratitude" for the unexpected "gift," or *dono*, she has received, a gift
that is "great." Vasari implicitly links the aesthetic quality of grace to the theo-
logical concept of grace, to the gift of grace made possible at the very moment
of incarnation reenacted in the *Annunciation*.

Vasari does something more here. When he twice refers to the gift that Mary
receives, he alludes to his earlier observation that the *Annunciation* established
Donatello's name. The artist's name is derived from the Latin verb *dare*, "to
give." By emphasizing the gift, the *dono*, in his description of the *Annunciation*'s
religious meaning, Vasari is playing on the meaningfulness of the artist's name,
for he tells us elsewhere on several occasions that Donatello was, in the explic-
itly Christian sense, a giving, even a saintly, person. It is only appropriate there-
fore that the artist, aptly named for his giving character, should so effectively and
artfully present the advent of the supreme gift of grace. Theology, aesthetics, and
biography are all shrewdly intertwined in Vasari's masterful description of
Donatello's sculpture. The theological character of Vasari's prose is a reminder

that the author wrote in the heart of the Counter Reformation and, if he does admire Donatello's handling of draperies and of the nude figure, if he does speak of the artist's "facility," "artifice," and "judgment,"[4] he nevertheless focuses our attention on the artist's devotional meaning – on the very subject of divine grace to which the artist's poetic artifice is dedicated. In this way, Vasari gives us a sense of what the Renaissance viewer might have appreciated in Donatello's sculpture. An uncommonly well-educated and sophisticated beholder of devotional art, Vasari gives us clues as to how Donatello's contemporaries might have responded to the expressive features of his *Annunciation*.

Throughout the pages of Vasari's *Lives* Donatello is a dominant figure among fifteenth-century artists, including Brunelleschi and Uccello.[5] He also figures prominently in the "life" of Luca della Robbia, where Vasari discusses Luca's wonderful *cantoria*, or organ loft, for the cathedral of Florence in relation to Donatello's companion work (Figs. 74 and 75).[6] Whereas Luca brings his figures to a high polish or finish, in other words, *pulitezza* or *finimento*, Donatello, Vasari says, leaves his work in a state of sketchiness, *abbozzata* and *non finita*. Vasari claims that Donatello did this because his figures, in such a state, would look better to the eye from a distance.[7] The finish or polish of a sculpture is a matter of degree, and although, strictly speaking, Donatello's figures are not as refined as

Figure 74. Donatello, *Cantoria*, Museo dell'Opera del Duomo, Florence, 1433–38 (photo: Alinari/Art Resource, N.Y.)

Della Robbia's, they are nevertheless nearly as polished. It seems that Vasari was inclined to magnify the quality of *bozza*, or unfinish, in Donatello because he saw it as an antecedent of Michelangelo's *non finito*. In some cases, Michelangelo's *non finito* was a sign that his work remained unfinished, but in other instances, as has been suggested elsewhere, Michelangelo's *non finito* was an intentional effect, an index of the work's "poetry," which in the root sense means "making" – a clue to the artist's virtuosity or skill in the metamorphosis of stone into the illusion of living form.[8]

Explicitly developing the analogy between sculpture and poetry, Vasari says that works like Donatello's (and here he is also thinking of Michelangelo's) that have a beautiful roughness, *bella bozza*, possess a "force," not to be found in sculpture, that is *lisciato*, or brought to a very high gloss or shine. Vasari's appreciation of Donatello's poetic *non finito* reminds us that Donatello and his followers, including Bertoldo and Francesco di Giorgio, often did not fully burnish their bronzes, preferring a somewhat roughened, unfinished texture in their work that was at once expressive, sensitive to the play of light, and as we have observed, evidence of the process of the artist's making of the work, a sign of the artist's virtuosity. In other words, Vasari calls to our attention that even before Michelangelo the *non finito* was already developing as an aesthetic phenomenon in the fifteenth century in the work of Donatello and his followers.

When Michelangelo became a legendary figure in the sixteenth century he came to be known not just for his poetic *furore* but also for the *terribilità* of his personality. In this respect, his persona was molded from that of Donatello,

Figure 75. Luca della Robbia, *Cantoria*, Museo dell'Opera del Duomo, Florence, 1431–38 (photo: Alinari/Art Resource, N.Y.)

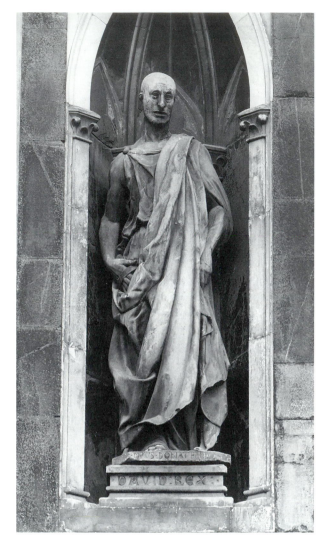

Figure 76. Donatello, *Zuccone*, Museo dell'Opera del Duomo, Florence, 1427–c.1436 (photo: Charles Seymour, Jr. Archive)

whose own capacity for rage was legendary in the pages of Poliziano's *Bel Libretto*.[9] Vasari embellishes this tradition in his account of Donatello's statue of a prophet nicknamed Zuccone, or Pumpkinhead, because of his baldness, carved for the Campanile, or bell tower, of the cathedral between 1427 and c. 1436 probably (Fig. 76). Vasari says that the figure is a portrait of Giovanni di Barduccio Cherichini. This is a fiction that we easily dismiss, but a telling one. For by saying that *Zuccone* is a likeness of a contemporary of Donatello's, Vasari is suggesting its lifelike quality. So real is this haunting and powerful figure that Donatello would tell it to "speak, speak, or may you shit blood."[10] At first this story evokes the poetic myth of Pygmalion creating a work that seems alive. Only on reflection do we see that Vasari's fable inverts Ovid's. Whereas Pygmalion was inspired by love for his own work, Donatello, enraged, curses his statue. His emotion is nevertheless appropriate to the work, for the wrathful visage of the figure is one with the rage of its maker. Vasari's marvelous little poetic fable captures the aura of Donatello's intensely lifelike effigy of a stormy prophet. In the poetic manner of Vasari, we might almost say that the *Zuccone* is the petrified persona of the fierce Donatello himself.

Donatello is by turns a man of great rage, as when he smashed a statue to bits after not being offered proper payment, and a person of considerable affability and good humor. We encounter this more engaging side of the artist in Vasari's vita of Donatello's *discepolo* Nanni di Banco, whose success, Vasari pretends, is owed to his great teacher's invention. According to Vasari's charming and revelatory novella, Nanni di Banco supposedly had difficulty fitting his *Quattro Coronati* into its niche at Orsanmichele (Fig. 77), which was originally the grain exchange of Florence and later a church, the site of a miracle-working painting of the Madonna and Child, where the major guilds of the city were given the privilege of placing statues of their patron saints on the exterior.[11] "Desperate" and "melancholic," Nanni went to Donatello, bemoaning his "disgrace." The smiling Donatello told him not to worry: "if you will buy lunch for me and my assistants, I'll get your saints into the niche without any trouble."[12] Having sent Nanni off on some errands, Donatello and his disciples, Vasari claims, successfully fit the figures into the niche. The difficulty had been in having to fit not just a single figure, like Donatello's *St. George* (Fig. 63), also at Orsanmichele, into a restricted space, but in having to place four figures into such a shallow area harmoniously. No easy matter! As Vasari inflates Michelangelo by making up stories suggesting that the artist was even greater than he actually was, so here Vasari magnifies Donatello by giving him the credit for

solving Nanni's problem. Only Donatello, he imagines, could have achieved such a result. Thanks to Donatello's "judgment" (that attribute Vasari most prominently associates with Michelangelo), Nanni's "error" could be concealed, and the four saints "placed together in unity," *unitamente commesse*. These four figures, so harmoniously arranged, embody for Vasari "concord and fraternity," *concordia e fratellanza*. As this was the first multifigure sculpture of the Renaissance, and the figures are almost life-sized, seem three-dimensional, and are capable of interacting with each other in physical and psychological terms, Nanni's ambitious work is extremely innovative. Vasari seems determined, however, to credit Donatello rather than Nanni in every way he can with artful solutions to the problems posed by Nanni's statues.

Vasari's little tale, which glorifies Donatello, is far more than a charming story. It is also a complex allegory dealing with the interrelations between theology, aesthetics, and social structure. Vasari tells us explicitly that the saints

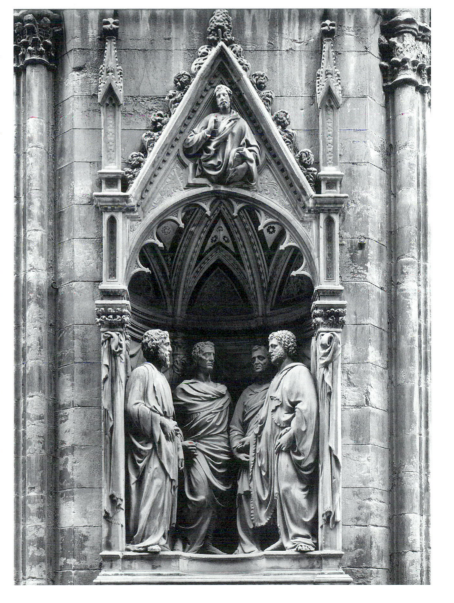

Figure 77. Nanni di Banco, *Four Crowned Saints* (*Quattro Coronati*), Orsanmichele, Florence, c. 1410s (photo: Charles Seymour, Jr. Archive)

carved by Nanni di Banco personify *fratellanza*, the spiritual "brotherhood" of all members of the Christian family, the *familia Christi*, the very *fraternitas* of which St. Paul spoke. Nanni's figures are ideal representatives of this Christian family, which is embodied in the harmony of the four patron saints of the guild that commissioned the statue. According to tradition, they had refused to carve a pagan idol and so were murdered for their beliefs. Vasari's characterization of these figures again reflects the spiritual aspirations of his own time, the Counter Reformation, when the Church promoted the zeal of the faithful with stories and works of art that presented saints who sacrificed their lives for the Church.[13]

The ideal of fraternity that Nanni's figures epitomize is also appropriate to the guild of stonecutters, carpenters, and masons for which the statue was made, because these artisans were united in a fraternal organization symbolized by the unity of saints.[14] The community of these saints thus stands for the ideal harmony of the diverse artisans united in their guild. But the

story cuts even deeper, because the concord of saints also expresses the fraternal relations between the artists working on behalf of the guild, the brotherhood of Donatello and Nanni. By helping Nanni, the giving Donatello, ever true to his name, conforms to the exemplary, saintly ideal of fraternity. Finally, the conjoining of figures reflects an artisanal ideal appropriate to the guild of carpenters. Carpenters are, as the English term "joiners" suggests, craftsmen who join parts into a whole, and the artist's ability to join four saints, to fit them together, reflects the carpenters' craft. In other words, in joining the figures together, the artist is himself, if metaphorically, a joiner.

The aesthetic harmony of Nanni's statue stands for religious and social harmony, just as it refers to the harmonious craftsmanship of the artisans for whom it was made. Vasari's tale of *concordia* that is brought to a work originally marked by *disordine* is ultimately a "comedy," a story with a happy ending. More than this, it is the utopian tale of a city in which brotherly love and harmony reign. In Vasari's imagination the statue becomes the dream of civic harmony – an antidote to the strife and discord that marked Florentine life in both Donatello's day and in Vasari's time.[15] Vasari's story is far more than a historical interpretation; it is a historical fiction rooted in the aesthetics of the statue, in its harmonious fitting of the parts into a whole. As such, it is one of the most splendid fables in Vasari's book, and it also sharpens our critical sense of the difficulties overcome in the realization of a great sculpture. Vasari helps us to see why Nanni di Banco's work was one of the most ambitious and successful sculptures executed in the first years of the fifteenth century. The story magnifies Nanni di Banco's splendid accomplishment, even though it gives the glory to Donatello.

When we pursue work at Orsanmichele we learn that Donatello carved a beautiful niche in the classical style for the guild of the merchants into which Andrea Verrocchio's *Christ and Doubting Thomas* was eventually placed (Fig. 78).[16] Verrocchio's sculpture in bronze portrays only two figures, whereas Nanni's statue was composed of four. But Verrocchio's sculpture is more ambitious in a different respect, for it is not merely an assemblage of figures harmoniously united, it is a narrative – a representation of the apparition of Jesus to St. Thomas (and to the beholder in the street below) – enacted in the shallow space of the niche. Giving Donatello pride of place once again, Vasari proclaims that Verrocchio's work was "worthy" of the tabernacle made by Donatello. Indeed, it can be argued that Verrocchio's statue is the most ambitious and successful monumental sculpture executed in Florence in the last years of the fifteenth century in the wake of Donatello.[17]

Characteristically, Vasari's description of Verrocchio's work reveals the sculpture's theological and aesthetic meaning. Speaking of St. Thomas, he says that the figure exhibits the saint's "love" of Jesus through the gesture of his hand extended to his Savior's ribs, which is articulated in a "most beautiful manner." Vasari is commenting both on the exemplary devotional emotion of the saint and on the loveliness of his gesture. Of the Christ figure, Vasari writes that with a great flourish, "*liberalissimo attitudine*," Jesus raises his arm and opens his gar-

ments, revealing his wound to the doubting saint, adding that Jesus is a figure of *grazia* and *divinità*. Once again, as he had in his description of Donatello's *Annunciation*, Vasari implies that there are relations between physical loveliness or *grazia* and the divine gift of grace.[18]

Vasari also illuminates the visionary character of a work in which Jesus, mysteriously appearing after his death to Thomas, is seen in a miraculous vision. Verrocchio's statue is made in bronze, and, like many bronze sculptures of the period, it is brought to a high finish. Polished bronze is of course luminous in its reflectivity, and this luminosity, an aesthetic phenomenon, resonates in Vasari's theological language. Describing St. Thomas, Vasari says that the saint aspires to "understand the truth," *chiarirsi del fatto*; observing Jesus, he writes that Christ "dispels Thomas's doubt," *chiarisce il dubbio*.[19] Using the verbs *chiarire* and *chiarirsi*, Vasari is employing words rooted in the Latin *claritas*, or "clarity," – that is, "lucidity." In other words, his vocabulary of "illumination" plays, in the spiritual sense, on the luminosity of the sculpture, as if to suggest that its glowing surface, its very aura, betokens the divine light flooding the doubting Thomas with understanding at this moment of revelation. Vasari's description is poetic, but his poetic rhetoric is true to the work's religious meaning.[20]

As a nearly life-size image of the risen Christ, Verrocchio's sculpture is unprecedented in Florentine art. It served as an example to the rising sculptor Michelangelo who, years later, returned to Verrocchio's work when he carved his own apparitional *Risen Christ* for the Church of Santa Maria sopra Minerva in Rome.[21] Michelangelo had, however, already learned a great deal from Verrocchio by the time he carved his beloved *Pietà* for St. Peter's in the last years of the fifteenth century (Fig. 79). This comparison may at first seem inappropriate because Verrocchio's statue is of bronze and Michelangelo's is of stone and because these works illustrate different subjects. I submit, however, that by studying closely the physiognomy, the characterization of anatomy down to its details, and the manner of drapery style of Michelangelo's Christ in St. Peter's we will see something of the way in which the still young artist assimilated Verrocchio's divine vision to his own.

Michelangelo's *Pietà* is so familiar to us that we almost cannot respond to it. Perhaps Vasari's description of the sculpture will give us a fresh purchase on Michelangelo's still astonishing work. Although Vasari elsewhere praises the poetic *furore* of works left unpolished, as we have seen, he here dwells approvingly on the "polish" and "finish" of Michelangelo's statue. This praise of Michelangelo's "perfection" is intriguing in light of the artist's signature, "MICHAEL. AGELUS BONAROTUS. FLORENT. FACIEBA[T]." Abandoning the traditional signature in the past tense *fecit* (from the Latin verb *facere*, "to make"), Michelangelo employed the third person "imperfect" form of the verb, *faciebat,* as if to suggest modestly that he had not achieved the "perfection" to which he aspired. Doing so, he made his verb wittily embody its own imperfection or incompleteness by not carving the "T" of "FACIEBAT," which is hidden under the Virgin's veil, thus leaving the word unfinished, *non finito,*

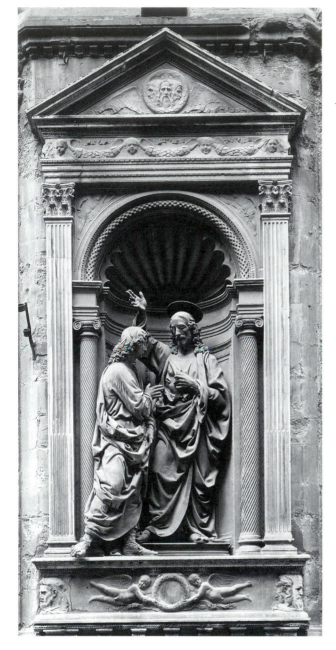

Figure 78. Verrocchio, *Christ and Doubting Thomas*, Orsanmichele, Florence, 1467–83 (photo: Charles Seymour, Jr. Archive)

imperfect. Michelangelo probably was responding to Poliziano's learned commentary on Pliny's *Natural History* which referred to the use of the Greek equivalent of *faciebat* by Apelles and Polyclitus, as if to suggest the comparison of his own work to that of the ancient Greeks.[22]

Implicitly revising the artist's seemingly modest, if not paradoxical, claim of imperfection, associated with the greatness of the Greeks, Vasari speaks of Michelangelo's "perfection." When Vasari employs the word *perfezione* to describe Michelangelo's work, we recall that for him this word means far more than technical excellence or accomplishment. It is charged with spiritual indeed biblical meaning, referring to spiritual completion – a perfection embodied both in the work and in its maker, who is a deeply spiritual being. He speaks of the "divine draperies" of the statue, adding that one is filled with "wonder" that a human hand has been able to work the stone "so divinely." Michelangelo's achievement is, Vasari proclaims, a "miracle."[23] By metaphorically playing on Michelangelo's identity, both "divine" and "human," Vasari is elaborating on the very subject of the artist's statue, which represents the incarnational mystery of Jesus. It is as if Michelangelo, rendering Christ, were himself Christlike.

Vasari adds to our understanding of the statue when he quotes a contemporary poem inspired indirectly by the *Pietà*. In this madrigal, the poet writes that Jesus is the "spouse, son, and father" of Mary and that she is his "spouse, daughter, and mother."[24] These lines, which elaborate famous visionary words of Dante's *Divine Comedy*,[25] suggest that Michelangelo's holy subject ultimately stands outside of time, that it is mysteriously universal. We see, for example, how Michelangelo's Virgin is maternal, filial, and spouselike all at once. What Michelangelo has wrought with divine artifice, as Vasari suggests, is a divine vision, a sacred mystery in stone.

I wish to bring our little survey of works described by Vasari to a close with Michelangelo's *David*, carved in the first years of the sixteenth century in Florence for the Piazza della Signoria (Fig. 80). This is a fitting place for the discussion to end because, although Michelangelo would go on to create other great works in stone, which in turn would inspire his mannerist followers, Vasari treats the *David* in dramatically climactic terms, declaring that the *David* surpassed all previous sculpture, "modern and ancient, Greek and Roman." The *David* is the epitome of perfection in sculpture, and once again, Vasari, who sees the history of art in a spiritual way, interprets this statue of a biblical subject in

Figure 79. Michelangelo, *Pietà*, St. Peter's, Rome, c. 1497–99 (photo: Alinari/Art Resource, N.Y.)

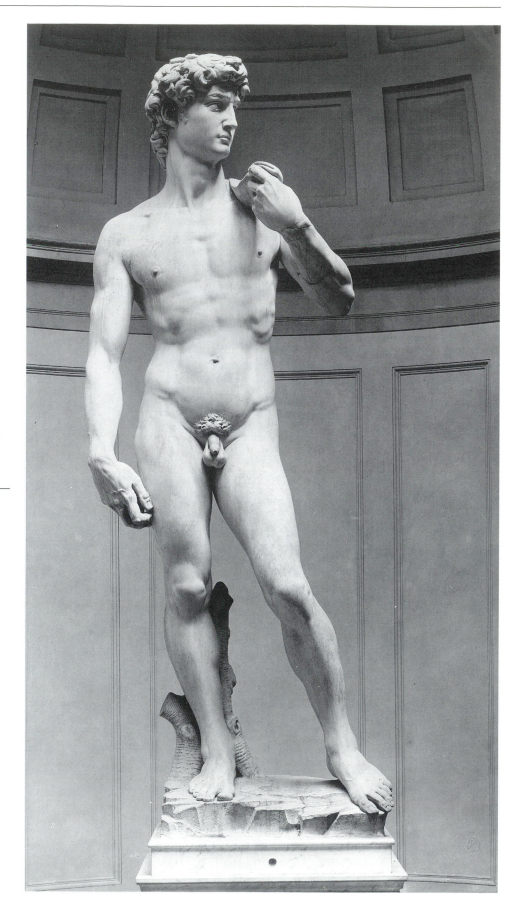

Figure 80. Michelangelo, *David*, Gallerie dell'Accademia, Florence, 1501–4 (photo: Charles Seymour, Jr. Archive)

biblical terms. Saying that Michelangelo carved the statue from a block of mar-
ble that was damaged by the artist who had previously worked it, Vasari
describes the stone *storpiato*, that is, "crippled." It is as if the Christlike Michelan-
gelo had healed a cripple. Vasari makes his meaning explicit when he says that
certainly it was a "miracle" that Michelangelo "resuscitated" a stone that was
"dead."[26] Developing the theme of Michelangelo as a miracle worker in stone,
Vasari is fully aware that Michelangelo divinely carved the image of Christ's
most glorious ancestor.

When we write the history of art today we often talk primarily about style,
about what Vasari calls "manner." What we too easily forget or underestimate
is that Vasari's history of art, grounded in the piety of the Counter Reformation,
is the story of the journey or *cammino* of art toward spiritual perfection and grace.
In a phrase, Vasari's history of art is the account of the spiritual pilgrimage of art
toward redemption, which is brought about, finally, by the Messiah-like
Michelangelo. There are, of course, many other aspects of Vasari's writing about
sculpture that we might well have discussed, but certainly our survey from
Donatello's *Annunciation* to Michelangelo's *David*, exhibiting Vasari's spiritual
concerns, reveals that Vasari's responses to the artifice of sculpture are rooted in
his own devotion. Even when he poetically embellishes his descriptions and sto-
ries, often resorting to fiction or allegory, Vasari is ever faithful to the works of
art themselves, to their sublime grace and beauty, to their original spiritual pur-
poses and implications.

Notes

I am profoundly indebted to Sarah Blake McHam for her
extensive editorial assistance.

1. There are of course numerous editions of Vasari's *Lives*.
 The classic Italian edition is that of G. Milanesi in *Le opere
 di Giorgio Vasari*, 8 vols. (Florence, 1878–1906; reprint, Flo-
 rence, 1981) (hereafter abbreviated as Vasari-Milanesi). The
 standard complete English translation of the *Lives* is that of
 G. DuC. de Vere, *Lives of the Most Eminent Painters, Sculp-
 tors, and Architects*, 10 vols. (London, 1912–14; reprint, New
 York, 1979). Quotations in this essay are taken from the
 original edition.

 Recent books on Vasari as an artist and writer include
 P. Barolsky's *Michelangelo's Nose* (University Park, Pa.,
 1990), *Why Mona Lisa Smiles* (University Park, Pa., 1992),
 Giotto's Father (University Park, Pa., 1993), and *The Faun in
 the Garden* (University Park, Pa., 1994); P. L. Rubin, *Gior-
 gio Vasari Art and History* (New Haven, 1995), and *Vasari's
 Florence: Artists and Literati at the Medicean Court*, ed. P. Jacks
 (Cambridge, 1997).

2. Vasari focuses on this sculpture, enhancing its importance
 by making it the first he describes, even though it was actu-

ally carved towards the middle of Donatello's career; see
the *Lives*, II, 239–40; Vasari-Milanesi, II, 397–8. For a con-
cise account of the *Annunciation* and a series of useful pho-
tographs, see H. W. Janson, *The Sculpture of Donatello*, 2d
ed. (Princeton, 1979), 103–8.

3. Vasari is stimulating our response to the sculpture, seeking
 to involve the beholder in its drama and meaning. For an
 analysis of the artistic means used to elicit various reactions
 to works of art, see J. Shearman, *Only Connect . . . Art and
 the Spectator in the Italian Renaissance*, Bollingen Series
 XXXV, 37 (Princeton, 1992).

4. These are terms of aesthetic approval current in sixteenth-
 century theoretical writing. See, for example, A. Blunt,
 Artistic Theory in Italy, 1450–1600 (Oxford, 1940), 86–102, J.
 Shearman, *Mannerism* (Harmondsworth, 1967), and D. Sum-
 mers, *Michelangelo and the Language of Art* (Princeton, 1981).

5. Vasari, *Lives*, II, 129–40; Vasari-Milanesi, II, 203–17
 (Uccello), and Vasari, *Lives*, 193–236 (Brunelleschi);
 Vasari-Milanesi, II, 327–87.

6. Vasari, *Lives*, II, 117–28; Vasari-Milanesi, II, 167–85. The
 best analysis and photographs of Luca's *cantoria* are found in
 J. Pope-Hennessy, *Luca della Robbia* (Ithaca, N.Y., 1980),

19–29, figs. 1–28. For Donatello's, see Janson, *Donatello*, 119–29. For an examination of Donatello's deliberate distortion of forms and use of unfinished surfaces, employed with the spectator's viewpoint in mind, see R. Munman, *Optical Corrections in the Sculpture of Donatello* (Philadelphia, 1985).

7. Vasari, *Lives*, II, 120–2; Vasari-Milanesi, II, 170–1.

8. This interpretation is elaborated in Barolsky, *The Faun*, 63–76.

9. The so-called *Bel Libretto* is generally attributed to Poliziano and was composed in the second half of the fifteenth century. Seven of the anecdotes concerning Donatello are translated and discussed in Janson, *Donatello*, 85–6 and 154.

10. Vasari, *Lives*, II, 243–4; Vasari-Milanesi, II, 404–5.

11. The creation of the niches at Orsanmichele and their patronage by the guilds of Florence is discussed in McHam, "Public Sculpture in Renaissance Florence," in this volume. On Orsanmichele, see D. F. Zervas, *Orsanmichele Documents 1336–1452 Documenti 1336–1452* (Florence, 1996); on Nanni di Banco's sculpture, see J. Pope Hennessy, *An Introduction to Italian Sculpture, I, Italian Gothic Sculpture*, 3d ed. (New York, 1985), 217–8, 283.

12. Vasari, *Lives*, II, 114–15; Vasari-Milanesi, II, 163.

13. The emphasis on martyred saints during the Counter Reformation is discussed by E. Mâle, *L'Art religieux après le Concile de Trente: Etude sur l'iconographie de la fin du xvi siècle, du xvii, du xviii siècle, Italie-France-Espagne-Flandres* (Paris, 1932), 109–49.

14. On the social organization and business practices of Renaissance artists, see M. Wackernagel, *The World of the Florentine Renaissance Artist: Projects and Patrons, Workshop and Art Market*, trans. A. Luchs (Princeton, 1981), 299–370. For the changes in the social status of artists during the fifteenth and sixteenth centuries, see *ibid.* and Blunt, *Artistic Theory*, 48–57.

15. The evolution of Florence from a republic, in which the guilds played a significant role, to a duchy controlled by the Medici family, for whom Vasari worked as a court artist, is examined by G. Brucker, *The Civic World of Early Renaissance Florence* (Princeton, 1977), and J. R. Hale, *Florence and the Medici: The Pattern of Control* (London, 1977).

16. The niche created by Donatello at Orsanmichele is the first one in an architectural style derived from ancient Roman precedents and one of the first examples of fifteenth-century architecture of any type based on such classicizing models. The earlier niches had been based on Gothic forms. The architecture and the gilded bronze statue of *St. Louis of Toulouse*, the patron saint of the Guelph political party, for which it was originally made, are considered by Janson, *Donatello*, 45–56.

17. On Verrocchio, see J. Pope-Hennessy, *An Introduction to Italian Sculpture, II, Italian Renaissance Sculpture* (New York, 1985), 293–7, and the catalogue of the exhibition of the statue following its recent conservation, *Verrocchio's Christ and St. Thomas: A Masterpiece of Sculpture from Renaissance Florence*, ed. L. Dolcini (New York, 1992).

18. Vasari's description of the physical beauty of Christ and of Thomas's touching him reveals an understanding of the way in which the beholder's physical response to a work of art can heighten that individual's devotion. For this phenomenon, especially relevant to the tactile quality and palpable presence of sculpture, see D. Freedberg, *The Power of Images: Studies in the History and Theory of Response* (Chicago and London, 1989), 294–326, and the essay by James M. Saslow in this volume.

19. Vasari, *Lives*, III, 269–70; Vasari-Milanesi, III, 363.

20. Again Vasari's interpretation is shaped by the concern in his own period, the Counter Reformation, with illumination and miraculous apparitions. See Mâle, *L'Art religieux*, 151–201.

21. See C. de Tolnay, *Michelangelo, III, The Medici Chapel* (Princeton, 1948), 89–96, on this sculpture.

22. For Michelangelo's comparison of himself to Phidias, see Barolsky, *Michelangelo's Nose*, 106–9. For an important discussion of Michelangelo's signature on the *Pietà*, with full bibliography, see L. Pon, "Michelangelo's First Signature," *Source* XV, no. 4 (Summer 1996): 16–19.

23. Vasari, *Lives*, IX, 14–15; Vasari-Milanesi, VII, 150–2. The *Pietà* was commissioned by the French cardinal Jean de Bilhères Lagraulas for the Chapel of the French Kings at St. Peter's. For differing recent interpretations of the sculpture, see W. E. Wallace, "Michelangelo's Vatican Pietà: Altarpiece or Grave Memorial," *Verrocchio and Late Quattrocento Italian Sculpture*, ed. S. Bule *et al.* (Florence, 1992), 243–55, and K. Weil-Garris Brandt, "Michelangelo's 'Pietà' for the Cappella del Re di Francia," *Il se rendît en Italie: Etudes offertes à André Chastel* (Rome, 1987), 77–120.

24. Vasari, *Lives*, IX, 15; Vasari-Milanesi, VII, 152: "Bellezza ed onestate / E doglia e pietà in vivo marmo morte, / Deh, come voi pur fate, / Non piangete si forte, / Che anzi tempo risveglisi da morte; / E pur, mal grado suo / Nostro Signore e tuo / Sposo, figliulo, e padre, / Unica sposa sua, figliuola, e madre."

25. Dante, *Paradiso*, XXXIII, 1.

26. Vasari, *Lives*, IX, 15–16; Vasari-Milanesi, VII, 153–4.

A Week in the Life of Michelangelo

William E. Wallace

MICHELANGELO WAS THE greatest sculptor of the sixteenth century, as Donatello was in the century before him and Bernini in the century after him. We admire the products of his genius, but we less frequently pause to consider the magnitude of the tasks he undertook, the problems he encountered, and the setbacks, even failures, he may have suffered. The *Pietà* and the *David* (Figs. 79 and 80), for example, are stunning accomplishments that blur the tedium and more mundane facts of their creation. We tend to overlook that they were fashioned from raw and resistant stone, by hands that were strong and dexterous but also occasionally tired or bruised. Before these sculptures became the sublime marvels we admire today, they were inert and spiritless material.

Carving marble is extremely difficult. Forget the frequently invoked image of the artist "peeling away" layers of stone, or "liberating" a figure from the block. Giorgio Vasari vividly but inaccurately described marble carving as a gradual issuing forth from the block, like a figure that is raised little by little from a tub of water.[1] Michelangelo's contemporary and rival, Leonardo da Vinci, was closer to the mark when he described sculpture as a "most mechanical exercise." In his notebooks Leonardo wrote:

> The sculptor in creating his work does so by the strength of his arm by which he consumes the marble, or other obdurate material in which his subject is enclosed: and this is done by most mechanical exercise, often accompanied by great sweat which mixes with the marble dust and forms a kind of mud daubed all over his face. The marble dust flours him all over so that he looks like a baker; his back is covered with a snowstorm of chips, and his house is made filthy by the flakes and dust of stone.[2]

Leonardo preferred to paint and considered painting a more noble enterprise than sculpture. Marble carving is hard work, the "blue collar" of the fine arts. It is loud and dirty. Every blow of hammer to chisel is a collision of metal against metal striking stone. Marble chips fly in all directions; the dust lies thick. Modern stone workers wear goggles; Michelangelo did not. He had to see the stone, to see each mark, to make tiny adjustments to the angle of his chisel and to the

force of his blow. He could not afford to slip. One wrong stroke could break a finger, an arm, or worse. A figure comes alive after only thousands and thousands — tens of thousands — of perfectly directed hard and soft blows. Marble carving is unforgiving, hard work.

This is the story of one week in the life of one of the greatest marble carvers of all time.[3] Although set in July 1525, the "week" is a condensation of real episodes that transpired over a longer span of time. Extant documentation regarding Michelangelo's artistic practice is unusually rich for two intense work periods: 1518–19, when he was preoccupied with quarrying marble, and 1524–26, which are the years of his peak activity at San Lorenzo. I have taken the liberty of drawing upon these particularly well-documented years to furnish the episodes presented here. Thus the seven days described are not "typical" in that they are a composite and probably more eventful than most weeks. At the same time, I have attempted to convey a sense of the routine that often must have characterized the life of a professional artist. In recreating these events, I have remained as accurate as possible given the incomplete nature of the historical record.

In July 1525, Michelangelo's principal patron was his former boyhood acquaintance, Giulio de' Medici, recently elected Pope Clement VII. Michelangelo, who was fifty at the time, was working simultaneously on two projects for the Medici at their family church of San Lorenzo in Florence: the Medici Chapel, or New Sacristy (commissioned in 1519), and the Laurentian Library (commissioned in 1524). These projects followed the cancellation of Michelangelo's first commission for the Medici at San Lorenzo, the erection of an all-marble facade for the church. Michelangelo remained in Florence working on the San Lorenzo projects until the death of Pope Clement in 1534. At the time of his departure, the chapel and library were well advanced but left unfinished. Not until the 1540s did Giorgio Vasari and his fellow Florentine artists substantially complete the projects as we know them today.

Monday, 24 July 1525

"Meo, will you please meet me in the Piazza San Lorenzo tomorrow morning a little earlier than usual so that we are not bothered by the sun and so that we can examine two pieces of marble. Get some of the others to come with you . . ."[4] Michelangelo penned this note to his trusted overseer, Meo della Chorte, an older and experienced Florentine craftsman. Meo was in charge of about a dozen marble carvers (*scarpellini*) who were helping Michelangelo with the interior decoration of the Medici Chapel at San Lorenzo (Fig. 81). These carvers were responsible for the chapel architecture and much of its marble ornament; Michelangelo carved the figural sculptures — *Day, Night* (Fig. 82); (see also P/R illus. 7.16), *Dawn*, and *Dusk*.

At his workshop in Via Mozza near San Lorenzo, Michelangelo reread the letter he had just received from Rome. His patron, Pope Clement VII (Giulio de' Medici), had acceded to Michelangelo's request to replace some faulty marble.

Michelangelo had ordered the blocks in Carrara more than six months earlier, but they had just arrived from the quarries. The blocks certainly were of impressive size, some as large as seven and eight tons. Marble this size had not been quarried in more than one thousand years — not since Roman times. The delivery of these giant blocks had excited much interest, especially when one of them slid crookedly off the back of the cart, breaking its axle and nearly crushing the hapless drayman.

Michelangelo had not been present at the delivery, but there were plenty of onlookers, many proffering unwelcome advice. Some persons wondered whether the growing mountain of marble would ever be anything other than a colossal mess that disfigured their piazza and disrupted business. Maestro Michelangelo seemed to work so slowly. Of course, they did not appreciate the years he spent quarrying marble for the aborted facade project, nor did they see him in the privacy of his workshop. There, long after the masons and carvers at San Lorenzo had gone home, Michelangelo worked by candlelight well into the night. He spent a small fortune on candles because he preferred an expensive variety made of pure goat's tallow.[5]

It seemed that Michelangelo worked slowly because he didn't finish one sculpture and then move on to the next. Rather, he worked simultaneously on more than a half-dozen blocks, depending on his fancy and creative urge or problems that temporarily stymied him. And even as figures neared completion, he tended to keep them in his workshop. The *Moses*, for example, was begun in 1513 but sat on the floor of his Roman studio for more than thirty years. Michelangelo constantly carved and rarely finished.

After unloading the blocks, the carters, Michele Lelli and Luca Fancellotti, went to find Michelangelo at the cathedral where they demanded payment for the delivery. For hauling the seven blocks from the river port at Signa, they charged forty-five *lire*, or about two months' wages for a skilled craftsman. Other middlemen had been paid for quarrying the blocks, bringing them down the mountain, and delivering them by oxcart to the marina where they were loaded on a ship hired in Genoa. The shippers charged little for the trip between Carrara and Pisa, but it cost a lot — in money, manpower, and equipment — to offload the giant blocks from ship to river barge for the trip upstream to Signa. From Signa, the blocks were once again loaded onto oxcarts and hauled the final nine miles to Florence.

Michelangelo paid Michele and Luca the forty-five *lire*. He trusted them, having worked with them for several years. However, when he returned to San Lorenzo he decided he had been overcharged. Of course, there were no scales to weigh such large blocks; one just eyed them and estimated their weight and how many oxen were required to haul each block — usually between ten and twenty — and how many days it required to get from Signa to Florence — sometimes one but often two, which cost more because the carters had to unharness and reharness the team, as well as feed and bed the oxen for the night.

The next time Michelangelo saw Michele and Luca he demanded nine *lire* back, and got it. The carters respected Michelangelo and knew that he understood their business almost as well as they did — rather remarkable given that

Michelangelo was an aristocratic artist working for the pope and had a nearly unlimited budget. Obviously, Michelangelo could speak the language of the carters, moved comfortably in their mundane world, and was knowledgeable about even the tiniest details of his enterprise.[6]

Michelangelo also had a legendary ability to judge the quality of a block of marble; it was even said that he could see the figure imprisoned in it.[7] More likely, his was knowledge gained from long experience and numerous disappointments. He could spot disfiguring veins, and he could judge the soundness of the block from a few hammer blows. Recently, however, not only had he been overcharged by the carters, but he felt certain that some of these big beautiful blocks were not as good as they seemed. He would ask Meo's opinion tomorrow.

Tuesday, 25 July

The workday was sunrise to sundown, six days a week, which meant a fourteen-hour day during the labor-intensive summer months. Saturday was payday, and Sunday was the day of rest. In addition, there were numerous church holidays – about fifty a year.[8]

Mostly Michelangelo worked with one or two assistants at his Via Mozza stu-

Figure 81. Michelangelo, Medici Chapel, S. Lorenzo, Florence, c. 1519–34 (photo: Charles Seymour, Jr. Archive)

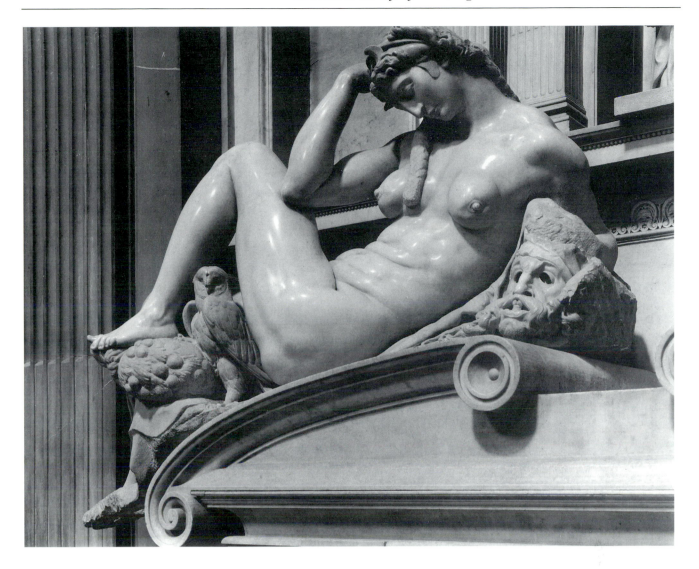

Figure 82. Michelangelo, *Night*, Medici Chapel, S. Lorenzo, Florence, c. 1519–34 (photo: Ralph Lieberman)

dio, arriving at San Lorenzo around midday to deliver drawings and instructions and to inspect work. This had become especially important because he had given some of his more experienced carvers license to invent on their own. Moreover, he recalled the incident with Francesco da Sangallo who, immediately after arranging to be paid for his carving "by the foot," tried to earn extra money by working more rapidly, but also more sloppily. Michelangelo had docked Francesco's pay because the work was not as finely finished as that of the previous week, and, noted Michelangelo on the weekly payroll, Francesco "didn't abide by what he promised."[9] There had been no more problems.

Michelangelo always supervised special tasks, such as the moving of a particularly large block or the raising of a column or cornice. For the most part, however, he left his overseer Meo in charge of the marble carvers, and the talented but independent Bernardino Basso ("He is a proper scoundrel, shun him like the devil") supervised the stone carvers at the library.[10]

Meo lived with some half-dozen of the most skilled marble carvers in a house that Michelangelo rented near San Lorenzo. Most other workers, such as the hundred stone carvers employed on the contemporaneous Laurentian Library,

walked to work or rode into Florence with the market carts. Many lived in nearby Fiesole and Settignano, two small villages in the hills overlooking Florence, a thirty- to forty-minute walk. As was usual practice, they brought their own tools, but Michelangelo provided the basic equipment needed in the workshop – benches, stools, and rulers – and hired a smithy to sharpen their chisels. In addition, he purchased a mallet, an extra-large hammer, and a bell to sound the hours. He built a hoist to raise the heavy blocks and a shed to protect the valuable marble. Michelangelo also purchased candles so that the marble carvers could work inside the New Sacristy during the gloom of inclement weather.[11]

Michelangelo did not furnish regular allotments of wine as was customary at some building sites, such as Milan cathedral and the Venetian Arsenal, nor did he provide a meal celebrating completion of an important portion of the project. On the other hand, his workers were paid well, better than the average skilled and unskilled laborers of Florence. This was a well-funded papal project; as long as the pope remained alive, San Lorenzo offered good employment.[12]

Meo and his companions were already at work when Michelangelo arrived at the piazza. On the back of the note that Michelangelo had sent him, Meo was scribbling calculations regarding the marble: how many running feet of molding could be obtained from the blocks on hand and so forth. But Michelangelo was not happy with the quality of the marble, and the artist insisted that Meo go to Carrara to deliver Michelangelo's precise instructions to the quarrymen. Although it had been more than twenty-five years since Michelangelo had selected the block for the Rome *Pietà* (Fig. 79), and four years since he himself had been to the quarries, he nonetheless was able to instruct Meo della Chorte exactly where to locate the vein of pure white marble that had yielded that earlier masterpiece.

Later that day, Meo departed for the quarries. Although normally Michelangelo would have gone to Carrara himself, he was learning how to delegate work to his competent subordinates. Moreover, a more enticing task lured Michelangelo: he wished to inspect a new source of marble in Seravezza, some ten miles southeast of Carrara.

Wednesday, 26 July

Michelangelo was on his way before dawn, but not before he wrote out a set of detailed instructions for his personal assistant Pietro Urbano, and left the man with forty *ducats* (more than two thousand dollars):

> Pay the bargemen when they present the bills of lading and keep the receipts; pay the carters for the marble they bring from Signa at the rate of 25 *soldi* per thousandweight for large pieces and 20 *soldi* per thousandweight for smaller, and keep track of who you pay and what they deliver; pay the 90 *lire* customs duty to the Duty Office and get the ledger and account sheets; give Baccio Puccione the money he asks for in connection with the work he has done on the Via Mozza workshop and make a note of it; buy some canes and trim the vines in the Via Mozza garden and try to find some earth or other dry material to put on the work-

shop floor; buy a rope about 60 feet long that won't rot and make a note of it; set-
tle the account with my brother Gismondo and get a reckoning from him; go to
confession, apply yourself to your studies, and take care of the house.[13]

The ride was long but uneventful; Florentine domination of Tuscany and a
Florentine pope ensured that it was a safe trip. Michelangelo had made the trip
many times before – more than fifteen times between 1516 and 1519 when he
had quarried marble for the aborted San Lorenzo facade project. He went by
way of Prato and Pistoia and on to Lucca where he sometimes stayed at an inn
overnight. Today, with a good start and a good horse, he could make the fifty-
mile trip in one weary day. The horse rented for five *lire*, nearly twice the cost
of a much slower mule and the equivalent of five days' wages for one of his
skilled marble carvers. Michelangelo had occasionally borrowed his family's
mule, but it was needed on the farm in Settignano. He had owned horses, but
they were expensive to keep, and since beginning the San Lorenzo projects he
had had little need for one.[14]

Late in the afternoon Michelangelo reached the house of his trusted quarry-
master Donato Benti in Riomagno, a hamlet at the foot of the imposing alpine
mountains. It was too late to make the long trek up to the quarries so Michelan-
gelo reviewed the quarrying operations with Benti and stayed the night in the
poor man's crowded house. Benti was a talented, independent sculptor, but,
with a wife and five children to support, he and his sons were happy to work
for Michelangelo, which they did for nearly twenty years. For his part,
Michelangelo was grateful for the man's loyal service and, as a token of his
appreciation, once presented Benti with a length of expensive black cloth with
which to make a new doublet.[15]

Thursday, 27 July

It took more than two hours to make the long climb to the remote quarry site
(Fig. 83).[16] An immense quantity of pearly white debris spilling down the steep
slope gave the mountain a glacial appearance. That same debris helped create a
causeway along which blocks were lowered, slowly, slowly . . . a few hundred
feet a day depending on how things went (Fig. 84).

Quarrying was difficult and dangerous work. Already one man had been killed,
and Michelangelo nearly so, when an iron ring snapped and a large block slid
down the slope and shattered into hundreds of pieces. The death was a regrettable
accident but not uncommon – there are still occasional deaths in the modern mar-
ble quarries. But Michelangelo particularly lamented the loss of the splendid block,
in which he had invested great expense and nearly a month in raising it from its
geologic slumber. In an uncharacteristic understatement, Michelangelo lamented
"one must have patience."[17]

Shortly after the earlier accident, Michelangelo had fallen ill, whether from
overexertion or the cold rains is uncertain. The doctor had prescribed a strict reg-

imen that included, over the course of three days, a glass of tamarind syrup and seven ounces of pomegranate wine and seven ounces of quince jam, as well as four glasses of sugar water eight times a day, and four glasses of rosewater with oil and one of chamomile. On subsequent days he was to ingest eight ounces of julep rosewater and various confections, including one and one-half ounces of poppies, one ounce of bitter almond and oil of lavender, and a concoction to reduce spasms.[18] His concerned brother Buonarroto wrote, "You must value your person more than a column, the whole quarry, the pope, and all the world. . . . Come home by all means and let everything else go to hell."[19]

Altogether, it had taken four months to assemble the necessary quarrying equipment, mostly pulleys, heavy-duty ropes, and oversize block and tackle. Eleven men were on the job, earning a handsome wage (thirty *soldi* each a day, or 50 percent more than the wage of a skilled marble carver). To lower one large block cost an astronomical sixty *ducats*, or more than most highly skilled craftsmen earned in an entire year. Michelangelo complained about the rough locale, the ignorance of his Florentine assistants, and the need to "domesticate" the mountains. Now with a large block poised for its descent, Michelangelo felt the flush of success and the real possibility of fulfilling his promise to create "the most beautiful work that has ever been made in Italy, with God's help."[20]

The quarrymen made good progress that day, but it would be several more days

Figure 83 (above). Marble Quarries, Seravezza (photo: author)

Figure 84. Lowering Marble (photo: author)

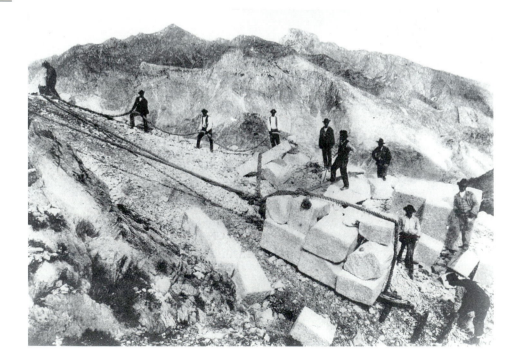

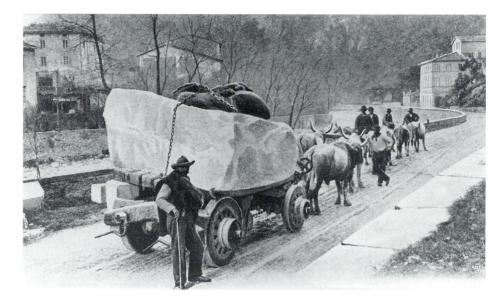

Figure 85. Transporting Marble (photo: author)

before the block reached the bottom, where Michelangelo's assistant would carve it into the rough shape ordered and then supervise its loading onto a cart for transport to the marina between seven and eight miles distant (Fig. 85). Because it would be three months to a year before Michelangelo saw the same marble in Florence, he made a measured drawing of every block that was ready for shipment (Fig. 86). He also made an order book with drawings for blocks he still needed and left it with the quarrymaster. If he remained a long time in the quarry – as he often did – he would draw scores of designs and sometimes fashion figures from red wax or clay.[21] He spent most of his time, however, in looking at prospective sites and marble samples, as well as in checking up on his quarry teams, scattered at numerous remote locales, and forever urging them to greater speed.

The majestic mountains and the limitless supply of the material he loved best helped stimulate Michelangelo's imagination and unleash his ambitions. It is said that, in emulation of the ancients, Michelangelo desired to carve a marble colossus using the entire mountain as his raw material.[22] But not today. The dark thunderclouds overhead warned of rapidly changing conditions – something that occurred with surprising frequency and potentially dangerous consequences in the high mountains.

Figure 86. Michelangelo, Drawings of Marble Blocks for the Medici Chapel (I, 82, fol. 230v–231r), Archivio Buonarroti, Florence, 1520s (photo: Archivio Buonarroti)

Friday, 28 July

Michelangelo returned to Florence by way of Pisa. He wanted to inspect the repairs made to the

hoist that Donato Benti had constructed for unloading the big blocks. Because of the unusual size of Michelangelo's marbles, the block and tackle had to be frequently replaced, at considerable expense. Even so, the rope recently had snapped, sinking a barge.

Michelangelo also wanted to check on the Arno River and pay the bargemen. Donati Benti had promised two of them a pair of shoes each for transporting especially large loads. Tingo and Remedio, the best bargemen on the river, promised to leave Pisa as soon as they could. It would take them about twenty days to make the trip to Signa, but the summer had been so hot that there was scarcely enough water to float the barges. "On this account I am more disgruntled than any man on earth," Michelangelo once lamented, "and I don't believe it will ever rain again . . . except to do me some mischief."[23] The bargemen were not sure if they could make another trip this season because the oxen used to haul the barges upstream might be needed for fall planting. If only the pope knew how much time Michelangelo spent worrying about rope, water, and bovines!

Back in Florence, Michelangelo did not bother to stop at San Lorenzo: the feast day of St. Martha was the next day, and the workers would have left early. At Via Mozza there was a letter from his friend and faithful assistant, Topolino, or "Little Mouse." The man's real name was Domenico di Giovanni di Bertino Fancelli per Ogni Santi, but everyone referred to him by the affectionate nickname. He wasn't the only worker that went by a nickname; practically half Michelangelo's workforce had some sort of sobriquet or pet name: the Stick, the Basket, the Little Liar, the Dolt, Oddball, Fats, Thorny, Knobby, Lefty, Stumpy, and Gloomy. There were assistants nicknamed the Fly, the Chicken, the Goose, the Horse, the She-Cat, the Porcupine, and the Woodpecker, as well as Nero, the Priest, the Rector, the Friar, the Godfather, the Turk, and – the likely butt of many jokes – the Anti-Christ.[24] Michelangelo knew them well because he recorded the name, days worked, and wage of every employee, every week (Fig. 87). Having grown up in the stone-working town of Settignano, Michelangelo was personally acquainted with most of his assistants; he was familiar with their talents and foibles and often knew and employed their fathers, cousins, and neighbors. Such familiarity was a form of quality control and helped ensure labor stability. It also helped Michelangelo to identify and recruit skilled labor, a potentially large problem for an artist without a *bottega* or a conventional artistic practice.

In his letter, Topolino reported having extracted several tons of marble, "among the most beautiful ever

Figure 87. Michelangelo, Employment Roster for 21 and 28 May 1524 (I, 41), Archivio Buonarroti, Florence (photo: Archivio Buonarroti)

quarried." He went on to complain about the capricious weather and his diffi-
culties with "these Carrarese rogues," who were proving to be reluctant work-
ers. It had been so stormy, wrote Topolino, that even the marble that had
already been quarried could not be shipped from Pisa, but it would be soon, "if
the weather gives us a break."[25] As usual, Topolino asked for more money.
Michelangelo certainly would send it, for despite the man's misplaced ambition
to be a great sculptor, Topolino was a skilled and thoroughly dependable quarry
manager. For Topolino and the quarrymen there were no holidays, only days
when the harsh weather prevented work. Michelangelo recalled the letter
Topolino wrote on Christmas Day asking Michelangelo to give greetings to his
wife and assuring him that he went up to the quarries "every day I can."[26]
Topolino was working hard, and so was Michelangelo, but this was the third day
that the sculptor had gone without touching his chisels. Tomorrow . . .

Saturday, July 29

Some months earlier, Michelangelo and his close assistant Baccio di Puccione
had made clay models of the Medici Chapel figures (Fig. 88). They were made
of inexpensive materials – clay mixed with tow, shearings, and string – built
around armatures of wood and wire. The two men had spent months building
four models. The models were life-size and nearly as heavy as their marble coun-

Figure 88. Michelangelo,
Model of a River God, Casa
Buonarroti, Florence, mid-1520s
(photo: author)

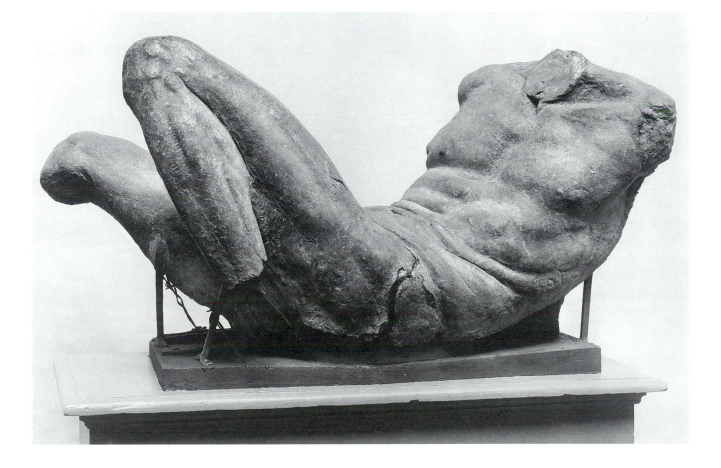

terparts. It was unusual to make full-size models, and it was time-consuming, but there was good justification for doing so. Michelangelo could not afford a mis-calculation of weight – what if a figure slipped off its curved support? – and he would have no other opportunity to judge the aesthetic effect of the figures before they were raised onto the sarcophagus lids. Thus, with the aid of a large wooden chest, Michelangelo tested the balance and appearance of the heavy, unorthodox figures. Having worked out the problems in models, Michelangelo could now proceed to translate the figures into marble.[27]

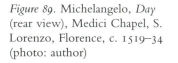

Figure 89. Michelangelo, *Day* (rear view), Medici Chapel, S. Lorenzo, Florence, c. 1519–34 (photo: author)

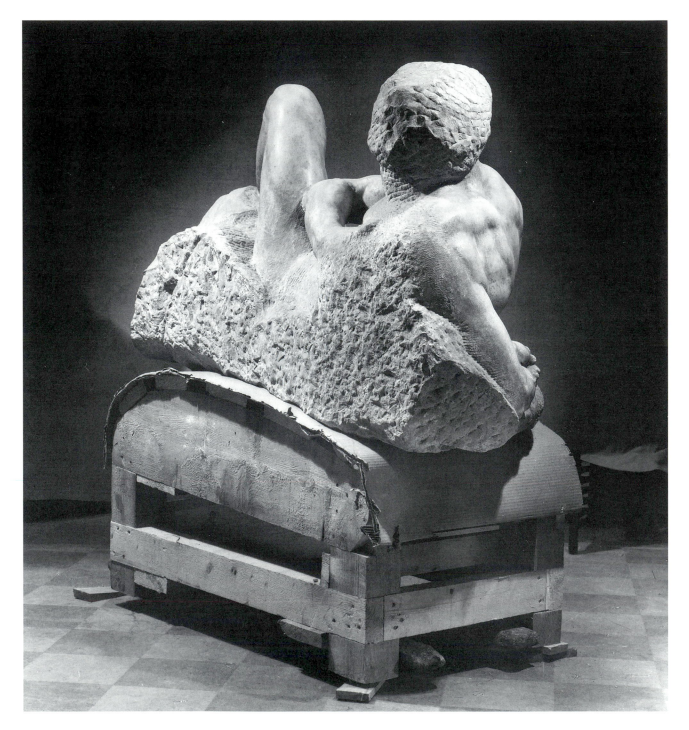

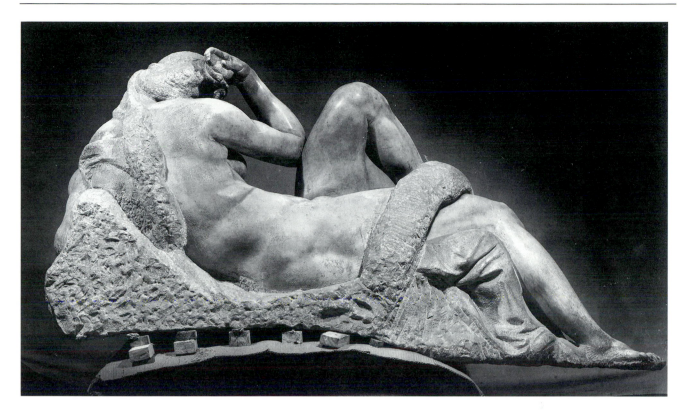

Figure 90. Michelangelo, *Night* (rear view), Medici Chapel, S. Lorenzo, Florence, c. 1519–34 (photo: author)

Michelangelo carved the marbles on heavy wooden tables that gave him access to all parts of the block (Fig. 89). Nonetheless, he had to keep in mind the figure's high placement, visualizing how it would be seen from below and in the context of a multifigure funerary complex. He worked with a wide-headed wood mallet and three chisels – a point for the rough and rapid working of the raw block (Fig. 90), a coarse claw chisel for the majority of figural carving, and a multitooth claw chisel (*gradina*) for the penultimate layer before polishing.[28]

How much tilt should he give the head? How much carving was needed at the rear of the block? How much marble could he remove before the projecting feet were in danger of being broken? Should he finish the figure in place to reduce the potential for damage? Would the figure look "right" once it was installed on the tomb?

Today he was going to work on the *Night* (Figs. 82 and 90), which was almost finished and even partly polished. The polishing was a punishing chore, carried out with rasps, pumice and grit, infinite patience, and lots of sweat. It took weeks, but he could not turn the task over to his assistants. Only Michelangelo could achieve the subtle variations in the surfaces of flesh, hair, and drapery. Cast in shadow, the face had to be polished less than the thigh, the hair less than the face. Moreover, he never did all the polishing at once. He worked little by little, often letting the figure rest for days while he judged the effect. As he brought a second figure to completion he might have to make corrections or adjustments to the first, yet another reason for not removing the carved sculptures from his studio too soon.

The results so far achieved were splendid. The surface of *Night* already had

a lustrous sheen that suggested the mysterious radiance of moonlight (Fig. 82). The beautiful but strangely muscular body was bent in impossible contortions; nonetheless, it had an air of perfect serenity. His assistant had tried the pose but failed to look comfortable or natural. Such a body was possible only in clay and marble. It was realizable only by Michelangelo. Poised ambiguously between sleep and wakefulness, *Night* was more divine than human, more flesh than marble. The final polishing was almost like painting, creating a subtlety of surface that was alluring, and alive. The figure was nearly complete, but one part – the left arm – still warranted the master's attention . . . and provoked some frustration.

As happened often, the block was not perfect. Despite his legendary ability to judge the quality of marble, and despite the pope's permission to reorder marble that Michelangelo deemed inferior, the artist could not abandon every block that proved to have a disfiguring vein, which many did. He often would cut out the bad marble or work around a bad spot; indeed, he purposely quarried his blocks extra thick so that he would have room to make adjustments as he carved a figure. The Julius tomb figures had taught him a painful lesson. He had discovered a crack running through the face and neck of the so-called *Rebellious Slave*. In trying to avoid the crack, Michelangelo sculpted the head as if it were tossed back; nonetheless, the thin block did not allow him to escape the disfiguring blemish.[29]

The marble of *Night* was vastly superior; even so, he encountered a bad area just below the figure's left shoulder. As Michelangelo removed the flaw, he found himself running out of room to carve the forearm and left hand. The contortion of the figure and the prominent mask would help disguise a problem that he could adequately but never perfectly resolve. But a sculpture less than perfect was a troubling thought.[30] He would not let anyone see the figure until he judged it truly finished. Having examined every surface with the palm of his hand, he picked up hammer and chisel and stepped up to the block. . . .

We have a remarkable contemporary description of the speed and energy of Michelangelo's carving, even in old age:

> I have seen Michelangelo, although more than sixty years old and no longer among the most robust, knock off more chips of a very hard marble in a quarter of an hour than three young stone carvers could have done in three or four, an almost incredible thing to one who has not seen it; and I thought the whole work would fall to pieces because he moved with such impetuosity and fury, knocking to the floor large chunks three or four fingers thick with a single blow so precisely aimed that if he had gone even minimally further than necessary, he risked losing it all . . . [31]

And Michelangelo himself reflected in a sonnet:

> If my crude hammer shapes the hard stones
> into one human appearance or another,
> deriving its motion from the master who guides it.[32]

Michelangelo evidently thought about poetry in the midst of carving for we frequently find poems scribbled on sheets made in the workshop. Michelangelo moved easily between poetry and sculpture. They were both forms of carving, the fashioning of beauty from raw materials, whether words or stone. The rhythmic strokes of the hammer suggested verse; his verse retained elements of its lapidary origins.

There was an exalted vision that drove the sculptor's arm, a spiritual meaning that lay beyond the sweat. At times, the poet and artist were one, divine, because like God, Michelangelo created human forms from inert material. He was so taken with the beauty of his *Night* that he kept carving – a lunar diadem, an owl, a large bunch of poppies, and a mask, which was really a mask within the mask, all strangely animated. The exuberant creator scarcely could restrain himself. He began to see how *Night*, coupled with *Day*, would form a suite of reclining figures – allegories of time and a meditation on transient fame.[33] Here again was the confidence of his Rome *Pietà*: the knowledge that he was a miracle worker, capable of anything, even of endowing marble blocks with human life. Today was one of those marvelous days when there was a perfect fusion of hand and chisel, sculptor and work, art and poetry. . . .

He had not eaten all day, nor bathed all week. His housekeeper, Mona Angiola, had prepared a fennel soup. Doodling on the back of a letter, Michelangelo noted his most recent meals: one consisted of pasta, a herring, two rolls, and a jug of wine; the second was more substantial: salad greens, four rolls, a plate of spinach, four anchovies, pasta, and wine. And then tonight's frugal repast: soup, a herring, bread, and wine.[34] He was busy, but it was also important that he eat lightly for he already was bothered at times by the kidney stones that would cause him such agony in his old age. He would have his Sunday meal with his father and brothers in Settignano. Their longtime family servant, Mona Margherita, would see that he was well fed.

Sunday, 30 July

Michelangelo rose later than usual but still before dawn; today was not a day to work unless to assist his father around the house. After reading some scripture Michelangelo went to confession at his old neighborhood church, Santa Croce. He spent time looking at the frescos by Giotto in the Bardi and Peruzzi chapels (where he had made his earliest drawings), at the tombs of Leonardo Bruni and Carlo Marsuppini (fine, but not so grand as his Medici mausoleum), and at the Annunciation tabernacle by Donatello (Fig. 73; beautiful despite being carved in the local *pietra serena* and not in marble).

From Santa Croce, Michelangelo walked past the houses on Via Ghibellina that he had purchased in 1508 and transformed into rental properties. His father generally lived at the family villa in Settignano, but when he came to Florence he stayed in a portion of the Via Ghibellina house. Outside Porta Santa Croce, the road rose gently, winding past farms and ripening vineyards. The walk took

about forty-five minutes and afforded a pleasant respite from the heat and foul smells of the city.

In honor of Martha's day, Mona Margherita cooked a pair of capons. Michelangelo assisted his father, Ludovico, with some chores, talked with his favorite brother, Buonarroto, about the wool shop he had in partnership with the Strozzi, conferred with Gismondo regarding certain accounts he was keeping for Michelangelo, and admonished Giovansimone for not showing proper respect to their father.

In the late afternoon, Michelangelo returned to Florence. He had to enter the gates before they were closed at dark; moreover, he wanted to get an early start the next morning. He had a light supper and some bitter almond cordial and rosewater to help with his digestion.

He had a busy week, although he had not carved much. He was really happy only when immersed in work, yet still in his workshop, mute witness to his many other obligations and constant interruptions, were the four allegories for the Medici Chapel, two blocks to carve the Medici dukes, the four partially carved slaves for the Julius tomb, a figure of *Victory* (Fig. 96), and so many other blocks, some begun . . . most just designs in his head. Now that he was a famous artist, he received frequent requests from friends, princes, and hopeful patrons. From the Venetian cardinal Domenico Grimani, to whom Michelangelo had promised a painting, he had recently begged indulgence: "I have many obligations, and I am old and ill disposed, so if I work one day, I need to rest for four."[35]

Three days this week he had found time to work on the Medici Chapel figures. It was not enough if he hoped to ever finish. Despite his weariness, he could not afford to rest. Michelangelo recalled the pope's recent admonition to concentrate on the Medici Chapel figures and "to think of nothing else."[36] How was that possible? With thousands of *ducats* invested in marble, hundreds of blocks in various locales between the quarries and Florence, and more than one hundred carvers who would appear at San Lorenzo tomorrow morning ready to work? Bernardino had asked him to make templates for the library moldings, and a problem with an incorrectly carved cornice in the Medici Chapel required his urgent attention. Meanwhile the pope had asked him for drawings of a crystal cross and ciborium for the high altar of San Lorenzo as well as designs for a reliquary tribune, papal tombs in the Medici Chapel, and a giant colossus to sit opposite the church. Clement repeatedly inquired about the reading desks and ceiling for the Laurentian Library; how many desks were there to be in the reading room and how many books on each desk; he wanted to know the source of the walnut wood, how long it had to cure, even the quality of the lime for making stucco . . . and yet, supposedly, Michelangelo was to think of nothing but the Medici Chapel figures![37]

At least the pope had a sense of humor – and a feeling for Michelangelo's human limitations. When pressed about the absurd notion of the fifty-foot colossus for Piazza San Lorenzo, Michelangelo finally was goaded into respond-

ing: Why not make it eighty feet tall with a barbershop under its ass, a cornucopia for a chimney, a dovecote in its hollow head, and bells ringing from its gaping mouth? He concluded the jesting letter with some gibberish that scarcely disguised his impatience: "To do or not to do the things that are to be done, which you say are not yet to be done, it is better to let them be done by whoever will do them, for I will have so much to do that I don't wish to do more."[38] A few days later, the pope replied in his own hand: "You know that popes do not live long, and we could not wish more than we do to see or at least to know that the chapel with the tombs of our family and also the library are finished . . . we pray that God give you courage to carry everything forward with all haste. Remain with God's blessing and ours."[39] Signed only with the initial of his given name – "G" for Giulio, as Michelangelo knew him when they were boys together in the house of Lorenzo the Magnificent – the letter was a frank expression of the pope's regard and warm affection for the artist. The subject of the colossus was quietly dropped.

Michelangelo felt fortunate to have this Maecenas for a patron; few others were as intelligent about art and as understanding toward the artist. Nonetheless, Michelangelo felt old. He was already fifty and beyond his life expectancy. Soon he would die . . . or so he expected. The interval would be filled by work and poetry. He hoped that he would live to complete the great projects at San Lorenzo. Tomorrow he would begin a figure of the Madonna and Child for the chapel. He took pen and paper, and he wrote: "Art and death do not go well together."[40]

Michelangelo did carve a Madonna and Child, which remained in his Via Mozza workshop when he departed for Rome in 1534. Although he considered himself old – and by Renaissance standards he was – Michelangelo still had the full lifespan of an ordinary mortal before him. He lived another forty-five years in Rome and died at nearly eighty-nine in 1564, the year that Galileo and William Shakespeare were born.

Notes

The picture sketched of one week in the life of Michelangelo is based on actual events and is drawn from a wealth of extant primary documentation, including letters, records, contracts, poetry, and drawings, as well as from the biographies of the artist written by Michelangelo's contemporaries Giorgio Vasari and Ascanio Condivi.

1. G. Vasari, *Lives of the Artists*, I, trans. G. Bull (London, 1987); 421 (hereafter Vasari, ed. Bull).
2. Leonardo's *Trattato* quoted from K. Clark, *Leonardo da Vinci*, rev. ed. (London, 1988), 136. Leonardo's remarks are part of the so-called *paragone*, or "comparison," a debate regarding the superiority of painting versus sculpture. The

topic is discussed in Baldassare Castiglione's *The Courtier* and by Benedetto Varchi who, in 1546, polled artists on the subject, including Michelangelo. For Michelangelo's response to Varchi, see E. H. Ramsden, *The Letters of Michelangelo*, II (Stanford and London, 1963), 2, 75 (hereafter Ramsden, *Letters*). On the *paragone* debate, see I. A. Richter, *Paragone: A Comparison of the Arts by Leonardo da Vinci* (London, 1949); J. White, "Paragone: Aspects of the Relationship between Sculpture and Painting," in *Art, Science, and History in the Renaissance*, ed. C. Singleton (Baltimore, [1967]); L. Mendelsohn, *Paragoni: Benedetto Varchi's 'Due Lezzioni' and Cinquecento Art Theory* (Ann Arbor, Mich., 1982); D. Summers, *Michelangelo and the Language of*

Art (Princeton, 1981), esp. 203–33, and C. J. Farago, *Leonardo da Vinci's Paragone: A Critical Interpretation with a New Edition of the Text in the Codex Urbinas* (Leiden, 1992).

3. The principal sources I have relied on are *Il Carteggio di Michelangelo; Edizione postuma di Giovanni Poggi*, ed. P. Barocchi and R. Ristori, 5 vols. (Florence, 1965–83) (hereafter *Carteggio*); *Il Carteggio indiretto di Michelangelo*, ed. P. Barocchi, K. L. Bramanti, and R. Ristori, 2 vols. (1988, 1995); *I Ricordi di Michelangelo*, ed. L. B. Ciulich and P. Barocchi (Florence, 1970) (hereafter *Ricordi*); *Le lettere di Michelangelo Buonarroti, pubblicate coi ricordi ed i contratti artistici*, ed. G. Milanesi (Florence, 1875); G. Vasari, *La vita di Michelangelo nelle redazioni del 1550 e del 1568*, ed. P. Barocchi, 5 vols. (Milan and Naples, 1962); and A. Condivi in *Michelangelo: Life, Letters, and Poetry*, trans. G. Bull (Oxford and New York, 1987) (hereafter Condivi, ed. Bull).

For Michelangelo's poetry I have used J. M. Saslow, *The Poetry of Michelangelo: An Annotated Translation* (New Haven and London, 1991), and for his drawings, C. de Tolnay, *Corpus dei disegni di Michelangelo*, 4 vols (Novara, 1975–80). In addition, I have made extensive use of my own book, W. E. Wallace, *Michelangelo at San Lorenzo: The Genius as Entrepreneur* (New York and Cambridge, 1994). A number of articles referred to in the following notes have been reprinted in W. E. Wallace ed., *Michelangelo: Selected Scholarship in English*, 5 vols. (New York, 1995) (hereafter, *Michelangelo: Selected Scholarship*).

4. *Carteggio*, III, 93; for an English translation of this letter, see Ramsden, *Letters*, I, 155.

5. Vasari, ed. Bull, 423.

6. For the particular instance involving Michele and Luca, as well as discussion of the complicated process of transporting marble, see Wallace, *Michelangelo at San Lorenzo*, esp. 51–62. See also A. Burford, "Heavy Transport in Classical Antiquity," *The Economic History Review* XIII (1960): 1–18, and C. Klapisch-Zuber, *Les Maîtres du Marbre: Carrare, 1300–1600* (Paris, 1969).

7. The most famous expression of this notion is found in Michelangelo's poem that begins "Non ha l'ottimo artista alcun concetto . . . " (Saslow, *Poetry*, no. 151; see also no. 236). For a discussion, see Summers, *Michelangelo and the Language of Art*, 203–33; R. J. Clements, *Michelangelo's Theory of Art* (New York, 1961), and C. de Tolnay, *The Art and Thought of Michelangelo*, trans. N. Buranelli (New York, 1964), ch. 4.

8. Wallace, *Michelangelo at San Lorenzo*, 103–4, 110.

9. For the incident, see *ibid.*, 124–5.

10. The well-documented and colorful Bernardino Basso offers an unusually full glimpse of the life and work of a skilled Renaissance artisan. See W. E. Wallace, "Michelangelo at Work: Bernardino Basso, Friend, Scoundrel and Capomaestro," *I Tatti Studies*, III (1989): 235–77, and Wallace, *Michelangelo at San Lorenzo*, esp. 175–9.

11. Notices of equipment and supplies for Michelangelo's workshop are found among his miscellaneous records or *ricordi*, for which see *Ricordi*, ed. Ciulich and Barocchi.

In general, on Renaissance workshops and workshop practice, see M. Wackernagel, *The World of the Florentine Renaissance Artist*, trans. A. Luchs (Princeton, 1981); E. Camesasca, *Artisti in bottega* (Milan, 1966); B. Cole, *The Renaissance Artist at Work* (New York, 1983); S. Connell, *The Employment of Sculptors and Stonemasons in Venice in the Fifteenth Century* (New York and London, 1988); *The Artist's Workshop*, ed. P. M. Lukehart, Studies in the History of Art, XXXVIII (Washington, D.C., 1993), and A. Thomas, *The Painter's Practice in Renaissance Tuscany* (New York and Cambridge, 1995).

12. On wages and work conditions, see Wallace, *Michelangelo at San Lorenzo*, 103–5; R. A. Goldthwaite, *The Building of Renaissance Florence: An Economic and Social History* (Baltimore and London, 1980), esp. 317–50 and 435–9; M. Warnke, *The Court Artist*, trans. D. McLintock (Cambridge, 1993), esp. 132–42; B. Pullan, "Wage-Earners and the Venetian Economy, 1550–1630," in *Crisis and Change in the Venetian Economy in the Sixteenth and Seventeenth Centuries*, ed. B. Pullan (London, 1968), 146–74; C. M. de La Roncière, *Prix et Salaires à Florence au XIVe siècle (1280–1380)* (Paris, 1982), and *Artigiani e salariati: Il mondo del lavoro nell'Italia dei secoli XII–XV* (Pistoia, 1984).

13. *Carteggio*, II, 174–5 (for an English translation of this letter, see Ramsden, I, 124).

14. On the luxury of owning a horse, see W. E. Wallace, "Miscellanae Curiositae Michelangelae: A Steep Tariff, a Half-Dozen Horses, and Yards of Taffeta," *Renaissance Quarterly* XLVII (1994): esp. 336–9 (reprint in *Michelangelo: Selected Scholarship*, V, 428–48).

15. On Donato Benti, see Wallace, *Michelangelo at San Lorenzo*, 29–32.

16. Related to the ensuing description of marble quarrying are the following books and articles on technology, construction, and the building trades: *A History of Technology*, ed. C. Singer, 5 vols. (London, 1954–8); R. J. Forbes, *Studies in Ancient Technology*, 2d ed., 9 vols. (Leiden, 1964–72); D. Arnold, *Building in Egypt: Pharaonic Stone Masonry* (New York, 1991); A. G. Drachmann, *The Mechanical Technology of Greek and Roman Antiquity* (Copenhagen, 1963); B. Ashmole, *Architect and Sculptor in Classical Greece* (New York, 1972); J. J. Coulton, *Ancient Greek Architects at Work* (Ithaca, N.Y., 1977); J. G. Landels, *Engineering in the Ancient World* (Berkeley and Los Angeles, 1978); M. E. Blake, *Ancient Roman Construction in Italy from the Prehistoric Period to Augustus* (Washington, D.C., 1947); J. B. Ward-Perkins, "Quarrying in Antiquity: Technology, Tradition, and Social Change," *Proceedings of the British Academy* LVII (1971): 137–58; *idem, Marble in Antiquity* (London, 1992); F. B. Andrews, *The Mediaeval Builder and His Methods*

(1925; reprint, Totowa, N.J., 1974); P. Du Colombier, *Les Chantiers des Cathédrales*, rev. ed (Paris, 1973); J. James, *Chartres: The Masons Who Built a Legend* (London, 1982); L. F. Salzman, *Building in England Down to 1540: A Documentary History* (London, 1967); Klapisch-Zuber, *Les Maîtres du Marbre*; Goldthwaite, *Building of Renaissance Florence*; L. and T. Mannoni, *Marble: The History of a Culture* (New York, 1985); J. Fitchen, *Building Construction Before Mechanization* (Cambridge, Mass., 1986), and *Les Chantiers de la Renaissance*, ed. J. Guillaume (Paris, 1991).

17. On the specific incident as well as the constant danger from quarrying, see Wallace, *Michelangelo at San Lorenzo*, 45–51.

18. *Ricordi*, 20–2, 41–2.

19. *Carteggio*, II, 85.

20. *Ibid.*, 82–3 (for an English translation of this letter, see Ramsden, *Letters*, I, 117–18).

21. On these order books for marble, see W. E. Wallace, "Drawings from the *Fabbrica* of San Lorenzo during the Tenure of Michelangelo," in *Michelangelo Drawings*, ed. C. H. Smyth (Washington, D.C., 1992), 117–41 (reprint in *Michelangelo: Selected Scholarship*, III, 17–41), and Wallace, *Michelangelo at San Lorenzo*, 41–3. On the making of small models, see J. Montagu, "Disegni, Bozzetti, Legnetti and Modelli in Roman Seicento Sculpture," in *Entwurf und Ausführung in der europäischen Barockplastik*, ed. P. Volk (Munich, 1986), 9–30.

22. Condivi, ed. Bull, 24–5, and related by Vasari as well (Vasari, ed. Bull, 343). The story is an ancient *topos*. Michelangelo probably was familiar with a similar story told by the ancient architect Vitruvius (Preface, Book 2 of *De Architectura*) about Dinocrates, the Greek architect who imagined carving Mt. Athos into the likeness of a man for Alexander the Great.

23. *Carteggio*, II, 129 (for an English translation of this letter, see Ramsden, *Letters*, I, 121).

24. On the sometimes colorful names of Michelangelo's assistants, see Wallace, *Michelangelo at San Lorenzo*, 101–2, 164–6. On Renaissance names, see also C. Klapisch-Zuber, "The Name 'Remade': The Transmission of Given Names in Florence in the Fourteenth and Fifteenth Centuries," in *Women, Family, and Ritual in Renaissance Italy*, trans. L. G. Cochrane (Chicago and London, 1985), 283–309; D. Herlihy, "Tuscan Names, 1200–1530," *Renaissance Quarterly* XXXXI (1988): 561–82; R. S. Lopez, "Concerning Surnames and Places of Origin," *Medievalia et Humanistica* VIII (1954), 6–16; P. Barolsky, *Why Mona Lisa Smiles and Other Tales by Vasari* (University Park, Pa., 1991) and *idem, Giotto's Father and the Family of Vasari's 'Lives'* (University Park, Pa., 1992).

25. Such complaints frequently occur in the correspondence between Topolino and Michelangelo; see especially *Carteggio*, II, 332, 362, 365, and III, 44–5, 59, 68–9.

26. *Carteggio*, III, 123.

27. On the practice of making small and full-size models, see *Vasari on Technique*, trans. L. S. Maclehose, ed. G. B. Brown (1907; reprint, New York, 1960), 148–53; B. Cellini, *The Treatises of Benvenuto Cellini on Goldsmithing and Sculpture*, trans. C. R. Ashbee (New York, 1967), 135–6; Camesasca, *Artisti in Bottega*, ch. 14, 299–317; I. Lavin, "Bozzetti and Modelli: Notes on Sculptural Procedure from the Early Renaissance through Bernini," in *Stil und Überlieferung in der Kunst des Abendlandes: Akten des 21. Internationalen Kongresses für Kunstgeschichte in Bonn 1964*, II: *Michelangelo* (Berlin, 1967), 93–104; R. Wittkower, *Sculpture: Processes and Principles* (New York, 1977), esp. ch. 6; and J. Montagu, *Roman Baroque Sculpture: The Industry of Art* (New Haven and London, 1989), 36, 111.

On Michelangelo's models in particular, see L. Goldscheider, *A Survey of Michelangelo's Models in Wax and Clay* (London, 1962), and Wallace, *Michelangelo at San Lorenzo*, 92–3.

28. The point chisel work is most visible on the lower part of each block. The coarse claw chisel marks are well seen on *Day*'s head, and the *gradina* marks on each figure's shoulder. See also Fig. 1. On the sculptor's tools, technique, and procedure, see Pomponio Gaurico, *De Sculptura* (Florence, 1504; facs. ed. New York and Williamstown, 1981); Orfeo Boselli, *Osservazioni della scultura antica*, ed. P. D. Weil (Florence, 1978); C. Blümel, *Greek Sculptors at Work* (1927; London, 1955); K. Friederich, *Die Steinbearbeitung in ihrer Entwicklung vom 11. bis zum 18. Jahrhundert* (Augsburg, 1932); S. Casson, *The Technique of Early Greek Sculpture* (Oxford, 1933); B. Putnam, *The Sculptor's Way* (New York, 1948); J. C. Rich, *The Materials and Methods of Sculpture* (Oxford, 1963); S. Adam, *The Technique of Greek Sculpture in the Archaic and Classical Periods* (London, 1966); V. W. Egbert, *The Medieval Artist at Work*, (Princeton, 1967); H. J. Etienne, *The Chisel in Greek Sculpture* (Leiden, 1968); L. R. Shelby, "Medieval Masons' Tools: The Level and the Plumb Rule," *Technology and Culture* II (1961): 127–30; *idem*, "Medieval Masons' Tools II: Compass and Square," *Technology and Culture* VI (1965): 236–48; Wittkower, *Sculpture: Processes and Principles*; P. Rockwell, "Stone-carving Tools: A Stonecarver's View," *Journal of Roman Archaeology* III (1990): 351–7, and *idem, The Art of Stoneworking: A Reference Guide* (Cambridge, 1993).

29. Michelangelo had to recarve the *Risen Christ* because the first block proved bad (see Wallace, "Miscellanae Curiositae," 332, and A. Parronchi, "Il primo 'Cristo Risorto' per Metello Vari," in *Opere Giovanili di Michelangelo*, II [1975], 157–90). So too did frustration with the quality of the marble, which Michelangelo found hard and full of emery, partly explain his abandoning the Florentine *Pietà* (Vasari, ed. Bull, 404).

30. Giorgio Vasari wrote: "For Michelangelo used to say that if he had had to be satisfied with what he did, then he

would have sent out very few statues, or rather none at all. This was because he had so developed his art and judgment that when on revealing one of his figures he saw the slightest error he would abandon it and run to start working on another block, trusting that it would not happen again. He would often say that this is why he had finished so few statues or pictures" (Vasari, ed. Bull, 404).

31. Quoted from I. Lavin, "David's Sling and Michelangelo's Bow: A Sign of Freedom," in *Past-Present: Essays on Historicism in Art from Donatello to Picasso* (Berkeley, 1993), 43; see also R. J. Clements, "Michelangelo on Effort and Rapidity in Art," *Journal of the Warburg and Courtauld Institutes* XVII (1954): 301–10 (reprint in *Michelangelo: Selected Scholarship*, V, 327–36).

32. Saslow, *Poetry*, no. 46.

33. On the attributes of *Night* and the allegorical meaning of the times of day, see Condivi, ed. Bull, 46; Vasari, ed. Bull, 368–9; E. Panofsky, "The Mouse that Michelangelo Failed to Carve," in *Essays in Memory of Karl Lehmann*, ed. L. F. Sandler (New York, 1964), 242–51 (reprint in *Michelangelo: Selected Scholarship*, III, 88–101); idem, "The Neoplatonic Movement and Michelangelo," in *Studies in Iconology* (1939; New York, 1972), 171–230 (reprint *in Michelangelo: Selected Scholarship*, V, 253–326); C. E. Gilbert, "Texts and Contexts of the Medici Chapel," *Art Quarterly* XXXIV (1971): 391–409 (reprint in *Poets Seeing Artists' Work: Instances in the Italian Renaissance* [Florence, 1991], 227–48, and in *Michelangelo: Selected Scholarship*, III, 103–21); and J. T. Paoletti, "Michelangelo's Masks," *Art Bulletin* LXXIV (1992): 423–40 (reprint in *Michelangelo: Selected Scholarship*, V, 399–416).

34. *Ricordi*, 37–8. For an illustration of the sheet, see Tolnay, *Corpus dei disegni*, no. 117. On Michelangelo's personal habits, see Condivi, ed. Bull, 69–70, 72; Vasari, ed. Bull, 423–4, 430.

35. *Carteggio*, II, 384 (my translation; for a complete English translation of this letter, see Ramsden, *Letters*, I, 145–6). In the last thirty years of his life Michelangelo completed only the two frescoes in the Pauline Chapel and three sculptures: the *Rachel* and *Leah* for the tomb of Julius II, and the *Bust of Brutus*. This paucity was evident even to his greatest champion, Giorgio Vasari: " . . . there are few finished statues . . . and those he did finish completely were executed when he was young" (Vasari, ed. Bull, 404).

36. *Carteggio*, III, 24; see also similar, repeated admonitions, 25, 95, 210, 212, 214–15, 224, 232, 233.

37. See discussion of the frequent correspondence between the patron and Michelangelo in Wallace, *Michelangelo at San Lorenzo*, 136–7.

38. *Carteggio*, III, 191 (my translation; for a complete English translation of this letter, see Ramsden, *Letters*, I, 164–5).

39. *Carteggio*, III, 194–5 (my translation).

40. Saslow, *Poetry*, no. 283.

Michelangelo: Sculpture, Sex, and Gender

James M. Saslow

BEGINNING IN THE ARTIST's own lifetime, observers recognized an element of gender ambiguity in the sculpture, as well as in the painting and poetry, of Michelangelo Buonarroti (1475–1564) – though their reactions varied widely. His friend and biographer Giorgio Vasari praised Michelangelo's early statue of *Bacchus* (Fig. 91) for its androgynous mixture of male and female traits, "a marvelous harmony of various elements, notably . . . the slenderness of a youth combined with the fulness and roundness of the female form." In contrast, Ludovico Dolce, in his treatise *L'Aretino* (1557), complained that the master "does not know or will not observe these differences" between male and female because his women look like men (compare the *Night* from the Medici Chapel, Fig. 82).[1] Commentators ever since have continued to notice this ambiguity, especially its pervasive homoeroticism. Although some still deplore it, critics more openly attuned to issues of gender and sexuality view Michelangelo's oeuvre as a landmark in an emerging early modern vision of homosexuality, which gradually led to the artist's canonization as the archetype of the creative homosexual.

The experimental, unstable, even unorthodox permutation of sex and gender in Michelangelo's work offer a revealing case study in both sociological and individual terms. Early modern culture was greatly concerned with defining norms of sex and gender behavior; Castiglione's *Courtier* (1528) is only the best known of many advice manuals on male and female deportment. And the Renaissance is of special interest to such inquiry as the earliest Western era in which we can relate art to the biography of its creator and thus "read" an individual's attempt to negotiate the intersection between self and society. Psychologically, such issues were central to Michelangelo's own life and work, and the products of his lifelong obsession with the eroticized male body have held unequaled sway over Western images of ideal beauty. This impact is partly due to the unique physicality of sculpture, the medium with Michelangelo himself most closely identified: sculpture's sheer material presence far exceeds painting in the ability to literally "embody" real masses in three-dimensional space, to evoke the tactile presence that underlies sexual desire.

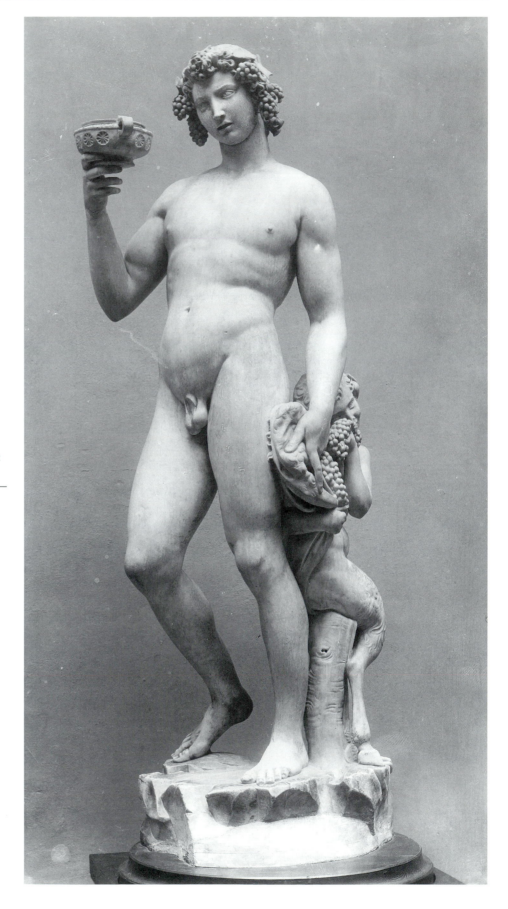

Figure 91. Michelangelo, *Bacchus*,
Museo Nazionale del Bargello,
Florence, c. 1496–98 (Alinari/Art
Resource, N.Y.)

Both the sources and the meanings of Michelangelo's treatment of gender are manifold and overlapping. They range from current aesthetic and social theories to the available classical sources for sculpture, the interests of specific patrons and advisors, and the artist's own unique psychosexual makeup. Consequently, the methods needed to understand this legacy extend beyond art history to embrace social history, particularly sexual practices and attitudes; intellectual history, including the philosophy and theology that separated normal from deviant; and psychology, which takes as its premise that, alongside its public meanings, a work of art is also an artist's attempt to resolve personal conflicts through symbolic creativity – to express both the exaltation of love and the anxiety of unacceptable desires. (As used here, the term *sex* is biological, referring to the body as male or female and the term *gender* is cultural, a system of assigning qualities to the sexes as appropriately masculine or feminine; *sexuality*, or eros, although founded on biological desire, is socially channeled.)

The psychological aspect is of particular importance for Michelangelo, who as much as admitted that all his art, whether visual or written, was in some sense autobiographical: in sculpting or painting another, declares poem no. 242, "one portrays himself."[2] Moreover, he called himself "the most inclined to love persons," and love was the driving force and greatest satisfaction of his life. Fortunately, he is the best-documented artist up to his time, having left us more than five hundred surviving letters, three hundred poems, and two contemporary biographies, by Vasari and Ascanio Condivi (a thinly disguised autobiography). His poetry often uses sculptural metaphors or images, so the two media are mutually informative. Though he carved and wrote about both men and women, the focus here is on the male figure, which so dominated both his work and his emotions: his dozens of verses to Tommaso de' Cavalieri are the first large body of love poetry in any modern European vernacular directed by one man to another.

Whether Michelangelo was homosexual, in the modern sense of a self-conscious identity, has long been debated. Certainly he was almost exclusively homosexual in orientation, though he had strong inhibitions about acting on those desires and was probably celibate in later life. But where Renaissance society drew a sharp divide between chaste feeling and forbidden behavior, what controls sexual identity today is the object of one's attraction rather than the degree to which that desire is expressed. Especially because he resisted physical acts, Michelangelo would not have thought of himself as "a homosexual," an identity that only crystallized much later; but his passionate outpourings of feeling are inspired by other men, and the reasons he seldom acted on these feelings physically are a crucial part of his homosexual psychology, not a proof of its absence.[3]

What seems like a contradiction to us was Michelangelo's logical response to his Christian culture, which held homosexual acts in unique opprobrium even as it confronted the alternative vision of a more erotic and freely bisexual classi-

cal arcadia. The central energizing tension of the Renaissance was the attempt to reconcile Catholic faith with the knowledge and values found in a newly revered pagan antiquity and the emerging secular sciences. Michelangelo's twin subject matters – the classical and the Christian – embody these opposing strands of Renaissance culture, intertwined in a fateful dialectic.

From classical literature and philosophy, Michelangelo absorbed both a knowledge of pederastic sexual relations between grown men and youths and the emotional ideal of *amicitia* – passionate friendship between men, who alone were considered capable of loving one another with comradely understanding – which the Neoplatonic philosophers developed into the highest poetic attachment. Antiquity not only challenged Christian sexual mores, but provided a visual model of this homoerotic male ideal in myriad surviving sculptures of Apollo, Pan, Bacchus, and Antinous. Christianity, equally misogynistic, also celebrated chaste male friendship, but reviled homosexual intercourse as part of the unspeakable act of sodomy, which St. Thomas Aquinas labeled the "sin against nature." Secular authorities concurred by making sodomy a civil crime, the penalties for which were continually increased.

Although these laws were only sporadically enforced, their existence registered the limits of open expression and inculcated caution, guilt, and self-repression. Discomfort with sexuality in art could lead to censorship, as when breeches were added to the nudes of Michelangelo's *Last Judgment*, or to discretion and bowdlerization: Michelangelo's poetry had to wait some sixty years after his death for publication, at which time his nephew and editor changed the sex of many addressees or appended moralizing paraphrases that allegorized unorthodox male passions beyond recognition. Small wonder, then, that his life and work are filled with sexual conflicts and frequent changes of attitude. As the nineteenth-century historian John Addington Symonds was the first to observe, "the tragic accent discernible throughout Michelangelo's love poetry may be due to his sense of discrepancy between his own deepest emotions and the customs of Christian society."[4]

How, then, was Michelangelo's sculpture shaped by contemporary views of gender and sexuality, particularly homosexuality? And how did it participate in the wider cultural project of defining gender norms, whether mirroring or subverting them? To answer such questions, we must triangulate between three sources of meaning: patrons, artist, and spectators. Their interactions are best examined chronologically, because his sculptures fall into distinct phases, and his personal evolution was bound up with broader changes in Renaissance society. In his early period, homoerotic classical subjects appealed to the artist and his private patrons; in his later public works, usually religious, homosexuality was more implicit and problematic; and a brief synthesis achieved in the 1530s gave way to a final rejection of sexuality in life and art. These phases are not a simple linear progression, but a dynamic interplay between opposing sensibilities that persisted throughout his life – and, indeed, are still with us.

Early Works: Greek Love Reborn

The student works and private commissions from the first decade of Michelangelo's career include the bulk of his mythological statues, which often carried significant homoerotic overtones. Such subjects were common currency among Renaissance art patrons and collectors, as but one aspect of the extensive recovery of antique art, mainly sculpture, as well as literature. Beyond general public interest, however, Michelangelo often chose these themes because they held some personal appeal among his circles of cultivated patrons, mentors, and teachers, and for the artist himself.

After an abbreviated apprenticeship with the painter Ghirlandaio, Michelangelo began studying sculpture in the "garden" workshop where the Medici family permitted access to their collection of antiquities. The fourteen-year-old apprentice made a faithful copy after a classical bust of a faun, which Vasari tells us was "in appearance very old, with a long beard and a laughing face." This earliest recorded work, though long lost, brought him the attention and patronage of the Florentine Republic's first citizen, Lorenzo de' Medici "the Magnificent," a discriminating patron and notable poet.[5]

Surrounded by writers, philosophers, and fellow artists profoundly fascinated with pagan antiquity, the young prodigy absorbed the lyrical, gently erotic, and Neoplatonic culture focused at Lorenzo's informal "court." Its central theorist was Marsilio Ficino, who translated Plato's dialogue on love, the *Symposium*, and endorsed its praise of pederastic eros; similar homoerotic themes appeared in the poetry and drama of Angelo Poliziano and were illustrated by such painters as Botticelli and Signorelli. Whereas Neoplatonic philosophy preached the uplifting ascent of love from the earthly body to the heavenly soul, the language in which it described both types of ecstatic union left room for considerable ambiguity in the passionate friendships between Ficino and the young Giovanni Cavalcanti or Girolamo Benivieni and Giovanni Pico della Mirandola.

Fauns, a familiar goat-footed subject from the world of classical pastorale, were satyrlike creatures proverbial for their randy, often tragicomic omnisexuality. Such ancient demigods had never been truly forgotten, but what marked their renewed popularity in the Renaissance was, in Erwin Panofsky's famous phrase, the reintegration of classical form with classical content. Antique sculptures featuring the homosexuality of legendary rustics became well known, such as a drawing made about 1455 by the school of Squarcione after a Roman relief in which a group of satyrs engage in fellatio.[6] At about the time Michelangelo was carving his faun, Signorelli painted for the Medici *The School of Pan*, which depicts the half-goat leader of the satyrs and fauns as classical literature records him, teaching music to the handsome nude boy Olympus, whom the infatuated deity made his disciple and lover.

Vasari's famous anecdote about the reception of Michelangelo's faun suggests a psychological parallel between the Greek myth and Michelangelo's own emo-

tional life. Lorenzo praised the head but joked that such an old man would not retain all of his teeth; mortified, Michelangelo promptly knocked one of them out. In this touching sign of his desire to please a mentor, he seems to have projected onto the faun, identified with Lorenzo, the archetypal relationship illustrated in *The School of Pan*: the love between an older and a younger man, educational and inspiring but also infused with a sexual charge. The faun/Lorenzo represented the first in a series of eroticized father figures whose loving encouragement Michelangelo yearned for, introducing the sublimated passion that would continue to inform his commissions from powerful male patrons.

Although Michelangelo's knowledge of the classical heritage did not extend to reading the original sources, others could and did translate for him. The most suggestive was Angelo Poliziano, the linguist and author whose verse drama, *L'Orfeo*, of 1480 provided an early, if misogynistic, literary justification of homosexuality as love for "the better sex," and who reportedly died from leaving his sickbed to serenade an adored young man. We can only speculate on the degree to which Michelangelo's own emerging homosexual feelings might have led him to feel a personal sympathy with Poliziano, but in artistic terms the poet forcefully shaped his protégé's iconographic interests. Condivi tells us that "recognizing in Michelangelo a superior spirit," Poliziano "loved him very much and . . . continually urged him on in his studies, always explaining things to him and providing him with subjects."[7]

Among the plots Poliziano suggested was that of the *Battle of the Centaurs*, which Michelangelo carved about 1492 (Fig. 92). Poliziano recounted in detail the myth, familiar from Ovid and others, of the wedding at which drunken centaurs tried to carry off the mortal women present, including the bride. The resulting fierce battle between the menfolk and the half-horse invaders symbolized the struggle of orderly civilization against the constant threat of disruption by the bestial irrationality within human nature. Officially, the legend concerned heterosexual desire run amok, but the combat between male centaurs and male humans was susceptible to further readings.

Already in this sculpture, Michelangelo shows his characteristic disinterest in narrative precision: only one horse body is clearly visible, at the bottom center, and the relief seems to depict a tangle of nude humans grappling with one another. Michelangelo hated to add symbolic appendages to his favorite subject, the unadorned male body (most of his angels similarly lack wings). This generalized beauty could signify either heroic action or eros – or, as in this work, where the energetic nude wrestling is all but indistinguishable from sexual embrace, an evocative blending of both.

A similarly suggestive work is the large classically inspired marble Hercules that Michelangelo, bereft of commissions after the death of Lorenzo de' Medici, carved for himself between 1492 and 1494. More than the faun or centaur, Hercules was a subject with repeated interest for the artist and appeared in a later drawing and in a statuette symbolizing devoted friendship. The muscular hero's

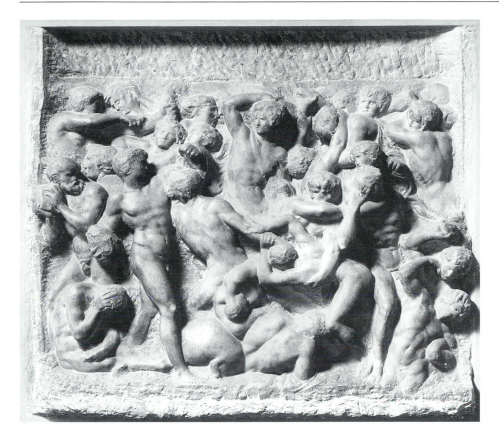

Figure 92. Michelangelo, *Battle of the Centaurs*, Museo Nazionale del Bargello, Florence, c. 1492 (Alinari/Art Resource, N.Y.)

customary public meaning was the epitome of the Greek warrior-athlete, but Hercules was also bisexual; indeed, he was busiest of all Greeks homosexually: his passion for the youth Hylas is celebrated in Poliziano's *L'Orfeo* in a catalogue of divine boy-lovers, including Apollo and Jupiter (lines 346–53). The young artist's visualization of an admired older man, now lost, no doubt embraced this erotic connotation, perhaps as a psychic memorial to Michelangelo's own beloved hero, Lorenzo.

His student days abruptly ended by Lorenzo's death and the French invasion of Florence, Michelangelo moved to Rome in 1496. Here he found a new circle of patrons for his mythological subjects: from the 1490s into the 1520s, High Renaissance Rome tolerated a hedonistic, even licentious, culture of light-hearted, classically inspired bisexuality. Michelangelo could also see ancient sculptures at first hand: throughout the old capital, surviving monuments were visible in the streets, and antiquities unearthed almost daily were snatched up for the collections of private connoisseurs, some with a special interest in homo-erotic history. The best-known of these influential discoveries was the Hellenistic marble of the vigorously bisexual Apollo, later given pride of place in the Vatican Belvedere (see the Renaissance statuette inspired by it in Fig. 52). Among the most widespread were statues of the Roman ephebe Antinous, beloved of Hadrian, erected throughout his realms by the griefstricken emperor after the youth's untimely death.

For one such patron and collector, the gentleman banker Jacopo Galli, Michelangelo carved a *Bacchus* in c. 1496–98 (Fig. 91), later set up in Galli's gar-

den among numerous ancient fragments (P/R illus. 6.41). The god of wine stands in a precarious *contrapposto*, brandishing the goblet whose contents have made him literally tipsy, with a grinning young satyr behind him who nibbles lasciviously at the grapes in his lower hand. The young ephebe is lazily seductive and androgynous, his softly modeled flesh and sensuously swaying form combining, as Vasari observed, boyish slenderness with female roundness. Antinous and the Apollo Belvedere were among several classical models available for this androgynous ideal; the most popular in art was Ganymede, the mortal shepherd boy carried off to Olympus by a smitten Jupiter to be his cupbearer and bedfellow.

As it did with all mythic characters, Neoplatonic philosophy assigned Bacchus a morally uplifting symbolism, in this instance as the allegorical source of divine inspiration. But the ancient associations of the patron of sensual abandon were equally erotic, and were bisexual: well-known sources recounted Bacchus's pursuits of both the princess Ariadne and the youth Ampelos. He shared with Pan the woodland acolytes who were long understood as playfully homosexual; one sculpture Michelangelo would certainly have studied in Rome was Filarete's early classicizing bronze doors for St. Peter's, cast in the 1440s, where a baby satyr tugs at the penis of an older one who is sleeping.[8]

The bisexual ephebe intersected with the hermaphrodite or androgyne symbolism common throughout Renaissance culture. The hermaphrodite, a fusion of male and female parts in a single body (sometimes worshipped as a god), had been linked to sexuality and especially homosexuality since Plato, whose *Symposium* traced the varieties of human desire to three types of primeval double figures – male/female, male/male, and female/female – split apart by the gods and ever seeking their other half. This mystical image embodied ideas about spiritual wholeness and gender fusion that resonated with emerging theories of homosexuality as a psychic hybrid or "third sex." Jacopo Sadoleto's literary dialogue *Phaedrus*, titled in imitation of the text in which Plato defended homosexuality by the example of Ganymede, was set in Galli's garden; their circle of Roman humanists shared a knowing appreciation of the homoerotic symbiosis between classical literature and art.

Also for Jacopo Galli, Michelangelo carved a life-size, marble standing *Cupid*, long lost (but recently tentatively identified with a fragment at the French consulate in New York);[9] earlier, in 1495–96, he had sculpted a sleeping *Cupid* in Florence, which was sold in Rome but does not survive. The sleeping version, like later classical Cupids, portrayed a cherub of age six or seven, but in the Galli commission the archer of love took the adolescent form of the original god of love, Eros or Amor, making him yet another handsome object of male desire like Ganymede.

Actual antique depictions of similar subjects were found in other Roman collections. Cardinal della Valle, for example, owned a marble Ganymede who wraps his arm around the eagle representing Jupiter; to celebrate the accession in 1513 of Pope Leo X de' Medici, Michelangelo's boyhood friend, it was dis-

played on the facade of the family palace alongside several other antique divinities, normally arranged in the garden in an iconographic pattern that juxtaposed Ganymede with Venus as contrasting avatars of homosexual and heterosexual love (where they were sketched by Amico Aspertini, Fig. 93). According to the visiting writer Pietro Aretino, the papal banker Agostino Chigi displayed at his Villa Farnesina, where he and his mistress entertained grandly, a marble group of a satyr chasing a boy. Such well-known works provided the context in which Michelangelo's contemporaries understood the latter-day variations on the same erotic themes that they requested from him.[10]

Figure 93. Aspertini, *Ganymede and Venus*, London Sketchbook I, Fol. 3r, British Museum, London, early 16th century (photo: British Museum)

Religious Works: Christian Ambivalence

From the late 1490s through the 1520s, Michelangelo's major commissions, in both Florence and Rome, mostly offered public opportunities for the sculptor to explore religious subject matter whose primary purpose was either spiritual, philosophical, or political. Although the characters changed to Christ, other biblical figures, saints, and allegories, his dominant theme remained the male nude. In these Christian and civic contexts the homoerotic appeal of heroic beauty remained implicit, though the reactions of patrons and viewers bear indirect witness to the discomfort raised by their nagging awareness of carnal overtones. Michelangelo's unprecedented eroticizing of divinity may have emerged as early as the wooden crucifix he carved in 1492–93 as a gift for the prior at Santo Spirito who helped him obtain cadavers for anatomical study: the sculpture sometimes identified as this work (Florence, Casa Buonarroti) is totally nude. Yet, like the society around him, Michelangelo was continually beset by moral scruples that saw the greatest obstacle to transcendent love of God in the conflict between earthly temptations and the call to heavenly abstinence – an irresolvable dilemma that, he lamented in poem 168, "keeps me split in two halves."

In his first large religious commission, the Vatican *Pietà* of 1497–99 for the basilica of St. Peter's (Fig. 79), Michelangelo illustrated the Virgin Mary after the Crucifixion, holding in her lap an ideally beautiful, almost nude Christ, whose pose might suggest either death or languorous sleep. As usual, the sculptor blurs narrative specifics: showing scant evidence of physical suffering, the body is still that of an athletic Apollo. Although the characters' tragic communion is hardly sensual, their broader relationship is theologically eroticized. Mary, younger than she should be, is not so much a grieving mother as she is a widow – the traditional personification of Ecclesia, the Church, the "body" of the faithful who are "married" to Christ in divine love. As in Neoplatonism, the highest

level of this love is spiritual, not carnal, but the language for it is hopelessly con-
flated with the earthly expectations attached to "bride" and "love." Thus,
although the plot is heterosexual, its implications are heterodox: it invites the
faithful spectators, male and female alike, to emulate the passionate gaze of Mary
toward a beloved nude male. The difficulties for women in sorting out suitable
and impure feelings of adoration were compounded for men, for whom any
relations with God or Christ raised the specter of feminine or even sodomitical
passivity.

Returning to Florence, from 1501–4 Michelangelo carved his best-known
work, the colossal statue of the Old Testament hero David waiting to slay
Goliath with a slingshot (Fig. 80), set before the town hall as a symbol of civic
resolve and divine favor. Here too, although the manifest content is not erotic,
the celebration of energetic male nudity unavoidably calls up classical associa-
tions, in an iconographic context more than a little tinged with homoeroticism.
(A somewhat later marble shows the easy slippage between pagan and Christian:
begun as another *David* about 1525, it was converted to the archer *Apollo* by a
slight change of weapon before being left unfinished.)

Michelangelo had before him the model of Donatello's famous bronze *David*
from c. 1430–50 (Fig. 7), the first freestanding nude male figure since antiquity
(the first such female came much later, an index of the misogyny that attached
greater importance to the male body, whatever its problems); in fact, another
David in bronze by Michelangelo commissioned in 1502 but now lost, closely
echoed the pose of Donatello's sculpture. Michelangelo took after his aesthetic
forebear in more personal ways as well. According to popular jokes of his time,
the older sculptor was also homosexual, and the androgynous beauty of
Donatello's *David* evokes the Greek pederastic ideal, acknowledging the youth's
erotic appeal to an older man by the feather on Goliath's helmet that caresses
David's thigh.[11]

Although the episode of David and Goliath is not expressly erotic, support for
such a reading could be found in another chapter of David's biblical saga: his
passionate bond with King Saul's son Jonathan, which David eulogized at
Jonathan's untimely death as "surpassing the love of women." In medieval
poetry and manuscript illumination, their mutual devotion was an allegory of
L'Amitié, a homosexual but theoretically chaste translation of classical *amicitia*.
This spiritualized friendship, exemplified by Jesus' love for his apostles – espe-
cially St. John the Evangelist, "the beloved disciple" – permeated Christianity
and Michelangelo's own poetry, where he yearns for a "love [that] makes us per-
fect friends" (no. 105).[12]

The Church was ever vigilant, however, lest the flood of desire for a beauti-
ful soul might spill over into forbidden physicality: the reformist preacher
Savonarola, whom Michelangelo admired in his youth, repeatedly exhorted the
Florentines to "give up your beardless boys." Michelangelo seems to have visu-
alized this cultural pressure in the *Doni Tondo* (Fig. 94), painted while he was
working on the *David*. The picture combines the standard religious foreground

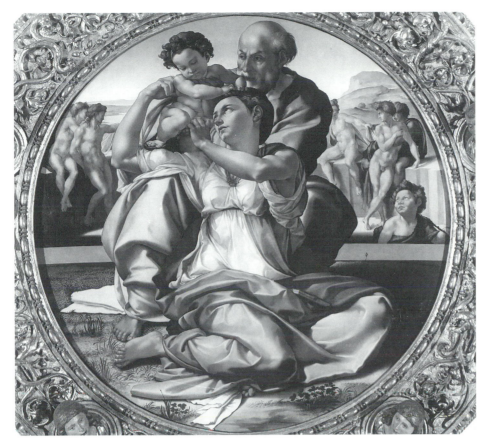

Figure 94. Michelangelo, *Doni Tondo*, Uffizi, Florence, 1504 (photo: Alinari/Art Resource, N.Y.)

scene of the Holy Family with an ambiguous background of nude males in intimate embrace, the two groups separated by a child John the Baptist who gazes forward adoringly at his divine cousin. Among numerous interpretations of this novel iconography, one appealing theory sees symbols of three stages of human moral progress, from distant paganism to monostheistic Judaism to the final revelation of Christian grace. If the athletic loungers are Greeks, the allusion to homosexuality seems fairly open, but it figures such love negatively, as a vestige of a childish, benighted past that is to be left behind – yet which, if it is to be clearly rejected, must nonetheless be acknowledged.

Civil authorities made the sin a crime, aiming to suppress both acts and images. Just among Michelangelo's professional circles in Florence, Leonardo da Vinci was arrested for sodomy in 1476, Botticelli in 1502 (while the *David* was in progress), and the mannerist sculptor Benvenuto Cellini was fined in 1523 and imprisoned in 1557. Across the Atlantic, Spanish conquistadores righteously reported destroying a gold relief discovered in Colombia that depicted "a man mounted upon another in that diabolic and nefarious act of Sodom."[13]

The *David* itself, though far from nefarious, still raised suspicions within this framework of hostility. Piero Soderini, the city's chief officer, ordered the statue's first fig leaf, actually a vinelike iron waistband, soon after the statue was installed in the Piazza della Signoria. Another religious work, the *Risen Christ* for Santa Maria sopra Minerva in Rome (1519–20), also shocked spectators with a totally nude Jesus; increasing censorship, including the repainting of the *Last*

Judgment about 1560 (P/R illus. 8.42), culminated in the seventeenth century with a metal loincloth for this marble Christ.

It could be argued that the authorities' primary concern was the modesty of female viewers, a problem that did surface in an anecdote about an altarpiece of the young Roman St. Sebastian recounted in Vasari's life of Fra Bartolommeo: when women parishioners admitted to their confessors that such nude beauty prompted unclean thoughts, the anxious clerics removed the image to their own quarters. But unspoken, perhaps because even more unsettling, is what thoughts the image provoked in these men, who probably knew the legend of Sebastian's intimacy with the emperor Diocletian. We do know that clerics of all ranks were notorious for homosexuality: Cellini's autobiography gossips that Luigi Pulci, a young friend of his and Michelangelo's, had caught syphilis while employed by a cardinal. Although the viewer in the public sphere was assumed to be male, and that viewer's gaze was assumed to be potentially attracted to men, the rarity of such immediate testimony forces any inquiry into his imaginative response to remain speculative and incomplete.[14]

During these same decades Michelangelo worked intermittently on the extravagant tomb for Pope Julius II, originally intended to comprise dozens of life-size allegorical figures (P/R illus. 7.26). Though none is expressly erotic, they too offered the sculptor a focus for personal and private interpretation, such as the titanic *Moses* (much discussed by Sigmund Freud) and the series of "slaves" begun in 1513, including the *Dying Slave* (Fig. 95). Plans for the tomb were frequently revised and scaled down, obscuring its original iconographic program: the slaves' poses of physical bondage may symbolize the human soul trapped by earthly limitations, the liberal arts constrained by the death of their patron, or conquered territories.

Whatever the original intent, Michelangelo characteristically uses the ideal nude male body in place of traditionally female personifications. The *Rebellious Slave* seems to struggle against his captivity, whereas the action of the *Dying Slave* is more ambiguous: still erect, he is not actually dying, but is he stirring in a dream, or awakening? His passive languor captures the yearning soul's tension with its mortal body: sleep, dreams, eros, and the ultimate union with divine love at the end of life are psychically interlinked in Michelangelo's own desire for a love that will "make death sweet for me" (poem no. 99).

Also originally for the Julius tomb was the *Victory*, c. 1527–29 (Fig. 96), in which the base figure, an older man forced to cower beneath a nonchalantly triumphant youth, is perhaps another allegory of earthly temptation defeated by higher instincts. But here the personal reading was probably more specific: although the older face is not literally a self-portrait, psychologically it reflects Michelangelo's oft-lamented experience of feeling overwhelmed and enslaved by the dazzling beauty of younger men, such as Febo di Poggio, whom Michelangelo compared poetically to his namesake, the sun god Phoebus Apollo (poems 99–101). These private emotions would, of course, have remained largely hidden from the general public, but they are far from unrelated

to the tomb's official iconography, revealing as they do how the ideal of rapturous submission to the divine was understood and experienced by a passionate lover of men.

Cavalieri and Colonna

The porous boundary between official doctrines and individual experience, which created a tense overlapping of public and private meanings, showed most clearly in works created after the *Victory*, in the 1530s and 1540s. These were the fruits of Michelangelo's most profound personal relationships, both male and female, and of his struggle toward a personal imagery to express those ambivalent and unprecedented loves. Here he was his own patron, and his audiences were small and intimate, so the language could be more overtly passionate, if no less conflicted. Whereas he was always careful not to articulate or expose his precise meanings too openly, his visual and literary work in this period stretched the traditional structures of gender and sexuality in novel, and potentially subversive, directions. Not surprisingly, the unstable balance he achieved remained subject to both inner and outer pressures toward conformity, and it ultimately collapsed.

Michelangelo first met the cultivated Roman nobleman Tommaso de' Cavalieri around late 1532 and formed an immediate and fervent attachment to this handsome youth, who became the proverbial, albeit largely unfulfilled, love of his life; Cavalieri, although basically heterosexual, was flattered and touched, and he loyally attended on the artist's deathbed. Michelangelo poured out his feelings for Tommaso in a series of symbolically confessional drawings on mythological themes which he gave to him. The most directly erotic are the *Rape of Ganymede* and its companion, the *Punishment of Tityos*. Such themes had established meanings in moralizing and Neoplatonic thought, but at the same time, the drawings speak very personally of the inextricable joy and pain of love, particularly in its homosexual form.[15]

Ganymede provided the highest classical justification for the love of man for boy. As Michelangelo imagines him, the youth, uplifted in the enfolding wings of the eagle/Jupiter, bespeaks his own fantasy of ecstatic union with another loving man and his rejoicing in the fulfillment of an overwhelming passion that foreshadows the divine. By contrast, Tityos, chained to a rock in hell for sexually assaulting the nymph Latona, with another phallic bird eternally devouring his liver, figures desire negatively, as painful enslavement to earthbound lust: as Michelangelo wrote in a poem to his beloved around the time of the drawings, punning on the recipient's name, "an armed cavalier's prisoner I remain" (no. 98). Even more subversive than the mere address of such sentiments to a man is their explicit celebration of male passivity: the same poem explains that "to be happy, I must be conquered and chained" – and implicitly, like Tityos, supine and penetrated. High or low, love entails for Michelangelo not the customary masculine ideal of aggression, but submission.

Such submission was dignified by the Neoplatonic doctrine of analogy,

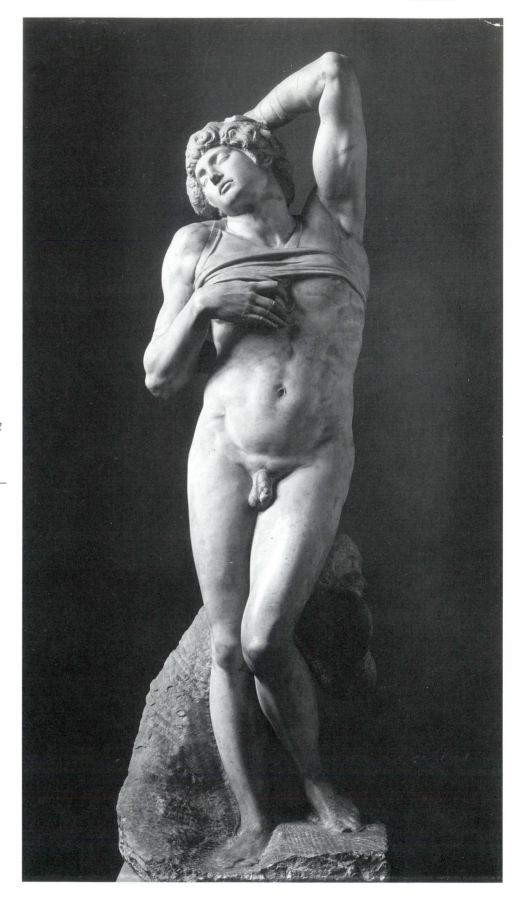

Figure 95. Michelangelo, *Dying Slave*, Louvre Museum, Paris, c. 1513 (photo: Giraudon/Art Resource, N.Y.)

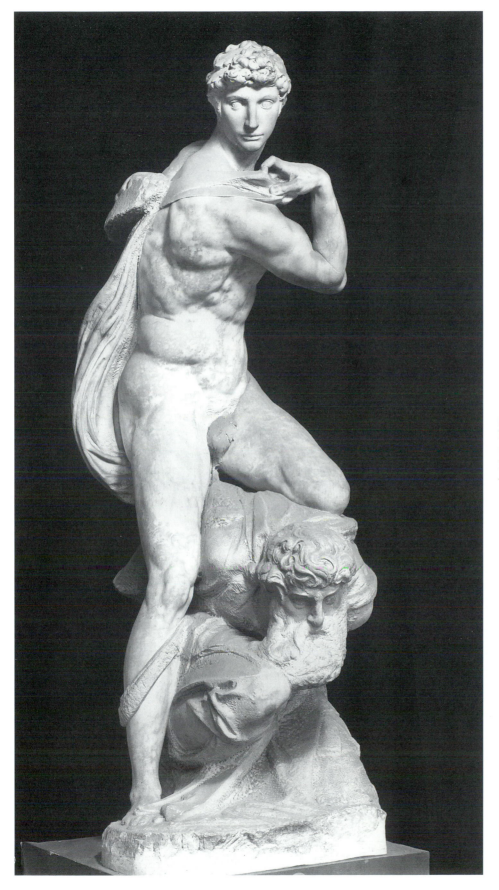

Figure 96. Michelangelo, *Victory*, Palazzo Vecchio, Florence, c. 1527–29 (photo: Alinari/Art Resource, N.Y.)

Figure 97. Bernardi, *The Rape of Ganymede*, National Gallery of Art, Washington, D.C., Samuel H. Kress Collection, mid-16th century (photo: National Gallery of Art)

through which physical passion was to lead morally to a chaste homosexual equivalent of Dante's uplifting adoration for the unattainable Beatrice. But this elevated philosophy did not percolate down very far from elite humanist circles, and Michelangelo also functioned in the everyday world, where people assumed his infatuations with young men and his artistic gifts to them indicated a more readily consummated, Tityos-like, form of desire. We know that the father of one prospective apprentice offered as an incentive the boy's services in bed, which Michelangelo indignantly refused. Referring to salacious finger-pointing on the part of an "evil, cruel, and stupid rabble" (poem no. 83), he assured Cavalieri that he should not take such accusations seriously, and he took pains to avoid fueling public suspicion. Two drafts of his letter accompanying the *Ganymede* and *Tityos* explain that "it would be permissible to name to the one receiving them the things that a man gives, but out of a sense of nicety it will not be done here"; the final version omits even this discreet demurral.[16]

Although his gifts to Cavalieri were not originally sculptures, one drawing did become one, in an incident that dramatizes the constraints on homoerotic expression. When the powerful art lover Cardinal Ippolito de' Medici insisted on having sculptural copies made of the series, Cavalieri wrote to the artist, "I tried hard to save the Ganymede," which suggests that both men felt some need to prevent public disclosure of such a suggestive image. But Tommaso could not prevail, and Giovanni Bernardi's resulting carving in rock crystal was later copied in several bronze casts (Fig. 97).[17] We can only guess at the meanings that made this motif popular among sophisticated male patrons, whose little medallions testified in an open, if exclusive, arena to the personal relations between the well-known sculptor of Galli's *Bacchus*, who was widely rumored to sleep with younger men, and his aristocratic beloved.

As his pursuit of Cavalieri cooled to friendship, Michelangelo increasingly turned his emotional ardor toward Vittoria Colonna, the most important, in fact, virtually the only significant, woman in his adult life. This serious and learned aristocrat, a proponent of Catholic reform who published considerable religious poetry, served the artist as friend, muse, and colleague with whom he could exchange verses and ideas. Michelangelo depicted her inspirational yet distant beauty in the longing images of courtly love; here physical union was blocked not, as with Cavalieri, by sex, but by the class and age of a pious, reclusive, widowed noblewoman. Vittoria too was given a series of drawings, but the themes shifted from mythology to religion, in tandem with Michelangelo's increasing turn toward spiritual concerns in his protracted old age. At the same time, his poetry for her created unorthodox metaphors of male and female, masculine and feminine, that highlight the intimate connections between the homosexual focus of Michelangelo's lifework and a broader feminist analysis of the arts and society.[18]

Michelangelo made no actual sculptures for Colonna, though he did imagine making a portrait of her, "so that a thousand years after our departure may be seen how . . . in loving you, I was no fool" (no. 239). This fantasy was never realized, in part because Vittoria's painful plainness could not be reconciled with the Neoplatonic ideal of a beautiful soul in a beautiful body. Posing a greater problem of representation than her deficiency in traditional feminine assets, Colonna was gender atypical for her time in claiming the male prerogative of public voice. Michelangelo symbolizes her intellect and valor – qualities generally associated more with the other sex – as "a man within a woman" and declares that it is precisely this inherent masculinity that has enflamed his love; he also refers to her as his *signore* (lord) and *amico*, using the masculine form of "friend." Such cross-gender flattery both subverts and reaffirms traditional norms: praise of her androgyny assumes the prevailing principles of Renaissance misogyny, that men are superior to women and that a woman is improved to the degree that she models herself on masculine norms and forms.[19]

Similar ideas inform Michelangelo's visual practice of basing female figures on male models, as he did in the *Doni Tondo* Madonna (Fig. 94), the Sistine Chapel sibyls (P/R illus. 7.30), and the figure of *Night* in the Medici Chapel from the 1520s (Fig. 82). *Night*'s massive, muscular body is clearly male, its breasts unconvincingly tacked on: as Dolce later complained, the sculptor's ideal of all human form is masculine. Yet her recumbent pose recalls a lost classical sarcophagus depicting the female Leda being penetrated by Jupiter in the form of a swan (which Michelangelo also sketched for a painting). The resultant gender ambiguity suggests "a man within a woman"; in another variation on the *Dying Slave* (Fig. 95) and *Ganymede* (Fig. 97), sleep, eros, death, and the spirit are all intertwined in an allegory of mortal life as a dream in which glimpses of divine love are felt as ecstatic submission that transcends the bodily particulars of the lovers.

On a complementary level of iconology, in his poems of the 1540s Michelangelo, referring almost interchangeably to his relations with Colonna and his psychic makeup as an artist, often embodies himself as a woman within a man. In the primal Western split between matter and spirit, body and mind, the artist was traditionally masculine, wielder of a creative intellect that imposes its will on the inert substances of earth, so often called Mother. But Michelangelo inverts that archetype, casting Colonna as the active partner. Drawing many metaphors from the arts, he envisions himself as unformed matter awaiting the inspired hand of the creator/lover to bring him to life or to improve him: as a rough sculptural model who is to be filed down and polished by Colonna, as a feminine mold waiting to be filled and then ruptured by the inflow of her seminal beauty, as paper awaiting her ink, even as a bride (nos. 152, 153, 236).

Michelangelo's images of the creativity thus inspired in him pose a parallel challenge to the Renaissance dichotomy between proper male and female traits. On one level, he understood his artistic ability as inherently feminine, a gift received passively from the woman's realm: according to Vasari, he often joked that "I sucked in with my mother's milk the chisels and hammer with which I

make my figures." Other metaphors of creativity are potentially double-sexed: he called his works his "children," and he repeatedly used the theoretical term *concetto*, which carries complementary overtones of ideation and gestation. In a final gender conflation, the artist-as-artist becomes a psychic androgyne, like Plato's primeval creatures, uniting female "conception" (material fecundity) with male "concept," the shaping and ordering mind.[20]

Last Years: Passion Expelled

Michelangelo's final two decades were dominated by his unending labor as chief architect of St. Peter's basilica in Rome, from 1547 until his death (P/R illus. 8.49 and 8.50). He found time for only a few sculptures, whose religious imagery, like that of his late poetry, confirmed his emotional shift from body to spirit. During these same years, the Council of Trent, whose bishops convened intermittently between 1545 and 1563, set in motion an aggressive program of doctrinal and administrative controls known as the Counter Reformation, aimed at stamping out not only the new Protestant heresy but also sinful behavior among the Catholic faithful and the humanists' seductive fascination with pagan antiquity. The campaign succeeded with Michelangelo: he became ever more orthodox in his rejection of all earthly delights as a distraction from impassioned anticipation of heavenly bliss.

The artist's most revealing personal statement of these years was the *Pietà* (Fig. 98) that Michelangelo carved for his own tomb in 1547–54. As a hulking Christ collapses into the lap of his mother, his left leg, now missing, would have been thrown across Mary's thigh. Michelangelo himself broke off this limb and left the work unfinished; explanations as to why he did so vary from a fit of pique at his assistant to psychosexual conflict. Leo Steinberg, demonstrating that the "slung leg" gesture commonly indicated erotic aggression, has proposed that the artist, shocked to realize that he had unwittingly tarred a sacred theme with pro-fane feathers, destroyed the offending symbol. Like all psychoanalytic interpretations, this one remains unverifiable; but it is consistent with Michelangelo's visual transformation of the tender communion in his earlier *Pietà* (Fig. 79) into a merely physical contact that is clumsy and accidental. The sculptor expressed his close identification with the narrative by carving a self-portrait in the face of the uppermost figure, gazing down on departed beauty in brooding melancholy.

In Florence at almost the same time, 1545–48, Michelangelo's younger com-patriot Cellini carved a group of three homoerotic classical subjects amid cir-cumstances that reveal the increasing hostility toward overt expression of desire for the male body. The first was a *Ganymede*; when Cellini suggested the sub-ject to Duke Cosimo I, his rival Bandinelli denounced him in front of the court as a "dirty sodomite." Cellini turned aside this insult with a witty retort, but when he consoled himself by carving two similar subjects – a *Narcissus* and an *Apollo with Hyacinthus* – he prudently kept them in his private studio until his death. The tightening social climate limited his behavior as well as his images: in

Figure 98. Michelangelo, *Pietà*, Museo dell'Opera del Duomo, Florence, c. 1547–54 (photo: Scala/Art Resource, N.Y.)

1557 he was convicted of sex with a young apprentice and sentenced to four years' house arrest.[21]

For Michelangelo himself, pressures both internal and external culminated in his last sculpture, the Rondanini *Pietà*, left unfinished at his death in 1564. This craggy wreck, bearing the detritus of several drastic reworkings, reduces Christ's male beauty and Mary's hovering form to a ghostly, imperfectly carved mass. His sculptural metaphor changed from physical celebration of the beloved body to the whittling away of corporeal life in a death agony that prepares the way for heavenly transcendence. As he had written some years before, "From what sharp, biting file / does your tired skin keep growing thin and failing, / O ail-

ing soul?" (no. 161). So, too, his own chisel hacked away at these bodies, leaving them shrunken, fragmented, etherealized, so that the soul, now all but freed from its earthly shell, might be swept up, as Ganymede had been earlier, in the all-encompassing embrace of eternity.

Throughout his long career, Michelangelo had explored a series of variations on the theme of the human body in all its physical and spiritual implications. And one continuous motif running through these variations was his questioning of the traditional polarities of masculine/active and feminine/passive qualities, roles, and emotional dynamics. From his early *Bacchus* through the drawings for Cavalieri, his images of the heroic male bespoke a deeply eroticized yearning for union – as he dreamed of Tommaso and himself becoming "one soul in two bodies" (no. 59). Later, he transferred this passion to a distant muselike female but endowed that female ideal with distinctly male traits. And finally, in art as in life, he resolved the deeply felt contradictions of desire by rejecting the embrace of either man or woman for that of God. In his last poems, he renounced not just the body, but creativity itself, the "affectionate fantasy" whose glorification of earthly beauty had falsely "made art an idol and sovereign to me":

> Neither painting nor sculpture will be able any longer
> to calm my soul, now turned toward that divine love
> that opened his arms on the cross to take us in. (no. 285)

Michelangelo in the Modern Eye

Notwithstanding this ultimate denial of bodily passion and art, later critics have continually reacted to the eroticism in Michelangelo's work with the same mix of enthusiasm and disapproval as did Vasari and Dolce. Over the past century and a half, modern culture has progressively canonized the artist as the patron saint of "the creative homosexual" – an identity that many consider a blessing, others a blasphemy.

Victorian and especially British historians and critics shaped much of our modern conception of the Renaissance. The influential moralist John Ruskin lamented the blow to medieval Christian purity suffered under the Renaissance, which he personified as a "licentious" prostitute, and he snidely deemed Michelangelo's *Night* a failure because the female form "is not one which he delighted to see."[22] But beginning in the 1860s, Walter Pater and John Addington Symonds and their circles of writers and activists, who shaped the newly emerging homosexual identity and subculture, reversed this view: if antiquity had been the Golden Age, then the Renaissance revival of pagan beauty and love made it a Silver Age, whose achievements provided a model and justification for a modern re-revival.[23]

When Pater, in his essay on Michelangelo's poetry, explained that the *Doni Tondo* (Fig. 94) dramatized the artist's fateful choice between "two great traditional types" of culture and deemed Michelangelo "the disciple not so much of

Dante as of the Platonists," he was enlisting a heroic ancestor for a cultural crusade in hostile territory. Similarly, when forced to defend himself at his 1895 trial for sodomy, Pater's student Oscar Wilde made an impassioned speech justifying the "great affection of an elder for a younger man" as a noble love that "Plato made the very basis of his philosophy" and that "dictates and pervades great works of art like those of Shakespeare and Michelangelo." Wilde's appeal to history failed to prevent his being given a sentence of two years' hard labor, which suggests that when Symonds, a closeted homosexual activist, located the roots of Michelangelo's "tragic accent" in a painful "sense of discrepancy" between individual and society, he was accurately projecting onto his subject the all-too-similar constrictions of his own time.

Since the Stonewall riot of 1969 in New York City, a protest against harassment of homosexuals by police and other authorities, which ushered in the latest wave of increasingly open activism and creativity, Michelangelo's life and sculpture have provided contemporary gay culture with the same venerable trademark for group sensibility and tradition. The American photographer Robert Mapplethorpe borrowed book illustrations of the *Dying Slave* for one of his assemblages, "The Slave," of 1974. This framed copy, "signed" by the photographer on a printed plaque, invokes such postmodern theoretical concerns as historical appropriation and the nature of originality in an era of mass reproduction. In more personal terms, however, Mapplethorpe was openly gay, notorious for his sexually graphic portraits and self-portraits, and died of AIDS in 1989. His adoption of an icon of male beauty produced by a "great homosexual" thus also bore subversive messages of sexual and cultural politics that were not lost on latter-day Ruskinians still concerned to limit public visualization of homosexual love. A memorial exhibition of Mapplethorpe's work was attacked by conservative politicians, who (unsuccessfully) prosecuted the show's 1991 venue, a Cincinnati arts center, for displaying obscenity. Half a millennium after Michelangelo's *Bacchus*, the visually compelling images that he produced, and the issues of gender and sexuality that they raise, still possess the power both to fascinate and enrage.

Notes

1. G. Vasari, *Le vite de' più eccellenti pittori scultori ed architettori*, ed. G. Milanesi (Florence, 1878–1906), was translated by G. duC. DeVere as *Lives of the Most Eminent Painters, Sculptors, and Architects* (New York, 1979). The Italian edition is hereafter abbreviated as Vasari-Milanesi; the biography of Michelangelo is found in volume VII, 150. The relevant section of L. Dolce, *Dialogo della pittura intitolato "L'Aretino,"* is translated in R. Klein and H. Zerner, eds., *Italian Art, 1500–1600: Sources and Documents* (Englewood Cliffs, N.J., 1966), 61–5.

2. His poetry is available in both Italian and English in J. M. Saslow, *The Poetry of Michelangelo: An Annotated Translation* (New Haven, 1991) (from which all text quotes are taken).

More specifically on relations between his poetry and visual art, see *idem*, "The Unconsummated Portrait: Michelangelo's Poems About Art," in *The Eye of the Poet: Studies in the Reciprocity of the Visual and Literary Arts*, ed. A. Golahny (Lewisburg, Pa., 1996), 79–101.

For psychological approaches to Michelangelo in modern literature, see especially R. S. Liebert, *Michelangelo: A Psychoanalytic Study of His Life and Images* (New Haven, 1983); L. Steinberg, "The Metaphors of Love and Birth in Michelangelo's *Pietàs*," in *Studies in Erotic Art*, ed. T. Bowie and C. Christensen (New York, 1970), 231–338.

3. Broadly, "social constructionist" historians follow M. Foucault in treating sexual identity as a constantly evolving

product of cultural forces and definitions, and "essentialists" maintain that even though the term "homosexual" was coined only in the nineteenth century it describes a desire and a range of personality types evident throughout history. Their debate, though acrimonious, is unnecessarily polarized. To the extent that sexual desire proceeds from bodies and results in sexual acts, it is necessarily grounded in biological constants; at the same time, all human behavior, especially between two or more individual bodies, is inescapably mediated by social norms and policies. The principal spokespersons for both schools are represented in E. Stein, ed., *Forms of Desire: Sexual Orientation and the Social Constructionist Controversy* (New York and London, 1990); see also J. M. Saslow, " 'A Veil of Ice Between My Heart and the Fire': Michelangelo's Sexual Identity and Early Modern Constructs of Homosexuality," *Genders* II (1988): 77–90 (reprinted in W. E. Wallace, ed., *Selected Scholarship in English*, 5 vols. [New York, 1995], V).

The social constructionist viewpoint has been expounded, for Renaissance culture, primarily by literary historians; see, among many others, J. Goldberg, ed., *Queering the Renaissance* (Durham, N.C. 1992); G. Bredbeck, *Sodomy and Interpretation: Marlowe to Milton* (Ithaca, N.Y., and London, 1991).

The best-known spokesperson for the contrasting view is J. Boswell, beginning with his study of the medieval period, *Christianity, Social Tolerance, and Homosexuality* (Chicago, 1980). For a trenchant critique of the current dominance of social constructionism and a detailed argument for significant continuities between Renaissance and modern sexual language, see J. Cady, " 'Masculine Love,' Renaissance Writing, and the 'New Invention' of Homosexuality," *Journal of Homosexuality* XXIII, nos. 1/2 (1992): 9–39. More generally on homosexuality and art in this period, see J. M. Saslow, "Homosexuality in the Renaissance: Behavior, Identity, Artistic Expression," *Hidden from History: Reclaiming the Gay and Lesbian Past*, ed. G. Chauncey, M. Duberman, and M. Vicinus (New York, 1989), 90–105; *idem, Ganymede in the Renaissance: Homosexuality in Art and Society* (New Haven, 1986); A. Sternweiler, *Die Lust der Götter: Homosexualität in der italienischen Kunst* (Berlin, 1993); R. and M. Wittkower, *Born under Saturn: The Character and Conduct of Artists* (New York and London, 1963), 169–75. On the social history of the period, see M. Rocke, *Forbidden Friendships* (Oxford, 1996), for Florence in the fifteenth century; G. Ruggiero, *Boundaries of Eros: Sex, Crime, and Sexuality in Renaissance Venice* (Oxford, 1985); and A. Bray, *Homosexuality in Renaissance England* (London, 1982), whose scope is somewhat wider than its title. Useful introductions to the period and to many major figures can be found in *The Encyclopedia of Homosexuality*, ed. W. Dynes and S. Donaldson, 2 vols. (New York, 1990), and in *The Gay and Les-*

bian Literary Heritage, ed. C. Summers (New York, 1995), both with further bibliography.

4. J. A. Symonds, *The Life of Michelangelo Buonarroti*, 3d ed., 2 vols. (London and New York, 1899), II, 385.

5. Vasari-Milanesi, VII, 143–6; A. Condivi, *Vita di Michelangiolo* (1553) (Florence, 1927), 15; in the recent translation by A. Sedgwick Wohl, *Life of Michelangelo* (Baton Rouge, La., 1976), see p. 12.

6. Illustrated and discussed in E. Lucie-Smith, *Eroticism in Western Art* (New York and London, 1972), 196.

7. Condivi, 18–19, trans. Wohl, 15. The hero of *L'Orfeo* extols "the better sex" at line 331; on Poliziano and his works see Saslow, *Ganymede in the Renaissance*, 29–32, with further bibliography.

8. Filarete's doors are illustrated and discussed in Saslow, *Ganymede in the Renaissance*, 39–43. See generally A. Emmerling-Skala, *Bacchus in der Renaissance* (Hildesheim and Zürich, 1994).

9. K. Weil-Garris Brandt, "A Marble in Manhattan: The Case for Michelangelo," *Burlington Magazine* CXXXVIII (October 1996): 644–59.

10. For the Aspertini drawing, see P. P. Bober, *Drawings After the Antique by Amico Aspertini* (London, 1957), 47–50. Aretino's description is published in E. Camesasca and F. Pertile, eds., *Lettere sull'arte di Pietro Aretino*, 3 vols. (Milan, 1957–60), no. II; English trans. by T. C. Chubb, *The Letters of Pietro Aretino* (Hamden, Conn., 1967), 33–4, no. 5.

11. On Donatello's homosexuality and its impact on his sculpture, see H. W. Janson, *Donatello*, 2 vols. (Princeton, 1957), I, 85; Saslow, *Ganymede in the Renaissance*, 215, n. 79.

12. The classical and medieval development of *amicitia* is thoroughly traced by Boswell, *Christianity, Social Tolerance, and Homosexuality, passim.*

13. This remark by the chronicler G. Fernandez de Oviedo is quoted by F. Guerra, *The Pre-Columbian Mind* (London, 1971), 56; for similar reactions to homosexual imagery in the New World, see *ibid.*, 123–4, 221–6, all cited and discussed in W. Williams, *The Spirit and the Flesh: Sexual Diversity in American Indian Culture* (Boston, 1986), 135–40. The Italian court actions are outlined by Wittkower and Wittkower, *Born under Saturn*, 169–73, and Saslow, *Ganymede in the Renaissance*, chs. 1, 4.

14. Vasari-Milanesi, IV, 188–95; B. Cellini, *Vita*, book I, section 32, trans. G. Bull, *Autobiography* (Harmondsworth, 1956), 64.

15. These drawings and their psychological symbolism are treated at length in Saslow, *Ganymede in the Renaissance*, ch. 1. On Cavalieri and his relationship with Michelangelo see also Liebert, *Michelangelo*, 270–311, and C. Frommel, *Michelangelo und Tommaso dei Cavalieri* (Amsterdam, 1979).

16. For Michelangelo's letters regarding the apprentice and the gift for Cavalieri, see *The Letters of Michelangelo*, trans.

and ed. E. H. Ramsden, 2 vols. (Stanford and London, 1963), nos. 191, 195.

17. On Bernardi's lost original and its progeny, see E. Kris, *Meister und Meisterwerke der Steinschneidekunst* (Vienna, 1929), no. 236. For the Kress version, see J. Pope-Hennessy, *Renaissance Bronzes: Catalogue of the S. H. Kress Collection* (London, 1965), 14, no. 33; for the identical cast in London, Victoria and Albert Museum, no. 4120–1854, see E. Maclagan, *Catalogue of Italian Plaquettes* (London, 1924), 70.

18. For biographical and literary background see J. Gibaldi, "Vittoria Colonna: Child, Woman, and Poet," in K. M. Wilson, ed., *Women Writers of the Renaissance and Reformation*, ed. K. M. Wilson (Athens, Ga., and London, 1987), 22–46; Ramsden, *Letters of Michelangelo*, II, 237–43, appendix 26; and *Vittoria Colonna, Dichterin und Muse Michelangelos*, ed. S. Ferino-Pagden (Vienna, 1997).

19. Poems 160, 235; for the word *amico*, see his original letter in *Il Carteggio di Michelangelo; Edizione postuma di Giovanni Poggi*, ed. P. Barocchi and R. Ristori, 4 vols. (Florence, 1965–79), no. 1147.

20. Vasari-Milanesi, VII, 137; Condivi, *Vita*, trans. Wohl, 6–7. For *concetto*, see especially poem no. 151 and nos. 62, 84, 236, 241, 279.

21. On Cellini, see Saslow, *Ganymede in the Renaissance*, ch. 4.

22. J. Abse, *John Ruskin: The Passionate Moralist* (New York, 1981); for his comments on Michelangelo, 249.

23. See W. Pater, "The Poetry of Michelangelo," in *The Renaissance: Studies in Art and Poetry* (1873), ed. D. Hill, (Berkeley, 1980); Symonds, *Life of Michelangelo*; and recent studies by R. Dellamora, *Masculine Desire: The Sexual Politics of Victorian Aestheticism* (Chapel Hill, N.C., 1990), and L. Dowling, *Hellenism and Homosexuality in Victorian Oxford* (Ithaca, N.Y., 1994). E. Cooper, *The Sexual Perspective: Homosexuality and Art in the Last 100 Years in the West*, 2d ed. (London, 1994), briefly summarizes the Renaissance before surveying the self-consciously gay art of the nineteenth and twentieth centuries.

Gendered Nature and Its Representation in Sixteenth-Century Garden Sculpture

Claudia Lazzaro

IN THE RENAISSANCE, nature was understood as female, sharing the essential characteristics of the female sex. In the hierarchy of genders, the superior male was associated with culture, and as a metaphor, the nature/culture binary was used to explain much about human behavior, institutions, and productions. As Foucault has shown, this reflects a system of knowledge very different from our own; it is one characterized by correspondences, in which all components are interrelated in an overall harmony, the analogies made evident partially through visual resemblances.[1] The natural world was perceived as interlocked with the human – practically, philosophically, morally, symbolically – in every way. In addition to their providing food, medicine, clothing, and shelter, plants and animals reflected and symbolized human virtues and moral and religious values. Assumptions about sexual differences and their significance also applied to the natural world.[2]

Conceptions about the essence of male and female in the Renaissance, although taken to be natural, were cultural constructions. Not without some overlap with our own, these ideas were nevertheless based on radically different assumptions about sexual difference. Thomas Laqueur has demonstrated that the sexes were understood as different in degree, not kind, the female being seen as an imperfect version of the male on a continuum. This contrasts with the understanding of the sexes since the late eighteenth century as incommensurable opposites.[3] Gender is a way of ordering and making sense of the world, as feminist scholarship has argued; the sense that the notion of male and female and the perception of much of the world as gendered made in sixteenth-century Italy must be examined on its own terms.[4] In this essay I explore some of the implications of gender differences and hierarchies in the Renaissance as well as in the twentieth century and their influence on the production and the study of art. My particular focus for these issues is on the art made out of nature itself – on gardens and on the sculpture within them that represented the natural world.

In the sixteenth century – a world of two genders but only one sex in Laqueur's formulation – there was much anxiety about maintaining boundaries between the male and the female and concern with differentiating them through

visible signs. The social importance of gender differentiation – in manners, gestures, movements, and dance – is evident in the manuals on conduct and courtesy that proliferated in the sixteenth century and that dictated appropriate masculine and feminine behavior. The same gender characteristics are manifest in painted figures of the time, and were duly noted, as is apparent in the gendered language of art criticism.[5] The gestures and poses of sculpted figures likewise reflect the social attitudes toward their gender and the need to make clear distinctions between them. In a cultural world of correspondences and similitudes, the same outward signs that signified gender could also convey associations with other human characteristics and activities or even with nonhuman aspects of the world, which were also understood as having a masculine or feminine gender.

Garden sculpture representing the natural world is not alone in displaying gendered visual signs, but it provides a particularly vivid example of them and of their significance. The sculptures examined here include examples from the major sculptors and architects of the second half of the sixteenth century as well as from anonymous artists; sculptures made of "high art" materials – marble and bronze – as well as of rough, local stone, and even of the living rock; and both monumental public sculpture and small-scale private works. Their visual resemblances and gendered visual language reflect the ideology of the time, transcending differences of regional and artistic styles. Sculpted representations of the natural world flourished, particularly in the gardens around Florence and Rome, in the second half of the sixteenth century, but they are not unique either to those geographical regions or to the garden context.

Art and Nature/Male and Female in the Renaissance

In the sixteenth century writers characterized gardens as an interaction of art and nature, which was the more common articulation of the nature/culture binary.[6] In a garden human artifice shapes the raw materials of nature into a work of art: trees in rows, regular and geometric planting beds, trees clipped into artful shapes, and so on. But the relationship of art and nature is not a fixed opposition: the terms are unstable and constantly shifting, as aspects of the garden range from the highly artificial to the artificially natural to the areas left in their natural state. "Art" and "nature" are relational terms, and, as with the continuum of male and female sex, the boundary between them is blurred. The Renaissance garden subverts any absolute distinction between art and nature in a variety of playful and ingenious ways, as in artificial grottoes that seem natural, hydraulic devices that imitate bird sounds, and fountains (or even an entire garden) that replicate the natural site in various ways, from stylized recreations to naturalistic imitations. The garden characterized by this fluid interaction of the terms "art" and "nature" was called a "third nature," one in which nature is also the creator of art and not simply the object of the shaping human hand.[7]

Within this system, the garden – the realm of nature – is relatively speaking a female space. Female imagery is dominant in its sculpted ornaments but is also

complemented by male figures, just as art and nature do not have the same relative importance in all parts of the garden. Although considered inferior within the hierarchy, female also had a positive valence, and a body of so-called feminist literature in the Renaissance suggests voices and contexts in which it could be superior.[8] Gendered analogies, metaphors, and signs demonstrate the wide range of uses of male and female in Renaissance culture. The familiar association of land with female informed the metaphorical language of war and, in particular, of Europe's encounter with the New World. The land and its inhabitants were gendered female, the European explorers male, and the acts of exploration and conquest were articulated as sexual ones.[9] Nevertheless, male sovereigns appropriated female characteristics among their attributes of rule; King Francis I even had himself depicted in female dress.[10] Because the female nature was understood as antithetical to the male activity of rule, Queen Elizabeth did the opposite of Francis and employed male metaphors of dress, speech, and action during her reign. Queen Catherine de' Medici, regent for her son in a state that forbade female succession, instead affirmed her femaleness by staging political activities in the female space of a garden – both in a real garden and in pictorial representations.[11] Similarly, my aim in this study is not to deny the existence of overriding gender hierarchies, but to suggest the complex and nuanced ways in which they operate and the purposes they might serve.

Man and Nature in Twentieth-Century Thought

Much twentieth-century scholarship characterizes Renaissance gardens not as a third nature, a playful interaction between two terms in an unstable binary, but as an expression of man's dominance over nature. Although they are not directly addressed, gender hierarchies are much at issue in this characterization, but those of the twentieth century, not the sixteenth. In this altered understanding of Renaissance gardens one-half of the binary remains in a fixed relationship of superiority over the other. In addition, the term "art," with its multiple cultural associations, has been replaced by "man," with the implication of "male," not the gender-neutral "human." Recently, interest in the origins of the very different attitude toward the natural world embodied in the notion of male dominance has been considerable. In *Man and the Natural World*, an illuminating account of the relationship between human and natural realms in England from the sixteenth through the eighteenth centuries, Keith Thomas suggests that the notion began in the late sixteenth century.[12] The concern with ecology in the twentieth century has been the stimulus for seeking the historical development of modern ideas about the control of and dominance over nature, for example, by Carolyn Merchant in *The Death of Nature: Women, Ecology, and the Scientific Revolution*. Merchant traces the association of nature with female and argues, as I do, that a change in the visual and verbal language used to describe nature signaled a change in society's attitude toward nature.[13] Her conclusion is that the modern attitude of dominance originated

in the seventeenth century, which has some correspondence with that century's, as compared to the Renaissance's, more formal garden style and sharper distinction between the component elements of art and nature. One question in these and other studies is when in time to locate the shift in attitude from an understanding of the natural world as being in a symbiotic relationship with humans, as in the art and nature binary in Renaissance gardens, to its being dominated and controlled by them. Thomas and Merchant locate the shift in attitude toward nature in the late sixteenth and seventeenth centuries, supported by evidence from a wide variety of texts and cultural productions. However, many compelling reasons suggest that this major transition occurred in the eighteenth century. One indication is evident in the frontispieces of natural history texts. In these frontispieces, at least through the mid-eighteenth century, nature continued to be personified as Diana of Ephesus, the many-breasted Mother Earth, just as it was represented in sculpture in Renaissance gardens.[14] Among the comprehensive philosophical, cultural, and scientific changes in the eighteenth century was, according to Laqueur, the transition from the human one-sex to the two-sex model. Also in the eighteenth century Linnaeus developed his system of classifying plants, which was based on notions of human sexual behavior.[15] This later date for the transition has resonance with the literature on gardens. Well into the eighteenth century in texts ranging from letters to agricultural treatises, nature is accorded a respect and reverence at odds with the idea of man's domination and throughout the period from the Renaissance to this time gardens are characterized as an interaction between art and nature.[16]

Renaissance gardens were not explicitly described as an expression of man's dominance over nature until the twentieth century. This occurred in texts on gardens that were produced in Italy in the 1920s and 1930s, against the backdrop of Mussolini's rise to power and his appropriation of Italy's artistic traditions to serve his own vision of a Fascist national identity. In 1924, in his book on the Italian garden, Luigi Dami presented the essence of the sixteenth-century Italian garden as the primacy of man and disdain for the natural.[17] The explicit characterization of the Italian garden as the "dominion of man over nature" first appeared in 1931.[18] Military metaphors proliferated in later texts, along with the description of the Italian garden as emphatically "male."[19] Thus it should be emphasized that the representation of the Renaissance garden as the subjection of female nature in a male space reflects not the attitude of the sixteenth century, but that of modern Italy. The Fascist ideology evident in these metaphors had an unsuspected influence on later scholarship.

An examination of modern scholarship reveals that the idea of man's dominance over nature is of our own times, an idea imposed upon the past rather than derived from it. Twentieth-century writers selected the words of one Renaissance sculptor intimating that architecture was superior to planting, to embody the essence of the Renaissance garden, while they ignored countless other comments.[20] A similar bias is evident in modern discussions of the rela-

tionship between human technology and nature. William Leiss has pointed out
the prevalence in twentieth-century writings, especially in utopian proposals of
the 1960s, of such phrases as "domination of nature," "control of nature," and
"conquest of nature" with reference to science and technology. In *The Domina-
tion of Nature*, Leiss offers some corrective to the displacement of this current
view onto the past by distinguishing it in cultural terms from its beginnings in
the seventeenth century.[21]

The transformation from a symbiotic relationship of two interlocked terms to
the superiority of one over the other is not merely incorrect, it has serious impli-
cations for how we understand the Renaissance and what aspects of it we study.
The period was indeed obsessed with competition and superiority – of the mod-
erns to the ancients, of painting to sculpture, of poetry to painting. But these,
along with art and nature, and male and female, were relational and unstable, not
fixed terms, deployed to further certain agendas. Sixteenth-century gardens were
not described by their contemporaries in the military language of domination,
conquest, and victory (such gendered metaphors were reserved for the conquests
of war or the New World). This occurs only in modern texts. The twentieth-
century formulation of the Renaissance garden has led to erroneous notions
about the plants that filled them and about how their contemporaries conceived
them.[22]

Because only one-half of an interlocked pair – art – predominated in the
study of Renaissance gardens, much was left out, especially nature as protago-
nist of the garden, as its substance and its subject, and as personified through the
female form, which embodied its generative powers. In the symbiotic relation-
ship between art and nature in Renaissance gardens, nature is the principal
theme of garden art – of its statues, fountains, and other ornaments; often the
same idea is told simultaneously through sculpted human figures and actual
nature – water, earth, or vegetation. The subordination of nature to art in
twentieth-century scholarship has diminished the importance not only of
nature itself but also of what is considered natural and innate in social and cul-
tural terms, all of which were gendered female in the Renaissance cosmology.
Besides fertility and abundance, nature signified sensuality, playfulness, and
freedom from societal constraints, manners, and morals – thus even sexual free-
dom – as well as inspiration for poetic endeavors.[23] All these ideas were freely
expressed in Renaissance gardens, if not always in the dominant culture. A gar-
den was the place for play, for getting drenched by hidden water jets, and also
for throwing off the constraints of artistic and social conventions. Some garden
sculpture and other ornaments alluded to a mythical earthly paradise – Parnas-
sus, the Garden of Hesperides, or the Golden Age, a time when humans lived
in harmony with a nature that was untouched by human art. The nostalgia of
a sophisticated and urban society for a natural state, for a time not dominated
by the requirements and restraints of civilization, including its strict gender
roles, is voiced in the dialogue between art and nature, and in their interaction
in the planting, design, and imagery of gardens.

Overflowing Breasts

Nature in Renaissance gardens was personified by the well-known ancient statue type of Diana of Ephesus, with female head and torso and shaftlike lower body, just as it was depicted in frontispieces to natural history texts. The Renaissance interpreted this image, as it had been understood since late antiquity, as "many breasted," although this may not have been the intention when the type was invented.[24] The mythographer Vincenzo Cartari, in his manual on the gods and goddesses of antiquity, described the goddess as covered with breasts, which, he added, signified that the universe takes its nourishment from the earth.[25] The human female sex and mammary glands were the means to represent a nature that was conceived as, above all, generative and fecund.[26]

Appropriate to the setting, a number of sixteenth-century Roman gardens displayed ancient statues of the Diana of Ephesus type, but there were also modern versions that functioned as fountains.[27] One of these (Fig. 99), designated the Goddess of Nature, was made in the 1560s for the Villa d'Este at Tivoli.[28] Closely modeled on an antique prototype but carved from the soft, local travertine, the figure underlines the association of nature with female through breasts rendered naturalistically with nipples from which water flows. The model for the statue type is antique, but its interpretation and presentation are distinctively Renaissance.

It is typical of sixteenth-century fountain sculpture to make the narrative action literal, as in spurting breasts, dripping hair, overflowing urns, or melting snow. In the Goddess of Nature Fountain the water flowing from the naturalistic breasts renders the figure both more female and less classical. Although the statue type is based explicitly on an antique model, the large-scale, rough stone, pendulous breasts, and dripping water, invert, perhaps even subvert, the ancient model, transforming it into something approaching the grotesque in the sense discussed by Mikhail Bakhtin, the Rabelais scholar.[29] The Goddess of Nature at Tivoli, in its distorted human form, with its multiple protuberances secreting bodily fluid, stands in opposition to the classical ideal. It suggests abundance, excess, and lack of restraint, all qualities also associated with female. Dislodged from the conventions of the classical by its subject and its garden location, the fountain is at the same time familiar and strange, playful and disturbing.

In the Renaissance pantheon of anthropomorphic representations of nature, overflowing breasts became the principal sign of the earth, which was personified by various goddesses, among them Ceres, Ops, and Venus.[30] Contemporaries explained that *Ceres* (Fig. 100), one of six over-life-size marble statues in Bartolomeo Ammanati's monumental Juno Fountain commissioned in 1555, signified the earth.[31] Although the figure type, drapery, and hair reflect ancient models, the pose of hands pressing breasts has no precedent in classical antiquity, nor does the gesture made literal by the water that originally emerged from them. This invention, which represented the essence of nature as generative and life-giving through analogy with a lactating woman, merged classical and

Figure 99. Goddess of Nature, Villa d'Este, Tivoli, 1560s (photo: Ralph Lieberman)

grotesque in a single figure. *Ceres* has no other attributes; she could be recognized as a personification of the earth only through this essential sign of nurturing. Other earth goddesses assume the same pose, and the type was not confined to fountain or garden sculpture. For example, Ammanati repeated it in his bronze statuette of Ops of about ten years later, for the Studiolo of Francesco I in the Palazzo Vecchio, which was reproduced in an engraving by Caraglio; another engraving, by Enea Vico, represents a personified nature lactating.[32]

Cesare Ripa, in his iconographical handbook for artists, first published in 1593, reflected common practice in recommending that "Terra," or Earth, be depicted with water shooting from her breasts to represent the springs and rivers that flowed from the earth.[33] The image illustrates the perceived analogy between the human female and the earth's generic life-giving property, but the lactating female could also be a metaphor for a specific natural phenomenon, that of water emerging from the earth. Contemporary explanations of Ceres similarly indicated that she signified that the earth generates water.[34] *Ceres* was the centerpiece of a monumental fountain, intended for the principal audience chamber of the Palazzo Vecchio, the seat of government in Florence, to celebrate the aqueduct that Duke Cosimo de' Medici built to supply Florence with fresh drinking water. Her sensual, generative pose, inviting the male gaze upon her frontal nudity, reflects the culture's view of woman. However, this huge fountain, dominated by female figures and intended for a charged political setting, also evoked other highly regarded attributes and values that were contained within the Renaissance idea of woman.[35]

Beasts and Breasts

Animals often accompany female personifications of nature as a sign of "wild," undomesticated nature analogous to the unbridled passion and absence of restraining rationality of the female sex as understood in the sixteenth century. The shaftlike lower body of the Diana of Ephesus type, as in the example at

Tivoli (Fig. 99), is ornamented with images of animals in rows and compart-
ments. Ceres, Ops (in Ammanati's statuette), and even Venus Genetrix were
represented with animals at their feet, as seen, for example, in the *Venus* with
dogs located in a grotto of the Villa Lante at Bagnaia (Fig. 101).[36] Animals live
in caves and follow the laws of nature, not culture, of instinct, not rationality.
In a letter of 1541, Jacopo Bonfadio characterized the ordered gardens on the
shores of Lake Garda as a third nature; he explained that to make the site on the
lake perfect, nature had provided high, rugged, and menacing mountains with
caves, caverns, and fierce cliffs, the homes of hermits and strange animals.[37]
When Annibale Caro, Cardinal Alessandro Farnese's secretary and artistic advi-
sor, made some suggestions for imagery inside a garden grotto or cave, he said
that the best would be Circe turning the men under Ulysses into animals.[38] As
these examples indicate, animals denote wild nature. The nature goddesses,
among them the *Venus* at Bagnaia, with their paired visual signs of animals and
lactating breasts, represent the essence of both nature and female as unre-
strainedly overflowing.

The same paired visual signs, animals and overflowing breasts, appear in
Ripa's personification of Benignity (*Benignità*), or kindness of heart (Fig. 102).
The visual resemblance signifies a conceptual relationship among nature, female,
and the character trait. In his handbook on mythology, Ripa indicated that
Benignity should be depicted with her hands squeezing her breasts, which spurt
milk, and with animals below her to drink the milk. The generative and nour-
ishing aspects of the earth, or nature, are intimately related to giving freely. Both
qualities imply something innate, something that comes from within and
emerges spontaneously. As Ripa explained, Benignity "presses the milk from her
breasts, which many animals drink, because the effect of benignity, together
with charity, is to spill lovingly that which she has by nature."[39] In his *impresa* for
King Ferrandino, Paolo Giovio attributed to the king liberality and clemency,
virtues that "come from nature, not from art."[40] The Renaissance construct of
female, which can be assembled through visually associated images as well as
from contemporary texts, includes fecundity, unbridled passion, abundance that
spills out of bounds, and innate goodness, which similarly overflows sponta-
neously.

Nature inspires poetry, and poetry, like nature, is fertile and flows freely. The
correspondence between them is conveyed visually in personifications of Poetry,
for which Ripa again found appropriate the image of bare breasts full of milk, if
not this time spurting. In this instance, according to Ripa, "[Poetry's] breasts
demonstrate the fecundity of conceits and inventions that are the very soul of
poetry," and that also overflow spontaneously.[41] That poetry comes naturally
Ripa explained by quoting the popular saying that poets are born and orators
made and by affirming that poetry's principal manners are not learned, but are
infused in the mind.[42] In gardens, poetry and the inspirational property of nature
were represented by the Muses. The garden is the place of poetry, often orna-
mented with a Mount Parnassus and called the home of the Muses, because

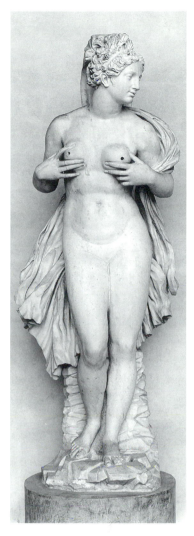

Figure 100. Ammanati, *Ceres*,
Museo Nazionale del Bargello,
Florence, c. 1555 (photo: author)

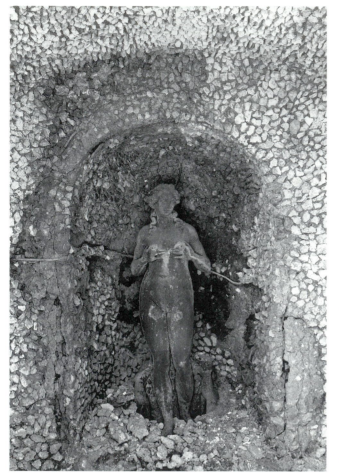

Figure 101. Grotto of Venus, Villa Lante, Bagnaia, 1570s (photo: Ralph Lieberman)

nature inspires poetry and also because the earth, like poetry, has a fertile and overflowing character. Cartari was explicit on the relationship between poetry and nature: he noted that the Muses often are the same as nymphs and that nymphs frequently signify the water of springs and rivers that is good to drink.[43] In the Fountain of Parnassus at Bagnaia, the busts of the Muses shoot water from their mouths, in the absence of breasts, presumably spilling poetic conceits along with fresh spring water from the hills beyond.

In the garden, then, is found the conjunction of nature, female, spontaneous giving, and poetry, and also of license, both artistic and sexual. One expression of this license is the grotesque. Bahktinian and Renaissance notions of the grotesque (from the ancient decorative motifs discovered in grottoes, such as the Golden House of Nero) converge in hybrid creatures – part human, part animal. Statues of such hybrids are common in Renaissance gardens, encapsulating the fusion of art and nature and also expressing artistic license, as is appropriate to the natural setting with its freedom from the strict requirements of both artistic conventions and behavioral norms. One example, at Tivoli, combines overflowing breasts, mythical animals, and an allusion to poetry (Fig. 103). One of a pair, this image resembles a sphinx (which is a lion's body joined to a female head and chest), but instead has horses' hooves and a winged body terminating in a curled fish tail. The winged horse within this hybrid evokes Pegasus, who in digging his hoof into the ground on Mount Parnassus created the inspiring spring Hippocrene. The individual components signify the generative, nourishing property of nature, the familiar association of female with animal, and the free flowing of both water and poetry. The pair of water-generating creatures, which recall the Goddess of Nature in the same garden, stand alongside the central axis at the head of the Fountain of the Dragons, the source of the water that cascades down the handrails of the great, sweeping, oval staircase. Like the sphinx, which in the Renaissance could symbolize voluptuousness,[44] this composite image conveys its meaning through its separate parts, but also through the sensual and suggestive effect of the whole.

Sensuality and Sex in the Garden

Tourists titter at Tivoli's busty hybrids. Surely Renaissance cardinals and their friends did as well. An acknowledgment that the sensuality of these images was both potent and meaningful comes in its rejection by some of the very creators of these fountains. In his treatise "The Nobility of the Ancient Arts," of about

1570–80, Pirro Ligorio, the designer of the garden at Tivoli, addressed the issue of decorum through an imaginary contest of fountain designs.[45] In this competition, the moralistic attitude voiced by Ligorio's fictive judges reflects the austere climate of the late sixteenth century. The fountain designs that the judges considered dirty, lascivious, and otherwise disreputable included a nude *Venus,* a *Leda and the Swan,* and a reclining female with water flowing from her breasts.[46] In 1590 the sculptor Ammanati fervently requested that the statues of his monumental Juno Fountain, which he had created almost thirty-five years earlier, including the shameless *Ceres* (Fig. 100), be draped to prevent their inspiring indecent and ugly thoughts.[47] Their sensuality, which was nevertheless still decorous, reflected the Renaissance idea of woman as inherently sexually unrestrained. Through the association of female with unbridled sexuality, Ammanati's statues and Ligorio's imaginary fountains, expressed the commonplace notion that the garden was a place of pleasure for all the senses, analogous to the social and sexual license of a prelapsarian natural state.

Venus is among the female figures in Renaissance gardens that signify nature as generative and life-giving through poses inspired by ancient models, but modified to enhance their sensuality. The grotto of Venus at Tivoli was dedicated to voluptuous pleasure;[48] and in her role as Venus Genetrix, the goddess symbolized generation and the source of water, as in the grotto at Bagnaia. In the

Figure 102. Benignità from Ripa, *Iconologia,* 1593 (photo: author)

Figure 103. Hybrid Fountain, Villa d'Este, Tivoli, 1560s (photo: Ralph Lieberman)

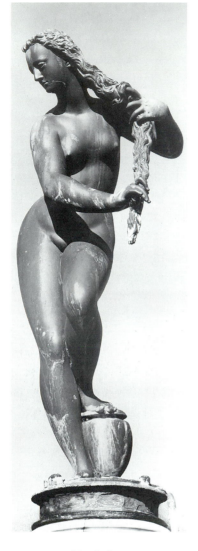

Figure 104. Giambologna, Fountain of Florence, Villa Medici, Castello, c. 1572 (photo: Ralph Lieberman)

Figure 105 (opposite). Giambologna, Fountain of Venus, Grotta Grande, Boboli Gardens, Florence, c. 1572 (photo: Ralph Lieberman)

Medici garden at Castello, the bronze statue by Giambologna of about 1572, which is atop a tall fountain shaft, represents *Florence* in the guise of Venus wringing her hair (Fig. 104)[49] (cities too were traditionally personified by a female figure). Through the intermediary of an engraving by Marcantonio Raimondi of Venus in the same pose, the statue recalls the famous lost painting of Apelles, which is known through an ancient description.[50] The gesture of wringing hair was again made literal in the fountain because water originally flowed from *Florence*'s tresses. The naturalistic action was also a metaphor for a natural phenomenon: according to Vasari, the statue represented a Florence watery with its local rivers.[51] The twisting of *Florence*'s hair echoes the rotation of her body in its serpentine pose. Her curving, swelling body, and the combination of frontality and stasis with implied movement and turning, of artificiality in the framing and display of her breasts with her naturalistic gesture, all enhance the sensuousness inherent in the serpentine line. She is ripe, full, sensual, and dripping with water, her form and pose suggesting that the city of Florence, like Venus, is fertile because of the abundance of water generated in its surrounding countryside.

The pose of Giambologna's *Florence* at Castello is related to that of a *Venus* he sculpted at about the same time (Fig. 105), which was brought to the Grotta Grande of the Boboli Gardens in 1592, about twenty years after its creation.[52] The poses of both *Florence* and *Venus* recall Leonardo's lost painting of *Leda with the Swan* and the ancient statue types that influenced the *Leda* – Venus Pudica and Venus Crouching.[53] The Renaissance versions retain from the antique prototypes the opposition of open and closed, bent and straight, and a gesture of modesty that displays as much as it conceals. Seen from the front, the Boboli *Venus* appears modest with her left arm reaching across her chest to her opposite shoulder; but the serpentine line encourages the viewer to walk around, and on one side the bent leg seems to reveal rather than veil her genitalia, while on the other, her twisted torso and extended arm similarly display her breasts. As with other sixteenth-century sculpture influenced by ancient types, the models are altered to produce a more sensuous figure, which in Renaissance terms is more female.

While *Venus* steps from her bath in the Boboli grotto, delicately balanced on the rocky mound beneath her, leering fauns peer over the rim of the vase. Jets of water once shot up from her rustic base into the vase and more jets from the fauns' mouths spat water back toward *Venus*. Her pose emphasizes her sensuousness, and the grotesque heads act out just what the critics of such images seem to have had in mind. The fauns' mood is like that of a painting Vasari proposed to make in which a nude and beautiful Venus is accompanied by three Graces and, hidden in the bushes, a satyr, in contemplating their beauty, "languishes in his lust, making lunatic's eyes, both distracted and obsessed."[54] The subtle and graceful sensuality in the pose of the watery, fertile *Venus* contrasts sharply with the crude and ugly fauns and their irreverent gesture. Together these figures playfully invite lust along with sensuality into this damp cavern, suggesting the

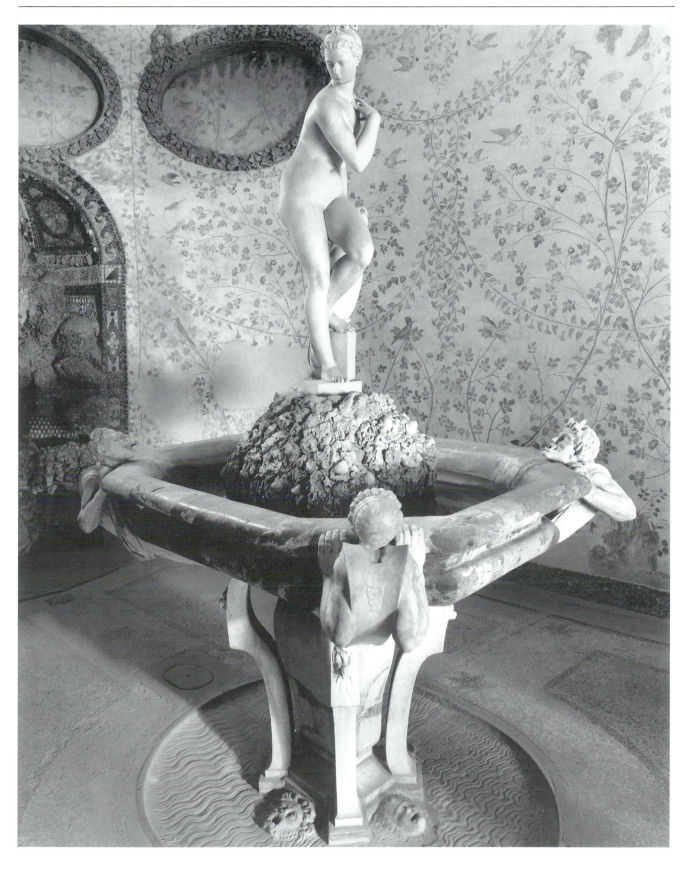

generation of water that takes place there through the metaphor of the human sexual act.

The contrast between masculine and feminine in personifications of nature is as important as female sensuality in expressing nature's generative powers in the garden. This is clear in Cosimo Bartoli's plans for an ideal garden, which include three pairs of male and female figures. The two principal statues represent Venus and Neptune, which, Bartoli explained, symbolized respectively heat and moisture, through which all things are generated.[55] Bartoli returned to the analogy in another context when he discussed the birth of Venus from the sea foam following the castration of Uranus by Saturn. Venus was born through the union of damp – the sea foam, with heat – the genitals of Uranus. The sea foam, Bartoli continued, represents the rubbing and stimulus of lust in the coupling of masculine and feminine, or as it would be in plants, in the joining of moisture and heat.[56] Generation in nature is understood by an analogy with human sexual coupling. It is made visible in sculpture through sensual female figures and also through emphatic and contrasting gender characteristics in male and female figures. Critics were rightly concerned that these images might arouse viewers; indeed, their suggestiveness was one vehicle through which they conveyed their meaning.

Male and Female in Nature

Different parts of the natural world were also gendered and correspondingly represented by male or female figures, with appropriately masculine or feminine poses and gestures. In his project for painted personifications in Francesco de' Medici's Studiolo in the Palazzo Vecchio, Vincenzo Borghini recommended that images be based on the gender characteristics of the elements: "for water I would put two statues of women because water is very generative, whereas for fire I would have both male, which is extremely active."[57] Paraphrasing Seneca, the mythographer Cartari characterized male and female aspects of each of the four elements: wind is masculine, whereas air that does not move and is always misty is feminine; the sea is masculine, whereas fresh water is feminine; fire that burns is masculine, whereas that which lights and causes no harm is feminine; and the earth that is the hardest, such as stones and rocks, is masculine, whereas soft earth is feminine.[58] Personifications of these elements were sometimes represented by both male and female figures, but more often they were fixed in their gender, in correspondence with linguistic gender as well as with long tradition. Among the male personifications (corresponding to their masculine linguistic gender) are rivers, streams, mountains, the sea, the ocean, and lakes. The mountain, or *monte*, a hard part of the earth, and the sea appear in Cartari's male category as well. Female, in addition to Nature herself and soft earth, are freshwater springs and sources, as Cartari noted. In gardens these male and female images stood either in isolation or in pairs.

The gendered poses of male and female personifications of natural elements

were also used to represent the partic-
ular nature at the site. As Borghini
implied, female was understood as sen-
sual and static, and none more so than
the type of the sleeping nymph, which
was very popular in sixteenth-century
Roman gardens in both ancient exam-
ples, as at the Villa d'Este at Tivoli
(Fig. 106), and in modern derivations.
The sleeping nymphs were often
placed in some kind of rustic setting, a
meaningful contrast of refined figure
and rough context, as in the Boboli
grotto. A widely known, pseudoan-
tique Latin inscription accompanying
the sleeping nymph in the Colucci
garden in Rome provides a narrative
context: she was lulled to sleep by the
sound of the murmuring water.[59] The
inscription explains her pose and also
suggests what contemporaries would
have recognized – that the sleeping
nymph represents female water, which
is fresh water. In the Renaissance gar-
den, the figure ornamenting a fountain
sometimes, as at Tivoli, signaled the
actual source of its water. The sleeping

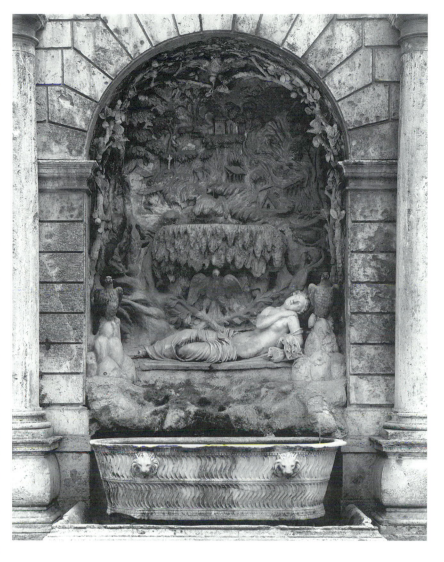

Figure 106. Sleeping Venus, Villa
d'Este, Tivoli, 1560s (photo:
Ralph Lieberman)

figure at Tivoli, identified as Venus, indicates that this fountain is one of the few
in that garden that receives its water from the Rivellese spring. The spring is
transported through the aqueduct that the garden's creator, Cardinal Ippolito
d'Este, had built to bring fresh drinking water to the town of Tivoli.[60] All of the
fountains in the garden not marked with appropriately indicative imagery instead
serve up water from the nearby river. The fountains with potable water refresh
thirsty tourists today as they did in the sixteenth century, but then no signs
announcing the water's qualities were needed.

There is a long tradition in art, from the ancients to Picasso, of a sleeping
female discovered by a male satyr. Its model is probably the story of Amymone,
which is told by Hyginus in the *Fabulae*.[61] The young girl had fallen asleep while
looking for water and was discovered by a satyr. In answer to her plea, Neptune
drove him away, then seduced her himself and created a spring where he had
thrust his trident into a rock. The parallel between their copulation and the gen-
eration of water is suggested through similar imagery in a garden grotto, the
locus of both activities metaphorically, if not actually. At Bagnaia (where all the
fountains are served by a mountain spring), in the Grotto of Venus (Fig. 101),

Figure 107. Sleeping Nymph and Climbing Male, Grotto of Venus, Villa Lante, Bagnaia, 1570s (photo: Ralph Lieberman)

chambers on either side of the goddess are inhabited by sleeping nymphs and male figures – two satyrs and two humans, all in poses of climbing (Fig. 107). The interior is cavelike, covered in small stones; originally water dripped from the walls, creating an oozing, damp, cool, and dark haven.[62] The conjunction of the female embodiment of the fresh–water spring that nourished the garden, in her static pose, and the active male figures suggests metaphorically that in this cave, generation takes place through the union of mirror opposites: male and female, hot and cold, dry and moist, active and passive (in the sense of the one penetrated, not passionless).

Male personifications of aspects of nature also derived from ancient types, and these too were modified into more active poses, or in sixteenth-century terms, given stronger gender characteristics, just as ancient female types were made more sensuous. Statues of Neptune often physically activate the water, in contrast to the still figures of the Goddess of Nature, Ceres, and Venus, from whose breasts life-giving water emerges spontaneously. The statue of Neptune in the Boboli Gardens overlooking the Pitti Palace seems by his strid–ing pose and energetic gesture to cause water to rush from his trident, as it

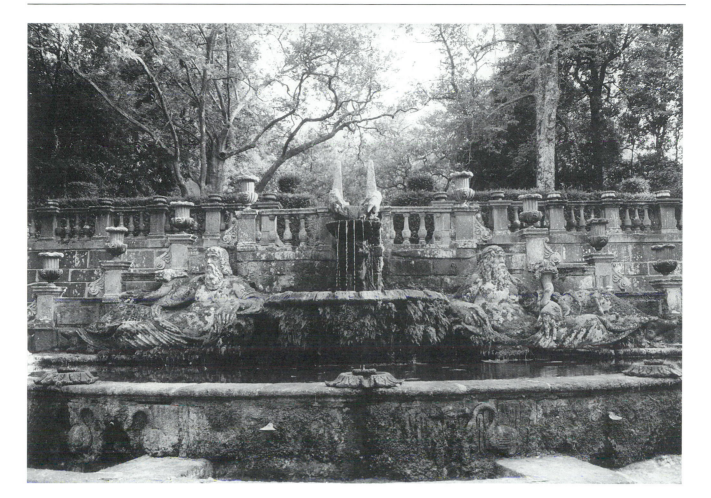

Figure 108. Fountain of the River Gods, Villa Lante, Bagnaia, 1570s (photo: Ralph Lieberman)

once did after a wet season, when the water from a spring in the hills beyond was plentiful.

River gods, which were traditionally male, became very common, closely following several ancient examples placed in prominent locations in Rome. Ancient monumental statues of the Tigris and Nile rivers, recognized as river gods only in the late fifteenth century, were given a place of honor on the Capitoline Hill in 1517. The colossal statues of the Tiber and Nile rivers, not excavated until 1512 or shortly after, were displayed on fountains in the Statue Court of the Vatican Belvedere.[63] These ancient statues inspired many modern versions in Renaissance villas and gardens, including the pair, made of the soft local volcanic stone, at the Villa Lante at Bagnaia (Fig. 108). They repeat the semireclining pose, resting on one arm, with one leg slightly raised, of their models. Renaissance river gods often held onto or leaned upon a cornucopia, symbol of abundance, or a vase pouring water. As with other personifications of nature, it was a Renaissance innovation to associate the anthropomorphic representation with the natural action. At Bagnaia, the river gods flank a sequence of basins of increasing size, the water overflowing from one to the next, so that the idea of a river is conveyed through both male personification and the moving, natural element, shaped with art into an imitation of nature.

In Ammanati's Juno Fountain, *Ceres* (Fig. 100) stood in the center, flanked by

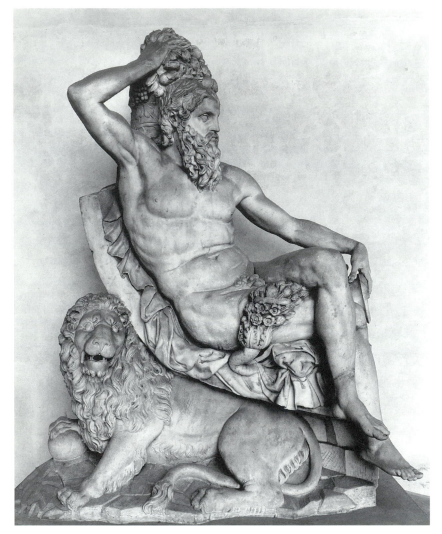

Figure 109. Ammanati, *Arno River*, Museo Nazionale del Bargello, Florence, c. 1555 (photo: Ralph Lieberman)

a male figure representing a river and a female representation of a spring, whose contrasting poses reinforce the different kinds of water that they personify. In the original fountain, the six statues arranged around an arc signified the generation of water in Florence, which took the form of the *Arno River* (Fig. 109) and, opposite, the *Spring of Parnassus* (Fig. 110).[64] It has been noted that the poses of both are reminiscent of Michelangelo's Times of Day in the Medici Chapel; the poses also correspond to the linguistic and traditional genders of these personifications and display emphatic contrasting gender characteristics. Ammanati emphasized these gender differences as much as he followed Michelangelo's models. The pose of the *Spring of Parnassus*, more reclining than sitting, is open and languid, with her vase resting suggestively between her legs. The seated, taut, male *Arno* instead crosses his legs firmly. His right arm is raised high and bent sharply to support the cornucopia behind his back, while his left arm is extended rigidly, grasping the urn beside his legs, in contrast to the relaxed extension of the *Spring of Parnassus*'s right arm. Movements at court, in dance, and in works of art were gendered, as was the corresponding descriptive vocabulary. The *Arno*'s virile pose could be termed a *gagliardo* movement – one that is difficult or forced, demonstrating difficulty and skill, and appropriate to men. The sensual *Spring of Parnassus* would instead be described as *leggiadro*, a term applied to women and indicating softness, without apparent musculature.[65] She could not have been intended to represent the Arbia River in Siena, as has been suggested, because rivers were always male and this figure unequivocally represents female water, which is spring water, and the poetry that similarly flows spontaneously and shares in the essence of female.[66]

For the Medici garden at Pratolino, Giambologna designed two personifications, in about 1577 and 1579, of a river and a mountain, respectively, whose active, *gagliardo* poses identify them as representations of male aspects of water and earth and also specify their relationship to each other. The *Mugnone River* (Fig. 111) is seated awkwardly, with right leg and left arm bent back and opposite limbs straining forward, his right arm reaching across his body to grasp the

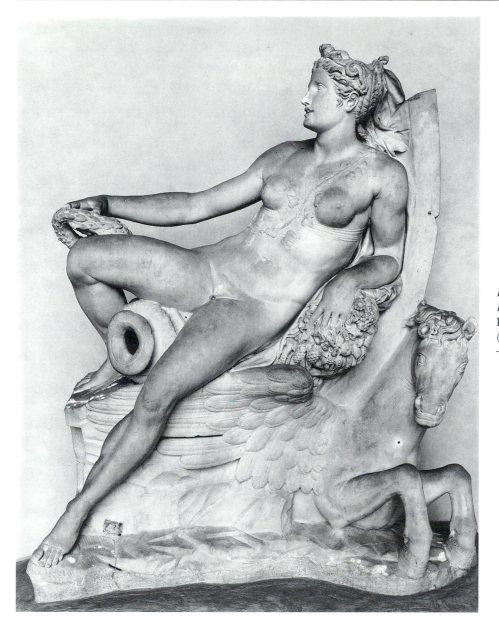

Figure 110. Ammanati, *Spring of Parnassus*, Museo Nazionale del Bargello, Florence, c. 1555 (photo: Ralph Lieberman)

vase lodged beneath his left leg.[67] His body position, more active and strained than any ancient river god, is a reflection of the colossal personification of the Apennine Mountains above him in the garden (Fig. 112). The related poses of these two figures convey the geographical reality that not only do rivers flow from mountains, but, more specifically, the Mugnone River has its source in the Apennines. Modeled on images in ancient literature, the *Appennino*, in a significant departure from his literary precedents, presses down with all his weight on the animal's head that emerges from his rocky base.[68] Like Neptune thrusting his trident, the *Appennino*'s action seems to activate the water that flows from the animal's head, as though he were squeezing a spring from the mountain's depths. Where female sensuality suggests the spontaneous generation of water, male exertion, in these two figures at Pratolino with arms crossing their torsos and water emerging from between their spread, lifted legs, implies a generation of

Figure 111. Giambologna, *Mugnone River*, Villa Medici, Pratolino, c. 1577 (photo: Ralph Lieberman)

water parallel to the active male sexual role. Giambologna's *Appennino* originally dripped water all over his hoary body, and behind him rose a mount of earth, so that from a distance man and mountain seemed to merge, and art and nature became indistinguishable. He is the male counterpart to the Goddess of Nature (Fig. 99), in having been inspired by classical models and in merging classical and grotesque bodies, his own body huge, ugly, covered with accretions, and dripping liquid.

Male and female and classical and grotesque come together again to tell of the earth generating springs, in a relief carved out of the living rock at the Fontana Papacqua (Fig. 113).[69] Located in a nymphaeum situated on a steep slope of the hill town of Soriano nel Cimino, at the site of a rushing natural spring, this relief, dating probably to the early 1560s, presents familiar personifications of the natural world in somewhat unexpected guises. With images carved in different scales and varied styles, the relief is dominated by a colossal, half-reclining female satyr surrounded by animals and sylvan creatures.

The satyress's striking face, which is reminiscent of ancient archaic sculpture, may allude to the Etruscan origins of the region. With three children, one at her breast, the Soriano figure recalls ancient images of Tellus, or Earth (without the goat legs, however), in which children are the emblems of her fertility. A familiar example is the principal figure in the central relief of the Ara Pacis, which has been interpreted as Earth, accompanied by Air and Water.[70]

Figure 112. Giambologna, *Apennine Mountains (Appennino)*, Villa Medici, Pratolino, c. 1579 (photo: Ralph Lieberman)

Figure 113. Fontana Papacqua,
Soriano nel Cimino, c. 1560s
(photo: Ralph Lieberman)

In the sixteenth century, the same image of a woman with children at her breast was a common personification of Charity, another of the attributes aligned with both female and nature. At Soriano, the goat half of her body distinguishes this female from her ancient and sixteenth-century antecedents. Goat-legged creatures also signify the earth, as Cartari explained,[71] and at Soriano the satyress, like the other hybrid creatures who inhabited Renaissance gardens, transforms a classical model into its grotesque counterpart, appropriate to the natural setting.

At the feet of the satyress at Soriano, the truncated torso of a great, bearded, and horned male seems to emerge from his rocky setting. In an Atlas-like pose of support, the sharp angle of his massive arm echoes and balances the jutting rock at the upper right. In some ancient reliefs a personification of the earth was paired with Atlas, the giant who supported the skies and who, in Ovid's account, was turned into a mountain.[72] Here the old satyr in an active pose of support represents the hard and rocky aspect of the earth – the steep, volcanic hill on which the nymphaeum and the town of Soriano were built. Next to him, the satyress represents soft earth, that which generates the water of the Papacqua spring, which bubbles up beneath her, and which, below the terrace of the nymphaeum, gushes out from the hillside. This relief has been deemed bizarre, mannerist, and enigmatic, but it can be easily comprehended as a creative invention on a familiar theme, a metaphorical representation of the nature at this particular site.

Alternative Conventions of Representation

The relief at Soriano departs from contemporary conventions of representation in its array of figures in varying scales, seen from different points of view and positions in space. In this characteristic it is similar to Benvenuto Cellini's bronze relief the *Nymph of Fontainebleau* of some twenty years earlier, which also featured a reclining female personification of a spring and included small-scale animals, distant trees, and in the foreground, a stylized representation of water.[73] Another relief that does not follow the rules of one-point perspective is sculpted inside the niche in which the *Sleeping Venus* at Tivoli lies (Fig. 106). In the hilly landscape scene (which may be intended to allude to the territory of Tivoli itself), trees, a castle, rustic structures, a shepherd with sheep, flowing water, and a mill are depicted from various points of view, one above the other, up to the high horizon line. The conventions of representation in the reliefs at Tivoli and Soriano differ from those expected in contemporary narrative painting. They do not correspond to the style of any particular time or place, medium or artist; rather, they follow conventions that represent metaphorically the laws of nature, which are not the same as those of art.

On the wall perpendicular to the satyress at Soriano is another relief, *Moses Striking the Rock*, also carved from the living rock.[74] In contrast to the metaphorical representation of the natural site in the satyress relief, this one represents the spring in narrative and allegorical terms, which is to say, in human terms. The striking of the rock by Moses produced a spring, like the one at Soriano, that emerges from the rock and from which the sculpted figures drink. The act of Moses is analogous to that of Cardinal Madruzzo, who made the water of the Papacqua spring available to the town by building an aqueduct. The Moses relief portrays a human acting on nature, following the conventions of Albertian *istoria*: a single scale, proportional parts, one-point perspective, and horizon-line isocephaly, all of which, in Alberti's system, are determined in correspondence with the height of a man standing at a fixed distance from the scene. In the satyress relief, however, with its reclining rather than active central figure, these Albertian characteristics are absent. The one-point perspective system comprises a set of conventions that can also be understood as a representation of male rationality. This system contrasts with an alternative set of conventions at the time that can be understood as representing the workings of nature. This alternative set does not include the proportional relationship of all parts and single vanishing point, but corresponds instead with the laws of nature (in the Renaissance understanding), a nature that is not rational, but spontaneous, abundant, unrestrained, and female.

Nature, Gender, and Scholarship

Renaissance writings present nature as an essential and highly valued component of gardens, which they characterize as an interaction between the ever-shifting

terms of art and nature. So too were things that were categorized as female, among them poetry, generosity, and charity, as well as nature, highly valued within an overall hierarchy in which male occupied the superior position. Denying the importance of nature in gardens has resulted in a body of scholarship that until recently omitted much of what Renaissance patrons held dear. Ignoring the importance of gender has led to similar lacks and biases in twentieth-century scholarship. These involve both what has been studied and how it has been interpreted.

I have argued here that the sensuality of and the allusions to sexual activity in these garden sculptures did indeed have meaning in Renaissance terms. They represented society's understanding of nature as generative, and its understanding of the generation of water in the earth as analogous to human procreation. Some twentieth-century scholarship has ignored the overt sensuality, as though it were not relevant to the sculptures' meaning. There is in this a prudishness that remains at odds with artistic production (until the more austere climate of the later sixteenth century), but even more, it raises questions about what and how images may mean. Often meaning has been sought exclusively in the high, literary, male culture, and not in society, gender, and ideology (or in nature). On the other hand, in some more recent scholarship those qualities ignored earlier are acknowledged, and they are explained principally as the female object intended for the male gaze. Men may indeed respond like Vasari's satyrs to images such as Ammanati's *Ceres* and Giambologna's *Venus*, all excited and driven crazy by their lust. This reaction may well have been the intention of the figures' creators, consciously or not, and it does reflect something of social attitudes toward women. But this too ignores the variety and complexity of gender positions in the sixteenth century.

In a cosmology in which all things were related to each other in a complex system of correspondences, and gender was a basic linking principle, male and female carried many associations, such as art with male and nature with female. Because of these associations, male and female could be mobilized for various metaphorical and allegorical purposes. At a time in which the cosmos was represented and understood through gendered personifications, gender, as the Renaissance understood it in scientific, philosophical, and societal terms, was always implicated in meaning.[75] It is a mistake to think that this gendering of the world, with its inherent hierarchies and values, no longer exists in modern times.

Notes

From Claudia Lazzaro, "The Visual Language of Gender in Sixteenth-Century Garden Sculpture," in *Refiguring Women: Perspectives on Gender and the Italian Renaissance*, ed. M. Migiel and J. Schiesari (Ithaca, N.Y., 1991). This essay has been revised by the author for republication in this volume with the permission of Cornell University Press. ED.

This article began with a paper at a conference at Cornell University in 1988 and was published in 1991 as "The Visual Language of Gender in Sixteenth-Century Garden Sculpture" in the anthology arising from it, *Refiguring Woman: Perspectives on Gender and the Italian Renaissance*. Since its initial conception and publication, my thinking on the subject has evolved, along

with other scholarship published in the interim. Consequently, in this essay I have modified the conceptual framework, but retained the core examples. I am grateful to Marilyn Migiel for encouraging and influencing the original article and to both Marilyn and Sheila ffolliott for reading and making perceptive comments on this version.

1. M. Foucault, *The Order of Things* (New York, 1971), ch. 2.

2. K. V. Thomas, *Man and the Natural World: A History of the Modern Sensibility* (New York, 1983); W. B. Ashworth, Jr., "Natural History and the Emblematic World View," in *Reappraisals of the Scientific Revolution*, ed. D. C. Lindberg and R. S. Westman (Cambridge, 1990), 303–32; and C. Lazzaro, "Animals as Cultural Signs: A Medici Menagerie in the Grotto at Castello," in *Reframing the Renaissance: Visual Culture in Europe and Latin America, 1450–1650*, ed. C. Farago (New Haven and London, 1995), 197–227 and 331–5.

3. T. Laqueur, *Making Sex: Body and Gender from the Greeks to Freud* (Cambridge, Mass., 1992); and on the idea of woman, I. Maclean, *The Renaissance Notion of Woman: A Study in the Fortunes of Scholasticism and Medical Science in European Intellectual Life* (Cambridge, 1980).

4. See especially J. Wallach Scott, *Gender and the Politics of History* (New York, 1988), ch. 2, "Gender: A Useful Category of Historical Analysis." S. B. Ortner, "Is Female to Male as Nature Is to Culture?" in *Women, Culture, and Society*, ed. M. Z. Rosaldo and L. Lamphere (Stanford, 1974), 67–87, attempts to understand the widespread subordination of women in different cultures through the pancultural association of women with nature and male with culture.

5. S. Fermor, "Movement and Gender in Sixteenth-Century Italian Painting," in *The Body Imaged: The Human Form and Visual Culture Since the Renaissance*, ed. K. Adler and M. Pointon (Cambridge, 1993), 129–45.

6. My discussion of the Renaissance garden draws on my own study, *The Italian Renaissance Garden: From the Conventions of Planting, Design, and Ornament to the Grand Gardens of Sixteenth-Century Central Italy* (New Haven and London, 1990).

7. For the third nature and the related concept of a second nature, see my *Renaissance Garden*, 9.

8. For example, C. Jordan, *Renaissance Feminism: Literary Texts and Political Models* (Ithaca, N.Y., 1990); and P. J. Benson, *The Invention of the Renaissance Woman: The Challenge of Female Independence in the Literature and Thought of Italy and England* (University Park, Pa., 1992).

9. L. Montrose, "The Work of Gender in the Discourse of Discovery," *Representations* XXX (1991): 1–41.

10. M. Dickmann Orth in *Livres d'heures royaux: La peinture de manuscrits à la cour de France au temps de Henri II*, exh. cat. (Paris, 1993), 30; and for two very different and con-troversial interpretations, R. Waddington, "The Bisexual Portrait of Francis I," in *Playing with Gender*, ed. J. R. Brink *et al.* (Urbana, 1991), 99–132; and B. Hochstetler Meyer, "Marguérite de Navarre and the Androgynous Portrait of François Ier," *Renaissance Quarterly* XLVIII (1995): 287–325. I thank Sheila ffolliott for the Orth reference.

11. S. ffolliott, "A Queen's Garden of Power: Catherine de' Medici and the Locus of Female Rule," in *Reconsidering the Renaissance*, ed. M. A. Di Cesare (Binghamton, N.Y., 1992), 245–55.

12. Thomas, *Man and the Natural World*, ch. 1.

13. C. Merchant, *The Death of Nature: Women, Ecology, and the Scientific Revolution* (San Francisco, 1980).

14. G. Broberg, "Natural History Frontispieces and Ecology," in *The Natural Sciences and the Arts: Aspects of Interaction from the Renaissance to the 20th Century: An International Symposium* (Stockholm, 1985), 84–97. Londa Schiebinger also finds a change in the late eighteenth century from personifications of science as female, in "Feminine Icons: The Face of Early Modern Science," *Critical Inquiry* XIV (1988): 661–91.

15. L. Schiebinger, "Why Mammals Are Called Mammals: Gender Politics in 18th Century Natural History," *American Historical Review* LXXXII (1993): 382–411.

16. For specific examples, see my "The Visual Language of Gender in Sixteenth-Century Garden Sculpture," in *Refiguring Woman: Perspectives on Gender and the Italian Renaissance*, ed. M. Migiel and J. Schiesari (Ithaca, N.Y., 1991), 74–5.

17. L. Dami, *Il giardino italiano* (Milan, 1924), 22.

18. Ugo Ojetti, in the preface to *Mostra del giardino italiano*, exh. cat. (Florence, 1931), 23.

19. For example, Gherardo Bosio, "Invito alla visita delle ville Medicee: A proposito della mostra fiorentina del giardino," *Domus* IV, no. 39 (March 1931): 56; and see my forthcoming article on the Italian garden tradition in the service of the Fascist myth of Italy.

20. Asked to design a fountain for the Boboli Gardens in Florence, which was ultimately executed by Giambologna, the sculptor Baccio Bandinelli wrote in a letter of 1551 that he would make one to correspond to a wall that was to be constructed, because "le cose che si murano, debbono esser guida, e superiori a quelle che si piantano" (the things that one builds must be the guide and superior to those that one plants). G. G. Bottari and S. Ticozzi, *Raccolta di lettere sulla pittura, scultura ed architettura*, 8 vols. (Milan, 1822) I, 93–4.

21. W. Leiss, *The Domination of Nature* (New York, 1972), 12–15, and ch. 2 and 3, esp. 35 and 68. Other correctives to a distorted understanding of the past are R. Attfield, "Christian Attitudes to Nature," *Journal of the History of Ideas* XLIV (1983): 369–86, and the learned and sensitive

book by C. J. Glacken, *Traces on the Rhodian Shore: Nature and Culture in Western Thought from Ancient Times to the End of the Eighteenth Century* (Berkeley, 1967).

22. For example, F. Fariello, *Architettura dei giardini* (Rome, 1967), 74: "Nato in un clima di magnificenza, il giardino del Cinquecento riflette il razionalismo umanistico dell'epoca, che afferma il dominio dell'uomo sul mondo sensibile." (Born in a climate of magnificence, the sixteenth-century garden reflects the humanistic rationalism of the epoch, which affirms the dominion of man over the material world.); J. Shearman, *Mannerism* (Harmondsworth, 1967), 123: "The sixteenth-century garden is more obviously a product of man than of nature; it seems that the garden artist's material is not organic, or rather that it has no life that he does not give it"; and G. Jellicoe, S. Jellicoe, P. Goode, and M. Lancaster, eds., *The Oxford Companion to Gardens* (Oxford and New York, 1986), 284: "However, one of the features which was to remain central and constant in Italian gardens until the end of the 18th century was already apparent (in 15th century gardens) – the subordinate role in the whole design played by plants, which were almost entirely evergreens." See my *Renaissance Garden* for the variety of planting in Renaissance gardens, as well as the important role of nature in every aspect of garden design and ornamentation.

23. Contemporary writers stress the freedom and sensual pleasures of gardens, although cautioning that these are "honest" pleasures. On the association of gardens with love, see T. Comito, *The Idea of the Garden in the Renaissance* (New Brunswick, N.J., 1978); and for sexual license as part of the Renaissance understanding of the Golden Age and other earthly paradises, H. Haydn, *The Counter-Renaissance* (Gloucester, Mass., 1966), 499–505, and H. Levin, *The Myth of the Golden Age in the Renaissance* (Bloomington, 1969), ch. 2. For the role of gardens and their associated values in literature, A. B. Giamatti, *The Earthly Paradise and the Renaissance Epic* (Princeton, 1966).

24. *Lexicon iconographicum mythologiae classicae* (Zurich, 1984), II, 1, 755–63, esp. 763. Some now think that the breastlike protrusions were intended instead to signify udders, for example, P. Pray Bober and R. O. Rubinstein, *Renaissance Artists and Antique Sculpture: A Handbook of Sources* (London, 1986), 87.

25. V. Cartari, *Le imagini de i dei de gli antichi* (Venice, 1571; facs. ed., New York and London, 1976), 118.

26. On the association of female with generative nature, in particular in painted portraits and in Leonardo's *Mona Lisa* and his writings, see M. D. Garrard, "Leonardo da Vinci: Female Portraits, Female Nature," in *The Expanding Discourse: Feminism and Art History*, ed. N. Broude and M. D. Garrard (New York, 1992), 59–85; W. Smith, "Observations on the *Mona Lisa* Landscape," *Art Bulletin* LXVII (1985): 183–99; M. Kemp, *Leonardo da Vinci: The Mar-*

velous Works of Nature and Man (Cambridge, Mass., 1981), 261–70 and 275; and L. Schneider and J. D. Flam, "Visual Convention, Simile, and Metaphor in the Mona Lisa," *Storia dell'arte* XXIX (1977): 15–24.

27. Lazzaro, *Renaissance Garden*, 144 and n. 85.

28. D. R. Coffin, *The Villa d'Este at Tivoli* (Princeton, 1960), 18 and n. 10, notes that the statue at Tivoli was executed by the Fleming Gillis van den Vliete after an ancient statue formerly in the Farnese Collection, and that Niccolò Tribolo also carved a statue of the Goddess of Nature as Diana of Ephesus for a fountain, which was sent to Francis I of France.

29. M. Bakhtin, *Rabelais and His World*, trans. H. Iswolsky (Bloomington, 1984); P. Stallybrass and A. White, *The Politics and Poetics of Transgression* (Ithaca, N.Y., 1986), esp. 9–10 and 21–3; and on the female grotesque, M. Russo, "Female Grotesques: Carnival and Theory," in *Feminist Studies, Critical Studies*, ed. T. de Lauretis (Bloomington, 1986), 213–29, and B. Spackman, "*Inter musam et ursam moritur*: Folengo and the Gaping 'Other' Mouth," in *Refiguring Woman: Perspectives on Gender and the Italian Renaissance*, ed. M. Migiel and J. Schiesari (Ithaca, N.Y., 1991), 19–34.

30. In the Renaissance, Diana of Ephesus was also called Isis, and the Earth was identified as Tellus or Terra Mater – the Great Earth Mother, who was in turn conflated with the goddesses Cybele, Ceres, and Ops; see Bober and Rubinstein, *Renaissance Artists*, 85–6. On the cultural significance of breasts, see Schiebinger, "Why Mammals," *passim*.

31. D. Heikamp, "Ammannati's Fountain for the *Sala Grande* of the Palazzo Vecchio in Florence," in *Fons Sapientiae: Renaissance Garden Fountains*, ed. E. B. MacDougall (Washington, D.C., 1978), 115–73; M. Campbell, "Observations on the Salone dei Cinquecento in the Time of Duke Cosimo I de' Medici, 1540–1574," in *Firenze e la Toscana dei Medici nell'Europa del '500*, 3 vols. (Florence, 1983), III, 821–4; and Lazzaro, *Renaissance Garden*, 152–4.

32. The statuette and engraving after it are illustrated in Heikamp, "Ammannati's Fountain," figs. 35–8.

33. C. Ripa, *Iconologia* (Rome, 1603; facs. ed., Hildesheim and New York, 1970), 125. The first edition without illustrations appeared in 1593.

34. Raffaello Borghini in 1584 explained the significance of the entire fountain as "il generar dell'acqua" (the generation of water), in which "Cerere figurata per la terra, la quale si premea le mammelle, e ne usciva fuor l'acqua" (Ceres, representing the Earth, presses her breasts and water issues forth from them), cited in Heikamp, "Ammannati's Fountain," 121.

35. Campbell, "Observations on the Salone," 822–3, points out the predominance of female imagery in this fountain, and associates the female principle in nature with the female half of the ruling Medici family, the Duchess

Eleonora of Toledo. Never erected in its original location (with no known explanation), the fountain was brought to Grand Duke Francesco de' Medici's garden at Pratolino in 1580, transferred to the terrace of the Palazzo Pitti overlooking the Boboli Gardens in 1588, dismantled in 1635, and finally reassembled and installed in the Bargello Museum in 1977.

36. In all the printed views of the villa from the earliest in 1596 by Tarquinio Ligustri, the figure is identified as Venus, along with the unmistakable Neptune opposite. The figure dates from the 1570s and is made of local peperino stone.

37. J. Bonfadio, *Le lettere e una scrittura burlesca*, ed. A. Greco (Rome, 1978), 97.

38. A. Caro, *Lettere familiari*, 3 vols. (Florence, 1959), II, 100.

39. Ripa, *Iconologia*, 43 (my own translation). *Sostanza* or Substance (as in food, property, etc.) is similarly represented with overflowing breasts in Ripa's text and accompanying image.

40. P. Giovio, *Dialogo dell'imprese* (Lyons, 1574), 39.

41. Ripa, *Iconologia*, 406–7: "Le mammelle piene di latte, mostrano la fecondità de concetti, & dell'inventioni, che sono l'anima della Poesia." These characteristics of poetry are emphasized by R. J. Clements, *Picta Poesis: Literary and Humanistic Theory in Renaissance Emblem Books* (Rome, 1960), 34.

42. Ripa, *Iconologia*, 215; and Clements, *Picta Poesis*, 34 and 48.

43. Cartari, *Imagini*, 417.

44. One of Andreas Alciati's emblems of 1555 explains that the sphinx represents ignorance, of which there are three causes, among them desire for worldly pleasures. A. Alciati, *Emblems*, ed. P. M. Daly, 2 vols. (Toronto, 1985), I, no. 188. See also G. de Tervarent, *Attributs et symboles dans l'art profane, 1450–1600* (Geneva, 1958), 364.

45. Pirro Ligorio, "Trattato di alcune cose appartenente alla nobiltà dell'antiche arti . . . ," discussed by D. R. Coffin, "Pirro Ligorio on the Nobility of the Arts," *Journal of the Warburg and Courtauld Institutes* XXVII (1964): 191–210, and published in *Scritti d'arte del Cinquecento*, ed. P. Barocchi, 3 vols. (Milan and Naples, 1971), I, 1412–70.

46. Coffin, "Ligorio," 200; and Ligorio in Barocchi, ed., *Scritti*, II, 1420, on Venus: "questo disegno fu beffato da alcuni religiosi, i quali dissero che, per esservi Venere ignuda, era cosa sporca et obscena" (this design was mocked by some friars, who said that, since there was a nude Venus in it, it was a dirty and obscene thing); on Leda and the Swan, 1426: also "cosa sporca" (dirty thing), "deono le cose lascive essere usate e poste ne' luoghi che non sempre si veggono, benché sono degne di non essere in niun luogo permesse" (lascivious things should be used and stationed in places that are not always seen, although they are not fit to be permitted in any place); on the woman with water pouring from her breasts together with

Pegasus, 1428: "E per esser disgraziatamente finto, non piacque; essendo cosa [dis]onesta e sciocca, parve loro cosa insipida" (And because it was miserably made, it did not please; being a shameful and silly thing, it seemed to them stupid).

47. Heikamp, "Ammannati's Fountain," 143 and 166, Documents XLV and XLVI. A belt of gilded copper leaves was created to cover her nudity. It was attached at the hole at the crotch of the *Spring of Parnassus* (Fig. 110).

48. Coffin, *Villa d'Este*, 34. The grotto originally contained an ancient statue of the Capitoline Venus type stepping from her bath, and the manuscript attributable to the creator of the garden, Pirro Ligorio, indicates that it is dedicated to voluptuous pleasure (144).

49. H. Keutner, "La statua del Giambologna," in *Fiorenza in Villa*, ed. C. Acidini Luchinat (Florence, 1987), 44–5. C. Avery, *Giambologna: The Complete Sculpture* (Mt. Kisco, N.Y., 1987), 130 and cat. 27, dates the statue instead to about 1560. G. Vasari, *Le vite de' più eccellenti pittori scultori ed architettori*, ed. G. Milanesi, 8 vols. (Florence, 1887), VI, 79, attributed the model to Tribolo before his death in 1550.

50. I. H. Shoemaker and E. Broun, *The Engravings of Marcantonio Raimondi*, exh. cat. (Lawrence, Kan., 1981), 68. For Apelles's painting and the description by Sidonius, see N. Comes, *Mythologiae* (Venice, 1567) (1st ed., 1551), 119–20.

51. Vasari, *Vite*, VI, 79.

52. Avery, *Giambologna*, 218–21 and cat. 7, dates the statue about 1570. D. Heikamp, "The Grotta Grande in the Boboli Garden, Florence," *Connoisseur* CXCIX (1978): 42, notes the date of the transfer to the grotto.

53. W. Stedman Sheard, *Antiquity in the Renaissance* (Northampton, Mass., 1979): 42; and Bober and Rubinstein, *Renaissance Artists*, 62–3.

54. K. Frey, *Der Literarische Nachlass Giorgio Vasaris*, 2 vols. (Munich, 1923), I, 2, Vasari to Niccolo Vespucci, 1532, "si struggie nella sua lussuria, facendo occhi pazzi, et tutto astratto et intento à quello effetto."

55. C. Bartoli, *Ragionamenti accademici sopra alcuni luoghi difficili di Dante* (Venice, 1567), 20v: "Voi sapete che tutte le cose che si generano, si generano mediante la calidità, et mediante la humidità. Io haveva preso Venere per essa calidità, et Nettuno per la humidità, accioche mediante queste due qualitadi, tutte le herbe et tutte le piante di questo Giardino, andassero di bene in meglio, multiplicando, e crescendo" (You know that all things that are generated, are generated by means of heat, and by means of moisture. I have taken Venus to be heat, and Neptune to be moisture, so that by means of these two qualities all the herbs and all the plants of this Garden would go from good to better, multiplying and growing.)

56. Frey, *Literarische Nachlass*, I, 410, Cosimo Bartoli to Vasari, 1555: "Il qual Tempo overo Saturno dicono che castrò il

Cielo et gli tagliò i genitalj et gli gitto nel mare, cio è cavò dal Cielo la possibilità et la faculta del generare. La qual mescolatasi col mare delle cose mondane, generò Venere di spuma marina: Cioè essa faculta del generare si transferi nella actione del congiungnersi insieme di tutte le cose creabilj mediante il calore, per il quale si intendono i genitalj, et mediante lo humore, per il quale si intende il mare; et la stiuma marina è presa per quello sfregamento et incitamento di lussuria nel congiungnersi insieme il mastio et la femina, o volete dire, come sarebbe nelle piante il congiugnimento del calore et della humidita" (They say that Time, or Saturn, castrated Heaven [Uranus] and cut off his genitals and threw them into the sea, that is, he took away from Heaven the possibility and ability to generate. When the ability to generate was mixed with the sea of earthly things, it generated Venus from the sea foam: that is, the ability to generate transferred itself in the action of joining together all things capable of being created through heat, represented by the genitals; and through moisture, represented by the sea; and the sea foam is that rubbing and stimulus of lust in the joining together of male and female, or we might say, in the example of plants the joining of heat and moisture.)

57. Vincenzo Borghini in *Lo Stanzino del Principe in Palazzo Vecchio: I concetti, le immagini, il desiderio*, ed. M. Dezzi Bardeschi *et al.* (Florence, 1980), 31 (my translation).

58. Cartari, *Imagini*, 551–3.

59. D. R. Coffin, *Gardens and Gardening in Papal Rome* (Princeton, 1991), 33–4 and 38–40. The earlier literature on the sleeping nymph includes O. Kurz, "*Huius Nympha Loci*: A Pseudo-Classical Inscription and a Drawing by Dürer," *Journal of the Warburg and Courtauld Institutes* XVI (1953): 171–7; M. Meiss, "Sleep in Venice," *Proceedings of the American Philosophical Society* CX (1966): 348–82; E. B. MacDougall, "The Sleeping Nymph: Origins of a Humanist Fountain Type," *Art Bulletin* LVII (1975): 357–65; P. Pray Bober, "The *Coryciana* and the Nymph Corycia," *Journal of the Warburg and Courtauld Institutes* XL (1977); 223–39; and Bober and Rubinstein, *Renaissance Artists*, 97–8.

60. Coffin, *Villa d'Este*, 9, notes that the white marble figure is antique, following T. Ashby, "The Villa d'Este at Tivoli and the Collection of Classical Sculptures Which It Contained," *Archaeologia* LXI, pt. 1 (1908): 249. Several contemporaries identified her as Venus (among them Ligorio and Foglietta, in Coffin, *Villa d'Este*, 9 n. 19 and 150); and M. de Montaigne, *Journal du Voyage en Italie (1580–1581)*, ed. A. D'Ancona (Città di Castello, 1895), 327, recognized her as a "sleeping nymph." For the water sources in different fountains at Tivoli and the imagery that keyed them, see Lazzaro, *Renaissance Garden*, 146, 219, and 225.

61. Hyginus, *Fabulae*, no. 169, cited in the literature on sleeping nymphs noted above.

62. C. Lazzaro Bruno, "The Villa Lante at Bagnaia," Ph.D. diss., Princeton University, 1975, 77; and F. J. Alvarez, "The Renaissance Nymphaeum: its Origins and its Development in Rome and Vicinity" (Ph.D. diss., Columbia University, 1981), 148–9.

63. See Bober and Rubinstein, *Renaissance Artists*, 99 and 101–3, for all four ancient river gods.

64. Tanai de' Medici in a letter of 1579 identifies them as the Arno River and the Spring of Parnassus, because "Fiorenza habbia molto proprio la poesia, et Arno . . . fa fertile la città" (Florence has very properly poetry, and the Arno . . . makes the city fertile), and on the meaning of the entire fountain, he explained, "e tutto questo gruppo significa come nasce l'acqua, perchè la terra succ[h]ia l'aria, e poi getta fuori l'acqua, e ne nascono le fonti e i fiumi . . . " (And this entire group signifies how water is born, since the earth sucks the air, and then throws forth water, and from it are born springs and rivers), cited in Heikamp, "Ammanati's Fountain," 121, and see also 130–3, on the style of the sculptures.

65. Fermor, "Movement and Gender," 139–42.

66. R. Starn and L. Partridge, *Arts of Power: Three Halls of State in Italy, 1300–1600* (Berkeley, 1992), 176 and n. 101, who misinterpret Heikamp's mention of the eighteenth-century identification of the figure as the river Arbia.

67. Avery, *Giambologna*, 221–3 and cat. 166.

68. *Ibid.*, cat. 165. For the ancient literary sources for personifications of mountains, Giambologna's *Appennino*, and the source of the water in the garden, see Lazzaro, *Renaissance Garden*, 148–50 and 164–5.

69. For the nymphaeum of which this fountain is a part, see Lazzaro, *Renaissance Garden*, 156–61, figs. 158–63. Cardinal Cristoforo Madruzzo, bishop of Trent, acquired jurisdiction of the town in 1560. An inscription dated 1561 and a letter from the cardinal of 1564 suggest that the nymphaeum was created during those years. For other interpretations of the nymphaeum, see S. Lang, "Bomarzo and Soriano: A Study in Iconography," *Architectural Review* CXXI (1957): 429–30; J. Theurillat, *Les Mystères de Bomarzo et des jardins symboliques de la Renaissance* (Geneva, 1973), 143–53; and M. Festa Milone, "La triplice allegoria dell'acqua di papa: La fonte del Cardinal Madruzzo a Soriano nel Cimino," *Psicon* VIII–IX (1976): 121–31.

70. The relief was discovered only in about 1568. A letter of 1569 from Cardinal Giovanni Ricci of Montepulciano to Cosimo I's secretary interprets the three figures as the elements Air, Water, and Earth, published in part in E. Petersen, *Ara Pacis Augustae* (Vienna, 1902), 132 n. 1, no. 3; and see S. Settis, "The Altar of Peace," *FMR* VIII (1995): 92. Several recent studies propose that the principal figure represents Venus, the Earth, Ceres, or Peace, individually or all at once. See K. Galinsky, "Venus, Poly-

semy, and the Ara Pacis Augustae," *American Journal of Archaeology* XCVI (1996): 457–75. For a discussion of the traditional identification as the Earth, see E. Strong, *"Terra Mater* or *Italia?" Journal of Roman Studies* XXVII (1937): 114–26.

71. Cartari, *Imagini*, 138.

72. *Lexicon*, III, 1, 2–49, s.v. "Atlas," no. 46 for the relief with Tellus, and III, 2, figs. 11–49. Ovid, *Met.*, IV, 627–62.

73. J. Pope-Hennessy, *Cellini* (New York, 1985), 137–40 pls. 69 and 75–82. The relief was completed in 1543.

74. Lazzaro, *Renaissance Garden*, 157–8, fig. 160, and see the illustration in "The Visual Language of Gender in Sixteenth-Century Garden Sculpture," in *Refiguring Woman*, fig. 21.

75. For example, Schiebinger, "Feminine Icons," on the personification of science as the female Scientia.

Selected Bibliography

Alberti, L. B. *On the Art of Building in Ten Books*, trans. J. Rykwert, N. Leach, and R. Tavernor, Cambridge, Mass., 1988.

———. *On Painting and On Sculpture: The Latin Texts of* De Pictura *and* De Statua, ed. C. Grayson, London and New York, 1972.

Allen, D. C. *Mysteriously Meant: The Rediscovery of Pagan Symbolism and Allegorical Interpretation in the Renaissance.* Baltimore, 1970.

Avery, C. *Giambologna: The Complete Sculpture.* Oxford, 1987.

Avery, C., and A. Radcliffe. *Giambologna, 1529–1608: Sculptor to the Medici.* London, 1978.

Barolsky, P. *The Faun in the Garden.* University Park, Pa., 1994.

———. *Giotto's Father.* University Park, Pa., 1993.

———. *Michelangelo's Nose.* University Park, Pa., 1990.

———. *Why Mona Lisa Smiles.* University Park, Pa., 1992.

Beck, J. *Jacopo della Quercia,* 2 vols. New York, 1991.

Blunt, A. *Artistic Theory in Italy, 1450–1600.* Oxford, 1940.

Bober, P. P., and R. O. Rubinstein. *Renaissance Artists and Antique Sculpture: A Handbook of Sources.* New York, London and Oxford, 1986.

Bode, W. Von. *The Italian Bronze Statuettes of the Renaissance,* 2d rev. ed. Ed. J. D. Draper. New York, 1980.

Borsook, E. *The Companion Guide to Florence.* London, 1966.

Brucker, G. *The Civic World of Early Renaissance Florence.* Princeton, 1977.

Bush, V. *Colossal Sculpture of the Cinquecento.* New York, 1976.

Cellini, B. *The Autobiography of Benvenuto Cellini.* Ed. C. Hope. Oxford, 1983.

———. *The Treatises of Benvenuto Cellini on Goldsmithing and Sculpture.* Trans. C. R. Ashbee. London, 1888. Reprint, New York, 1967.

Cennini, C. *The Craftsman's Handbook "Il Libro dell'Arte."* Trans. D. V. Thompson, Jr. New Haven, 1933. Reprint, New York, 1954.

Les Chantiers de la Renaissance. Ed. J. Guillaume. Paris, 1991.

La Civiltà del Cotto. Ed. A. Paolucci and G. Conti. Florence, 1980.

Cox-Rearick, J. *Dynasty and Destiny in Medici Art: Pontormo, Leo X, and the Two Cosimos.* Princeton, 1984.

Darr, A. P., and G. Bonsanti, eds. *Donatello e i Suoi: Scultura fiorentina del primo Rinascimento.* Milan and Florence, 1986.

Dolcini, L., ed. *Verrocchio's Christ and St. Thomas.* New York, 1992.

Draper, J. *Bertoldo di Giovanni: Sculptor of the Medici Household.* Columbia, Mo., 1992.

The Elder Pliny's Chapters on the History of Art. Trans. K. Jex-Blake and ed. E. Sellers. London and New York, 1896. Reprint, Chicago, 1968.

Ettlinger, L. D. *Antonio and Piero Pollaiuolo.* New York, 1978.

275

————. "Hercules Florentinus." *Mitteilungen des Kunsthistorischen Institutes in Florenz*, XVI (1972): 119–42.

Fader, M. A. A. *Sculpture in the Piazza della Signoria as Emblem of the Florentine Republic.* New York, 1977.

Farago, C. J. *Leonardo da Vinci's Paragone: A Critical Interpretation with a New Edition of the Text in the Codex Urbinas.* Leiden, 1992.

Freedberg, D. *The Power of Images: Studies in the History and Theory of Response.* Chicago and London, 1989.

Fusco, L. "The Use of Sculptural Models by Painters in Fifteenth-Century Italy." *Art Bulletin* LXIV, no. 2 (1982): 175–94.

Gauricus, P. *De sculptura.* Ed. and trans. A. Chastel and R. Klein. Geneva and Paris, 1969.

Goldthwaite, R. *Wealth and the Demand for Art in Italy, 1300–1600.* Baltimore and London, 1993.

Gombrich, E. H. "The Early Medici as Patrons of Art." In *Norm and Form: Studies in the Art of the Renaissance.* Chicago, 1985.

Haftmann, W. *Das italienische Säulenmonument.* Leipzig and Berlin, 1939.

Hale, J. R. *Florence and the Medici: The Pattern of Control.* London, 1977.

Hibbard, H. *Michelangelo.* New York, 1974.

Hill, G. F. *Medals of the Renaissance.* Oxford, 1920.

Holderbaum, J. *The Sculptor Giovanni Bologna.* New York and London, 1983.

Janson, H. W. *16 Studies.* New York, 1973.

————. *The Sculpture of Donatello.* 2d ed. Princeton, 1979.

Kenseth, J., ed. *The Age of the Marvelous.* Hanover, N. H., 1991.

Keutner, H. "Über die Entstehung und die Formen des Standbildes im Cinquecento." *Münchner Jahrbuch der bildenden Kunst* VII (1956): 138–68.

Klapisch-Zuber, C. *Les Maîtres du marbre: Carrare, 1300–1600.* Paris, 1969.

Krautheimer, R., and T. Krautheimer-Hess. *Lorenzo Ghiberti.* 2 vols. 2d ed. Princeton, 1970.

Lavin, I. "On Illusion and Allusion in Italian Sixteenth-Century Portrait Busts." *Proceedings of the American Philosophical Society* CXIX, no. 5 (October 1975): 353–62.

————. "Bozzetti and Modelli: Notes on Sculptural Procedure from the Early Renaissance through Bernini." In *Stil und überlieferung in der Kunst des Abendlandes: Akten des 21. Internationalen Kongresses für Kunstgeschichte in Bonn 1964. II: Michelangelo,* 93–104. Berlin, 1967.

Lazzaro, C. *The Italian Renaissance Garden: From the Conventions of Planting, Design, and Ornament to the Grand Gardens of Sixteenth-Century Central Italy.* New Haven and London, 1990.

Leithe-Jasper, M. *Renaissance Master Bronzes from the Collection of the Kunsthistorisches Museum Vienna.* London, 1986.

Mannoni, T. *Marble: The History of a Culture.* New York, 1985.

Michelangelo: Life, Letters, and Poetry. Trans. G. Bull. Oxford and New York, 1987.

Michelangelo: Selected Scholarship in English. Ed. W. E. Wallace. 5 vols. New York, 1995.

Mills, J. *The Encyclopedia of Sculpture Techniques.* London, 1990.

Natur und Antike in der Renaissance. Ed. H. Beck and P. C. Bol. Frankfurt, 1985.

L'Oreficeria nella Firenze del Quattrocento. Florence, 1977.

Panofsky, E. *Renaissance and Renascences in Western Art.* Uppsala, 1960.

————. *Tomb Sculpture.* New York, 1964. Reprint, New York and London, 1992.

Paoletti, J. "Wooden Sculpture in Italy as Sacral Presence." *Artibus et Historiae* XXVI (1992): 85–100.

Poeschke, J. *Donatello and His World: Sculpture of the Italian Renaissance.* New York, 1993.

————. *Michelangelo and His World.* New York, 1996.

Pope-Hennessy, J. *Cellini.* New York, 1985.

————. *Donatello.* New York, 1993.

————. *Essays on Italian Sculpture.* London, 1969.

————. *An Introduction to Italian Sculpture. I: Italian Gothic Sculpture; II: Italian Renaissance Sculpture; III: Italian High Renaissance and Baroque Sculpture.* 3d ed. New York, 1985; (4th ed. London and New York, 1996).

————. *Luca della Robbia.* Oxford, 1980.

————. *The Portrait in the Renaissance.* Washington, D.C., 1966.

————. *The Study and Criticism of Italian Sculpture.* Princeton, 1980.

Pope-Hennessy, J., and R. Lightbown. *Catalogue of Italian Sculpture in the Victoria and Albert Museum.* 3 vols. London, 1964.

Riess, J. B. "The Civic View of Sculpture in Alberti's *De re aedificatoria.*" *Renaissance Quarterly* XXXXII (1979): 1–17.

Rockwell, P. *The Art of Stoneworking: A Reference Guide.* Cambridge, 1993.

Saslow, J. M. *The Poetry of Michelangelo: An Annotated Translation.* New Haven and London, 1991.

Scher, S. K. *The Currency of Fame: Portrait Medals of the Renaissance.* New York, 1994.

Seymour, C., Jr. *David: A Search for Identity.* Pittsburgh, 1967.

————. *Sculpture in Italy, 1400–1500.* Harmondsworth and Baltimore, 1966.

————. *The Sculpture of Verrocchio.* Greenwich, Conn., 1971.

Seznec, J. *The Survival of the Pagan Gods: The Mythological Tradition and Its Place in Renaissance Humanism and Art.* 3d ed. Princeton, 1995.

Sheard, W. S. *Antiquity in the Renaissance.* Northampton, Mass., 1978.

Shearman, J. *Mannerism.* Harmondsworth, 1967.

————. *Only Connect . . . Art and the Spectator in the Italian Renaissance.* Bollingen Series, XXXV, 37. Princeton, 1992.

Stone, R. "Antico and the Development of Bronze Casting in Italy at the End of the Quattrocento." *Metropolitan Museum Journal* XVI (1981): 87–116.

Summers, D. *Michelangelo and the Language of Art.* Princeton, 1981.

The Thyssen-Bornemisza Collection: Renaissance and Later Sculpture. Ed. A. Radcliffe, M. Baker, and M. Maek-Gérard. London, 1992.

Tolnay, C. de. *Corpus dei disegni di Michelangelo.* 4 vols. Novara, 1975–80.

————. *Michelangelo.* 5 vols. Princeton, 1943–60. 2d ed., 1970.

Trexler, R. C. "Florentine Religious Experience: The Sacred Image." *Studies in the Renaissance* XIX (1972): 7–41.

————. *Public Life in Renaissance Florence.* New York, 1980.

————. "Ritual Behavior in Renaissance Florence: The Setting." *Medievalia et humanistica: Studies in Medieval and Renaissance Culture,* n.s. IV (1973): 125–44.

Vasari, G. *The Lives of the Most Eminent Painters, Sculptors, and Architects.* Trans. G. DuC. de Vere. 10 vols. London, 1912–15. Reprint, New York, 1979.

————. *Le vite de' più eccellenti pittori scultori ed architettori.* Ed. G. Milanesi. 8 vols. Florence, 1878–1906. Reprint, Florence, 1981.

Vasari on Technique. Trans. L. S. Maclehose and ed. G. B. Brown. New York, 1907. Reprint, New York, 1960.

Verrocchio and Late Quattrocento Italian Sculpture. Ed. S. Bule *et al.* Florence, 1992.

Vitruvius. *The Ten Books on Architecture (De architectura).* Trans. M. H. Morgan. New York, 1960.

Vossilla, F. *La Loggia della Signoria: Una galleria di scultura.* Florence, 1995.

Wackernagel, M. *The World of the Florentine Renaissance Artist: Projects and Patrons, Workshop and Art Market.* Trans. A. Luchs. Princeton, 1983.

Wallace, W. E. *Michelangelo at San Lorenzo: The Genius as Entrepreneur.* Cambridge, 1994.

Weil-Garris, K. "On Pedestals: Michelangelo's *David,* Bandinelli's *Hercules and Cacus,* and the Sculpture of the Piazza della Signoria." *Römisches Jahrbuch für Kunstgeschichte* XX (1983): 377–415.

White, J. "Paragone: Aspects of the Relationship between Sculpture and Painting." In *Art, Science and History in the Renaissance.* Ed. C. Singleton. Baltimore, 1967.

Wilk [McHam], S. Blake. *Fifteenth-Century Central Italian Sculpture: An Annotated Bibliography.* Boston, 1986.

Wittkower, R. and M. *Born under Saturn.* London and New York, 1963.

———. *Sculpture: Processes and Principles.* New York, 1977.

Zuraw, S. "The Medici Portraits of Mino da Fiesole." In *Piero de' Medici "Il Gottoso" (1416–1469): Kunst im dienste der Mediceer / Art in the Service of the Medici.* Ed. A. Beyer and B. Boucher. Berlin, 1993, 317–39.

Index